A ZACK SNYDER FILM

REBEL MOON

WOLF: EX NIHILO: COSMOLOGY & TECHNOLOGY

REBEL MOON: WOLF: EX NIHILO:
COSMOLOGY & TECHNOLOGY

ISBN: 9781803365220
e-book ISBN: 9781803366111

Published by
Titan Books
A division of Titan Publishing Group Ltd
144 Southwark St
London
SE1 0UP

www.titanbooks.com

First edition: March 2024
10 9 8 7 6 5 4 3 2 1

REBEL MOON ™/© Netflix. Used with permission.

Photography by Clay Enos, Chris Strother and Justin Lubin.

Did you enjoy this book? We love to hear from our readers. Please e-mail us at:
readerfeedback@titanemail.com or write to Reader Feedback at the above address.

To receive advance information, news, competitions, and exclusive offers online, please
sign up for the Titan newsletter on our website: www.titanbooks.com

A CIP catalogue record for this title is available from the British Library.

A ZACK SNYDER FILM

REBEL MOON

WOLF: EX NIHILO: COSMOLOGY & TECHNOLOGY

WRITTEN BY PETER APERLO

PHOTOGRAPHY BY CLAY ENOS, CHRIS STROTHER AND JUSTIN LUBIN

TITANBOOKS

CONTENTS

122 TECHNOLOGY

192 ACKNOWLEDGMENTS

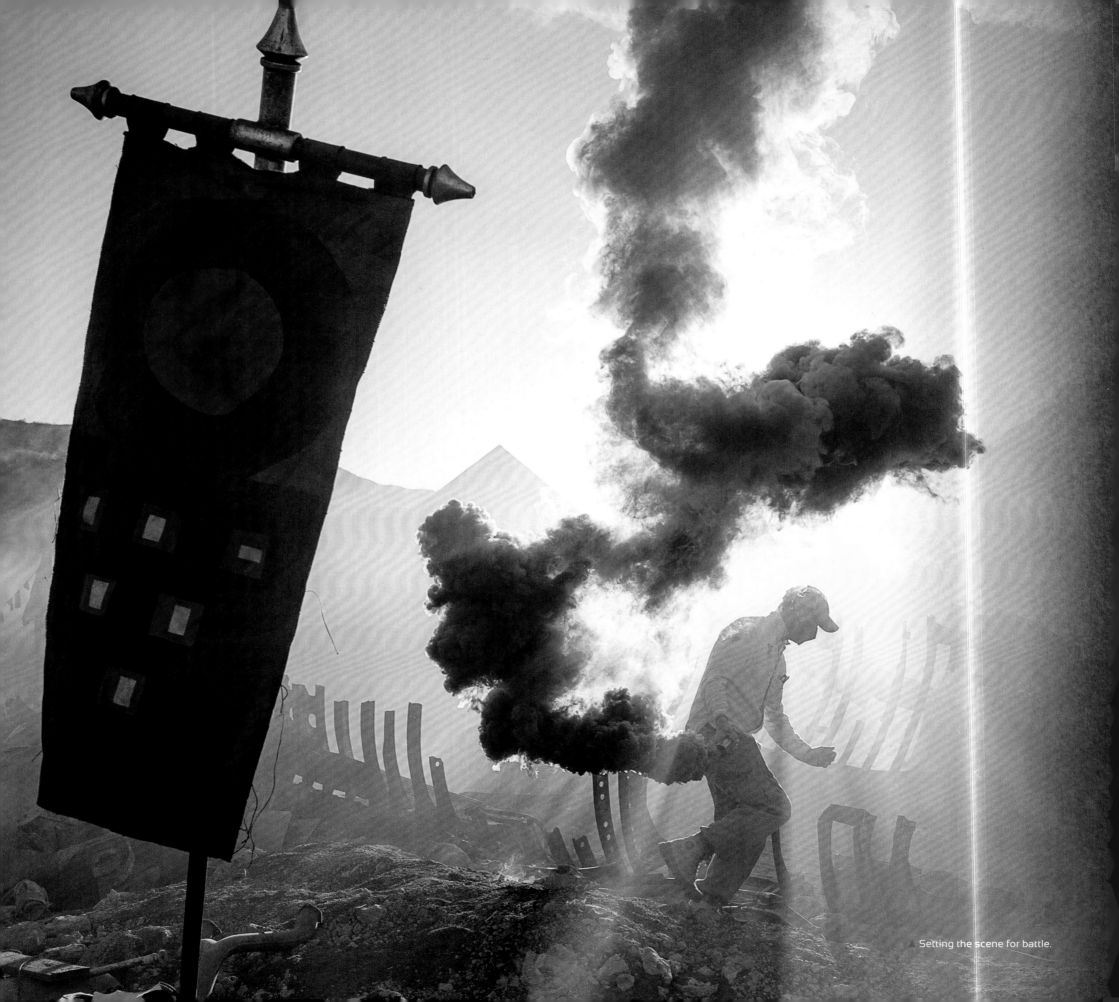

Setting the scene for battle.

COSMOLOGY & TECHNOLOGY
FOREWORD

"FOLLOW YOUR BLISS AND THE UNIVERSE WILL OPEN DOORS FOR YOU WHERE THERE WERE ONLY WALLS."–JOSEPH CAMPBELL

It's hard to conceive of an entire universe being brought into existence. Whether we believe the painstakingly constructed theoretical models pieced together by cosmologists, astronomers, and astrophysicists over decades, or we place our faith in any one of countless origin myths from around the world going back millennia, the widely held consensus is that our own universe essentially arose out of nothing. A limitless void, empty of all matter, enduring before even time itself—then all of creation suddenly burst forth. Willing a cinematic universe into existence, at least at the outset, is a lot like that, too. There are no boundaries, no restraints. The tabula is indeed rasa. There's a heady freedom in all that nothing. But you soon realize that something else is necessary to set off this act of cosmic procreation and see it through to fruition: Hunger. The hunger of the creative. That ache inside the belly of a ravenous wolf that can never be sated. It forces us to imagine endlessly what fantastic worlds might form in this blank, new universe of ours, what kinds of people might live, love, fight, and die there, and what marvelous machines those people might fashion to travel and conquer the sliver of the cosmos that they can see. Then, when you've imagined enough (although it's never enough), find a few hundred talented people wracked by that same hunger. Together, you will indeed create something out of nothing, an act of sheer will, simply because you must.

▲▲ A page of Zack Snyder's storyboards.

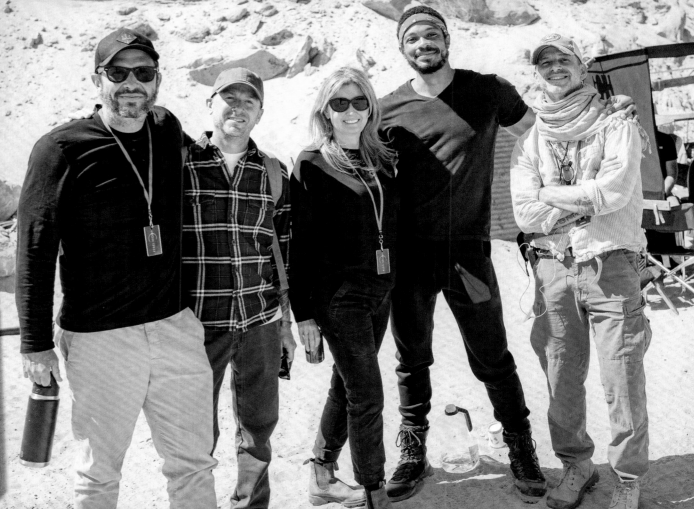

▲ (left to right) Producer Eric Newman, producer Wesley Coller, producer Deborah Snyder, actor Ray Fisher, director Zack Snyder.

COSMOLOGY & TECHNOLOGY
INTRODUCTION

MANY WOULD LOVE to create their own universes, but few make the attempt. Even fewer see them come to fruition in such a spectacularly realized manner as *Rebel Moon*. For creator Zack Snyder, this ambitious project is a culmination of fanciful dreams that go way back, eventually to childhood. "In incarnations, it's existed for probably twenty years," he says. "It's no secret that I'm a dork. I was a crazy sci-fi fanatic when I was growing up, and science fantasy is something that I've really loved. In a lot of ways, it's no different from mythological stories that you could set in, say, the Middle Ages or in some sort of fantasy world. We happened to choose this space environment to design worlds and tell a story that I've been thinking about for quite a while."

Snyder has been no stranger to fantasy worlds, super-powered characters, or extraordinary tech throughout his lengthy career behind the camera. But with the exception of *Sucker Punch* (2011) and *Army of the Dead* (2021), his cinematic forays have been mainly into intellectual properties (IPs) and franchises built by others. This time, however, the concept is all Snyder, something he and his team find incredibly liberating. "When we're creating a movie and there's previously existing IP, a large portion of the effort is put into finding a way to not only realize Zack's vision, but also making sure that we're checking all the boxes along the way and being aware of the previous canon. There are many, many people that have a relationship with that IP, and they will have expectations," producer Wesley Coller explains. "But it's great to have a blank slate, a canvas where no one knows where those lines are going to fall, or where that shading's going to happen, or what the palette is going to be. To have that freedom to tell stories and create characters, and build universes and worlds that can meet Zack's needs, with nothing else informing them except the story, is a fun adventure."

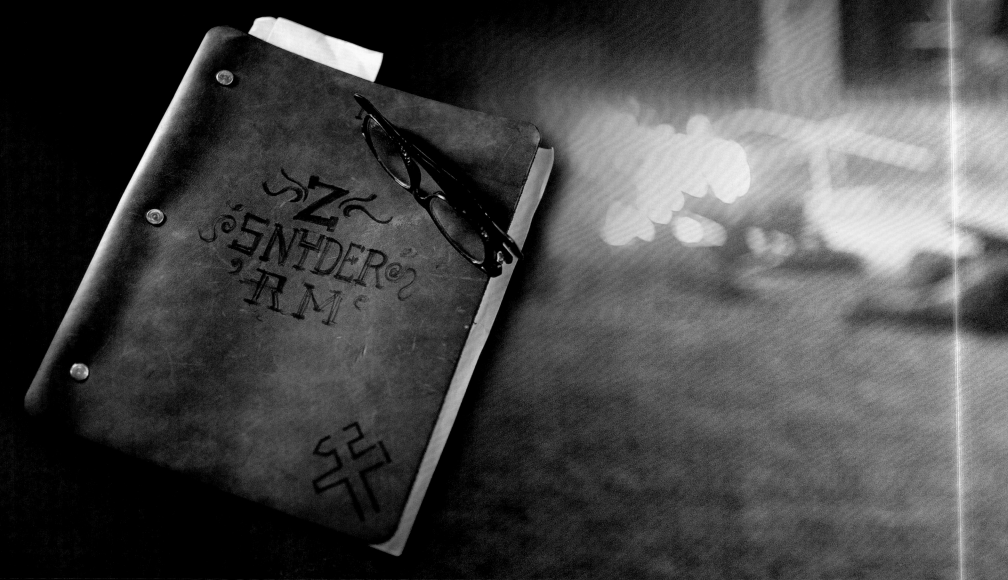

▶ Zack Snyder surveys the devastation wrought by the Motherworld.

◀ Snyder's *Rebel Moon* notebook.

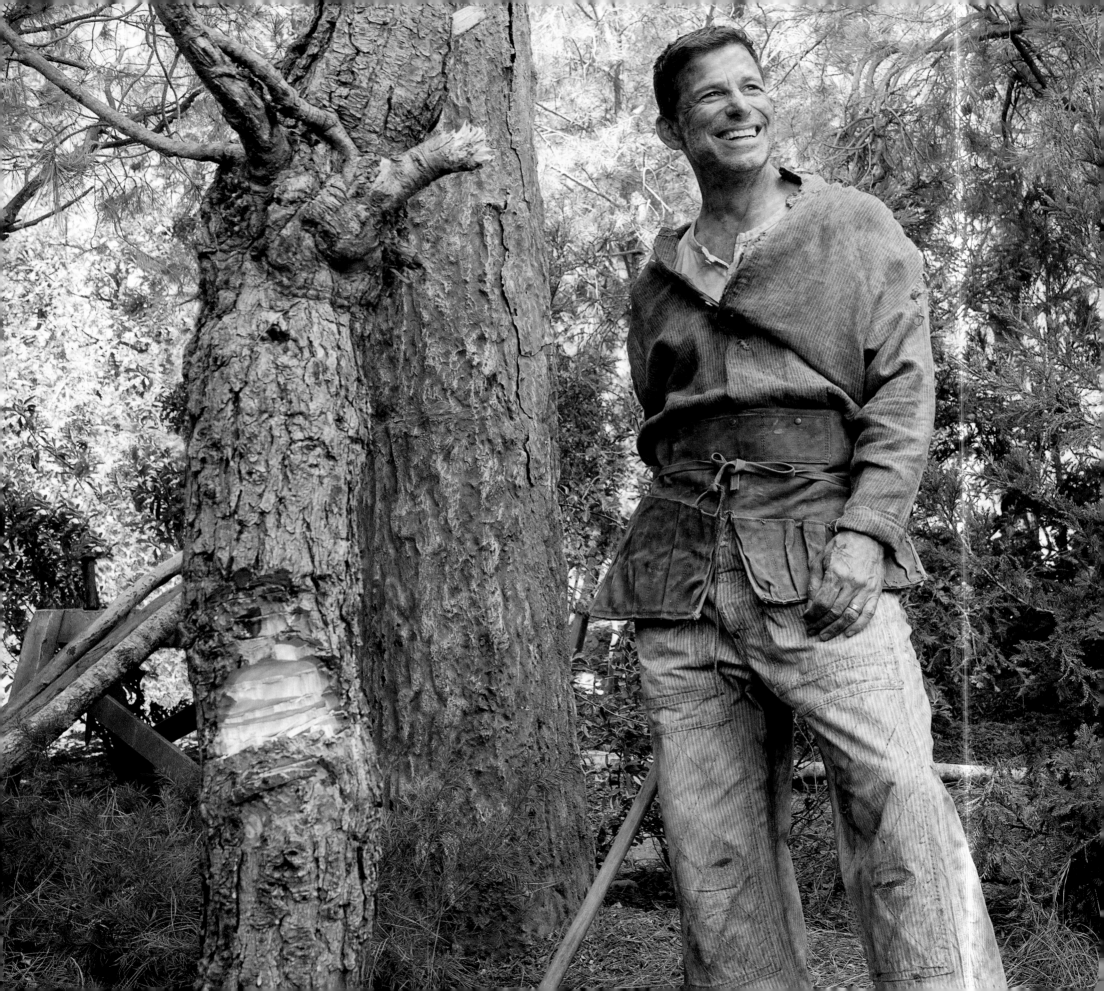

"Finally getting a chance to do it my way is really exciting and satisfying, I hope, for everyone," Snyder says. "I'm excited for the viewers to come to this and be immersed in a thing that they don't have a lot of reference for. They have to enter it, like going into some labyrinth, and really discover and explore, because it's simple at its core, but you can go just as far as you want, because the mythology is deep."

Producer Deborah Snyder is also excited about the open-ended possibilities. "What's so great about working with Netflix is they're willing to take risks. We're creating a universe. If you know Zack, you know that one of the things he's super great at is world building. So, for us to have this opportunity to create something wholly original that has different planets and different cultures and has a deep history... It's just an endless universe. It's endless where these characters can go," she says. Deborah Snyder adds that the incredible amount of detail that went into creating the *Army of the Dead* universe with Netflix, including its prequel, *Army of Thieves* (2021), laid the groundwork for this even more ambitious undertaking.

The narrative at the heart of *Rebel Moon* is a deceptively straightforward one: A small farming community is threatened by an overwhelming force from another world, and the inhabitants decide to fight back. "It's a story of a few against the many, impossible odds, good versus evil. There's a love story inside of it. It's sort of cleanly simple, which I am a fan of, and then the complexity gets to be laid over the top of that. It is a complex world with complex, overarching political stories, and the characters discovering their own heroic nature is a part of the movie," Snyder says.

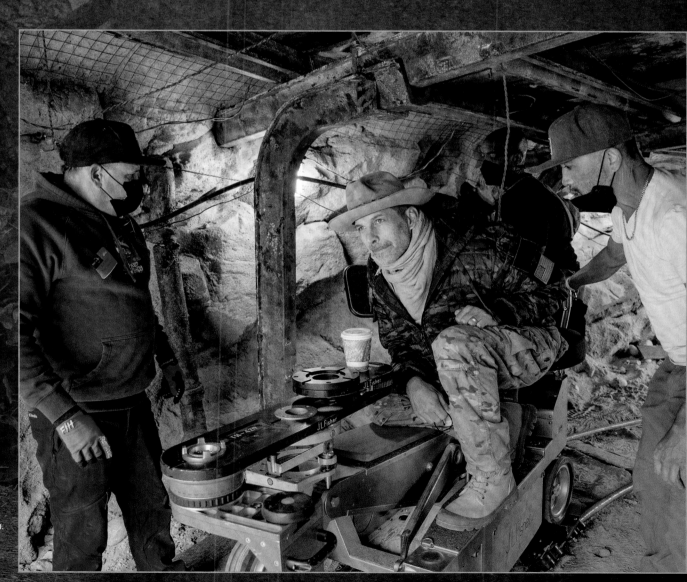

◀ Snyder adds "Veldtian lumberjack" to his long list of jobs on the film.
▶ Snyder lines up a dolly shot in the mine with the help of (left to right) Ryan Vonlossberg (B camera dolly), Kyle Davis (grip), and Darin Wong (B camera dolly).

In addition to being the director and a producer on the film, Snyder penned the screenplay with two previous collaborators, Kurt Johnstad and Shay Hatten. As with *Army of the Dead*, Snyder again served as his own cinematographer, but stresses that the look will be very different from that film. "It's an anamorphic film, so it's got a very big, widescreen look to suit the big farmland and big spaceships that we see in the movie. There's a very big studio vibe to the photography, very minimal amount of handheld," he explains. But like *Army*, practical sets were the norm, with green screens and digital effects reserved for the impossible. "I'm really endeavoring to keep those green screen environments full of the same texture and feeling as the real, physical locations."

Another filmmaking partner who signed up for the challenge was producer Eric Newman, whose professional relationship with Snyder goes back twenty years. While he describes his role on a film in many ways as the "ringmaster of an insane circus," Newman always knew that *Rebel Moon* was in steady hands. "Our job is to ensure that the thing that Zack expects, the thing that Netflix expects, the thing that our audience expects, finds its way into reality. In Zack's case, thankfully, with his level of artistry, you're going to get pretty much what he told you he was going to give you. So, to be honest—and don't tell anyone this—producing a Zack Snyder movie is actually kind of easy," he says.

With Snyder wearing so many hats on the production, was there ever a danger he would overextend himself? Despite being on the same strict diet and punishing workout regimen he put the cast on, the fifty-something jack-of-all-trades showed no signs of slowing down. As key grip Didier Koskas puts it, "He never stops. He's running circles around us like he's half our age. He's just amazing." With that energy came a positive attitude that everyone found infectious. "For 150 days of shooting and so much pre-production work, a consistent topic that continues to be brought up is how people are so positive and motivated to be here. Even on the last day, the energy here continues to be electric," Deborah Snyder says. Perhaps the giant "Getting Zacktivated" posters had something to do with it?

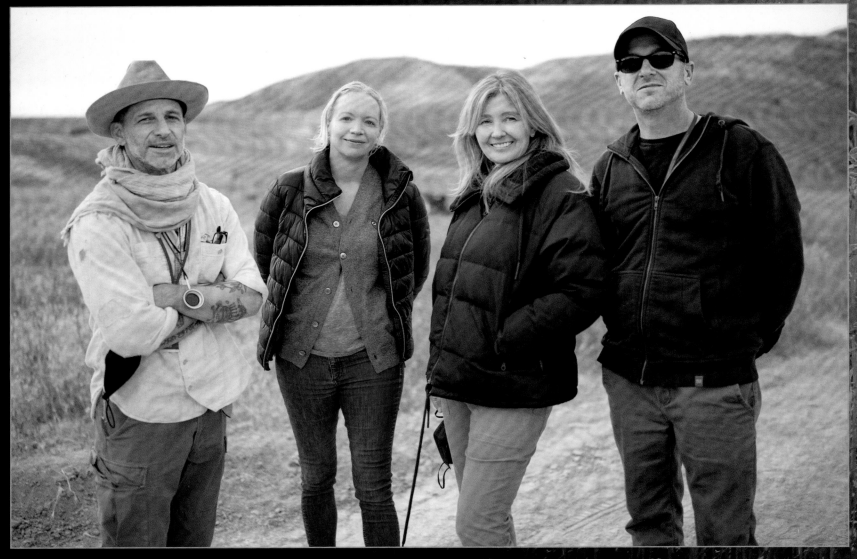

◄ Zack Snyder, executive producer Sarah Bowen, producer Deborah Snyder, and producer Wesley Coller.

► Zack and Deborah Snyder amid their acres of wheat.

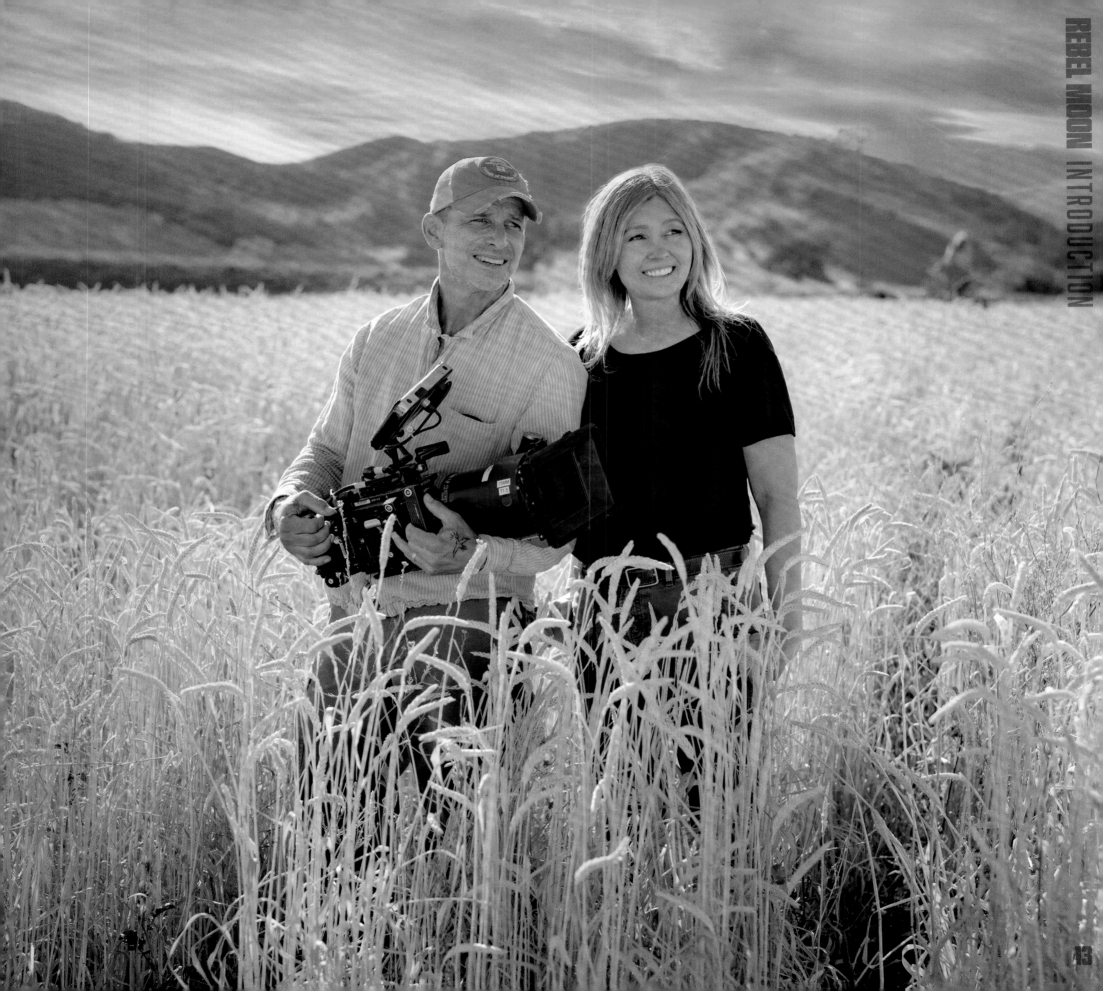

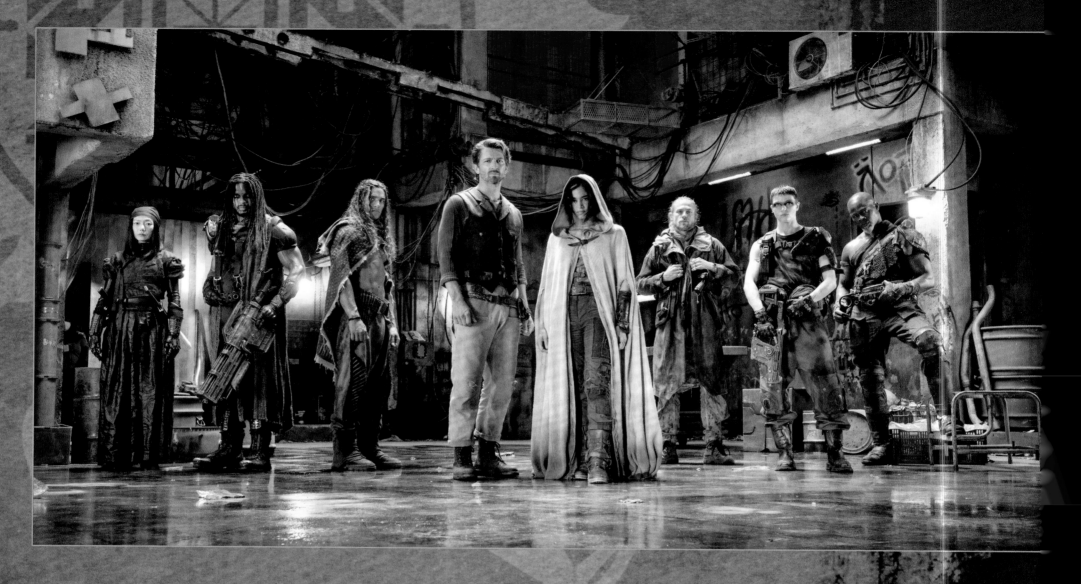

Certainly it helps if the person in charge is decisive and has a definite mental picture of what they want. "The thing that stays in my mind is how Zack's aesthetic is so crystal-clear focused. You could look at a hundred pictures and pick out Zack's vision in a second," says costume designer Stephanie Porter, who has worked with Snyder for more than a decade—a common trait among the crew. Some might fear that having one person with such a strong vision would result in stifling the creativity of others, but nothing could have been further from the truth. The feeling and practice on the set was one of true collaboration, as production designer Stefan Dechant explains: "It's almost like a call and response, as if you were in a jazz club. Zack's laying down that initial music, then you're going back and forth with him to create something that has more complexity to it, but always following the lead that he put down there first."

Nowhere was that collaboration more clearly demonstrated than when it came time to develop the sixteen worlds we would see. Snyder sat down with his international cast and incorporated many elements of their personal histories and ethnic heritages into the various cultures found around the Realm. Whether it was Algerian-born Sofia Boutella influencing the architecture of Kora's war-torn homeworld, Staz Nair lending Portuguese and Russian words to the language spoken on Samandrai, or elements of clothing from Doona Bae's native South Korea finding their way into Nemesis's wardrobe, each contributed something of themselves to the creation of the *Rebel Moon* universe. As Deborah Snyder explains, "We are living in a global world, and right now audiences want to see themselves in their movies. Representation is so important to us as filmmakers. When we cast this film we had a very organic opportunity in that we have all these planets, so we can have people from different walks of life, different ethnicities, different regions of the world, come together. We made a very conscious effort to do that."

Fundamentally, that is what *Rebel Moon* is all about: unlikely heroes from all over coming together to stand against an oppressive power that seeks to assert its dominance over all. For now, the story has focused on the struggles of one small farming community on a distant moon, but in the future, who knows? "The cool thing about this universe is it really is like a giant onion," Snyder says. "You could keep unfolding it for a while. I haven't reached the center."

▲ (left to right) Doona Bae (Nemesis), Ray Fisher (Darrian Bloodaxe), Staz Nair (Tarak), Michiel Huisman (Gunnar), Sofia Boutella (Kora), Charlie Hunnam (Kai), E. Duffy (Milius), and Djimon Hounsou (Titus).
► Snyder is ready to shoot.
▼ ▼ Concept art of Daggus.

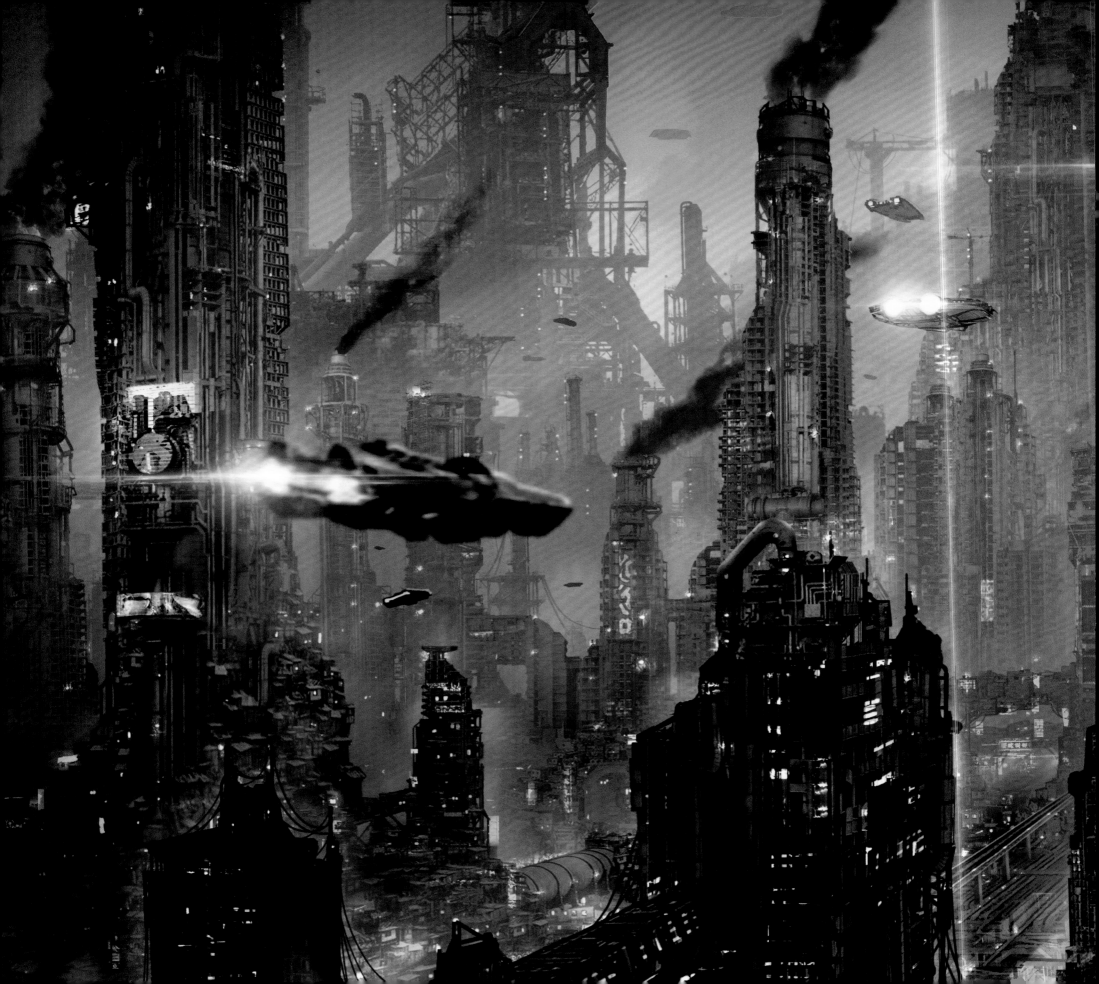

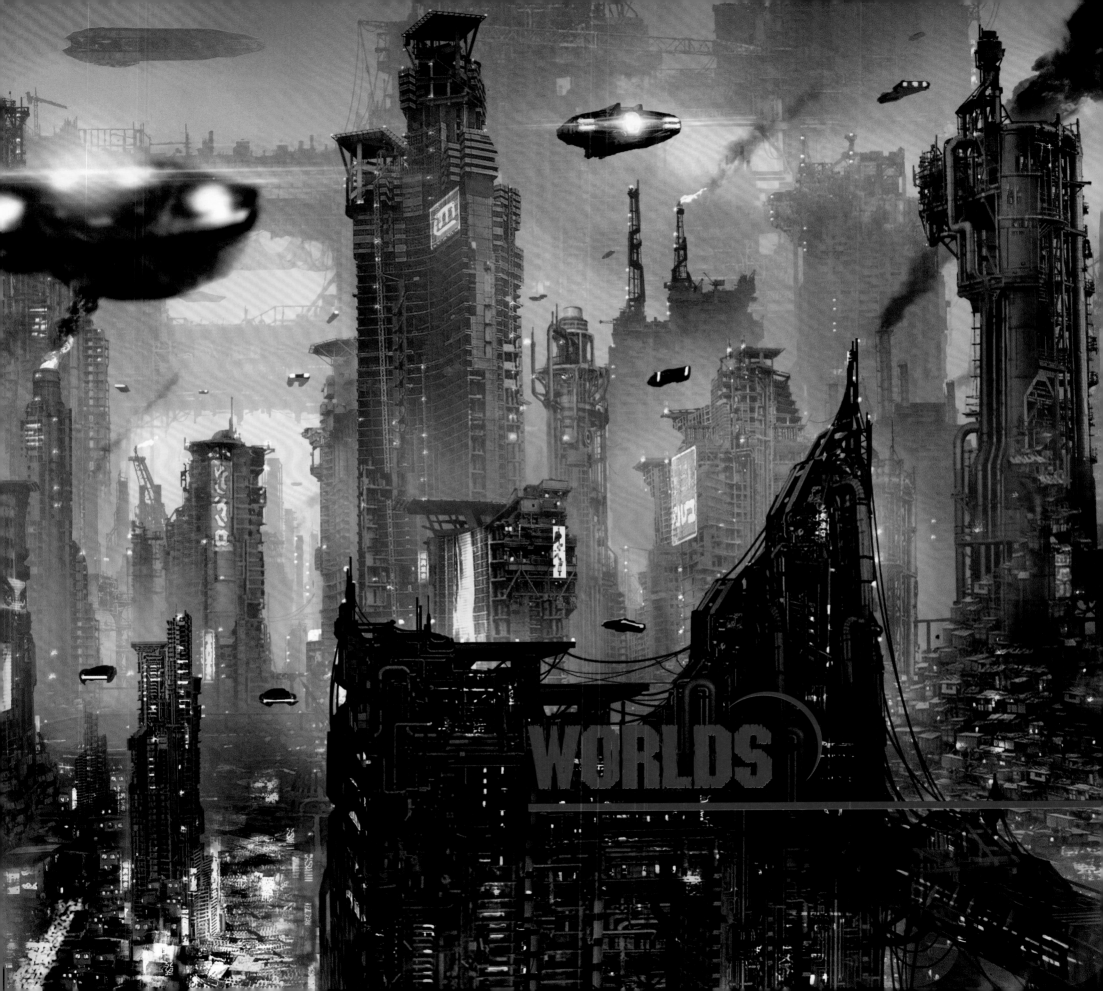

▲ Early concept art of Kora and the Veldt village bell silhouetted against the red light cast by Mara.

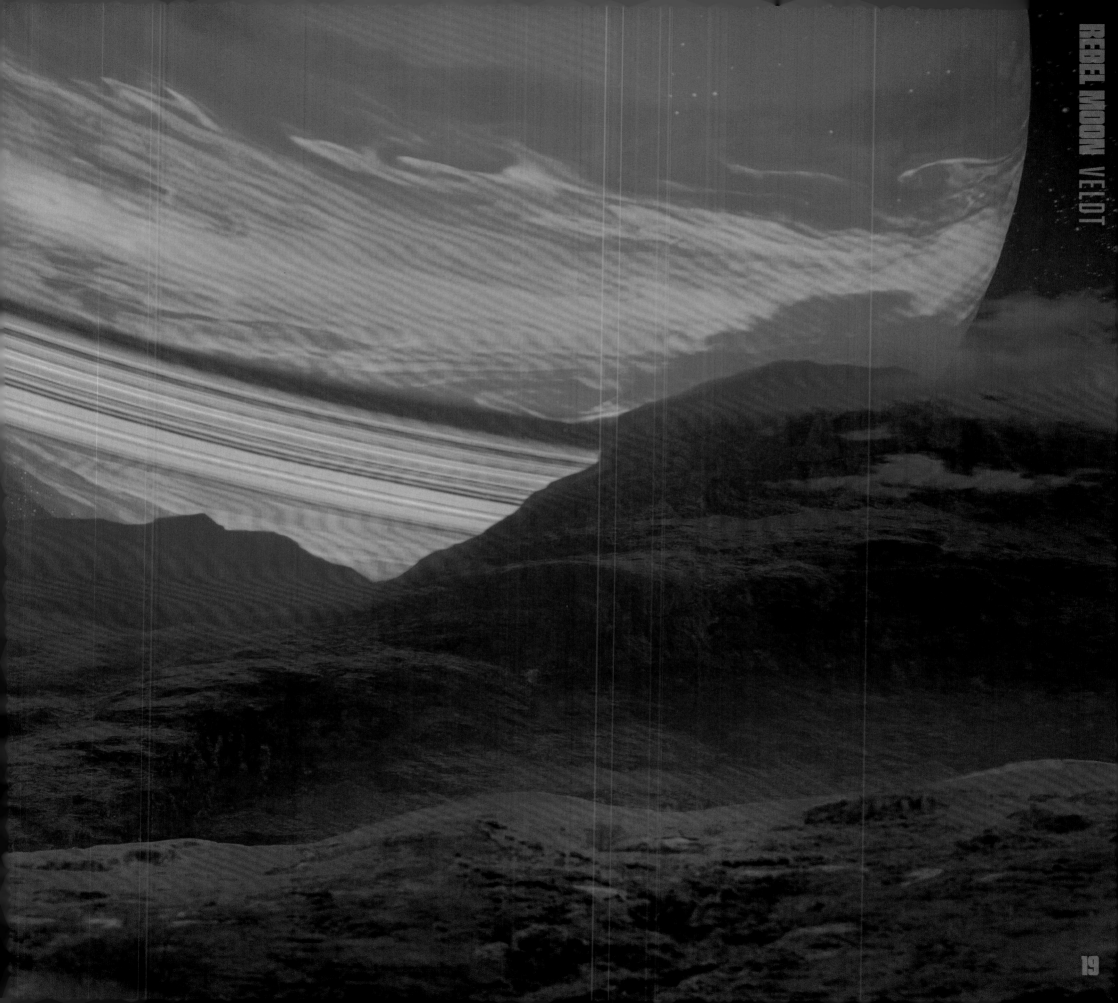

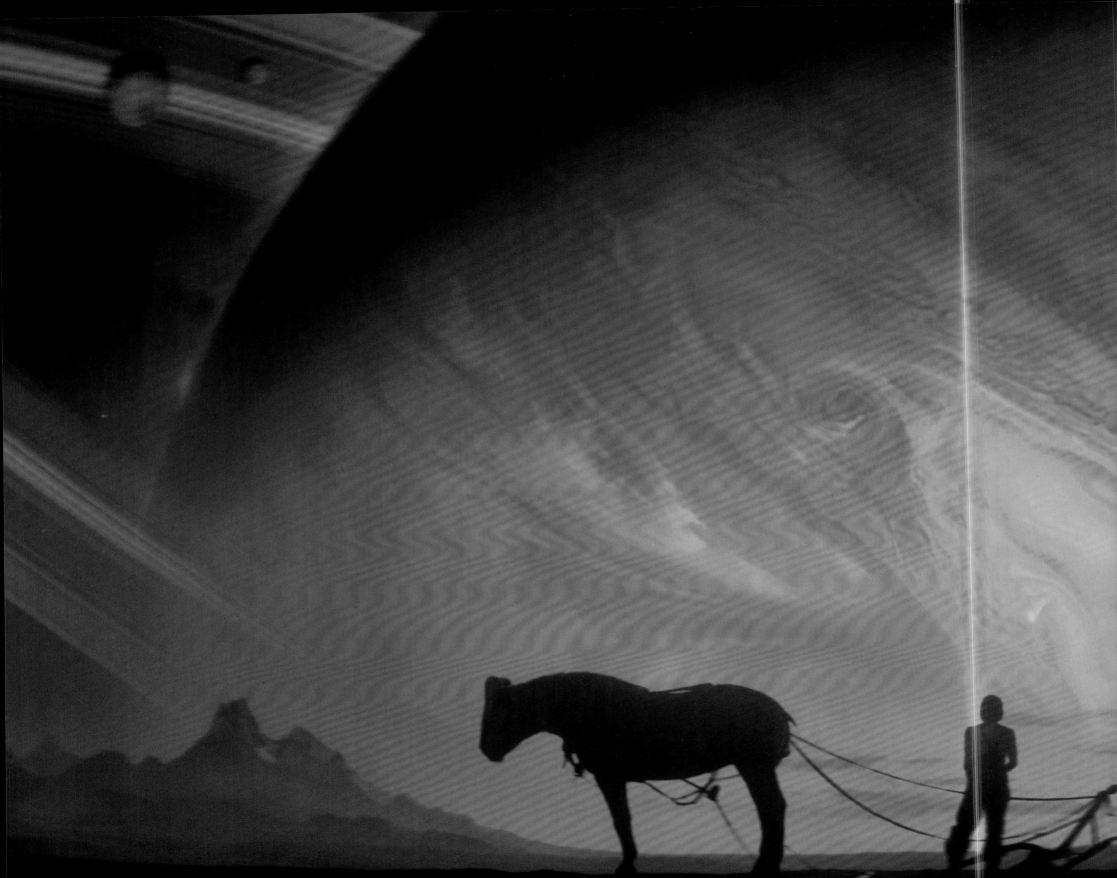

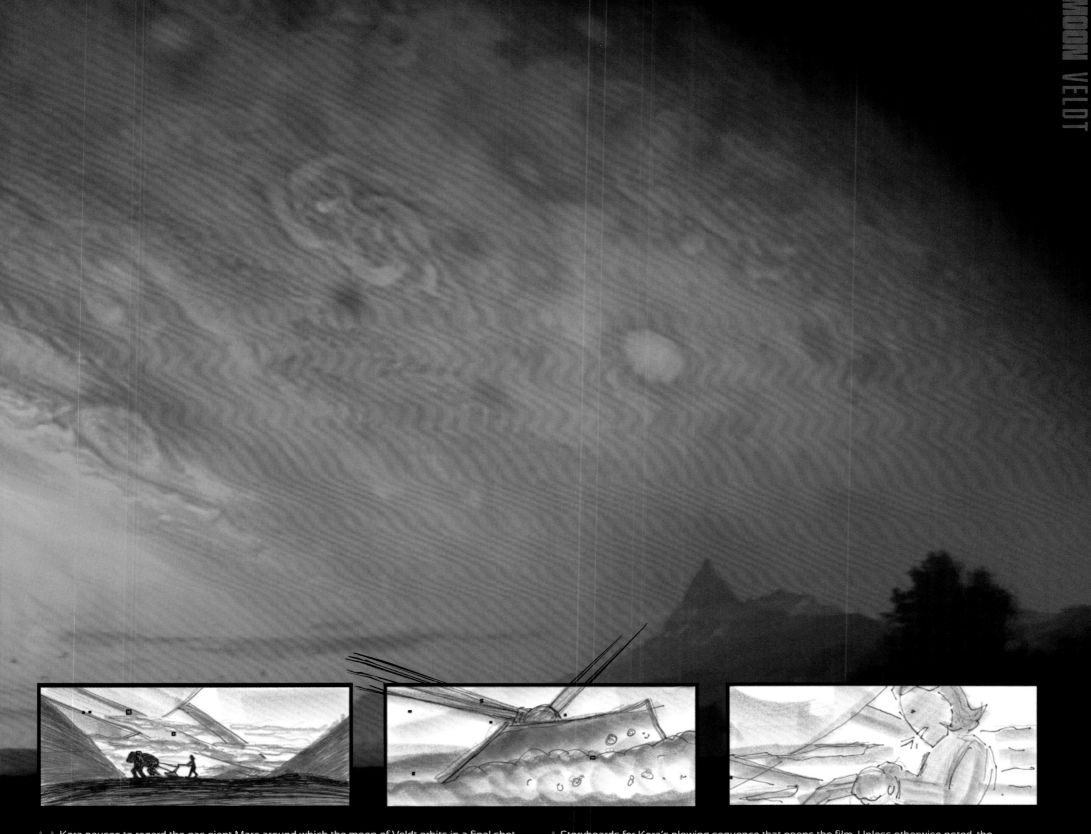

▲ ▲ Kora pauses to regard the gas giant Mara around which the moon of Veldt orbits in a final shot

▲ Storyboards for Kora's plowing sequence that opens the film. Unless otherwise noted, the

Far from the gritty hustle and bustle of Veldt's few trading hubs lies the peaceful farming village of Veldt, named after the moon itself. Well watered and blessed with fertile land, the village is bounded by dramatic mountain ranges and a wild, wooded countryside that offers plenty of opportunities for hunting. To call it idyllic would not be an overstatement, but there is always enough hard work to go around. Led by the elder Sindri, the village has weathered many trials through cooperation, mutual respect, and a deep connection to the land. It is here that Kora, although still an outsider, has begun to feel like she has a home—perhaps even a family.

To bring the village to life, Zack Snyder and his crew headed north of Los Angeles to the Blue Cloud Movie Ranch in Santa Clarita. Reshaping that arid Southern California landscape into a bucolic, temperate paradise turned out to be a massive undertaking—one that was so complicated it required two art directors—but it was a crucial element in building verisimilitude and the sense of kinship at the core of the story. "This place is the heart of the movie," producer Deborah Snyder explains. "Veldt is why we fight. It's our community, it's our family, and we needed it to be believable, we needed it to feel like it was alive, and

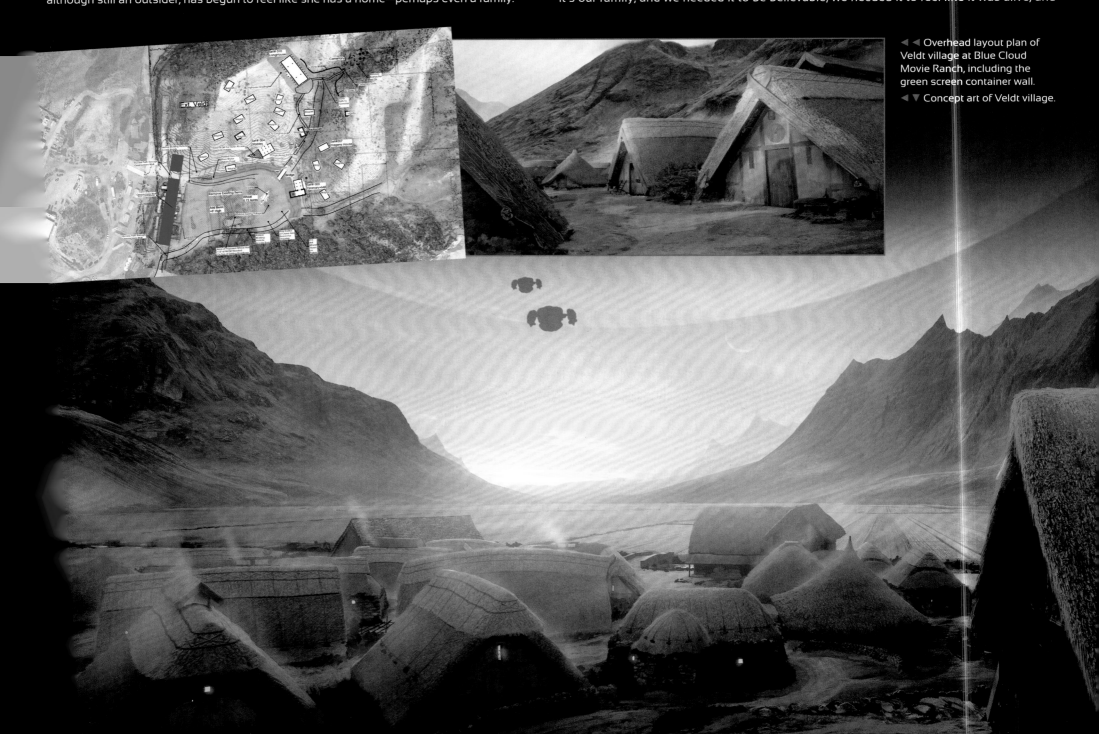

◄ ◄ Overhead layout plan of Veldt village at Blue Cloud Movie Ranch, including the green screen container wall.

◄ ▼ Concept art of Veldt village.

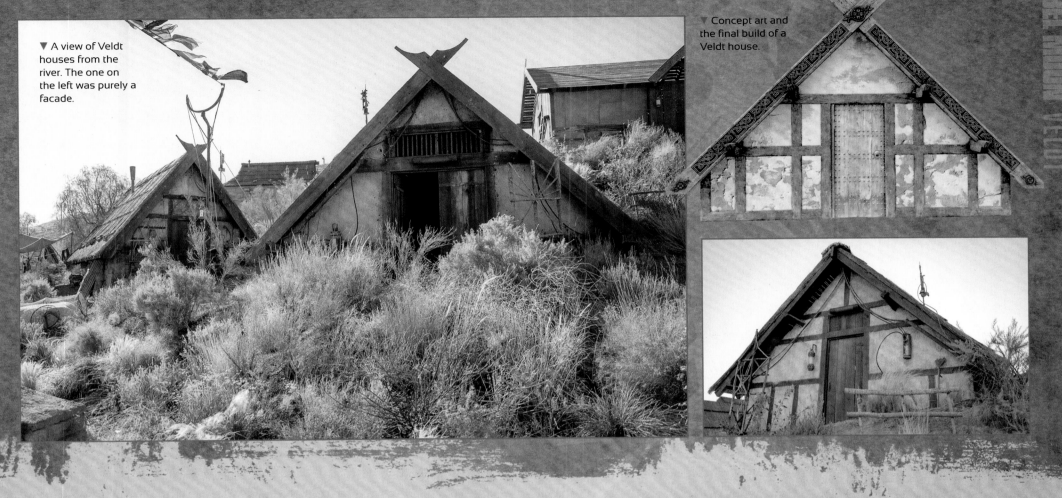

▼ A view of Veldt houses from the river. The one on the left was purely a facade.

▼ Concept art and the final build of a Veldt house.

that people actually lived here. There was nothing here when we arrived, except for our imaginations, and it was really fun to transform this bare land into whatever we wanted it to be."

Identified as a potential shooting location in late 2021, Blue Cloud became the frontrunner for a multitude of reasons. As producer Wesley Coller relates, "It gave us this beautiful hillside, this very natural village that is not shiny and sci-fi, but organic and accessible to invite our audience into our world, and it also gave us a footprint that could help to consolidate our production centers." The ranch eventually became a home base and, essentially, a temporary backlot, providing ample space not only for the village, but also prop and costume storage, the town of Providence set, the mountainous wilderness areas, a dropship crash site, and a portion of the all-important wheat fields.

The village itself consisted of some twenty buildings, a stone bridge, a central courtyard, stables, and even a flowing, artificial stream. While most of the buildings were facades or used as storage, quite a few were fully built-out practical sets that allowed filming inside them. But all that didn't appear overnight, and it required vision to imagine a village there. As unit production manager Bergen Swanson explains, when they first arrived the site was, "a parking lot with a bunch of junk on it, a bunch of wrecked cars and material from previous projects here at Blue Cloud. So we cleared up all the material that was there, we brought in I don't know how much soil—just fill soil, then fertile soil—compost, irrigation."

Inspired in part by Scandinavian architecture of the Viking Age, the filmmakers sought to achieve a very naturalistic and true-to-life feel with the village. For Snyder, job one for the art department was making sure the village "felt real and warm. And in the details, that these were artisans, these were farmers, who were deeply connected to the land. Their forms are very organic and natural, and the fabrics and the things they employed were very of the earth."

Production designer Stefan Dechant says, "From the very beginning, we really wanted to be grounded. We wanted to be as practical as possible. We're trying to give 360-degree sets.

▼ Storyboards for the arrival of Admiral Noble at the village.

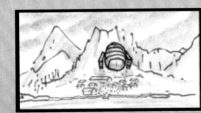

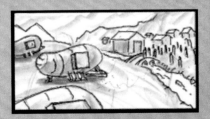

That allows the actors to know where they are, that allows the director to just be in the moment." The results can't be denied, in terms of the realistic spaces that were created to allow cast and crew to interact authentically with the environment. "In a lot of movies they would create a village that is at a smaller scale and let the visual effects team extend it," says Swanson. "But Zack is a director that moves around a lot. He's a very fluid, inspired director, so we try and give him as big of a playground to play in as possible."

Part of that fluidity and playfulness allowed for integrating architectural details from other traditions. "Zack was quite particular about certain elements, because they were plot-specific. Initially, we discussed Viking settlements, and later I introduced [Japanese] Minka house construction, which also appears in Providence," says production designer Stephen Swain. "The use of cut stone, sawn timber, and rudimentary joinery became key factors in the look development. How they constructed the roof, the sort of trusses, and how the beams work with the posts—being faithful to that look, but also pushing it slightly so that it didn't feel like we were doing this historical reenactment."

One example of how the village's ancient Nordic style fit in with the science-fantasy universe of *Rebel Moon* was in a certain design element

found on some of the thatched roofs. "We put this metal mesh on and had it held down by rocks," says set decorator Claudia Bonfe. "It was something that we had seen in some research of Viking buildings and roofing. Their mesh was more like rope, but we wanted to do a little bit of a futuristic feel. I found these big, metal nets and then put really beautiful, different-sized rocks to hold them down. We did eight of them with that detail."

For Dechant, the style and form of the village was rooted in understanding its people. "How do they live? How much technology is in there? It's a combination of what looks cool, and what feels right. It's an ethereal place to be. It's almost like a group of people who worship Steve Jobs live in this place, so it's just enough technology that it aesthetically and spiritually works for the people—what works in terms of the metaphor of harmony versus brutality. So, if the Motherworld is brutality, the harmony of these people is reflected in the design," he says. For Swain, "this was a careful balancing act, whereby the technology had to be apparent, but not obvious. Therefore, it was important to ensure any technology was functional and not a luxury."

What has always been understood by Snyder and his art department was that small-scale decorative elements are just as important as large-scale

▲ Storyboards from the end of the plowing sequence.

▼ Concept art of the view of the wheat fields from the village.

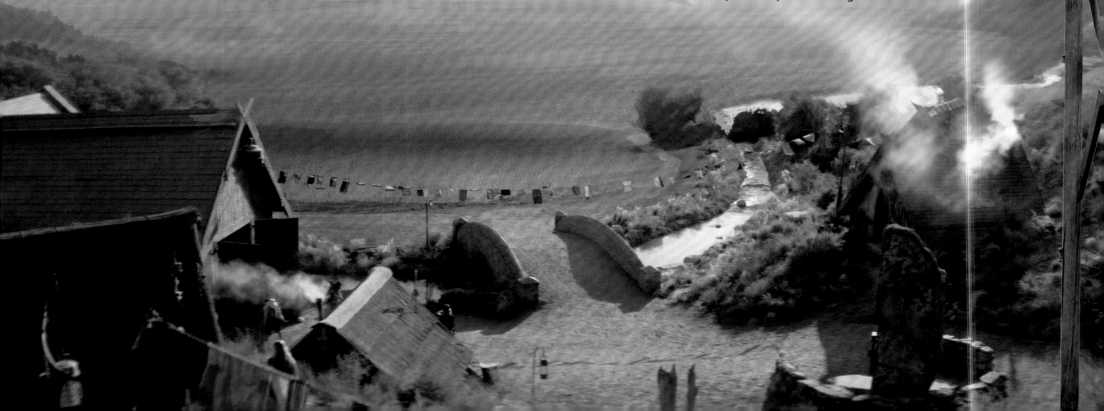

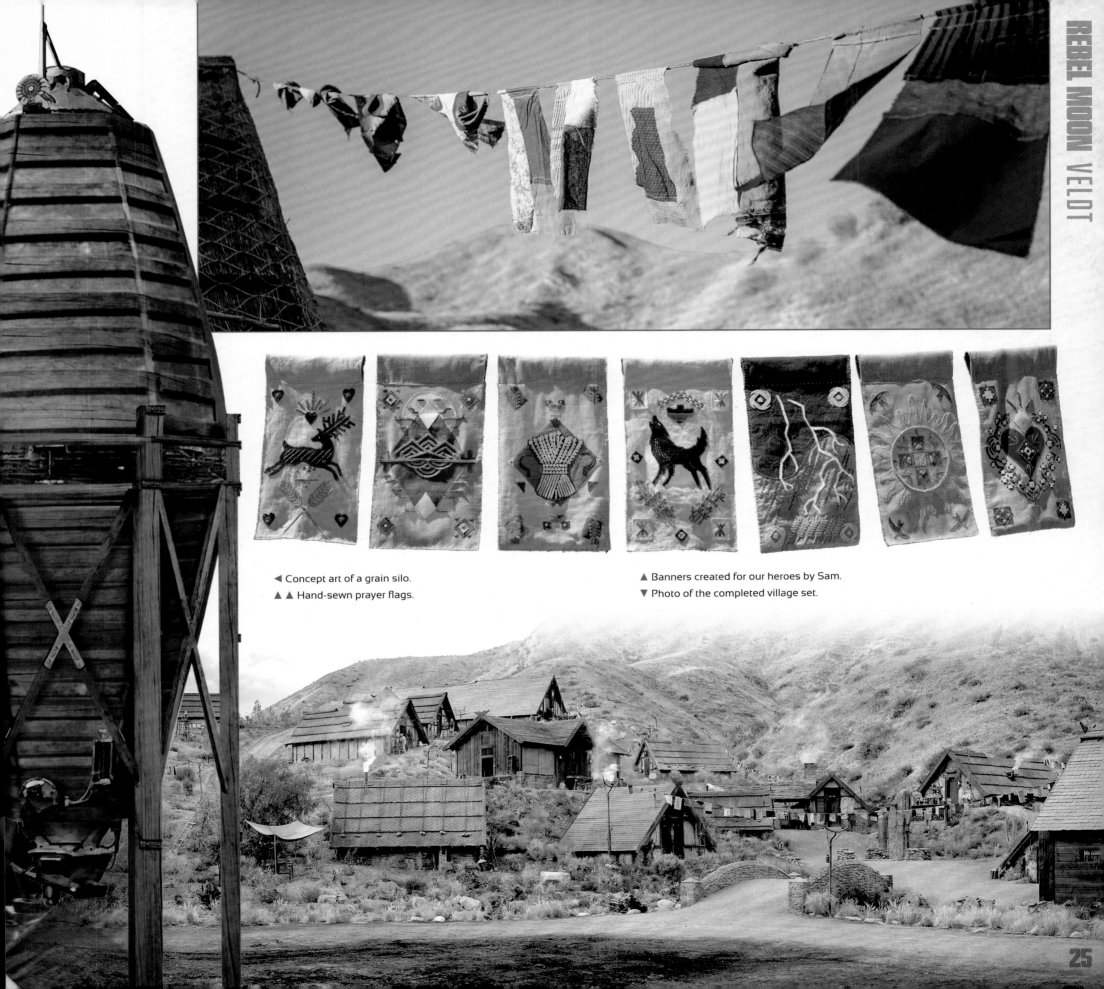

◀ Concept art of a grain silo.
▲▲ Hand-sewn prayer flags.

▲ Banners created for our heroes by Sam.
▼ Photo of the completed village set.

sets when trying to depict a community with deep roots. "My favorite detail of Veldt are all the handmade flags that you see hanging around, because they tell a story," says Deborah Snyder. "When you're creating these worlds that don't exist, it's so important that the details have a history. We talked about what religion was like, what the government was like, and what their symbols were like. All those things make the places you're creating real. The banners are just so beautiful, and they symbolize all the people of Veldt."

Inspired by prayer flags from the Himalayas, the banners added splashes of color to a village soaking in earth tones. "I had this reference photo of some real prayer flags that were hanging in the mountains, and [Zack] loved that and he wanted that throughout the village," Bonfe explains. "We spent about four weeks of two people hand sewing all of the strings of prayer flags. We used Japanese fabrics that we had found, and I found a vendor that had old turbans—I didn't realize how long turbans really were! That's where we got a lot of the color from. It got really windy out there. They took a beating with the sun, so we would have to take them down to resew them or reinforce them, and sometimes change some of the fabrics out." But all that hard work ended up being very gratifying. "I watched dailies, and they were very prominent in most scenes. I could tell Zack even moved some just so you could get a little corner of it, because after doing a lot of research and watching a lot of Zack Snyder movies—he loves fabric hanging, and flags or whatever blowing in the wind. It's beautiful in the way he does it," she says.

The care that went into the repairs and curation of the banners was also carried over to all the fabrics used in the village. This meshed very well with the other major design influence found on Veldt: Japan. "I fell in love with old Japanese textiles, and my vendor in Long Beach had a whole attic full of scraps, and blankets, and kimonos," Bonfe says. "We used a lot of *norens*, which are Japanese curtains that typically have some sort of symbol on it that will represent earth, water, or something in the sky, and some have a family seal. I was in heaven." She goes on to explain, "When they would mend things, there was a style that they would use called *sashiko*; it's this type of stitching. [The villagers on Veldt] are practical. They don't have any waste. Everything has a purpose. They repurpose it, recycle it. So there's a lot of mending done with the textiles. I talked a lot with Stephanie Porter, the costume designer, and looked at where she was going with the Veldt costumes. Lots of

▼ Veldt village under construction. The mill/granary is in the foreground.

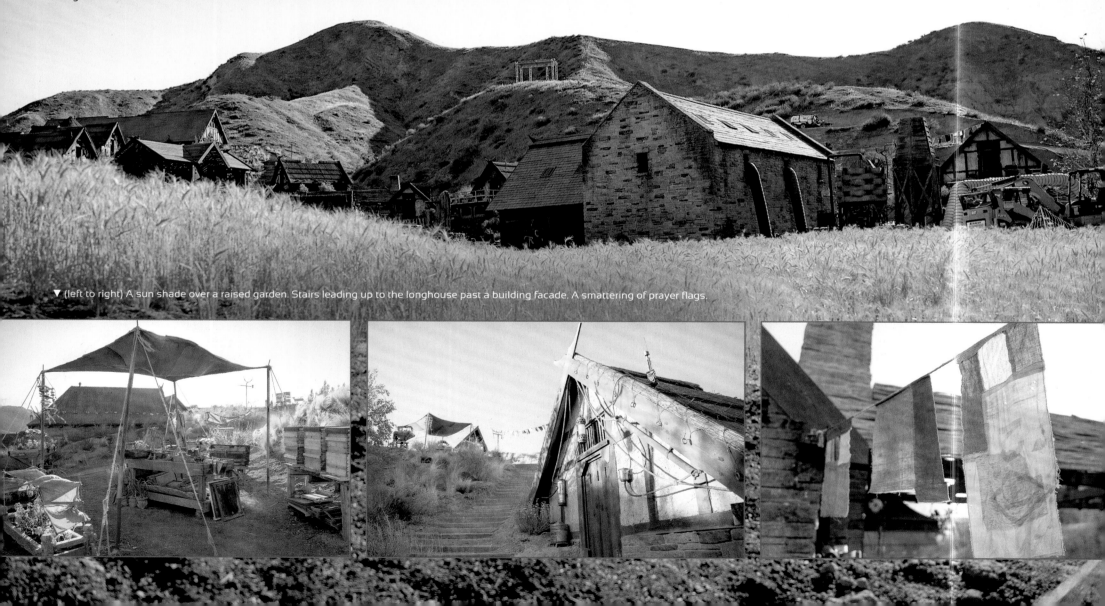

▼ (left to right) A sun shade over a raised garden. Stairs leading up to the longhouse past a building facade. A smattering of prayer flags.

patches on the shoulders. Again, very practical and no waste. They keep mending their clothes." The deep recycling ethos of this farming village even extends to worn out hardware and tools, such as reusing an old yoke to hang a tapestry, or putting a broken rake back into service as the arm of a scarecrow.

"Zack kept referencing the movie *Days of Heaven* [1978], and he loved a scene where they had this custom canopy made with some posts for some shade for the farmers. So we did that quite a bit—we made ten or so shade areas with low canopies, using some of our fabrics we got from Japan, so they could have their breaks during the farming. Those made it into the scenes quite a bit," Bonfe says.

Charlotte Maggi, who plays Sam, found that working in the village was a surreal experience: "It felt like a real town. It felt like people were actually living there, in its own, weird way. There's a lot of that Scandinavian influence to a lot of the houses, so you feel like you are in some crazy, crazy village in the 1800s in Norway or something. That's what it reminded me of the most. It definitely felt ethereal."

"The minute we scouted this place, I knew it'd be special," says Coller. "But the first day that we had a village full of people, and villagers in costume, smoke coming out of the little stacked chimneys, the village came to life. It was in that moment that I was in awe of what this place is and what it will be in the film. And to think that what we're looking at is the tactile, dusty, windy, organic version of it, and that above us there's still yet to come a giant gas giant planet and this magical, otherworldly landscape beyond the ridge we're seeing now. We could walk in and touch the dirt and feel the breeze and have this interactive moment, but beyond that, it would continue to grow into this amazing science-fantasy landscape."

VELDT SCRIPT

A B C D E F G H I J K L M

N O P Q R S T U V W X Y Z

The rune-inspired alphabet created for Veldt.
Some examples of Veldtian props and set dressing.

To achieve that desired level of science-fantasy expansion of your world, sometimes you need to lean more heavily on digital effects. That, however, requires some planning and preparation in order for this digital extension using computer generated images (CGI) to blend seamlessly with the lovingly detailed practical sets. One of the positives of the Blue Cloud location was that it had space for a truly enormous green screen just beyond the ridge past the wheat field. Fitted together from 104 shipping containers stacked five high by six wide, complete with an opening for trucks to pass through it, the structure took four months to construct. It provided a backdrop that would eventually allow shots of any number of spaceships swooping across the fields or vistas of magnificent, distant mountains to be inserted. Visual effects supervisor Marcus Taormina says, "It's the sheer expanse that we want to portray out there. It'll give us the opportunity to have a lot of play in post-production—but I kid you not, it's not large enough!"

The wall aided the filmmakers with in-camera effects, as well. "The other nice thing the container wall afforded us was a place to put this giant set of lights which pushed this beautiful amber light—this reddish, rusty light—over the village. That's the light being thrown by the gas giant planet that is suspended in the sky above Veldt," Coller explains. Another, smaller, horseshoe-shaped wall of containers to hang green screens was also built on the ranch for use in scenes where more wraparound images were needed.

It's important to appreciate what a Herculean task the construction at Blue Cloud was. "Just the scale of the build became a thing to be managed," says Coller. "In addition to all these buildings, all of the grading we needed to do, we needed to put in roads that would be on camera, but support roads as well. I always like to equate it to what we did on *Watchmen*—we built a big city block, and this is our rural, otherworld version of that."

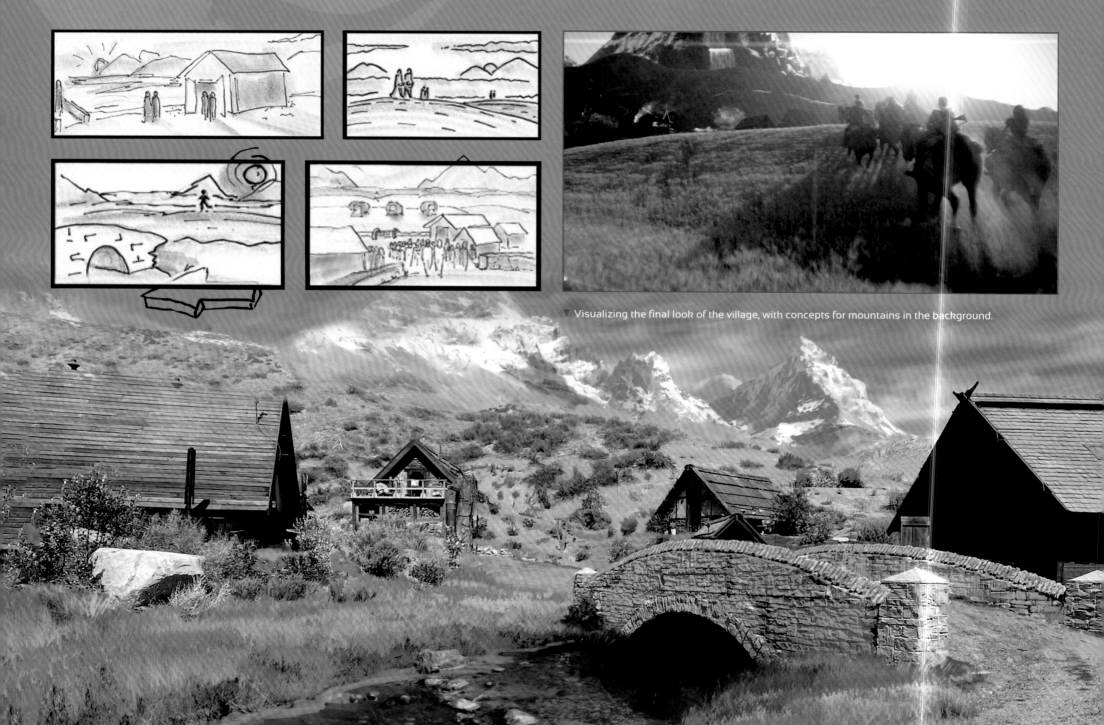

▼ Visualizing the final look of the village, with concepts for mountains in the background.

WHEAT FIELDS If the Veldt village is the heart of the film, wheat is its lifeblood. The village's existence, quite simply, depends on it. Village life is wholly organized around this vital crop, and the inhabitants have become intimately attuned to the rhythms it demands: plowing, sowing, weeding, harvesting, repeat. But one cannot possess such a treasure without someone else coveting it. Whether Frederick the Great or Napoleon Bonaparte first said it, the axiom, "An army marches on its stomach," is no less true in the futuristic universe of *Rebel Moon*. So, when the Imperial Dreadnought *The King's Gaze* appears in the skies over Veldt and the famished bellies aboard it look down at the sea of golden grain below, the village is faced with almost certain annihilation, whether or not a shot is ever fired.

"Wheat is a character in our film," says Deborah Snyder, "and we shot it in all its progressions: The soil, and planting the seeds... we shot scenes as it was growing, and then, once it was grown, we harvested it." With something so integral to the story—and so tactile, as well—using artificial or CG plants was simply not an option. The filmmakers had to become farmers. The production eventually planted three separate fields of wheat: One immediately across the river from the village at Blue Cloud Movie Ranch; nine acres(!) at the P.W. Gillibrand Company in Simi Valley, California; and another, smaller field at Gillibrand, designated the "green wheat field." Beside providing authentic spaces for the cast to work and fight in, these fields would also be digitally manipulated, multiplied, and integrated with the village—turning several acres into hundreds. A fourth field was also harvested by the greens and set decoration departments so the stalks could be used as dressing at the main village set. Finally, the Snyders themselves got into the act: "At our house, we had two boxes of wheat, so we could see how it was growing, because we couldn't come out to location every day," Deborah explains.

▲ (left to right) Sky Yang (Aris), Stuart Martin (Den), Ingvar Sigurdsson (Hagen), and Charlotte Maggi (Sam) take a break on a hover wagon.
▼ The Veldtians head out for the harvest.

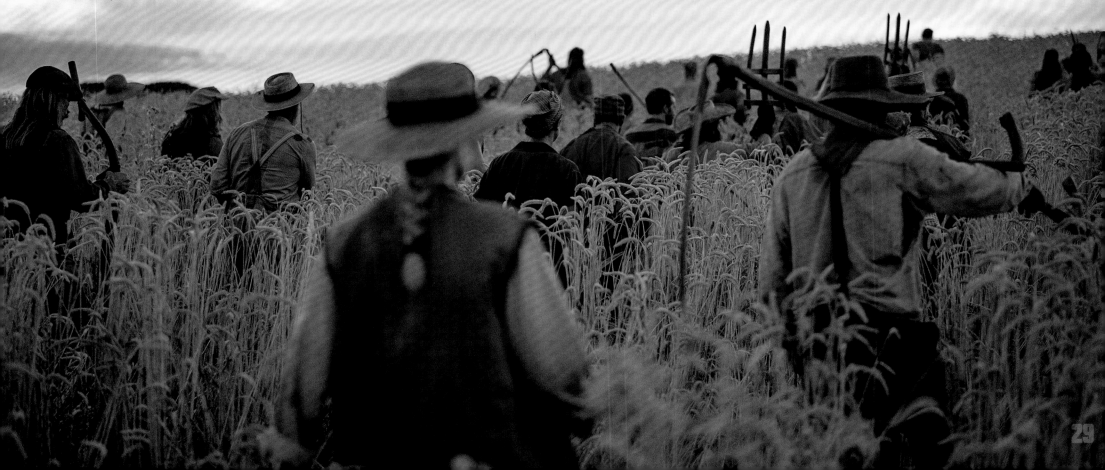

29

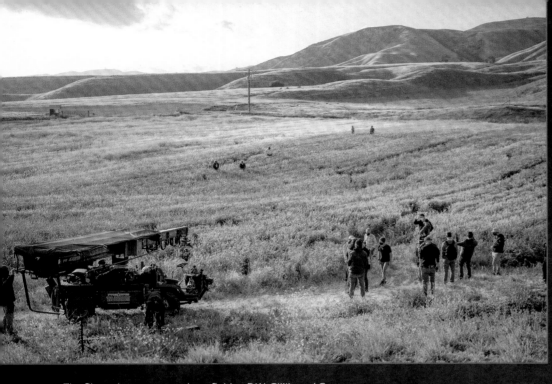

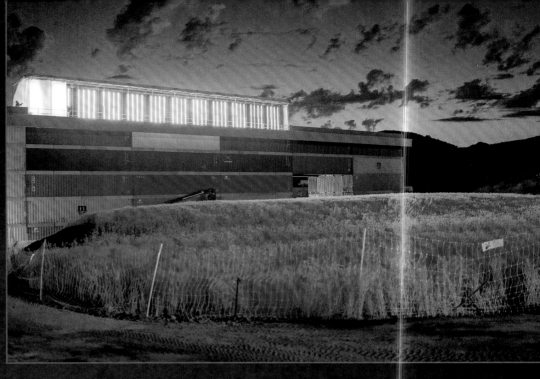

▲ The filmmakers scout a wheat field at P.W. Gillibrand Company.

▼ The Veldtians and our heroes head out for the harvest.

▲ Set atop the container wall, amber lights create the glow of the gas giant Mara over a wheat field.
▼▼ Kora and Gunnar return to the village with their new companions.

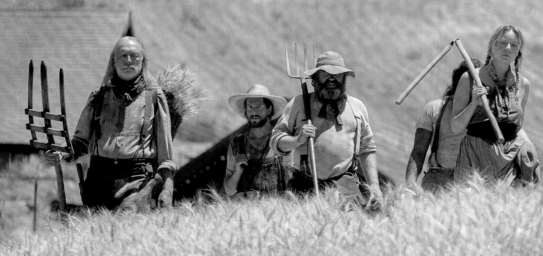

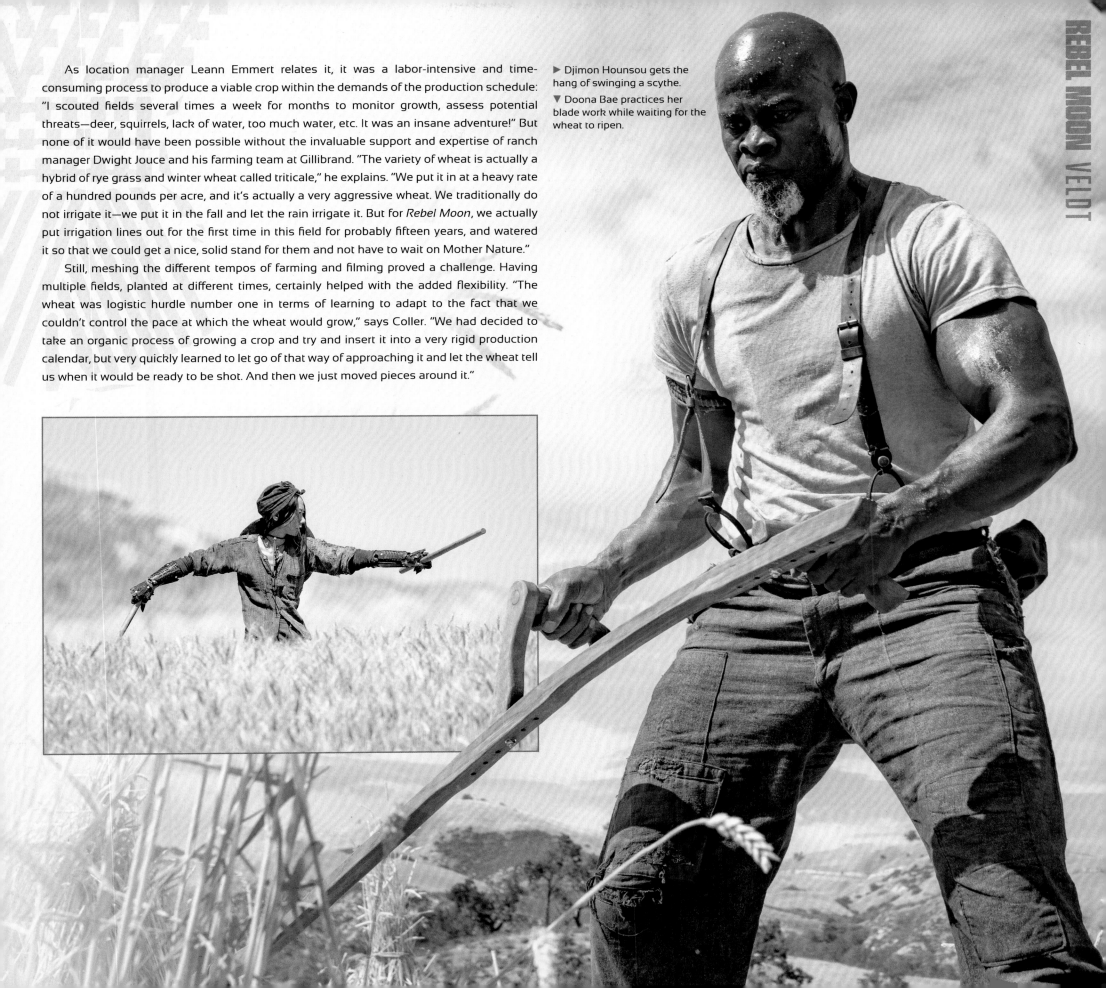

As location manager Leann Emmert relates it, it was a labor-intensive and time-consuming process to produce a viable crop within the demands of the production schedule: "I scouted fields several times a week for months to monitor growth, assess potential threats—deer, squirrels, lack of water, too much water, etc. It was an insane adventure!" But none of it would have been possible without the invaluable support and expertise of ranch manager Dwight Jouce and his farming team at Gillibrand. "The variety of wheat is actually a hybrid of rye grass and winter wheat called triticale," he explains. "We put it in at a heavy rate of a hundred pounds per acre, and it's actually a very aggressive wheat. We traditionally do not irrigate it—we put it in the fall and let the rain irrigate it. But for *Rebel Moon*, we actually put irrigation lines out for the first time in this field for probably fifteen years, and watered it so that we could get a nice, solid stand for them and not have to wait on Mother Nature."

Still, meshing the different tempos of farming and filming proved a challenge. Having multiple fields, planted at different times, certainly helped with the added flexibility. "The wheat was logistic hurdle number one in terms of learning to adapt to the fact that we couldn't control the pace at which the wheat would grow," says Coller. "We had decided to take an organic process of growing a crop and try and insert it into a very rigid production calendar, but very quickly learned to let go of that way of approaching it and let the wheat tell us when it would be ready to be shot. And then we just moved pieces around it."

▶ Djimon Hounsou gets the hang of swinging a scythe.

▼ Doona Bae practices her blade work while waiting for the wheat to ripen.

▲ ▼ Concept art and storyboards for Kora working the fields alone, before Noble arrives and changes everything.

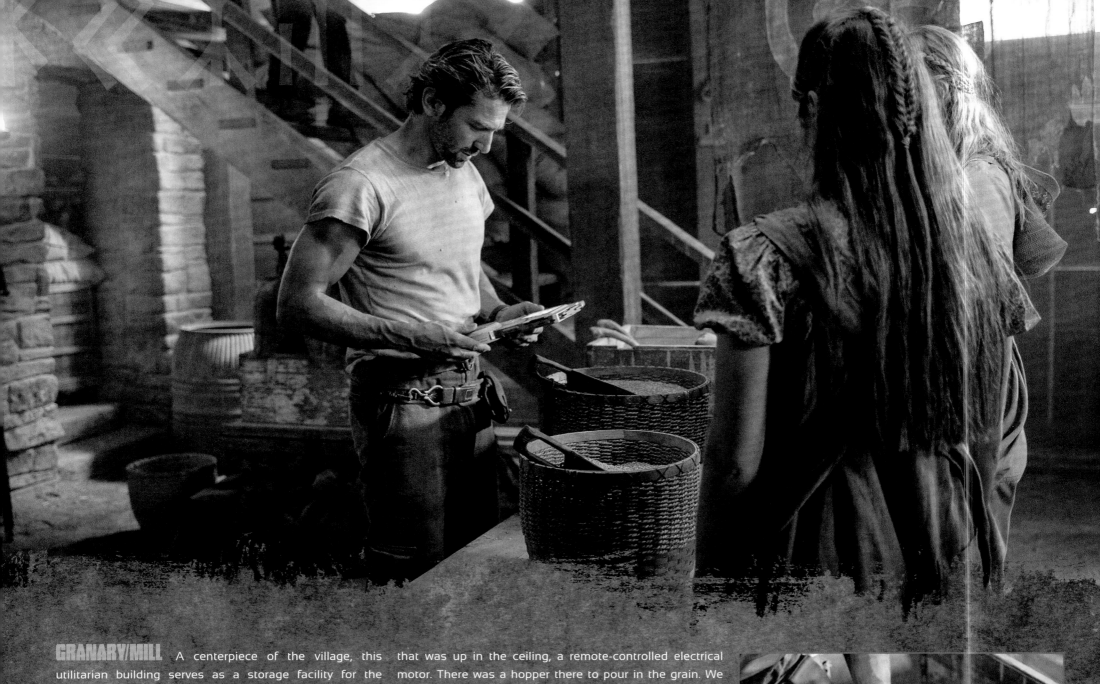

GRANARY/MILL

A centerpiece of the village, this utilitarian building serves as a storage facility for the community's precious grain. Additionally, it provides a means to process that wheat into flour, via a mill wheel powered by the stream that runs through the village. Situated just upstream from the stone bridge, the granary/ mill complex also includes a couple of external grain silos. Making that mill work—or at least appear to work—was the responsibility of the special effects department, headed up by supervisor Michael Gaspar: "I'm always intrigued by these old workshops that were run by steam, with these leather belts that come out of the ceiling. It's always running, but sort of loose when not in gear. When you engage it, it moves the gear over and engages the belt for that machine. So, we made the grindstone work off of an actual belt-driven device

that was up in the ceiling, a remote-controlled electrical motor. There was a hopper there to pour in the grain. We wanted to see flour come out of the other end, so we built a device that was pneumatic. There was an air bottle hidden in there, and we could push it through this long tube to shoot out a certain amount of flour. That was tricky."

It's here that stacks and stacks of grain bags find their way after the harvest. Around 2,500 grain bags were custom made, and then another 7,500 were outsourced. As for the filling, "We tried many things, and the critters were getting at them at night, the rats and the mice. So, then we did expanded polystyrene foam beanbag filling, which made them look like they were full of flour, but they were super light for the actors to carry," Bonfe says. Those 10,000 bags, however, took a three-person team weeks to fill!

Painstaking details and set dressing make the mill/granary come alive.

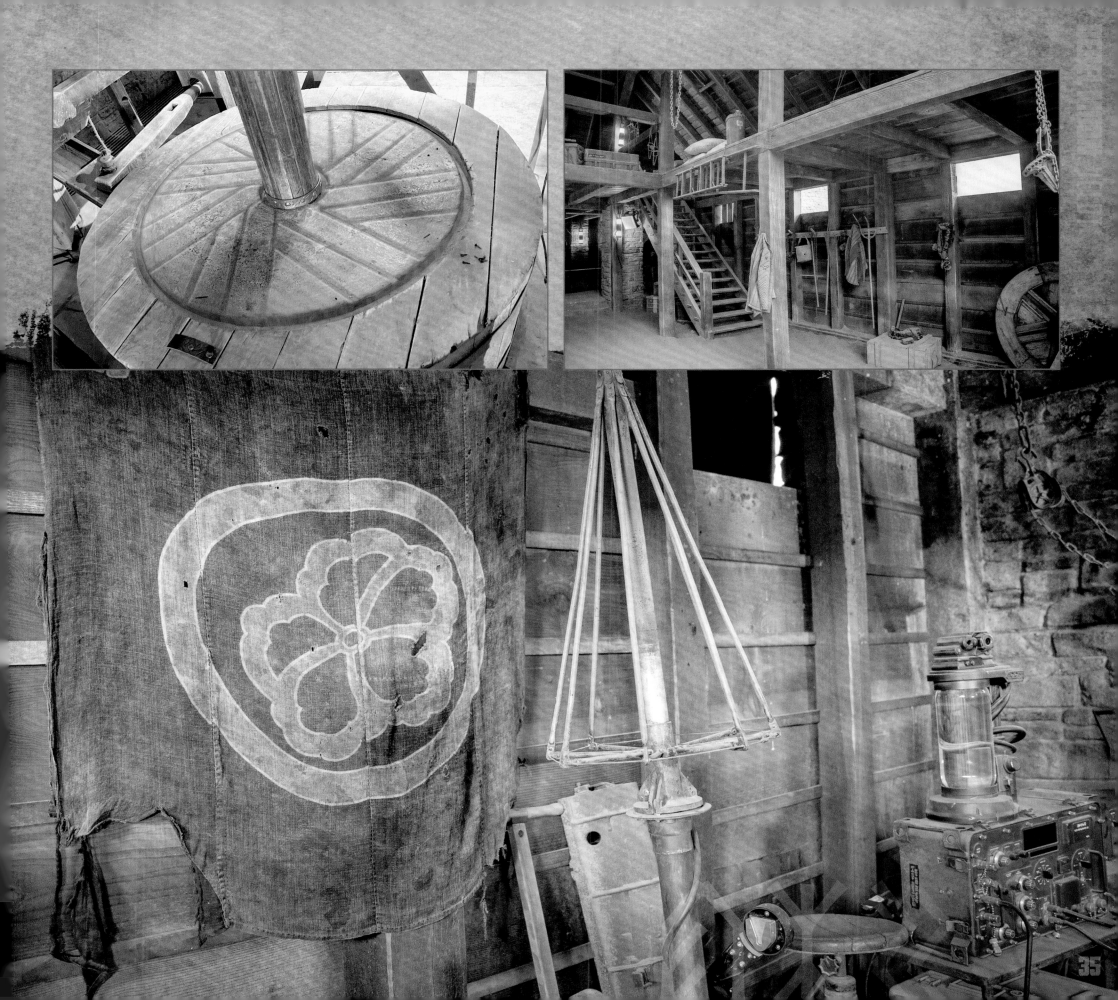

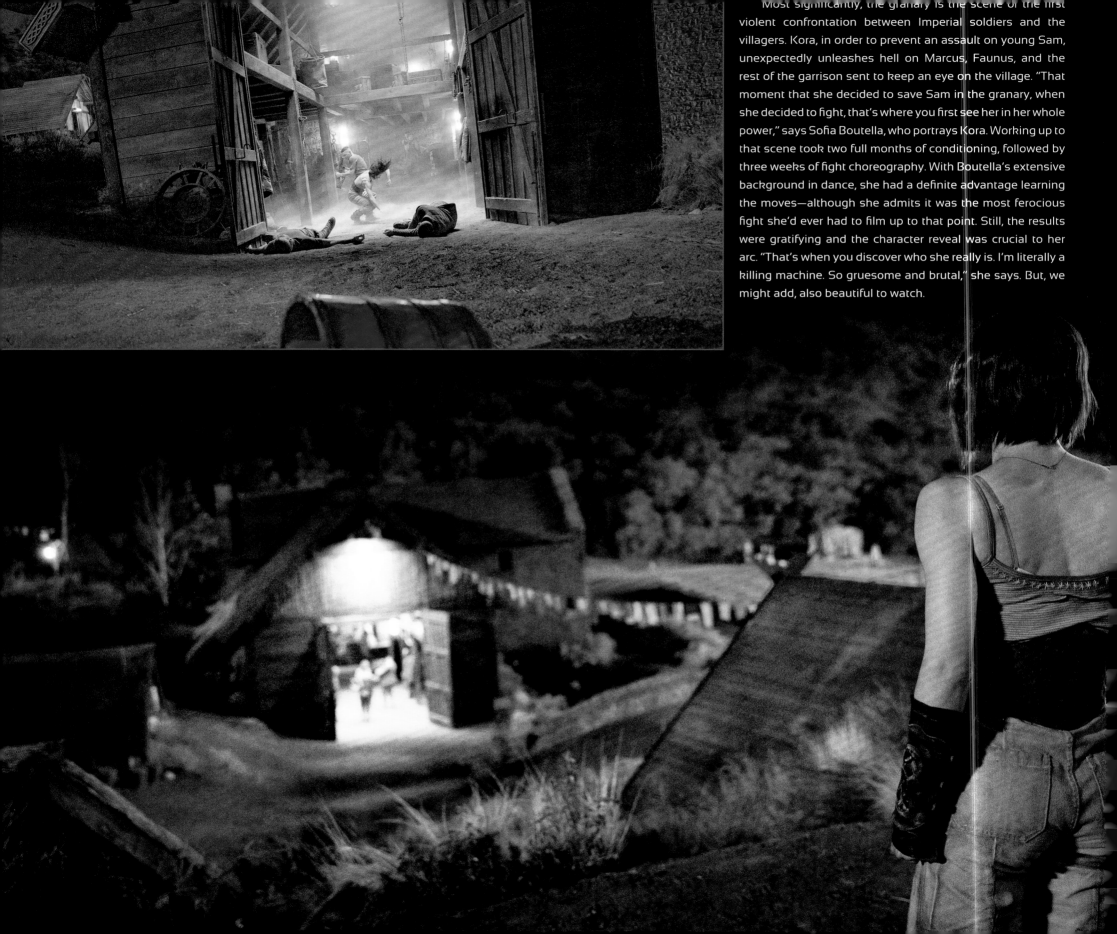

Most significantly, the granary is the scene of the first violent confrontation between Imperial soldiers and the villagers. Kora, in order to prevent an assault on young Sam, unexpectedly unleashes hell on Marcus, Faunus, and the rest of the garrison sent to keep an eye on the village. "That moment that she decided to save Sam in the granary, when she decided to fight, that's where you first see her in her whole power," says Sofia Boutella, who portrays Kora. Working up to that scene took two full months of conditioning, followed by three weeks of fight choreography. With Boutella's extensive background in dance, she had a definite advantage learning the moves—although she admits it was the most ferocious fight she'd ever had to film up to that point. Still, the results were gratifying and the character reveal was crucial to her arc. "That's when you discover who she really is. I'm literally a killing machine. So gruesome and brutal," she says. But, we might add, also beautiful to watch.

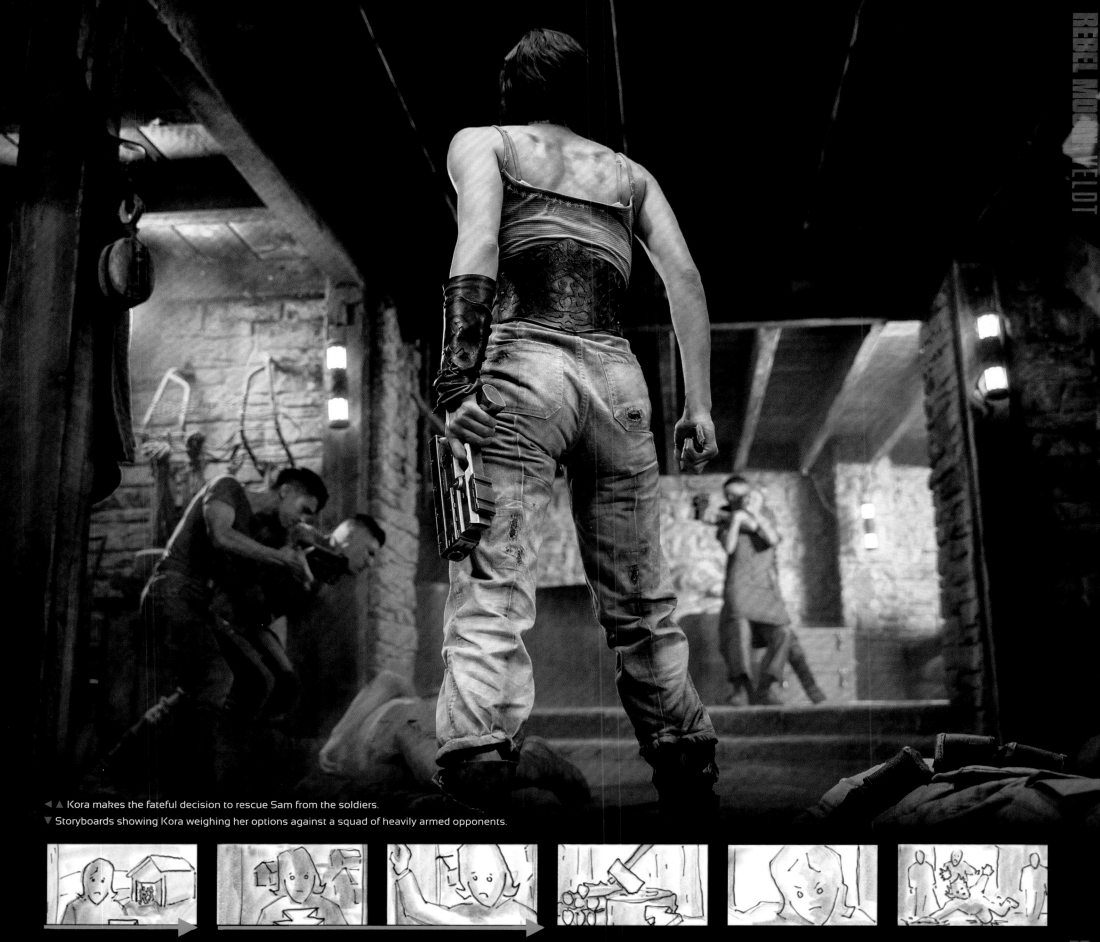

◄ ▲ Kora makes the fateful decision to rescue Sam from the soldiers.

▼ Storyboards showing Kora weighing her options against a squad of heavily armed opponents.

THE LONGHOUSE The longhouse is easily the most recognizable structure in the village for its clear Nordic influences. While standing at the center of the civic life of the community, it's actually situated at one end of the village. A multipurpose building, it's a meeting hall, used for public assemblies of the adult inhabitants of the village when thorny issues need to be hashed out, but it's also a festive space where folks can gather for dancing, feasting, and general merrymaking to celebrate any number of happy occasions. Strangely enough, the longhouse came before the idea to ground the village in Scandinavian architecture. As Zack Snyder explains, "We have all these communal scenes, whether it be dinner, or when they meet Noble—this idea of community. It really just made sense to me that they would have this kind of longhouse. That they're a slightly Viking-esque culture—a village with a sort of Scandi vibe to it—arose from the need for a communal building like that."

One way of highlighting the longhouse's role as an interior communal space was through the use of a repetitive decorative motif found throughout the village. The art department had developed the Nordic knot-work pattern, and had engraved it on long wooden trim on some of the facades of the buildings using a CNC (computer numerical control) router. "And then they used it again inside the longhouse, just as a detail to show that this was a pattern that was used only in this village," Bonfe says.

When planning the furniture for the longhouse and the rest of the village, however, designers were not feeling inspired by what they uncovered in research on Medieval Scandinavia. "There was nothing really interesting about it, and I felt like there needed to be something that was different than you would expect to see in a Viking village," Bonfe explains. "With Japanese influence being a big deal throughout this production, I started researching [ancient] Japanese furniture, which is so beautiful. But to be honest with you, a lot of it is so rare, and it would cost $10,000 or $20,000, and I can't afford that. So, I had an amazing fabrication shop full of carpenters, welders, people who ran our CNC routers and 3D printers. What those longhouse tables were based off was, I found a small Japanese desk with these really cute legs. I had my specialty set designer draw it up as larger, eight-foot cafeteria tables. Again, taking the idea of mending—they did the same thing on the furniture. They incorporated nails into something that looks so beautiful; it looks like they did it for decoration, but it wasn't. It was just to fix something."

Giving the tables that "lived-in look" was a whole process. "They may look like antiques, they may look like they're a hundred years old, but they're only a few months old," says set designer Andrew Reeder. "It's the aging process we do. We wire wheel the wood to take out the grain. We'll burn it a little bit to make the grain look old, but this is mostly brand new. We got some recycled wood from some places, but these are hand-pinned together with wood."

As for the benches, Bonfe says, "I had originally drawn benches that matched the table. Zack liked it, but instead of one long bench, he wanted to make it two smaller, four-foot benches. That's so it's easier for him to shoot around, and the actors can get in and out, and we can move the seats better." That table and bench combo was such a hit, "Everybody asked if they could have one after the show. It made us feel really good," she says.

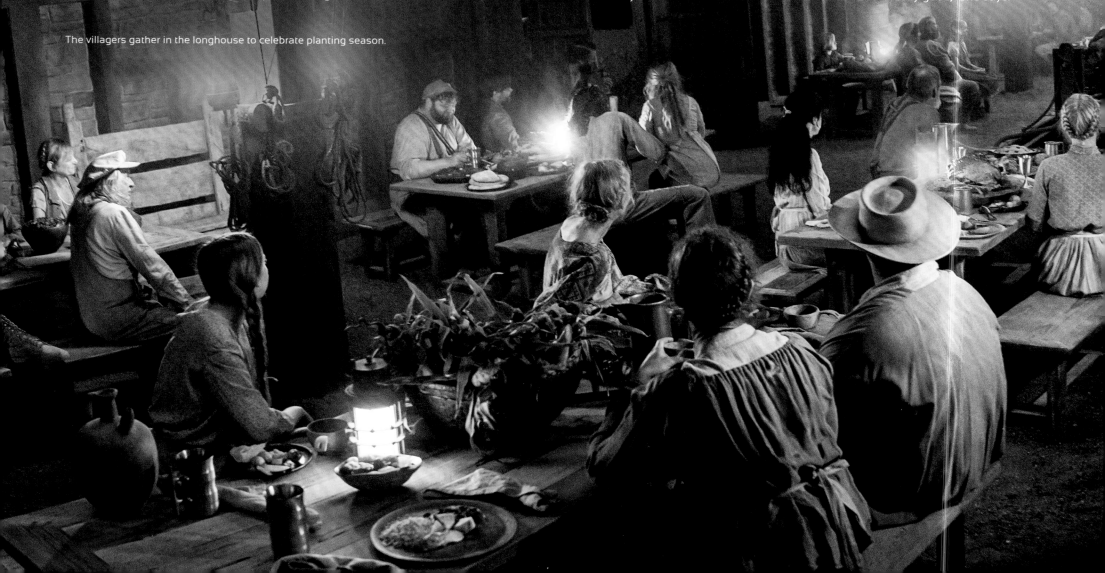

The villagers gather in the longhouse to celebrate planting season.

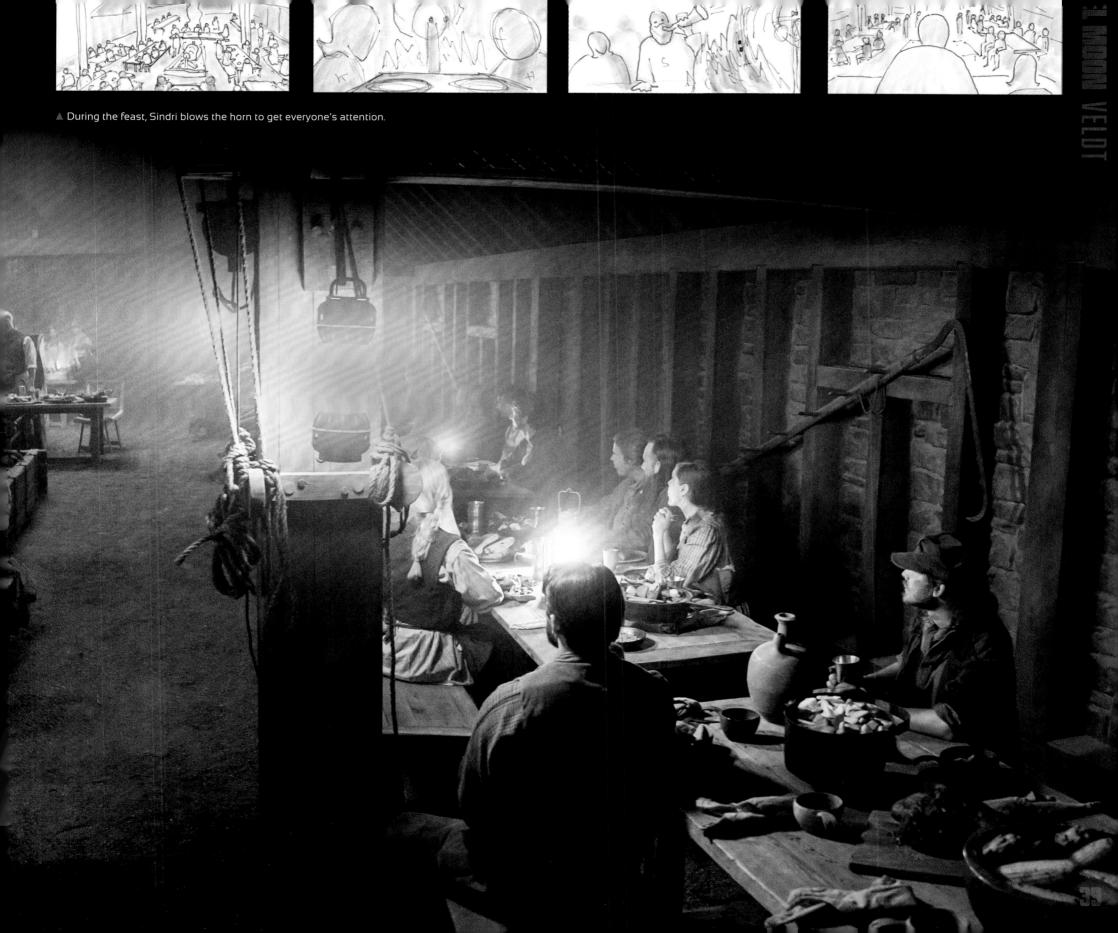

▲ During the feast, Sindri blows the horn to get everyone's attention.

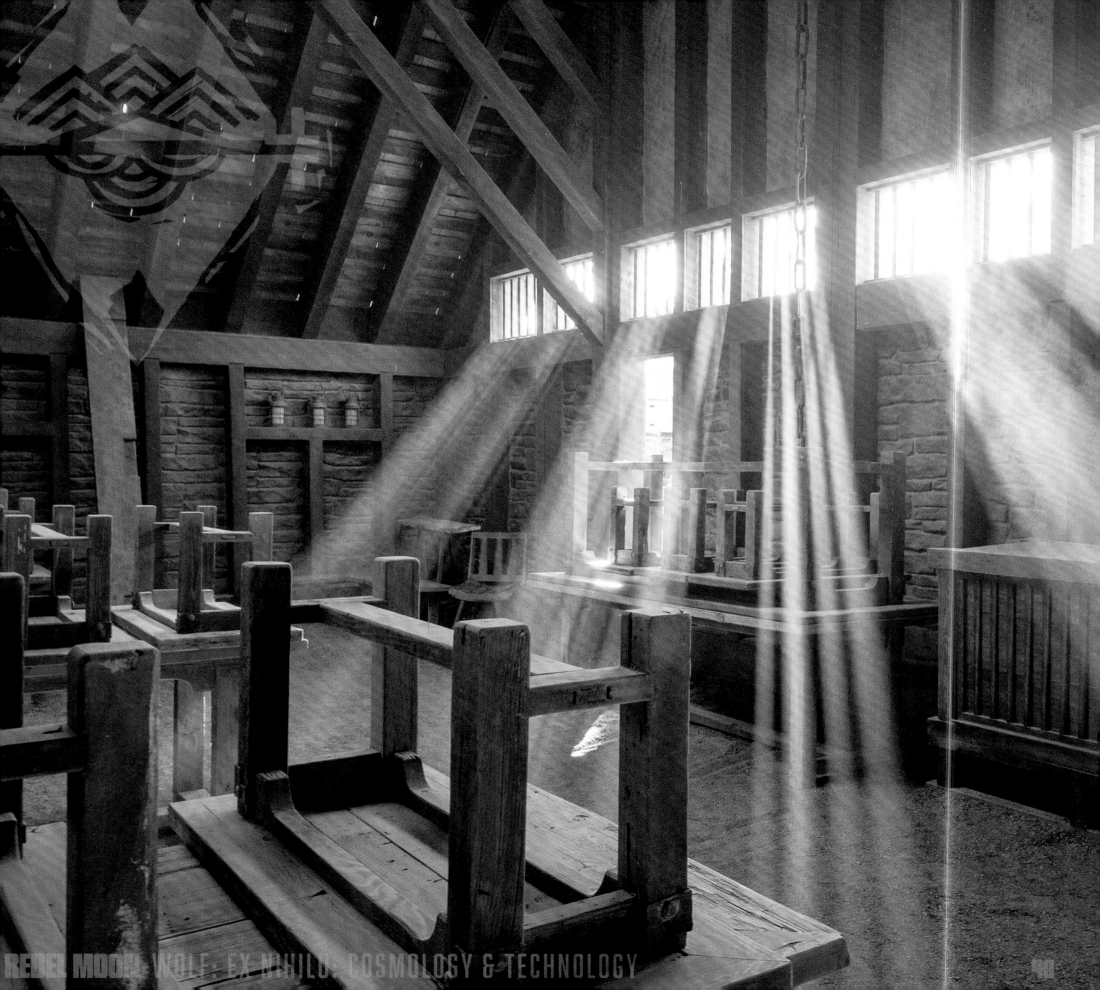

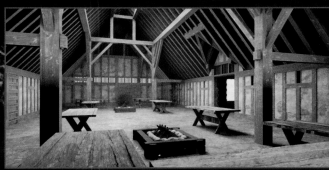

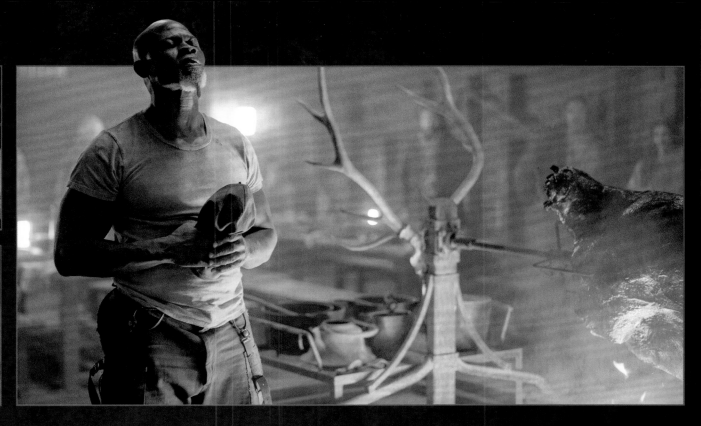

Another way set dressing was able to aid filming in the longhouse was by providing appropriate light fixtures. Luckily, the inhabitants of the village have no problem with some advanced conveniences like electric lighting (and automatic doors); the question was what form they should take. "There wasn't a lot of natural light that came in. It was pretty dark," Bonfe says. "So, Zack and his lighting department [remember: he was also the cinematographer] wanted three giant, six-foot-diameter light boxes. But they had to be hidden by something. I laid out some textiles, and

he really responded to them. I had bought a textile that had a symbol on it—we had three of them—but they weren't big enough; they were maybe four feet wide. So, on the top, bottom, and sides we added additional fabric, and then backed it so that you couldn't see his lighting. It just did a downlight, and it looked pretty incredible."

Finally, a place for meetings absolutely needs a means to call the room to order. Once again, modern production techniques came to the rescue to create something that looks masterfully artisanal. "In the longhouse we have a horn

that is blown to get everyone's attention," says prop master Brad Elliott. "Brandon Minton, who's an amazing modeler, took a horn that we had purchased that had a snakeskin carving put into it. He modeled the exact organic shape of the mouthpiece and the bell of the horn, and then created them as 3D models. We printed it out quickly on the nylon filament printer to make sure it fits. Once we know the model's good, we outsource it to this company, and get it printed in metal. They start with a powder substrate and lasers come together and actually fuse the metal in that powder to grow this piece in what looks to be an antiqued bronze that would handle crashing down on the table. It would take hours and hours of custom work to get this right on a mill or a lathe."

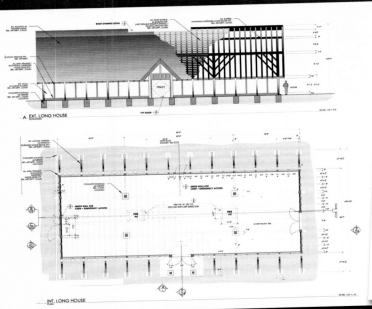

◀ ◀ Natural light illuminates the custom furnishings created for the longhouse.

▲ Titus sings an inspirational song.

◀ Detailed plans for the construction of the longhouse.

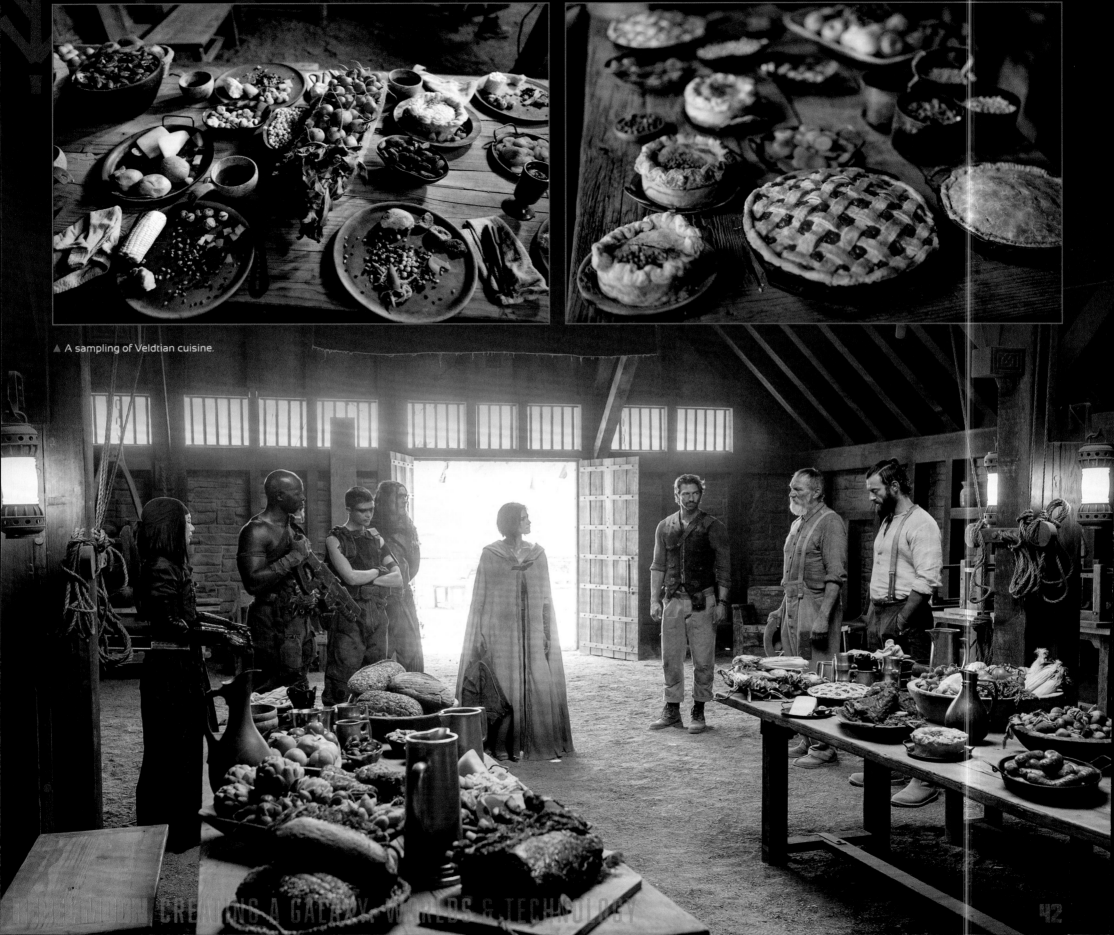

▲ A sampling of Veldtian cuisine.

HAGEN'S HOUSE A respected elder of the community, it was Hagen who took Kora into his home after she crashed on Veldt. He is her strongest connection in the village. "He takes care of Kora, he emotionally supports her," Bonfe says. "He's very sophisticated, so he had a writing desk and lots of books and journals." As for Kora, she has yet to become a full member of the village, and the sparse furnishings on her side of the house reflect that. "Kora had her own little space, but she has few things because she's not there for the rest of her life. She's just temporary. She found these people to be very pleasant to be around, but she is always ready to leave whenever she needs to," Bonfe says.

Their unusual living arrangement necessitated some accommodation for modesty and privacy. "We had a screen that divided the two beds. We found, when I was getting all these Japanese fabrics, that they use this mosquito netting that has a lot of blues and greens in it. After it gets aged by the sun, it becomes these beautiful colors," Bonfe explains. "We cut them up and made beautiful screens out of them."

▶ Hagen relaxes with a book during a quiet moment.

▲ Concept art of the interior of Hagen's house.

▲ Concept art for the final exterior build.

▲ Pieces of Hagen's simple life.

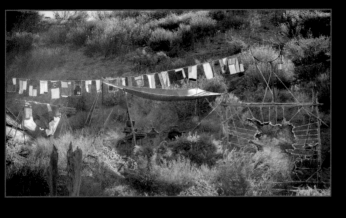 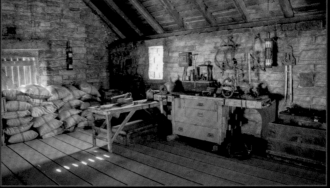 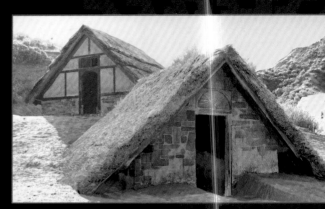

DEN'S HOUSE

DEN'S HOUSE Sometimes the art department doesn't have a whole lot of information to work off when designing a living space for a character—but they somehow manage to nail it, nonetheless. "I didn't really have a backstory on Den," Bonfe says, "but I saw his character in costume and had gotten a few things from Zack: 'He's a hunter, and then obviously, if you read the script, the ladies like him.' So, I was joking with my crew members, 'Just think of Gaston from *Beauty and the Beast.*' I thought that was funny and just ran with it. I never talked to Zack about that. So, we had some hides and hung them in his hut, and then we had some hides drying outside. Den eats a lot, because he's muscular, so he has a bigger table in his place. It was all based on looks, and food, and he works well with his hands. [Zack] walks in, he looks around, and he goes, 'He's a hunter. He's a ladies' man,' and I never said anything to him. And he walked out, and he was singing, 'I think like Gaston. I drink like Gaston...' and I was just blown away. He obviously liked it."

▲ Views around the village.
▼ Den's house interior.

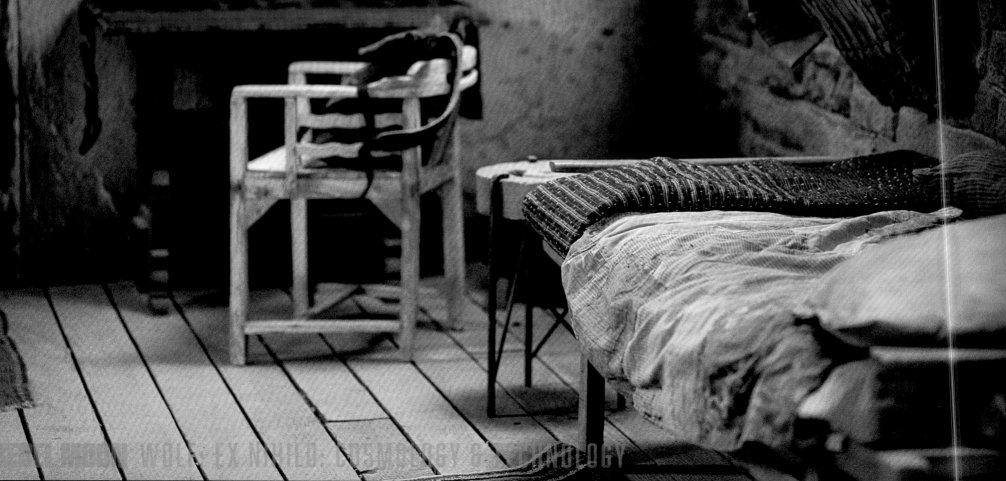

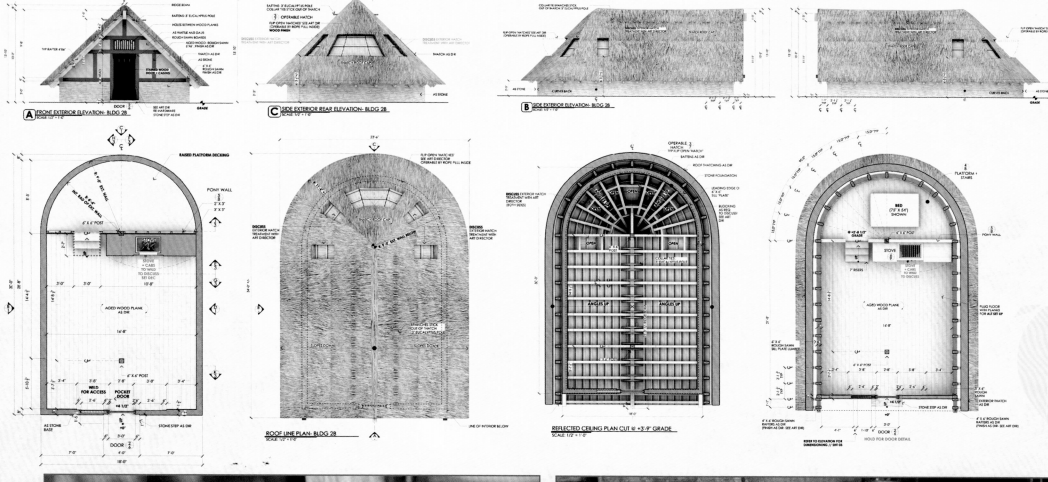

▲ ▲ Plans for the building that would serve as both Den's and Gunnar's houses.

▲ Some of Gunnar's journals and account ledgers.

GUNNAR'S HOUSE

In contrast with Den, Gunnar is quiet and serious. While they both have feelings for Kora, Gunnar appears to be more earnest, as evidenced by the epic, heroic journey he undertakes with her—something that's beyond his nature or abilities when we first meet him. "Gunnar is a bit more soft spoken. He's a nice guy, lovable," Bonfe says. "He's smaller, so he has a smaller kitchen. He has books, and maybe he writes a lot. Just a different approach." Funnily enough, the interiors of the homes of these two polar opposites were shot inside the same house in the village. Switching back and forth required not just redressing the sets, but changing the floor plans, as well. "When Gunnar shot, it had a little stage—some stairs and a little platform—where his bed was. Then when we shot Den, they closed that part off and took the stairs out. And so Den's house was just like an open room," Bonfe says.

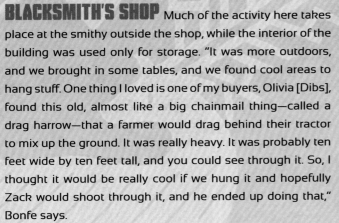

BLACKSMITH'S SHOP Much of the activity here takes place at the smithy outside the shop, while the interior of the building was used only for storage. "It was more outdoors, and we brought in some tables, and we found cool areas to hang stuff. One thing I loved is one of my buyers, Olivia [Dibs], found this old, almost like a big chainmail thing—called a drag harrow—that a farmer would drag behind their tractor to mix up the ground. It was really heavy. It was probably ten feet wide by ten feet tall, and you could see through it. So, I thought it would be really cool if we hung it and hopefully Zack would shoot through it, and he ended up doing that," Bonfe says.

▶ Tarak and the village blacksmith (Alessandro Komadina) sharpen a blade.

▼ Details of the anvil.

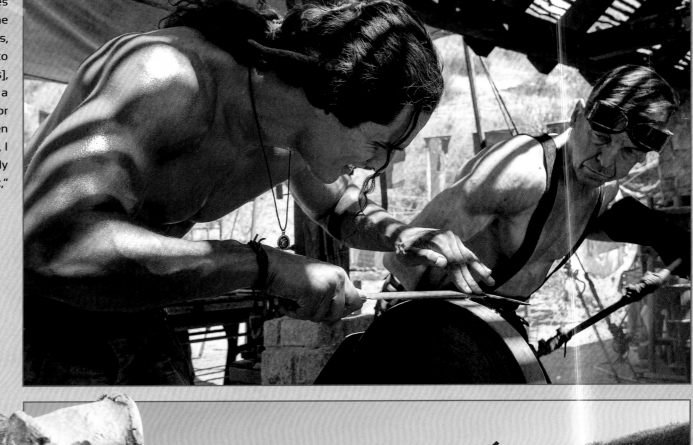

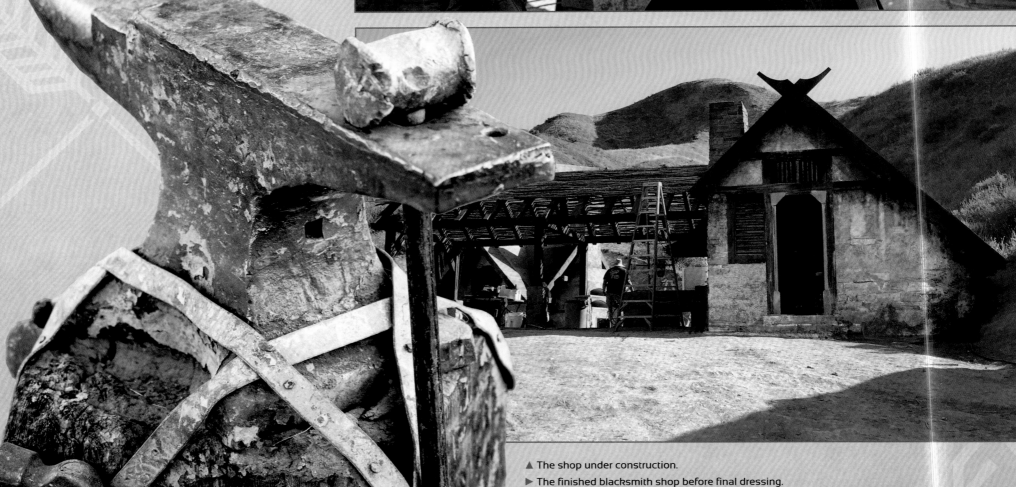

▲ The shop under construction.

▶ The finished blacksmith shop before final dressing.

STONE BRIDGE & RIVER The river not only provides power to the grain mill, but also serves as a boundary between the village and the wheat fields. And like the wheat fields, creating a flowing, sparkling stream beneath an idyllic stone bridge with the time and resources available was nothing short of a miracle. "When we showed up at Blue Cloud Movie Ranch there was no river," says Coller. "There was a bunch of dirt. And again, with a little ingenuity, some great designs, some shotcrete, and some water, we now have a flowing river." Those designs included pumps to keep the water circulating in a nearly 600-foot-long continuous circuit. But don't grab your swimsuit and inflatable tube just yet. Only half of this "lazy river" ran above ground; past the bridge, the water eventually collected in a sixteen- by twenty-foot holding tank, then—with the help of two eighteen-inch submersible pumps—entered two ten-inch subterranean pipes to be pumped back to start the course once again.

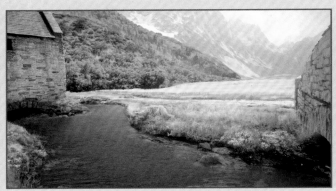

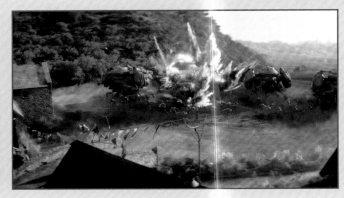

▲ Storyboard of Noble's arrival.

▼ The bridge is the gateway to Veldt village.

▲ Concept art of the river flowing under the bridge to the mill.

▲ Final frame showing the bridge and mill.

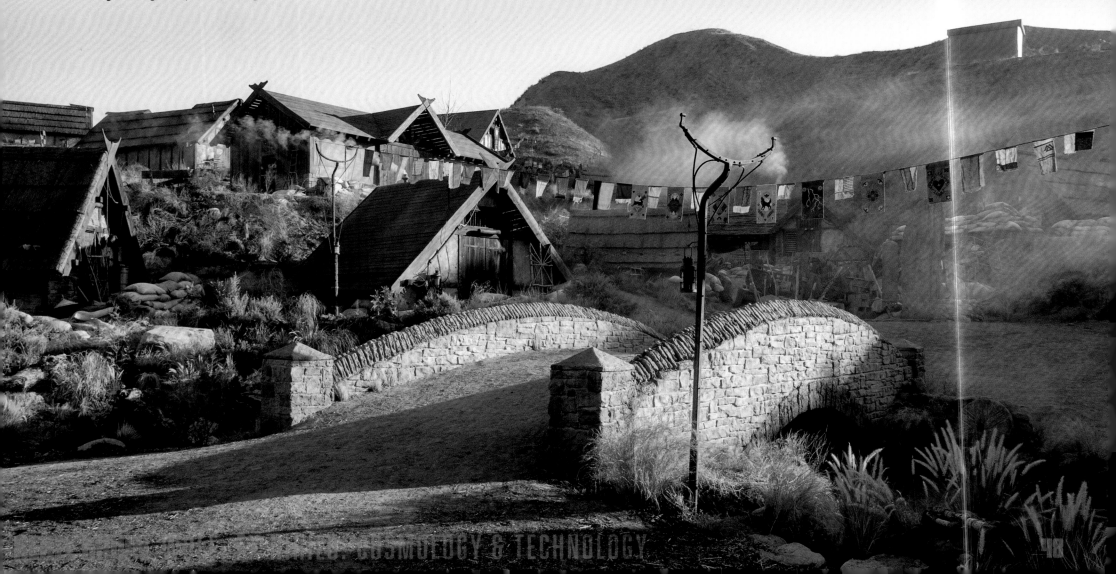

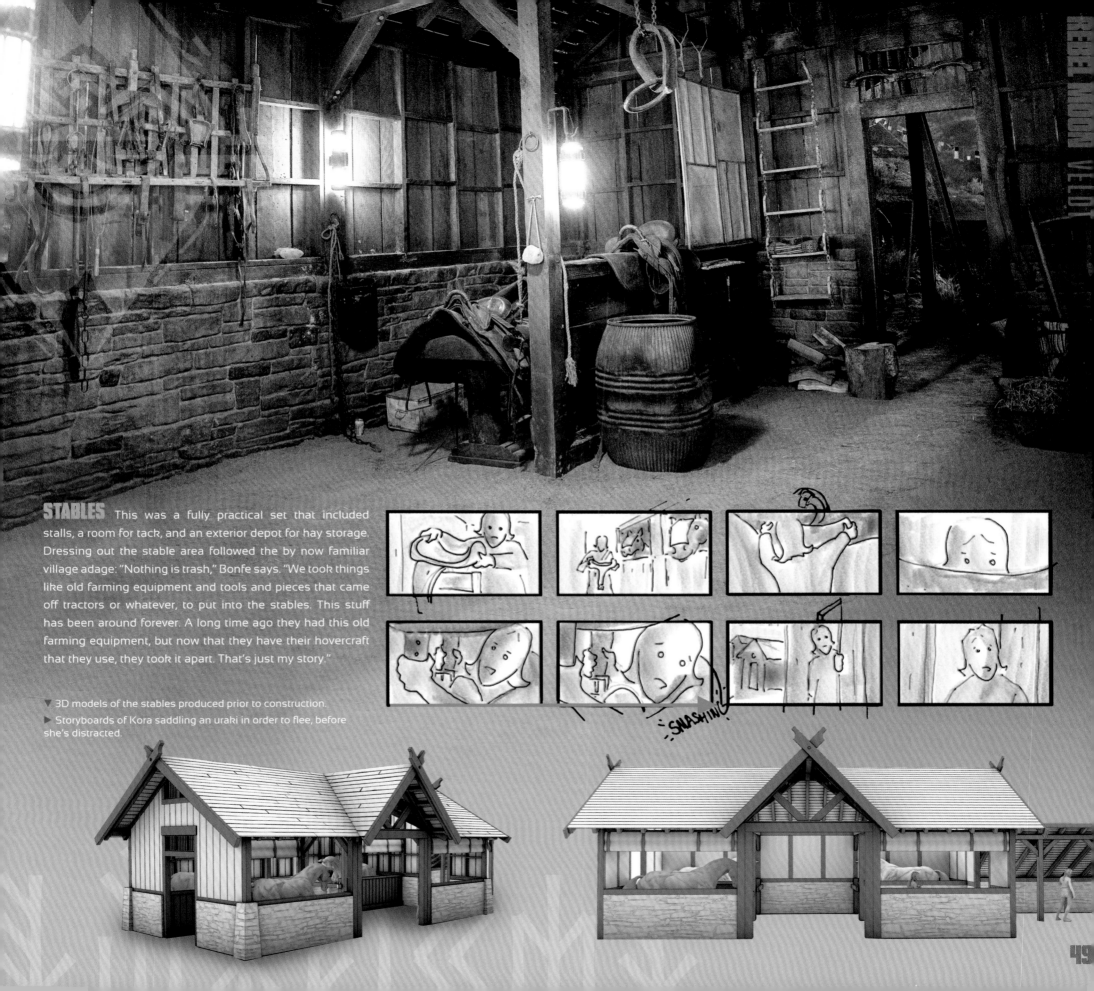

STABLES This was a fully practical set that included stalls, a room for tack, and an exterior depot for hay storage. Dressing out the stable area followed the by now familiar village adage: "Nothing is trash," Bonfe says. "We took things like old farming equipment and tools and pieces that came off tractors or whatever, to put into the stables. This stuff has been around forever. A long time ago they had this old farming equipment, but now that they have their hovercraft that they use, they took it apart. That's just my story."

▼ 3D models of the stables produced prior to construction.
▶ Storyboards of Kora saddling an uraki in order to flee, before she's distracted.

SMASHING

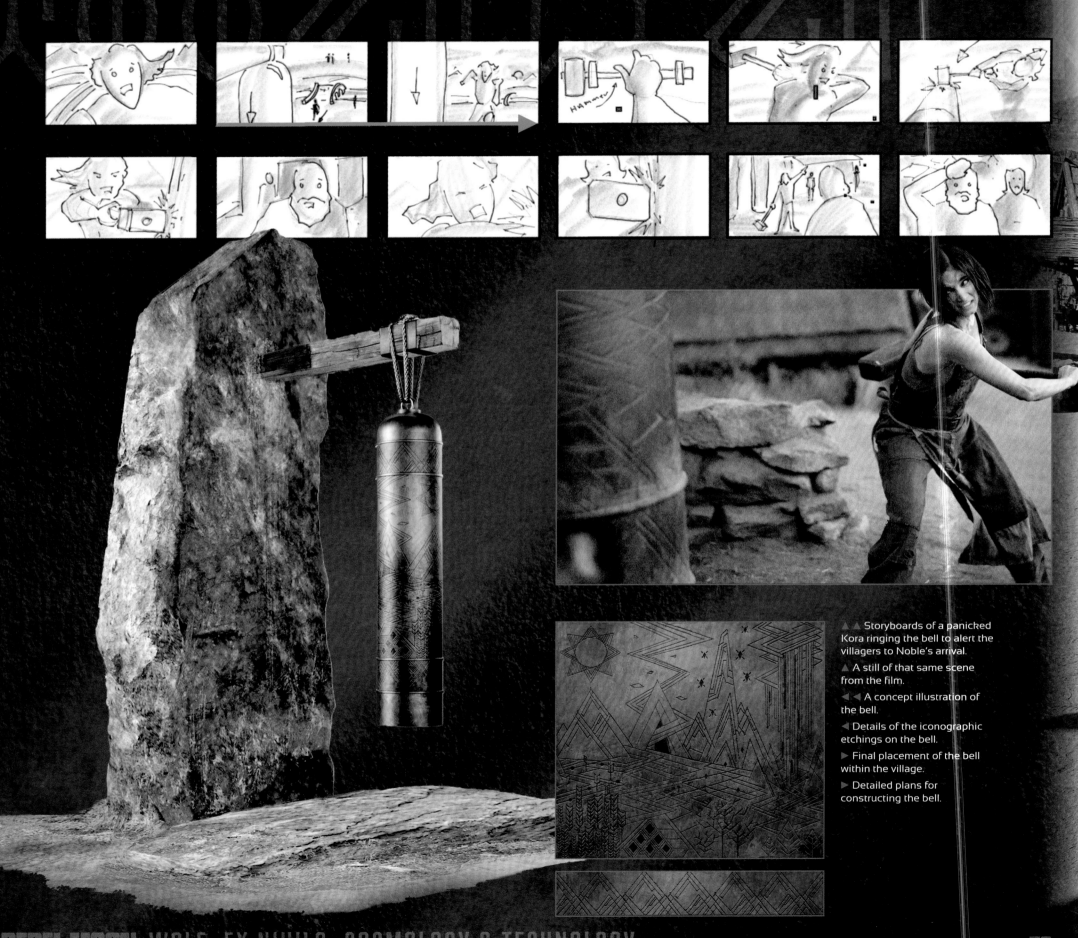

▲ ▲ Storyboards of a panicked Kora ringing the bell to alert the villagers to Noble's arrival.

▲ A still of that same scene from the film.

◄ ◄ A concept illustration of the bell.

◄ Details of the iconographic etchings on the bell.

► Final placement of the bell within the village.

► Detailed plans for constructing the bell.

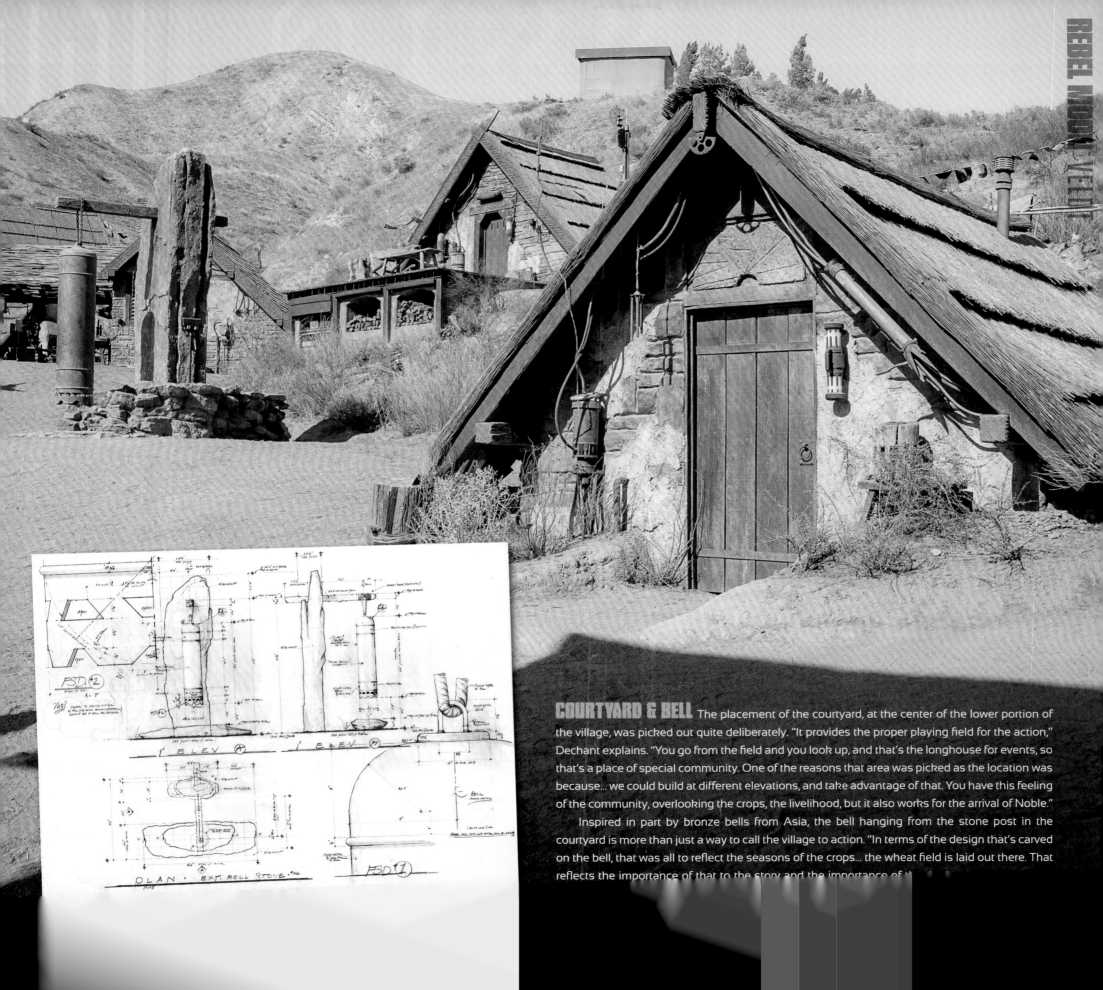

COURTYARD & BELL The placement of the courtyard, at the center of the lower portion of the village, was picked out quite deliberately. "It provides the proper playing field for the action," Dechant explains. "You go from the field and you look up, and that's the longhouse for events, so that's a place of special community. One of the reasons that area was picked as the location was because... we could build at different elevations, and take advantage of that. You have this feeling of the community, overlooking the crops, the livelihood, but it also works for the arrival of Noble."

Inspired in part by bronze bells from Asia, the bell hanging from the stone post in the courtyard is more than just a way to call the village to action. "In terms of the design that's carved on the bell, that was all to reflect the seasons of the crops... the wheat field is laid out there. That reflects the importance of that to the story and the importance of..."

PROVIDENCE

"I wanted there to be a dangerous place that was two days ride from the village," Snyder explains, "and Providence became that place for us. It's been strongly influenced by traditional Japanese buildings from the Tokugawa Period, with a bit of an Old West vibe." Building out a frontier settlement with such a clear design inspiration—paired with a sense of lawlessness—was a challenge, but also incredibly fun. As set decorator Claudia Bonfe puts it, "You don't often get to do a Japanese-Western town!"

▲ Concept art of Kora and Gunnar approaching the entrance to Providence.

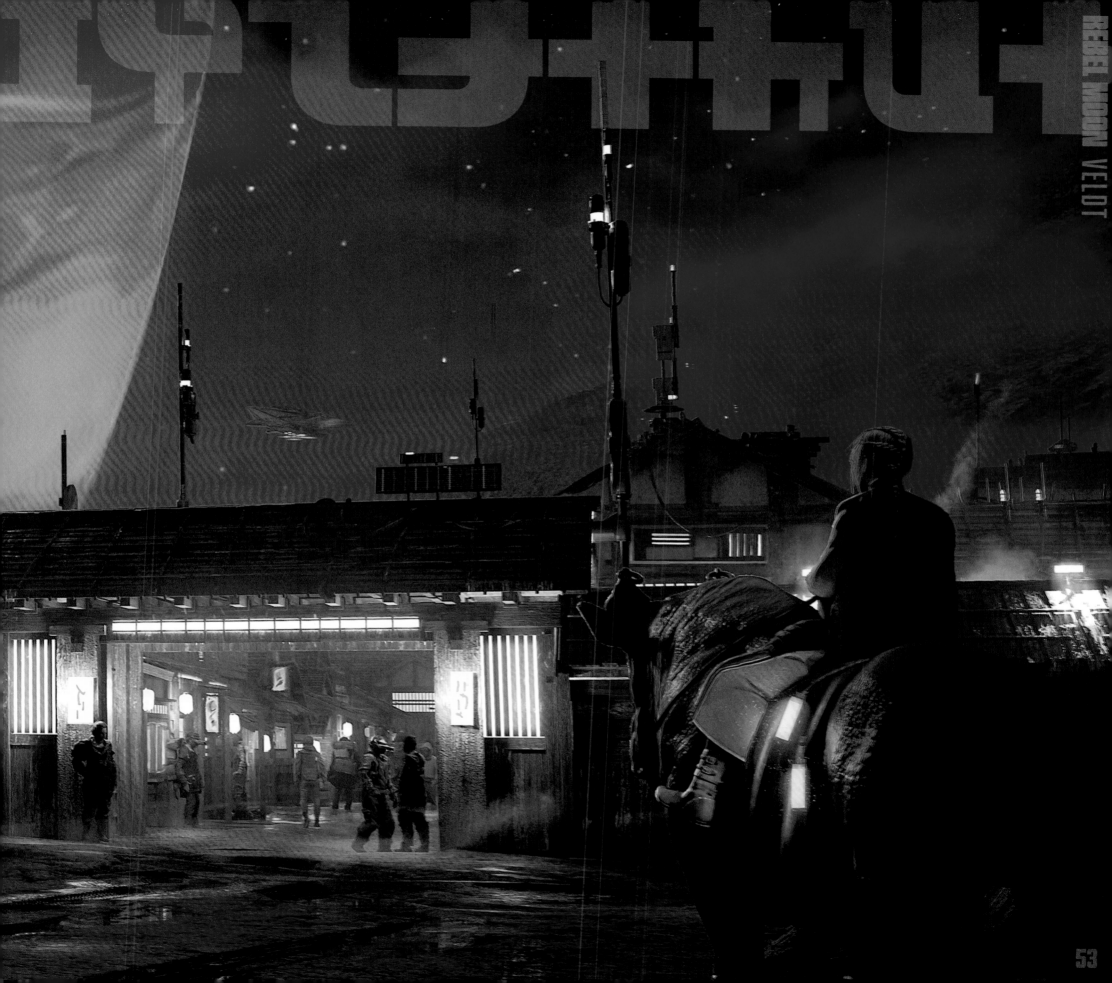

STREETS In actuality, Providence was only a short walk from the village, part of the same production complex constructed at Blue Cloud Movie Ranch. Although a smaller build than the village overall, the street sets of Providence comprised nearly an entire city block. The trick was to have that one block and its surroundings feel like a whole city. "We built that long hallway that they walk on to get a look at a little alley where they see [Ximon] getting taken away by the Hawkshaws," Zack Snyder says. "You really get a sense that there's much more to the city than what you see, because of the length of that hallway. Then when they cross the street, you really get a good look at the city through CG extensions."

Taking the Japanese influence and running with it, the art department dressed the storefronts in Providence with *norens*. These were printed with large symbols as well as language, using one of the constructed alphabets to denote the business inside.

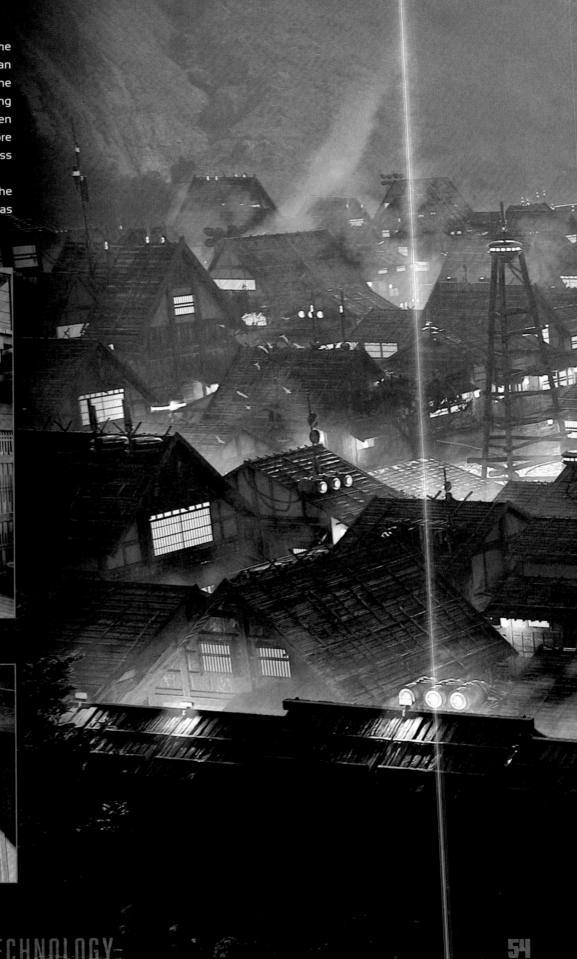

▲ ▼ Examples of local shop signage in Providence.

▶ Concept art of a bustling Providence that offers opportunities, but also danger.

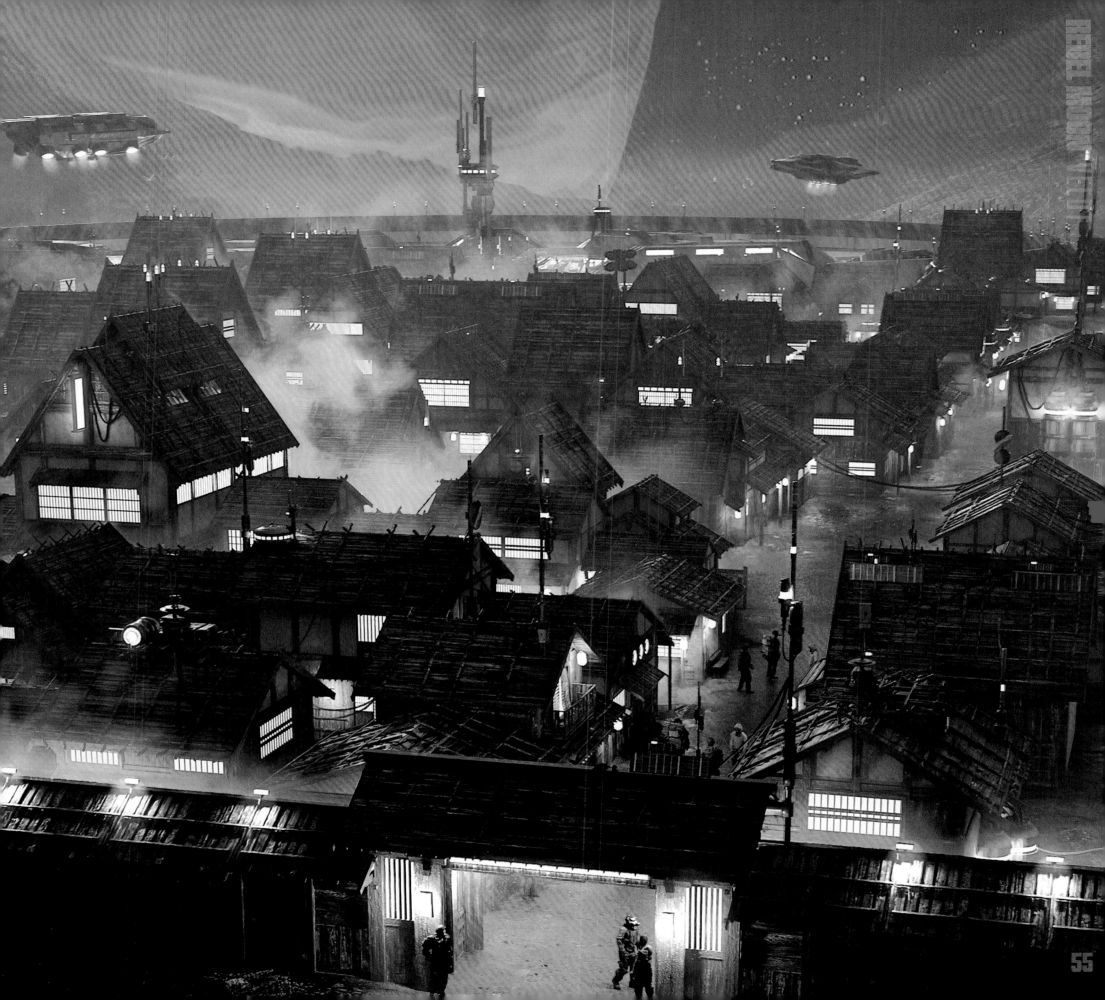

CROWN CITY EMPORIUM OF PLEASURE Kora and Gunnar quickly make both enemies and allies in this combination bar and brothel in the center of Providence. "Again, it was heavily influenced by Japanese architecture, but I also introduced some wonderful Tibetan motifs that I found in my research, and equally played on the depiction of the saloon bar in the Western genre," explains production designer Stephen Swain. "In terms of layout, I wanted there to be a lot of depth. Obviously, there is the central bar with the low ceiling for the main action, but I felt it was necessary to also create some height around the stage area and to suggest other rooms leading away to more secluded areas."

Snyder says, "The interior of the Emporium is very much meant to evoke comfort, in the most homey, dive bar kind of way. I wanted it to be dangerous, but also slightly intriguing and inviting." The furnishings and props were constructed from eclectic varieties of wood, metal, and glass. The latter offered plenty of opportunity for warm light to shine through the glasswork, such as the prominent twelve-foot-long glass heat exchangers. A custom-built, burnished copper brew tank, complete with pipes connected to the taps, adorned one end of the bar. Additionally, carefully selected pieces of furniture were duplicated in breakaway balsa wood for use in the bar fight between Kora and Dash Thif's gang.

As always, lighting was incredibly important, both for the aesthetic it conveyed and for the practicalities of filming. It was crucial that it also be very flexible in a set like the Emporium, where a dynamic action scene would take place. "At my first meeting with Zack, he said that sometimes he wants to move a light, but it's wired into the wall, so he can't, and then he has to wait," Bonfe explains. "In the Providence bar, we had battery operated table lamps that look like these little mushrooms. They had a handle on the top, and you could take it and move it throughout the scene. So we did that a lot."

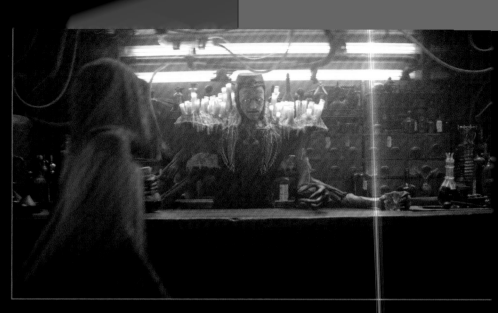

▲ The robotic bartender will take your order.

▼ Hawkshaws muscle Ximon off the street.

▲ Concept art of the exterior of the Crown City Emporium of Pleasure.

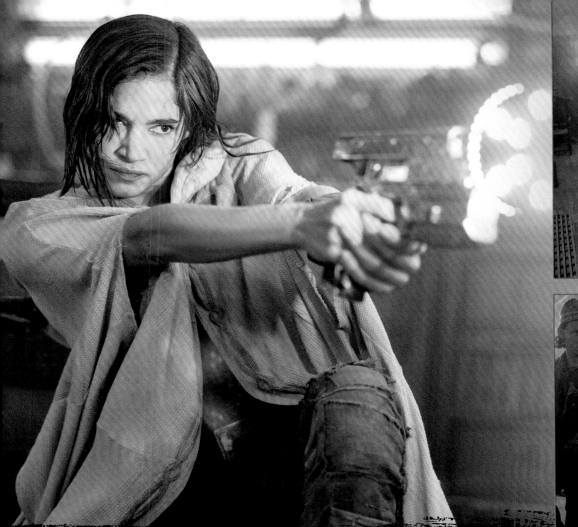

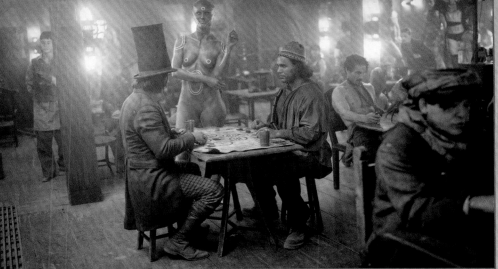

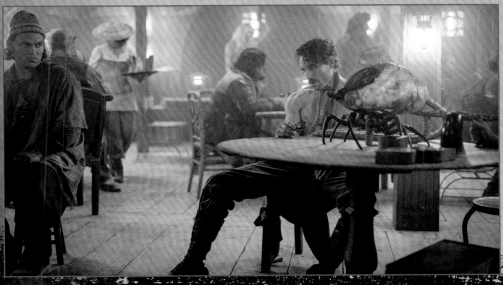

◀ LEDs provide practical muzzle flashes for Kora's gun during the fight in the Emporium.

▲ Some denizens and decorative details of the bar.

PROVIDENCE TYPE

BA	BE	BI	BO	BU	CA	CE	CI	CO	CU	DA	DE	DI	DO	DU	FA	FE	FI	FO	FU	GA	GE	GI	GO	GU	HA	HE	HI	HO	HU	JA	JE	JI	JO	JU	KA	KE	KI

KO	KU	LA	LE	LI	LO	LU	MA	ME	MI	MO	MU	NA	NE	NI	NO	NU	PA	PE	PI	PO	PU	QA	QE	QI	QO	QU	RA	RE	RI	RO	RU	SA	SE	SI	SO	SU	TA

| |
|---|
| TE | TI | TO | TU | VA | VE | VI | VO | VU | WA | WE | WI | WO | WU | XA | XE | XI | XO | XU | YA | YE | YI | YO | YU | ZA | ZE | ZI | ZO | ZU | TH | CH | SH | WH | PH | GH | NG | NK |

0	1	2	3	4	5	6	7	8	9	A	B	C	D	E	F	G	H	I	J	K	L	M	N	O	P	Q	R	S	T	U	V	W	X	Y	Z

- , ; : ! ? & $ " ' (/) ' ' `

CONSONANT-VOWEL **DIGRAPHS**

GO NG

CARBOST

Despite the fact that it is available in the bars in Providence, this alcoholic drink is generally not to the taste of the Veldtians and most likely originated off-world. "That was basically just a slurry of health food products," Elliott recalls. "Originally, the drink we had put together was a little bit of Gatorade, milk, lemon juice, and a touch of caramel food coloring. The milk and lemon were interacting in a curdling fashion, but it was really quite pleasant to drink. We brought the first example to Sofia [Boutella] early on—she had no dietary restrictions; she was open to everything. But by the time we got to the day before shooting, she had fully committed to the Zack Snyder actor workout program and she said, 'Oh no, I can't have any of that.' Well, we did what we could with some protein powders."

DARAMS

The coinage of the Realm is accepted as legal tender throughout the known star systems. "We designed three denominations of coins," Elliott explains. "The '100' has a gold color, the '10' has silver color, and the '1' is the smallest one with a copper color. The '100' has a little slogan underneath it that says, 'Death is the cost.'" Both sides of the coins are covered in Motherworld symbology, such as the Wolf, the Würm, and the King's Gaze.

▲ ▲ ▲ Gunnar gets his first taste of carbost.

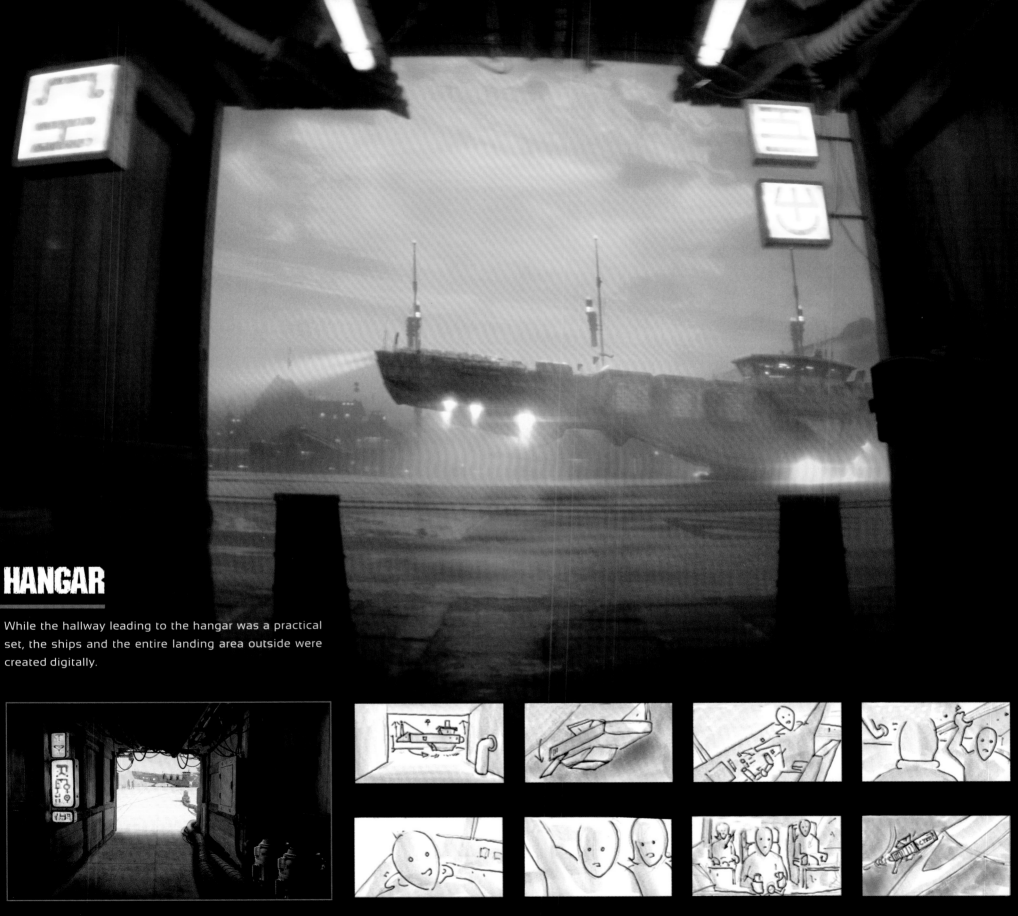

HANGAR

While the hallway leading to the hangar was a practical set, the ships and the entire landing area outside were created digitally.

▲ A final frame, concept art, and storyboards for Kora and Gunnar embarking on Kai's freighter.

MOUNTAINS

There are many wild places in the mountains beyond the village. Some hold danger, while others are locales for rest and reflection. For example, there is the campsite where Kora and Gunnar rest on their way to Providence (shot just out of sight of the village set at Blue Cloud). But there are also places where Jimmy experiences his inward journey, trying to find meaning in his rudderless existence after the death of the Royal Family; from the woods to the grotto overlooking the wheat fields, he contemplates his purpose and eventually chooses sides in the coming conflict.

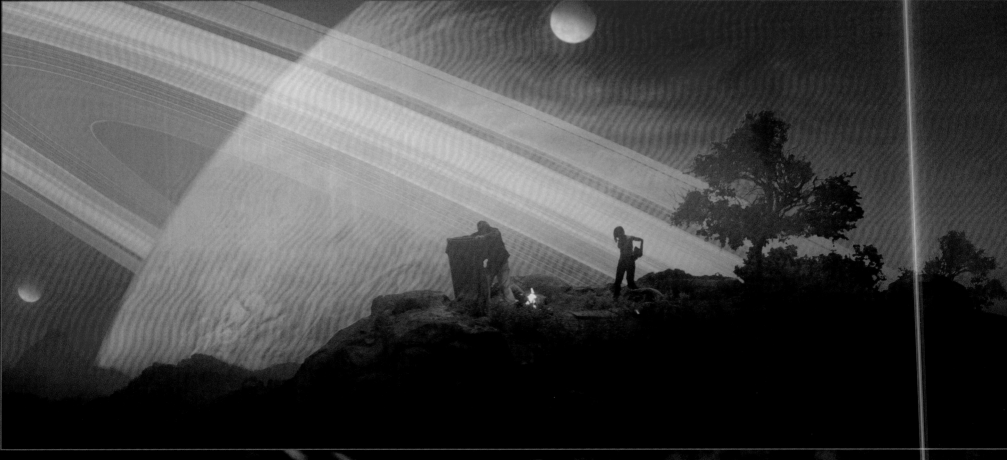

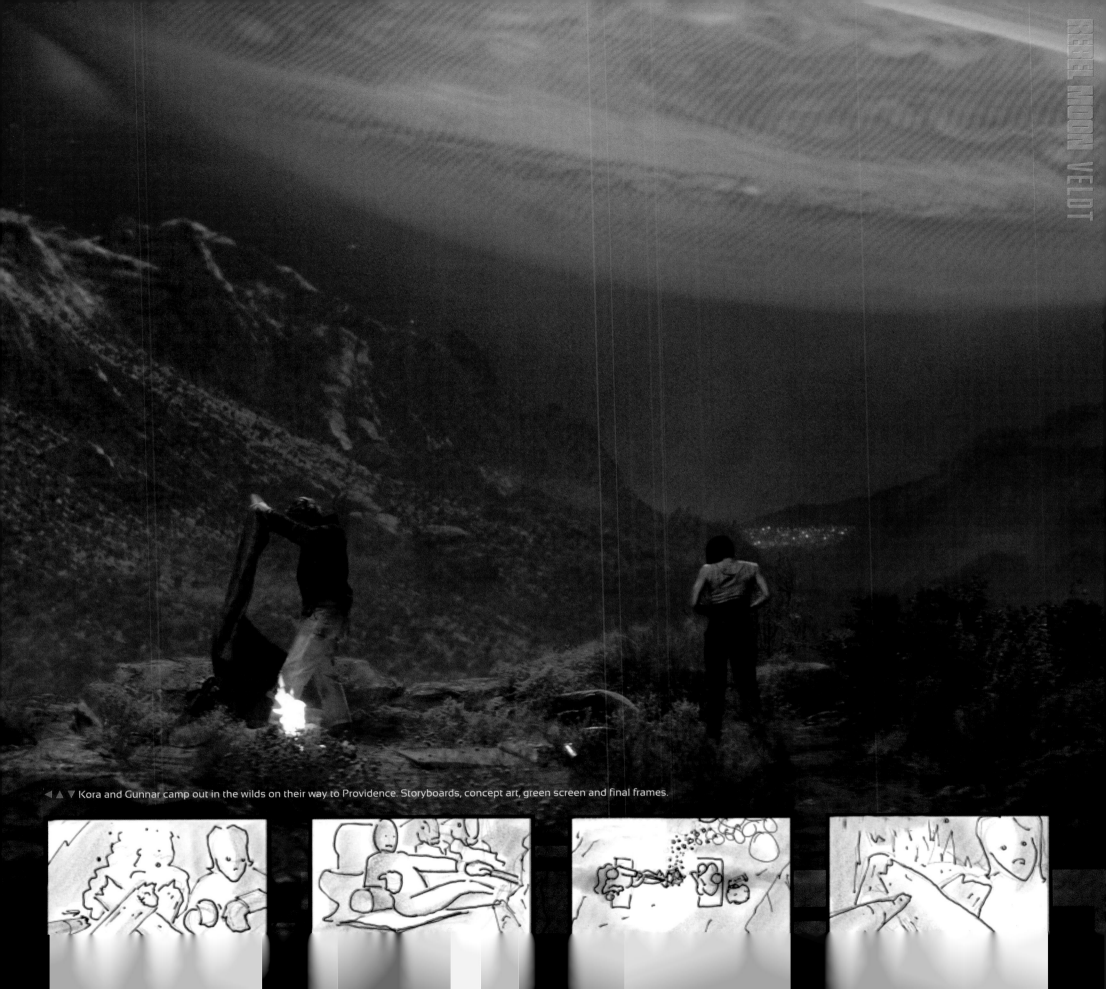

◀ ▲ ▼ Kora and Gunnar camp out in the wilds on their way to Providence. Storyboards, concept art, green screen and final frames.

KORA'S DROPSHIP CRASH SITE

When the villagers venture into the woods to pull Kora's old dropship out of its crash trench, it was for the most part accomplished practically, on camera—although they did need some help from the special effects department. "We had draft horses subbing in for urakis, and there are laws that you cannot hook an animal to a moving mechanical device," special effects supervisor Michael Gaspar explains. "The mechanical device was hydraulics to be able to tilt the ship thirty degrees and have it come down to zero as it was coming out of the trench. We put big twenty-four-inch I-beams down into the ground and made a trolley-hitch chassis that grabbed onto those I-beams. Then we had a second hydraulic arm that pushed it. It traveled forty feet. So it was quite an undertaking."

Viewers will no doubt notice that the paint job on Kora's dropship is a bit more vibrant than that on the majority of others in the films. The reason for that was having only one full dropship model (*see Dropship, p144*) that stood in for all of them. "We did two different color schemes," production designer Stefan Dechant explains. "There's the royal version, that's on Kora's, as hers is from the time of the King. Then we have what we call the standard dropship, which is this gray-beige color scheme, which is the time of the regency. We thought we were being clever, that it would be a quick paint job. We also thought we would schedule it, so we wouldn't have to keep repainting it. But that red came on and off that ship quite a bit."

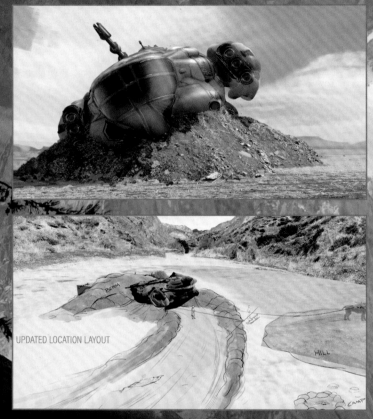

UPDATED LOCATION LAYOUT

▲ ▼ Concept art and plans for Kora's crashed dropship.
▶ The actual dropship with red royal markings in place, ready to be pulled out.

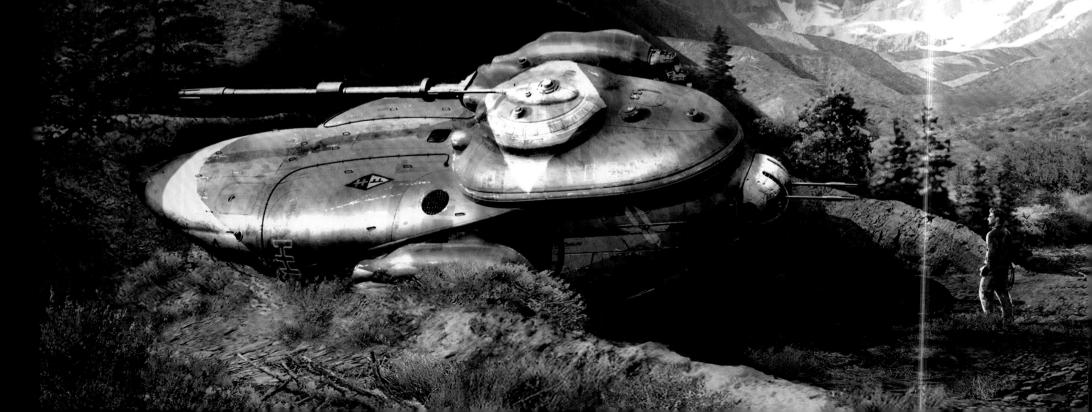

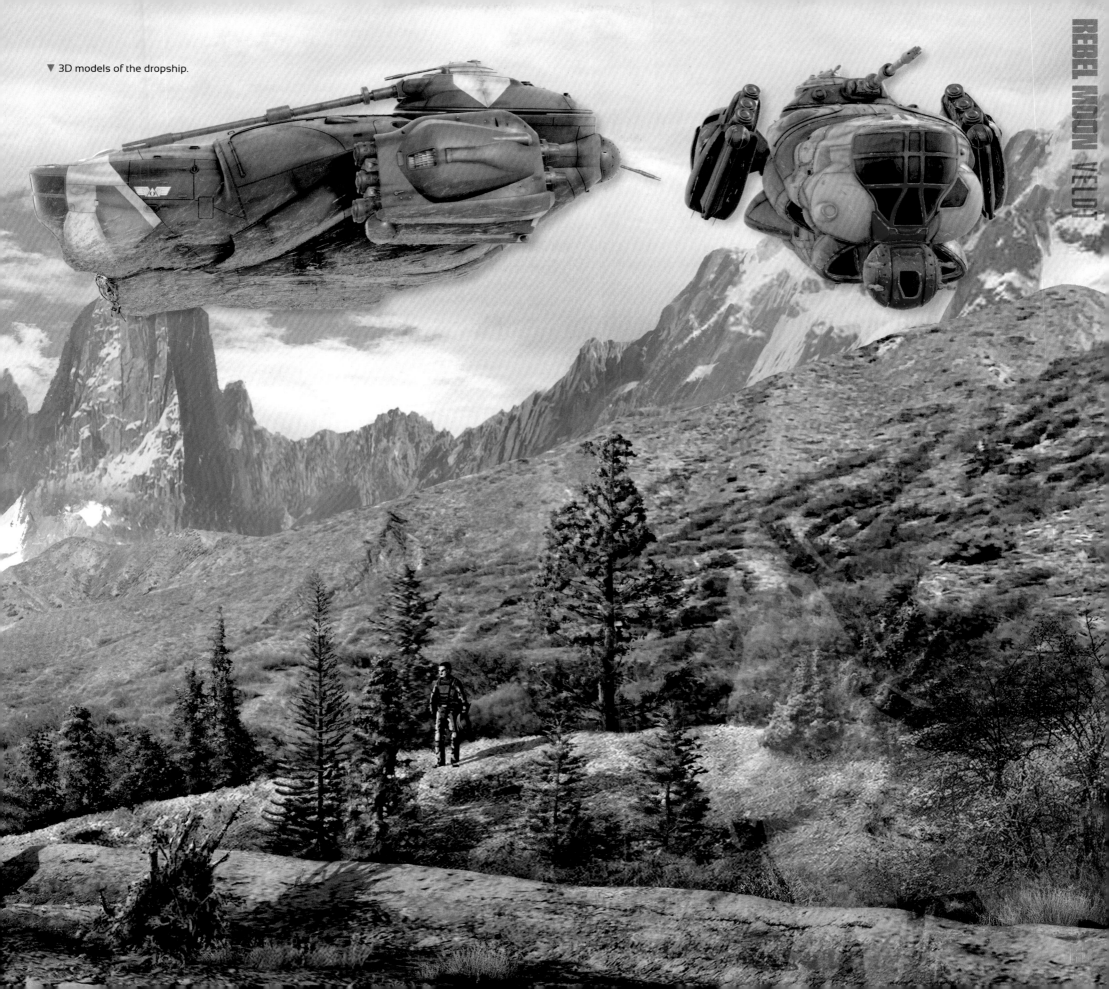

▼ 3D models of the dropship.

HAWKSHAW CAMP

"There's a big glacial snowpack above the village. On hot days, it runs off and creates a couple of waterfalls," Zack Snyder explains. No doubt using the noise it generates to mask their movements, the Hawkshaws make use of a flat space near one of these waterfalls to pitch their camp. "The Hawkshaw was there, watching from their post. They would have picked the spot that hides them from the village, and it also gives them a chance to climb up on the rock and surveil them. But then it gives Jimmy this opportunity to look down on them from one higher perch," he says.

Finding all of those specific elements in one location was essentially impossible within easy driving distance of the main production, so it was built outside, within the horseshoe-shaped green screen, allowing the waterfall to be created digitally. But not everything in that scene was purely CG magic. "The design challenge of that area was that you'd be able to do all those things there, as well as get some cool, low sun. We mapped the sun location, so we could shoot the sun raking across the Hawkshaw camp," Snyder says. (Also, if you look closely, you might spot a mushroom table lamp that the Hawkshaws must have swiped from the Crown City Emporium of Pleasure.)

▲ ▼ ▼ Jimmy watches the Hawkshaws as they watch the village.
▼ Concept art showing the camp's position above the village.

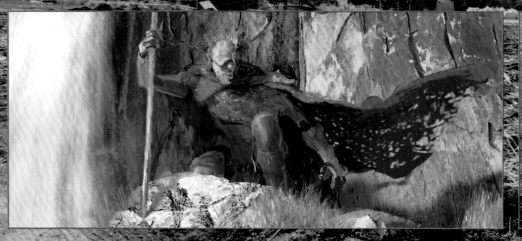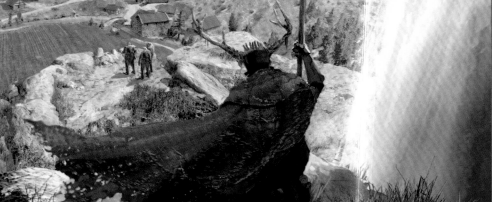

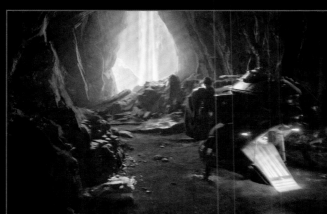
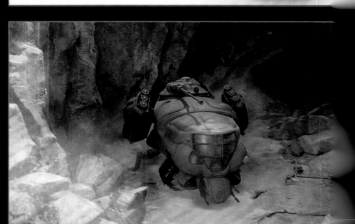

◀ ▶ Concept art and 3D models of the set for the crashed dropship's hiding place in the cave behind the waterfall.

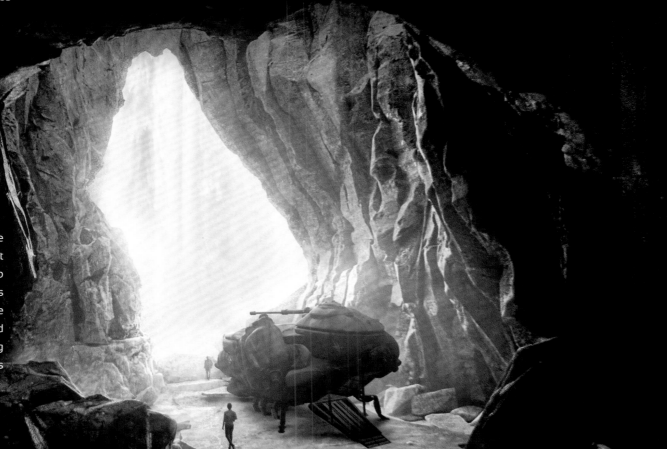

WATERFALL/CAVE

Another waterfall conceals a large cave in the mountains above the opposite side of the village. It also eventually conceals Kora's crashed dropship after Jimmy fixes it, and is where Kora first speaks to Jimmy. "We built that big set in the horseshoe as well," Snyder says. "We shot at night so it would feel dark in the cave, because there's no ceiling to it. We didn't have water when [Jimmy] walks through it. No real waterfall."

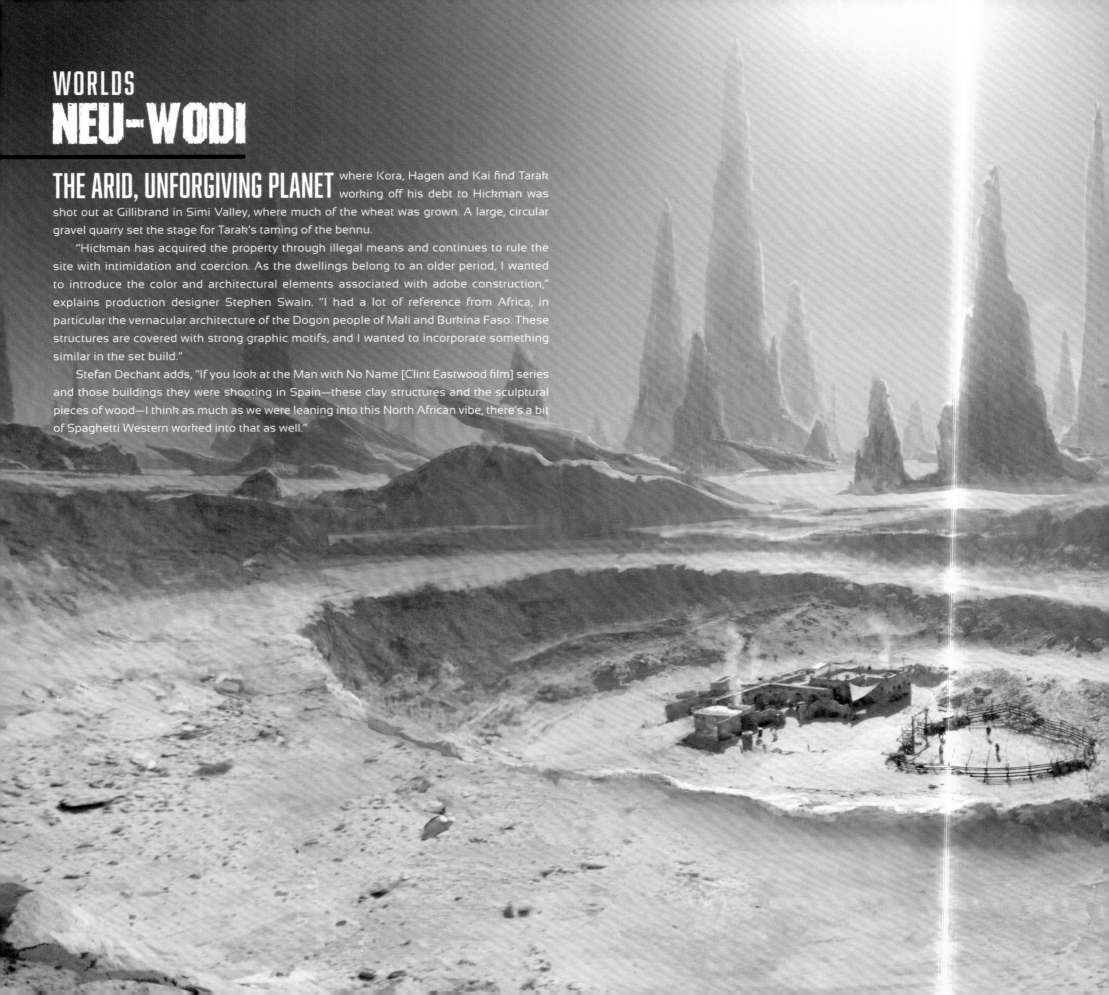

WORLDS
NEU-WODI

THE ARID, UNFORGIVING PLANET where Kora, Hagen and Kai find Tarak working off his debt to Hickman was shot out at Gillibrand in Simi Valley, where much of the wheat was grown. A large, circular gravel quarry set the stage for Tarak's taming of the bennu.

"Hickman has acquired the property through illegal means and continues to rule the site with intimidation and coercion. As the dwellings belong to an older period, I wanted to introduce the color and architectural elements associated with adobe construction," explains production designer Stephen Swain. "I had a lot of reference from Africa, in particular the vernacular architecture of the Dogon people of Mali and Burkina Faso. These structures are covered with strong graphic motifs, and I wanted to incorporate something similar in the set build."

Stefan Dechant adds, "If you look at the Man with No Name [Clint Eastwood film] series and those buildings they were shooting in Spain—these clay structures and the sculptural pieces of wood—I think as much as we were leaning into this North African vibe, there's a bit of Spaghetti Western worked into that as well."

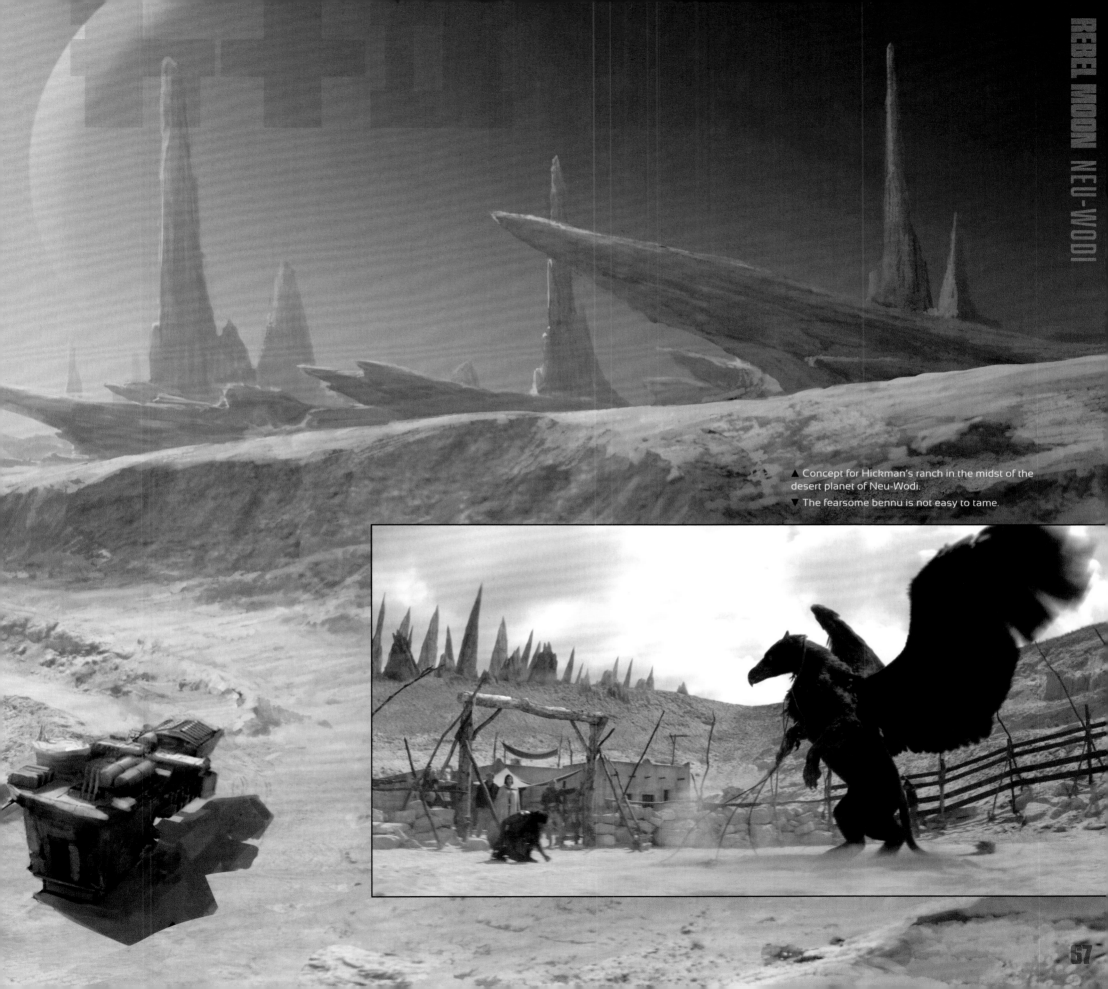

▲ Concept for Hickman's ranch in the midst of the desert planet of Neu-Wodi.

▼ The fearsome bennu is not easy to tame.

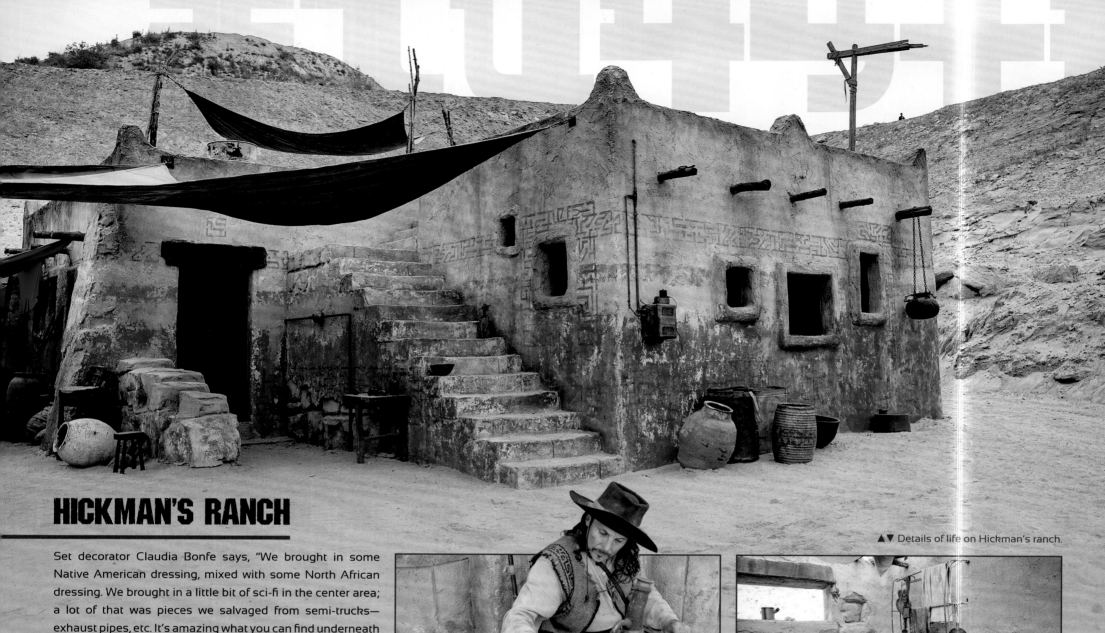

HICKMAN'S RANCH

Set decorator Claudia Bonfe says, "We brought in some Native American dressing, mixed with some North African dressing. We brought in a little bit of sci-fi in the center area; a lot of that was pieces we salvaged from semi-trucks—exhaust pipes, etc. It's amazing what you can find underneath a truck!"

Another design element of the ranch hinted at the lost history of the place, perhaps before Hickman acquired it, and added some color, as well. As Bonfe explains, "They used to do a lot of dyeing fabric there. The designer wanted to have these vats with dried-out colored dye in them. We had been in touch with Netflix assets people, because once a show comes out, and they don't think they're going to use them again, they allow other shows that are in production to come in and take them. The Western *The Harder They Fall* had just finished. [Assistant set decorator] Karen [Riemenschneider] had gone over there and she sent me a text: 'They have our vats.' So, that was great. They had eight of them. Repurposing—that's very important, and I know Netflix likes that, too."

▲▼ Details of life on Hickman's ranch.

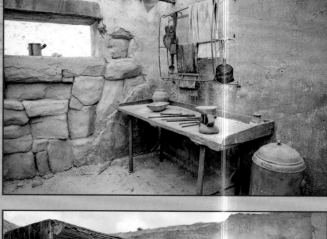

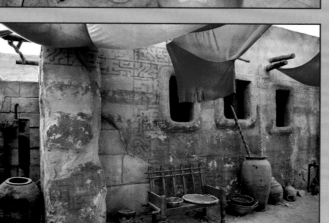

TARAK'S FORGE
Being enslaved, Tarak's living quarters are very minimal, consisting essentially of a small bed and the chain that secures him to the anvil where he works. Special effects supervisor Michael Gaspar explains how they got sparks to shoot out when Tarak hammered a piece of steel: "We practiced this with a bunch of different items, and we came up with ground-up flint. We actually forged a piece of steel, put it in a forger and got it red hot, loaded up the top of the anvil with little chunks of flint, and he put that hot piece of steel right on top. When he hit it with a hammer, it would explode those sparks. It wasn't a CGI thing. Staz [Nair, who plays Tarak] came over to our shop and practiced it so he wouldn't be surprised by the sparks, because it was quite pyrotechnic. If you can get the stuff practical, it's better, because you get interactive lighting—or maybe sparks bouncing off something—and they don't have to recreate things like that."

CORRAL
Just as they created visual interest with the buildings, the designers also did so with the corral. Dechant describes, "creating shapes out of these really sharp-edged pieces of wood you have lying around, so that there's something in there that's sculptural." And there's always an opportunity to add a little more color and movement to a scene, even in a place as desolate as Neu-Wodi. "Where the [bennu] was, we added some fabric. Zack wanted his fabric hanging on some of the posts," Bonfe says.

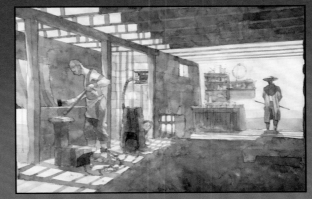
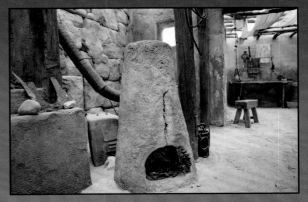
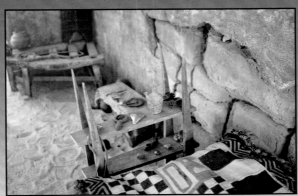
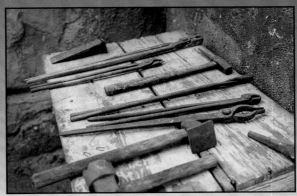

▲ ▲ Concepts for the ranch and forge.
▲ Tarak's sleeping area and some of his tools.

▼ The corral where Hickman hopes to break a bennu.

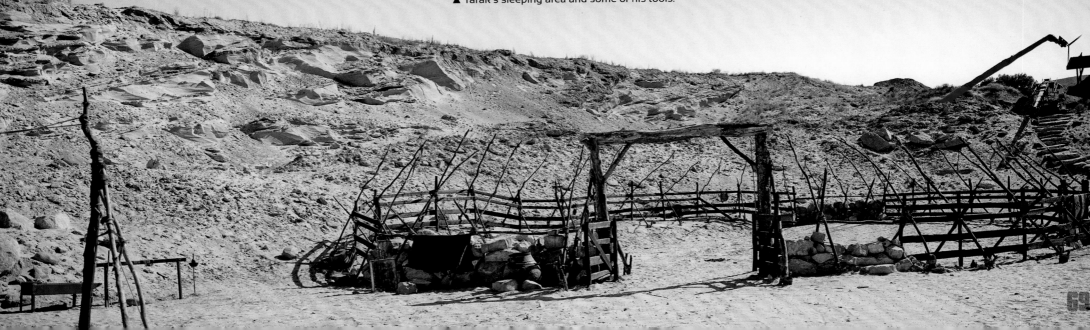

WORLDS
DAGGUS

DAGGUS MAY HAVE been a pleasant place once upon a time, but the discovery of cobalt and other rich mineral deposits beneath the surface of the planet have led to exploitation of its resources on a monumental scale. The results can only be described as a hellhole. As deep as mines go, the buildings above go even higher, with people practically living on top of one another. It should come as no surprise that Daggus was the largest stage set in the entire film.

"A lot of it is Brutalist architecture. Heavy concrete structures and quite unforgiving, really, almost like there's no consideration for the people that live amongst them," production designer Stephen Swain says. "Obviously, Kowloon and Gunkanjima were

massive influences... That very oppressive environment where over time there's a buildup of technology, and it fails, and things are replaced but never ripped down. It's this buildup of history and technology and structure."

"I come from a background in architecture, but all of my work in school was very narrative based. So I made my way to the film industry to tell stories, and to use architecture to tell those stories," art director Sandra Carmola says. "Daggus is a really industrial, polluted city. It rains a lot, and it's kind of grungy. It also has great verticality. There's a lot of refineries you'll see in our visual effects extensions—a tall, vertical city. We looked at a lot of Brutalist architecture and heavy, massive forms that could carry a city that's very tall and vertical."

▲ ▶ Concept art of Kora and a view of Daggus and final frame of the same scene.

NOODLE BAR

Once our characters get into the concrete *favela* that is Daggus, we're able to see some of the real-world influences as well as the practical considerations that went into its look. "Some streets in Hong Kong we looked at specifically for some of the alleys that you'll see in here. Also, some specific noodle bars," Carmola explains. Set decorator Claudia Bonfe adds, "This type of Asian influence is specific for this set. Veldt definitely does have some, but that's a little bit more of an organic feel. This is more of a recycled set of plastics and metals. Because of the mining and all the debris that's coming down into the city, you have to have materials that can easily be washed off. Let's just say it gets dirty every day. So, we wouldn't put any fabrics that are a cotton or a cloth that can't be washed simply with a hose."

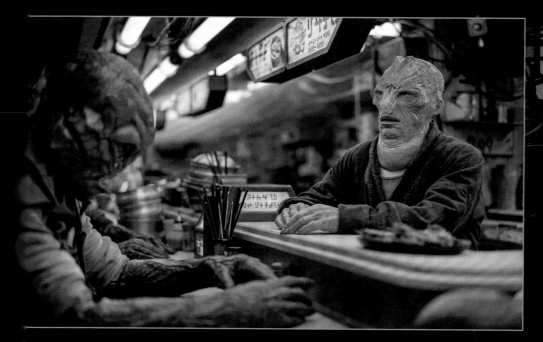

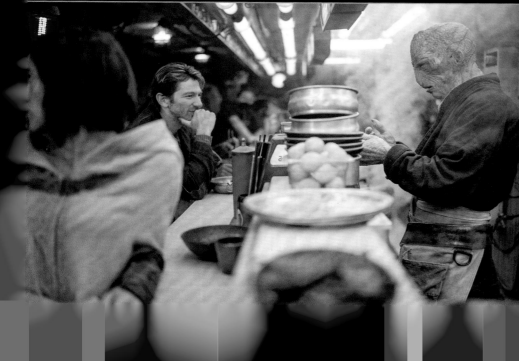

◄ Gunnar and other patrons order up at the noodle bar.

► Concept art of the noodle bar and some Daggus squalor.

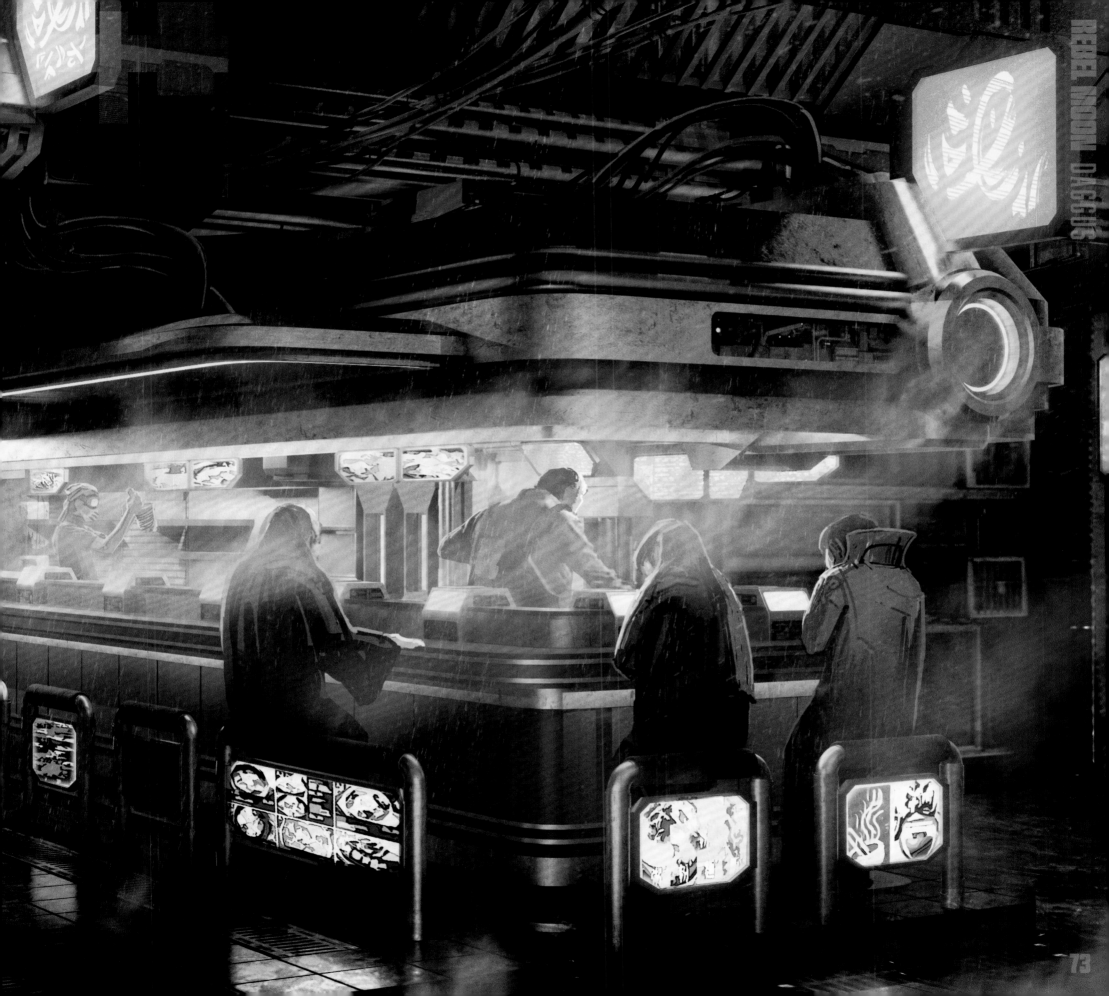

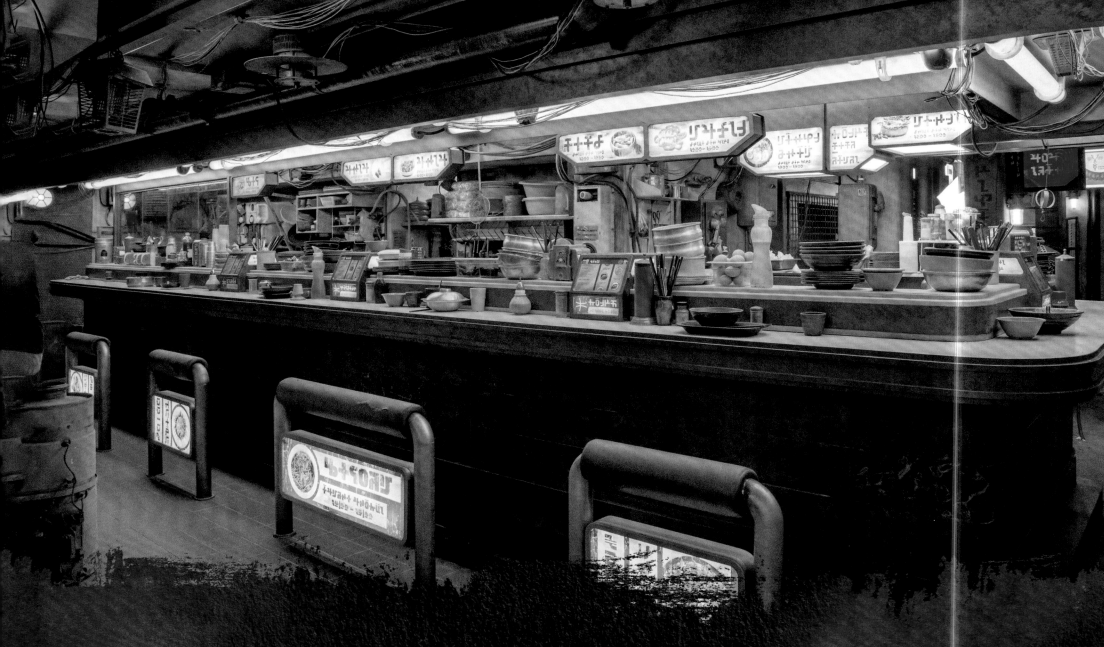

▲ The bar is fully dressed and open for business.

What makes the noodle bar such a feast for the eyes is all the layers—all the tiny details that elevated it to a living, breathing place with a story all its own. "This was a six-week dress, and we used every single day to dress the set," Bonfe says. "The background of the person who owns the noodle bar: They live here, it's a family-owned business. They have their cats behind the counter in a cage. They sleep all day long." (The cats were actually stuffed.) "I can tell when [Zack] likes the set, because he gets excited and he starts looking at all the props. He starts chopping on the chopping board," she adds.

Carmola points out a special detail: "This little shelf that's inside of the noodle bar. It was just an idea that the noodle bar is not totally buttoned up and refined and perfectly built, so the inside of the structure is exposed. It became a great place for set decoration to add a lot of tchotchkes that maybe over time the patrons might have left behind. Or the cats or the crew that work here might have put little tchotchkes up in all these shelves."

Every decent fast-food restaurant needs signage, and the noodle bar had plenty of it. In addition to signs, some twenty-three monitors of various sizes—including one that was fully interactive—helped patrons choose and order their food. "It's actually thought out. There's a specific alphabet that was created for this, and then multiple fonts were created from that alphabet. So the menu pieces actually say what they are," Bonfe explains. "We had three graphic designers working on this. Some of them were working on light boxes, some on all the moving graphics on the monitors, and then the still graphics on all of the vendor carts. Some of the set dressers would just take their marker pen and write some signs like, 'Wash your hands before you cook,' which is kind of funny because it's so dirty in here. I don't know if they ever clean."

When dealing with food, there's a strict divide on set between what's meant to be seen and what's meant to be ingested. The octopus on the chopping block, for example, although real, was purely for show. "Anything background is set dressing," Bonfe says, "and then anything the actors eat would be provided by the props department—because our food isn't as edible and as clean as what I would want to put in my mouth."

KINGDOM TYPE

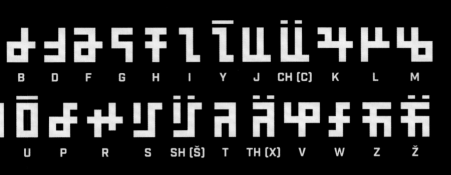

B	D	F	G	H	I	Y	J	CH (C)	K	L	M		

U	P	R	S	SH (Š)	T	TH (X)	V	W	Z	Ž

3	4	5	6	7	8	9			TALLY

E / U / Y

$? ! . , : ; () /

IMPERIUM
CREDIT

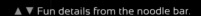

▲ ▼ Fun details from the noodle bar.

▼ ▼ Concept design for the noodle bar prior to construction.

HYPERLIFT

Getting anywhere on Daggus almost always involves going up or down on hyperlifts as part of the journey, and our heroes' search for Harmada is no different. That ordinary, everyday feel informed the build of the hyperlift. "They needed something to run the elevator, and we came up with the idea of using some sort of lift from construction equipment," Bonfe explains. "It was again, using things that exist in the world, and not making something new to look like it's super sci-fi. Just repurposing." Similarly, a low-tech, in-camera technique of using strobing light rigs gives the impression of rapid vertical movement.

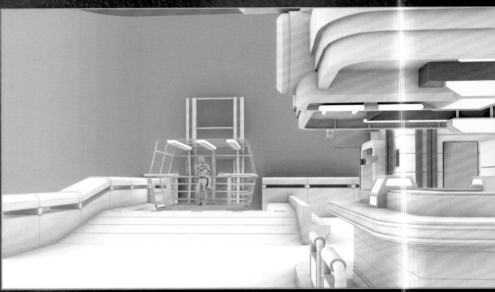

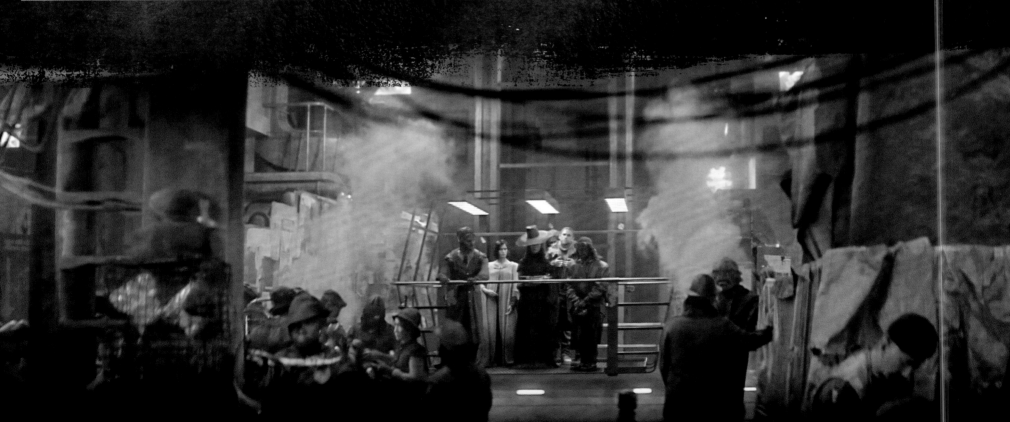

THE BOWELS

The miners have dug too deep, and now someone is going to pay. That leads Nemesis and the others to the bowels of Daggus. "Because of the limited stage space—but we still have a lot of ground to cover as they walk through the city—we designed it with multiple different streets and alleys that have different looks, so you feel like you're traveling farther than you are," Carmola says. Like walking on a web, that required a high degree of nimbleness from the crew. "There's a changeover overnight where the noodle bar gets redressed as a shanty. We bring in some other walls that cover other parts of the set, and we undress parts of the set to make our limited stage space act

as two different levels of the city as they travel up and down on the hyperlift."

Bonfe explains how they were able to make the necessary changes quickly and efficiently with a little planning: "What we did to make it easier, is that we pre-dressed it and took photographs. We're going to hide the noodle bar with our tents and other things, then it's dressed as a bodega, and on the other side we have a repair shop." Add some municipal lighting constructed from semi-truck filters, a few vending machines salvaged from the set of *Bullet Train* (2022), appropriate Imperial signage, and general dirtying up, and the alleys of Daggus could go on forever.

"Then, as we get closer to Harmada's lair, the finishes start to get more degraded," continues Carmola. "We start to see a little bit of her cobwebs, sort of remnants. It builds heavier and heavier as we get close to where she's living and we meet her. I love the part where Claudia and her team have brought all these wires in. They're kind of moving in, and they're hanging overhead." Bonfe explains, "The idea is that she's pulled all the wires out of the lights, out of all the electronics, and pulled the wires in to help make her web in her lair—which is where they end up and the fight takes place."

◀ Digital model and final frames of the hyperlift, where Nemesis joins the crew.

▲ ▶ Concepts for the bowels of Daggus, with Harmada's web of cables leading ever inward.

▶ ▶ Final frame of Nemesis's confrontation with Harmada (Jena Malone).

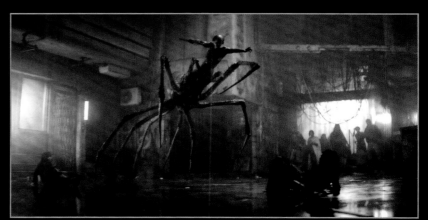

WORLDS
POLLUX

CASTOR AND POLLUX are two moons of a gas giant. Both have hosted gladiator games for eons, but their fortunes have diverged. "Castor is where the sort of first-class people are, but Pollux is where the new guys and the old guys come," Zack Snyder explains. "It's this slightly arid planet. It has a coliseum at the center of this one town that has been the training ground for some of the gladiators that have moved on to Castor. It's like being a gladiator on the farm club level. It's kind of at a low period. And that's where we find Titus."

▲ Concept art of Kora and company's arrival on Pollux.

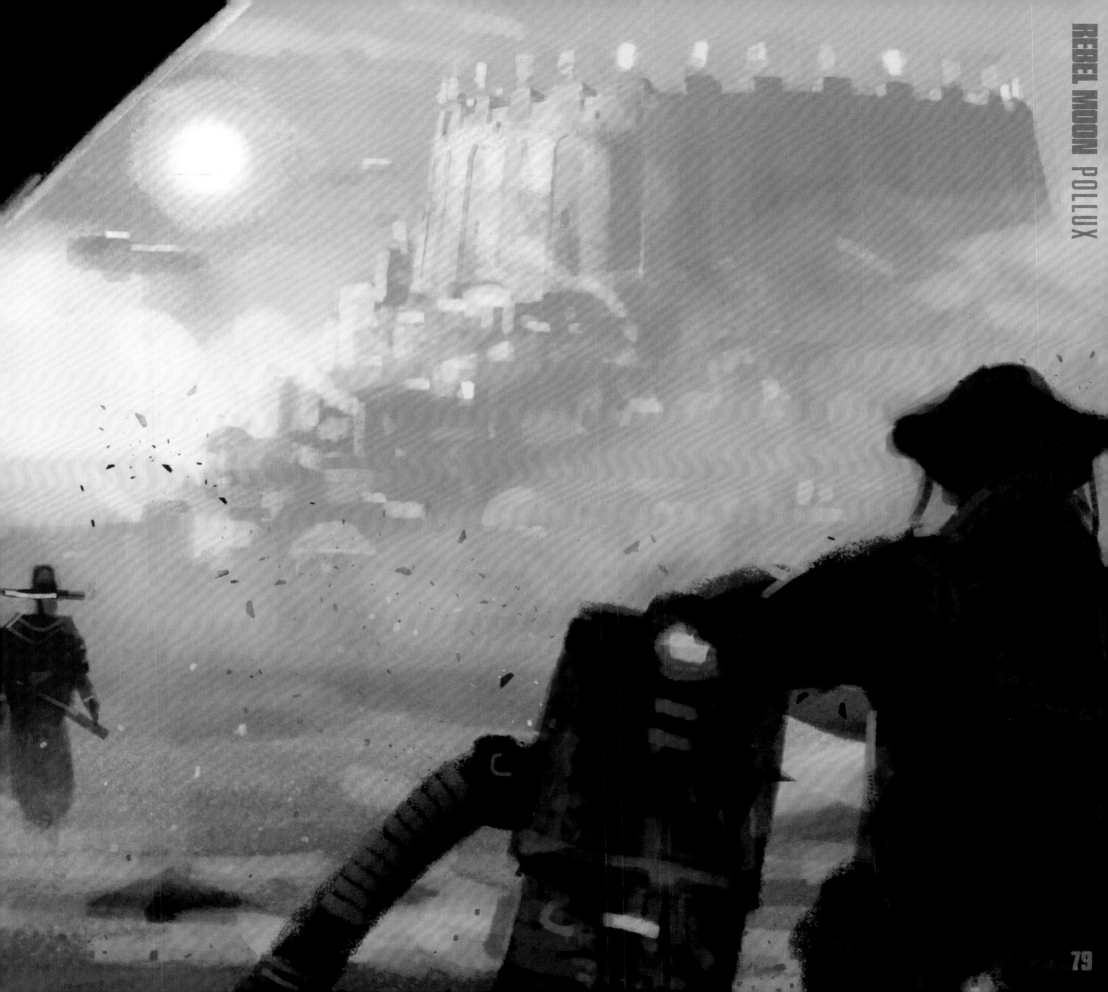

GLADIATORIAL TRAINING SCHOOL/COLISEUM

The impression Snyder wanted to convey was that both the coliseum and General Titus had seen better days, but he wanted to do it efficiently. "That was one of those key events that Zack created with one of his illustrators," says production designer Stefan Dechant. "There were three key images that they came up with: the outside of the arena, then the interior, and then [Titus] getting washed down and this piece of architecture that Zack wanted him to sit on. It all comes straight from Zack. He's the other designer in this movie that we're all following the lead of. We built that on stage with an exterior, and then the hallway that goes into where we see the first gladiator. Then we redress that to be the market where they find the general. We had another avenue that came off that, that goes into the shower room. It was an economy of design, so that we could reuse these pieces and allow us to get more from the same set."

Apart from the iconic, crumbling, Roman-style coliseum, selling the idea that Pollux's glory years were long past was, again, in the details. "That vibe of antiquity, of years and years of the Motherworld and other civilizations, we're leaning into that with

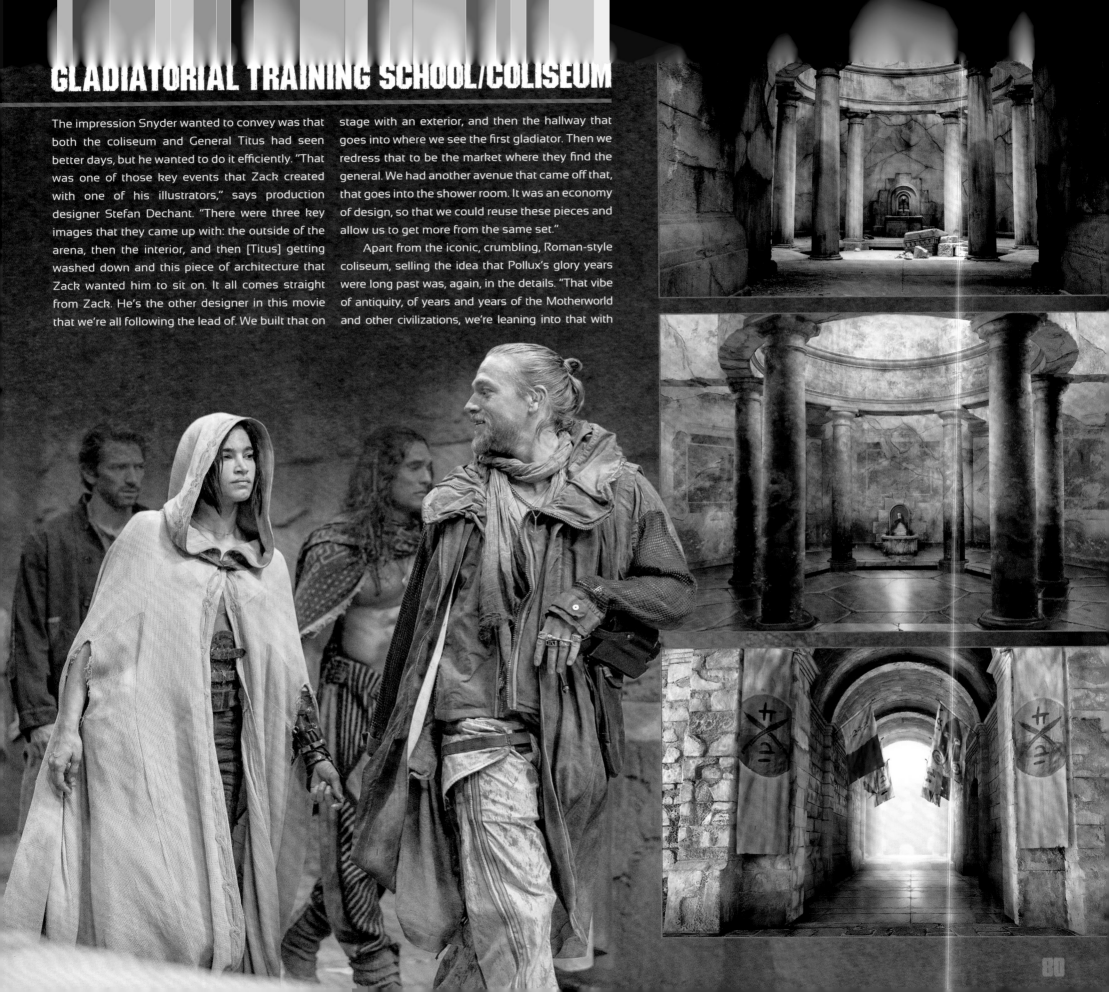

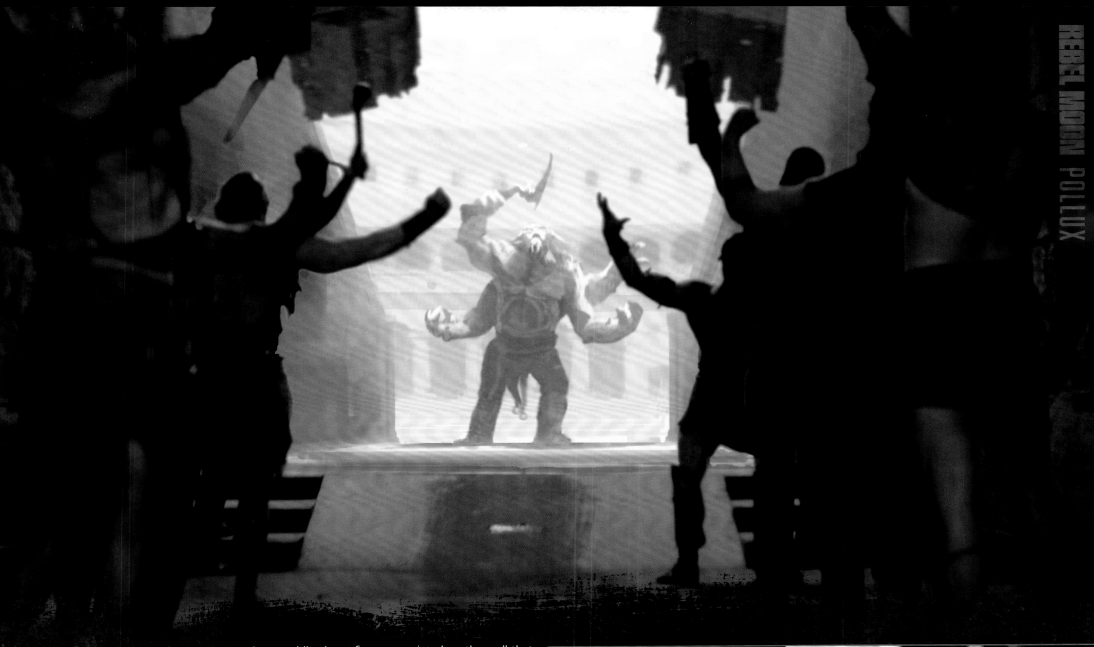

hints of color that's coming across as what would've been frescoes painted on the wall that have long since deteriorated," Dechant says. Set decorator Claudia Bonfe adds, "We had some pretty cool flags. Our graphic designer, Andy Campbell, came up with these beautiful graphics of fighters or old warriors, and each one represented someone who had fought there for many years and maybe had died."

While it would have been easier and cheaper to film General Titus passed out drunk in a barren alley, the filmmakers chose to do so in the midst of a living, breathing marketplace full of vendors selling everything from spices to clay pots and rugs. "So much of it depends on set decoration, and Claudia the set decorator was fantastic how she layered in these elements," says Dechant. "She would really take to heart, like, 'Who are the people here? What's this market? What's the color that's going to be in there?'" All of that thought helped to make Pollux a real place and Titus a real person.

◄◄ Kora and companions seek General Titus at the coliseum.

◄ (top to bottom) The washing station. Concept for the washing station. Concept for the entrance to the coliseum.

▲▶ Concept art of an alien gladiator and admirers, and a final frame.

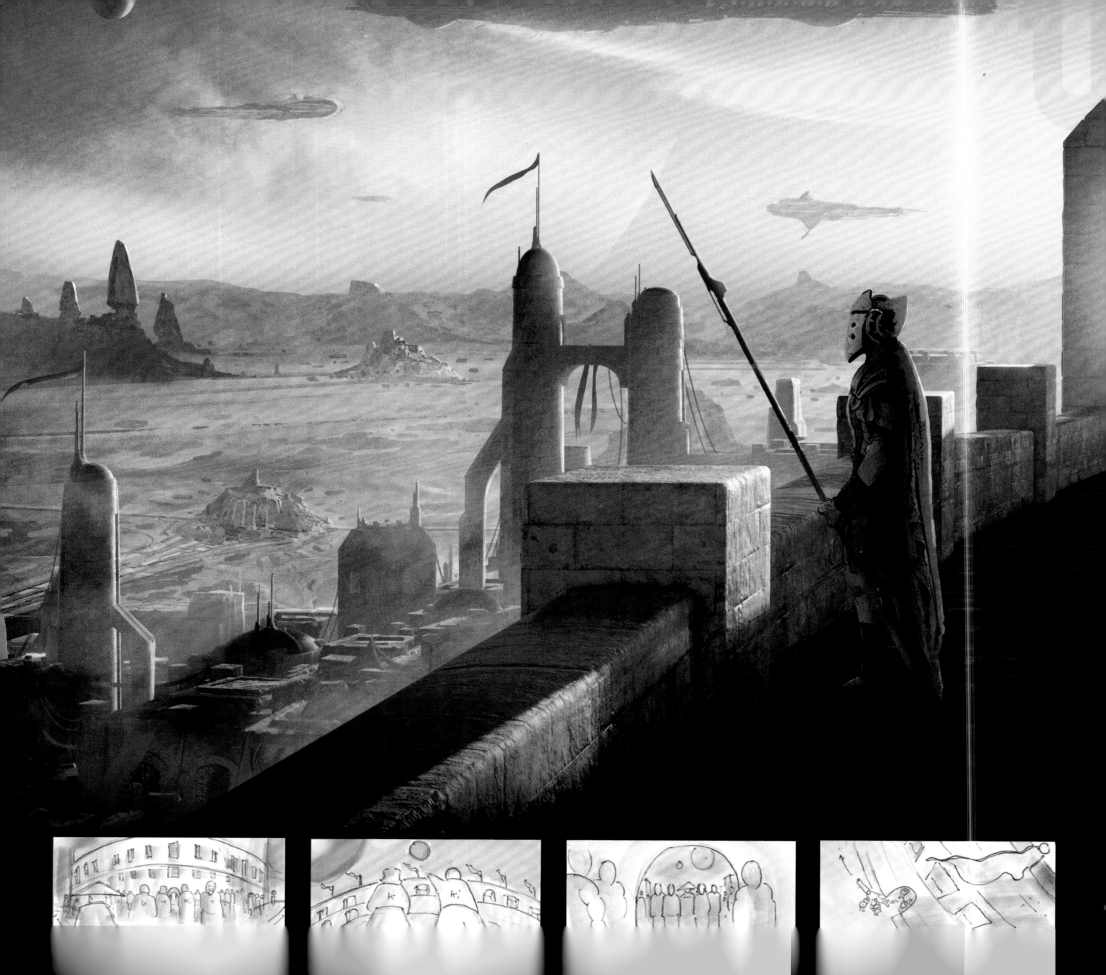

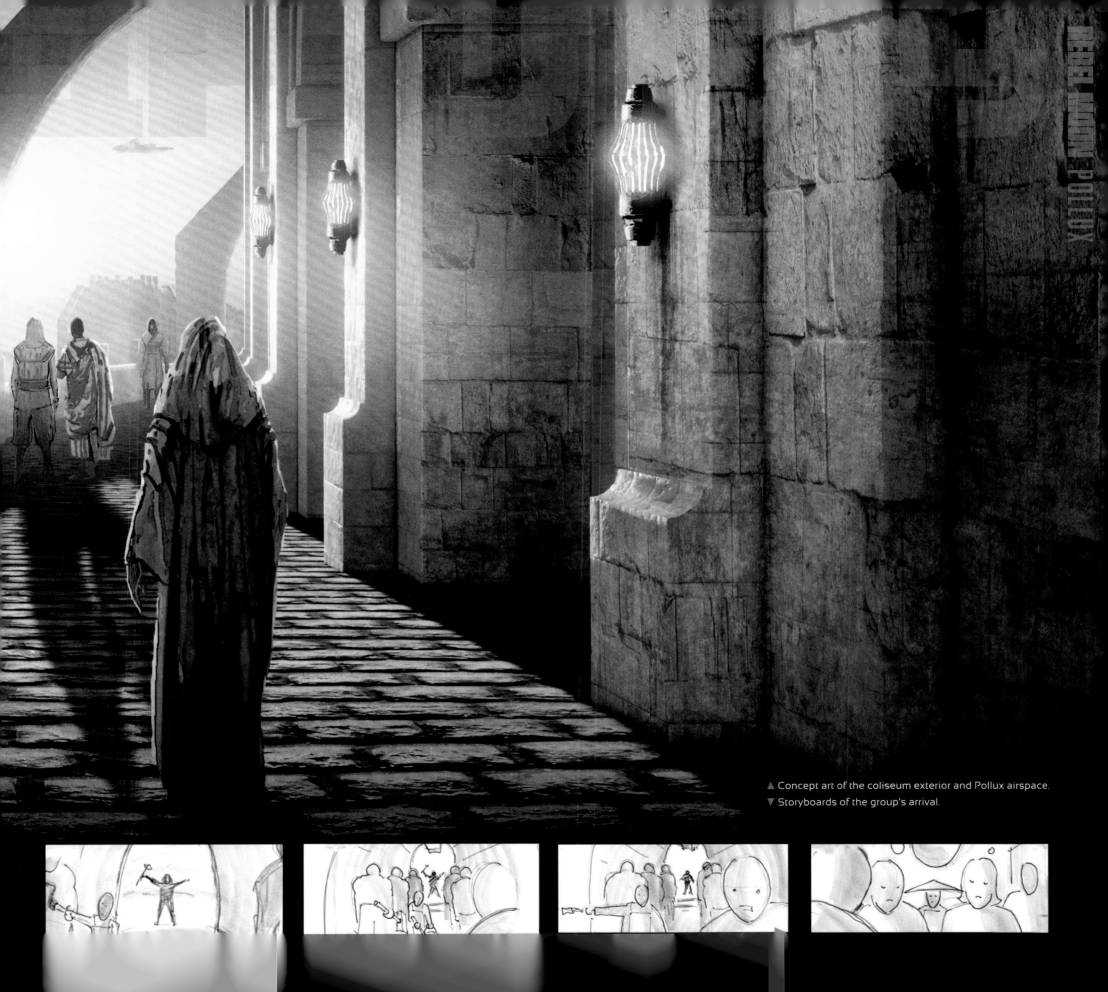

▲ Concept art of the coliseum exterior and Pollux airspace.
▼ Storyboards of the group's arrival.

WORLDS
SHARAAN

RULED BY KING LEVITICA, the planet Sharaan is home to an ancient culture steeped in the ideals of honor and charity. This is why the king extends his hospitality to Kora and her band and agrees to contact the Bloodaxes for them—a decision that ends badly for the king and his world. The design of the city lent itself to emphasizing the mystical, alien qualities of the people who lived there. "I didn't want it to be, 'Oh, here we are in another sci-fi place,'" Zack Snyder says. "It's black, monolithic buildings carved out of stone, but very smooth and sharp and angular, with stone engravings. This perpetual-eclipse world. It was a chance to be weird."

Bringing the weird and making it work turned out to be a challenge. "We knew generally what it was going to be, and we even did backings [to use as backdrops] for it, but the backings didn't work. We didn't have enough space, and the lighting wasn't going to work, so we went with green screen," production designer Stefan Dechant recalls. "What Zack was going for was a kind of spirituality of place, and he had some sketches of these floating columns. I worked with [concept artist] Craig Sellars, and we took the original plates and we would riff off them and go, 'Here are these elements, and this is the sun, or maybe it's an eclipse or a planet. How are we going to have these pieces that are floating? What does it look like?' We backed into the design based on what Zack had drawn. It's somewhere between being a kind of temple and being out in Monument Valley, where you just have these [natural] shapes. The sky creates its own kind of spirituality, without spelling it out."

▲ Concept art of *The King's Gaze* attacking Sharaan.
▼ Kora meets King Levitica (Tony Amendola).

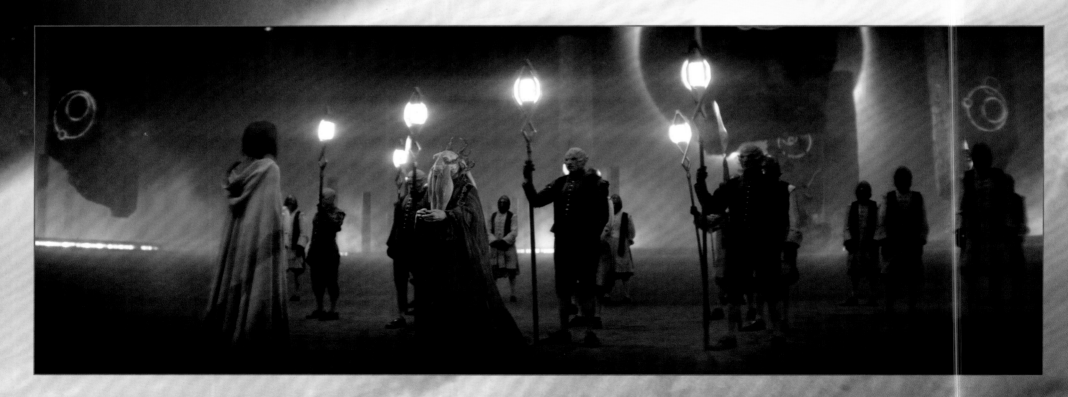

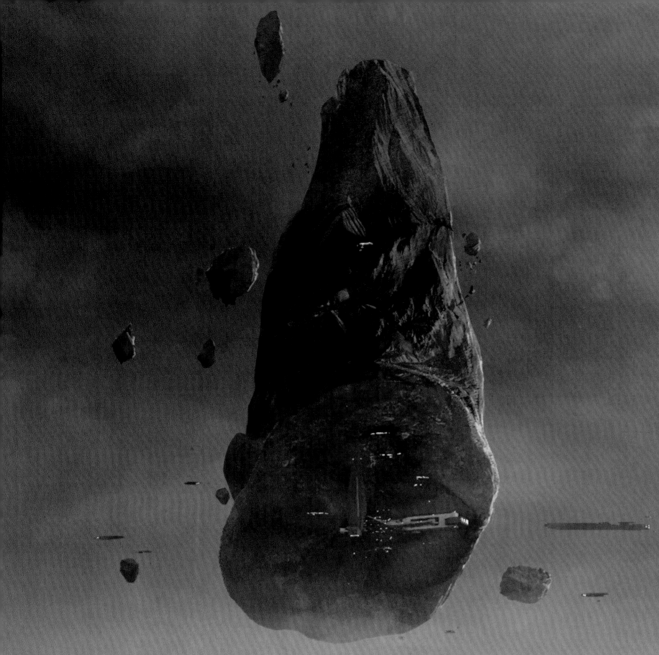

WORLDS
MOON OF GONDIVAL

BROUGHT TO DOCKS floating above a low-orbiting moon called Gondival because Kai claims to have buyers awaiting a delivery, Kora's team find themselves instead in Noble's trap. Thus begins the climactic battle of the first *Rebel Moon* film. "Gondival is this cloudy weigh station. It's like those little airports where they land to drop off drugs when they're bringing them up from the south. This place with shitty warehouses where they're hiding stuff, like you see in the movies," Zack Snyder says. Adding, "I've never been to one in real life."

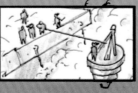

▲ ▲ Concept art showing a floating dock from a distance.
▲ Storyboards of some of the action over Gondival.

► Concept art depicting the buoy and details of the floating docks.

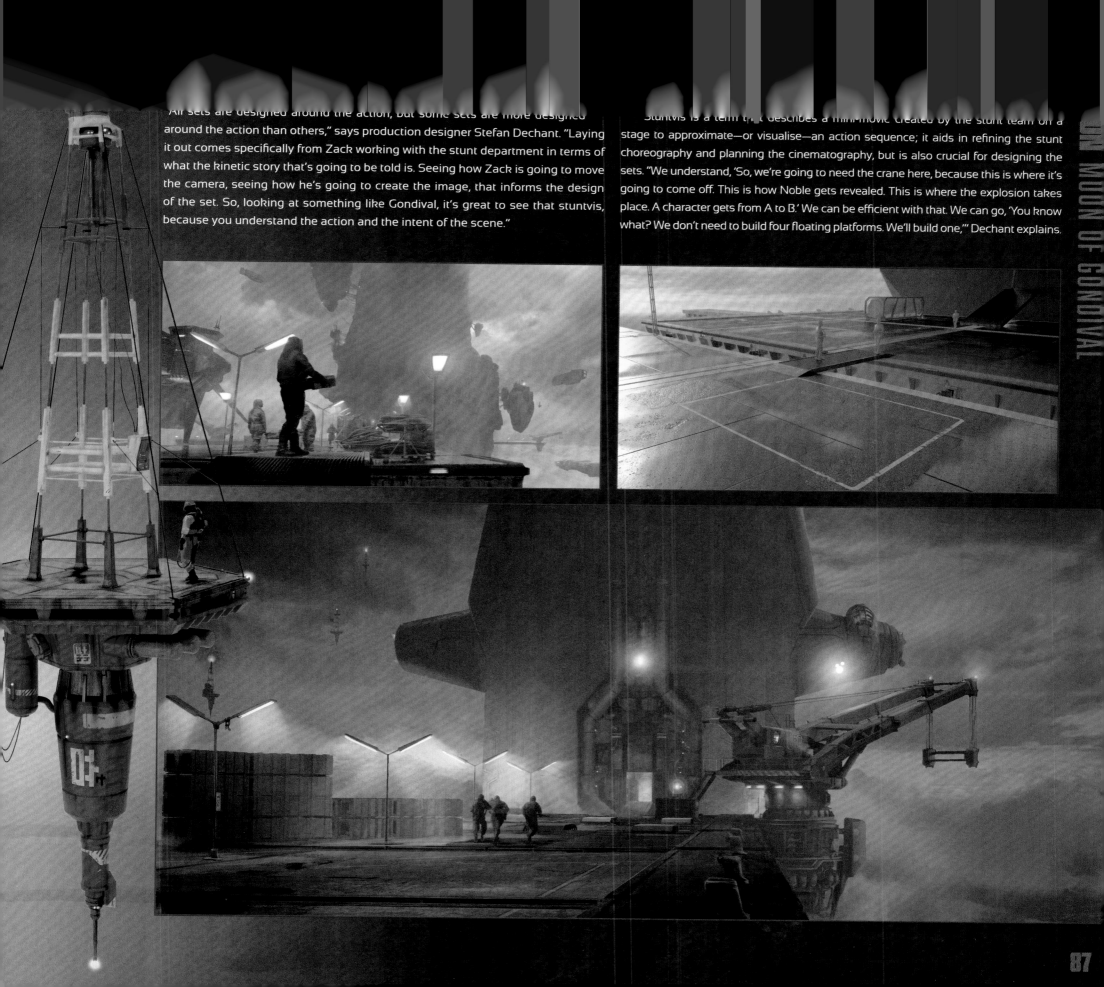

"All sets are designed around the action, but some sets are more designed around the action than others," says production designer Stefan Dechant. "Laying it out comes specifically from Zack working with the stunt department in terms of what the kinetic story that's going to be told is. Seeing how Zack is going to move the camera, seeing how he's going to create the image, that informs the design of the set. So, looking at something like Gondival, it's great to see that stuntvis, because you understand the action and the intent of the scene."

Stuntvis is a term that describes a mini-movie created by the stunt team on a stage to approximate—or visualise—an action sequence; it aids in refining the stunt choreography and planning the cinematography, but is also crucial for designing the sets. "We understand, 'So, we're going to need the crane here, because this is where it's going to come off. This is how Noble gets revealed. This is where the explosion takes place. A character gets from A to B.' We can be efficient with that. We can go, 'You know what? We don't need to build four floating platforms. We'll build one,'" Dechant explains.

Stuntvis also helps on the day of shooting. "As [Zack's] moving, we can move through that very, very quickly and get to the next setup, and the next setup," Dechant adds, "because we've seen it on camera already, and we've seen what's in Zack's mind."

In a scene that admittedly required a great deal of green screen and CGI to pull off, there were still quite a few low-tech effects used to elevate the action. Special effects supervisor Michael Gaspar cites one example: "Where they're running across the Insurgent ships and you see the ships are moving slightly, we did that with good old-fashioned semi-truck inner tubes. Basically, two pieces of plywood with an inner tube in between, and we mounted them underneath so they could have some movement to them." Similarly, the actors didn't need to pull the floating buoy to the floating dock using a rope; that traveled on a hydraulic track.

The confrontation over Gondival is a significant scene not simply because it gives our band of heroes a desperately needed victory, but also because it contains vital character moments—such as Gunnar's newfound bravery and Darrian Bloodaxe's selfless sacrifice. "There's a couple of different ways to inform what character is," Dechant says. "Many people think about character in terms of dialogue, but it's also in terms of action. In these action sequences, Zack is developing character, and what we're doing as the art department and as a designer is making sure we're creating environments that help support the character and the story that Zack is telling. Whatever he's seeing in his head, he's getting on screen."

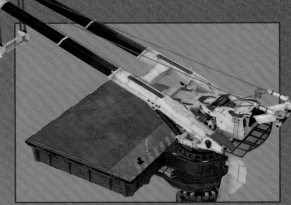

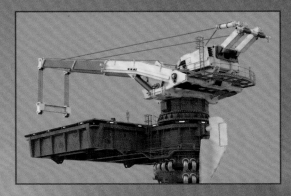

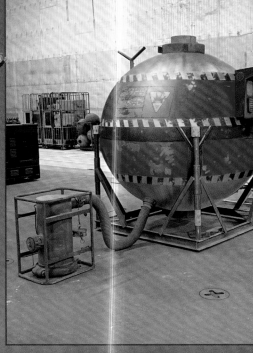

▲ Detailed digital models of the loading crane.

▲ Dock machinery under construction.

▼ A bird's-eye view of the docks, showing the location of Kai's freighter, the Admiral's launch, the crane, and the buoy.

COAST

Noble's shattered body comes to rest far below the docks, on the rocky coast of the volcanic moon. While appearing to be covered with fields of razor-sharp obsidian, the shore was actually soft foam rubber. While the surf was also a practical illusion: "I had six, 300-gallon dump tanks—pressurized tanks that spray the water on the back of the outcropping—to look like waves were crashing," Gaspar recalls.

▲ ▶ Noble and his entourage make their unexpected entrance.
▶ Titus fights for his life.

KORA'S HOMEWORLD

WHEN SHE WAS A CHILD, the Motherworld invaded Kora's home and killed off her family. After her attempt to kill Balisarius, he inexplicably chose to save her from the destruction. "Kora's homeworld was influenced by Sofia Boutella's Algerian roots. We thought we would have some sort of North African vibe to it," Zack Snyder explains. As discussed, making use of the actors' ethnicities and personal and family histories as inspiration was a common, collaborative element in developing the worlds and cultures of *Rebel Moon*.

Research on towns in the Middle East that had been devastated in conflicts over the past thirty or forty years gave rise to the final concept of the build as an urban environment. As luck would have it, a set used for scenes of the Iraq War in *American Sniper* (2014) already existed on the backlot at Blue Cloud Movie Ranch. "It had apartments and had staircases. It had a courtyard," production designer Stefan Dechant recalls. "Zack had storyboards of what the scene was, but once he was able to walk in there, he redesigned the scene as to how we wanted to tell the story."

Dechant credits set decorator Claudia Bonfe with bringing in "that kind of sci-fi retro tech she's adding to the exteriors, and making it its own place. In Kora's world, it's all about this cluster of boxes, the way the cables come out and whatnot. It's different from any of the other sets." The furniture was all mid-century, but not very beautiful—just straight lines and not too bulky—built for folks who do not have much money.

Naturally, this planet needed its own language and script to fit with the aesthetic and populate signage. "I wanted a kind of fluid-paintbrush feel to it, so it could feel like it had elements of Arabic writing to it, but we were also looking at Southeast Asian languages, like Thai," says Dechant. The result was a script called "Ahriq," which graphic designers utilized strategically as several different fonts on all sorts of signs. "I wanted it to feel like advertising without saying advertising," Dechant explains. "So, we looked at 1930s and '40s gas station iconography. We liked the color, we liked the shapes. They all say something like, 'this is somebody's power garage,' but we didn't want to be overly specific. We didn't want a character drinking Coke or anything like that. We just wanted to have lettering in the background that gives life and some history to the place."

▲▼ Concept art of the devastation on Kora's homeworld.

▼ A young Kora watches the destruction of her homeworld from aboard a dreadnought.

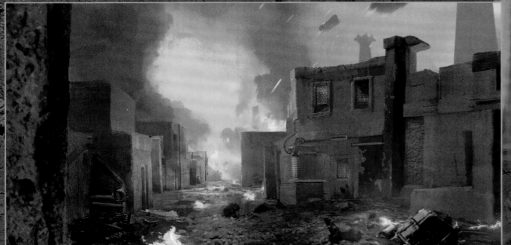

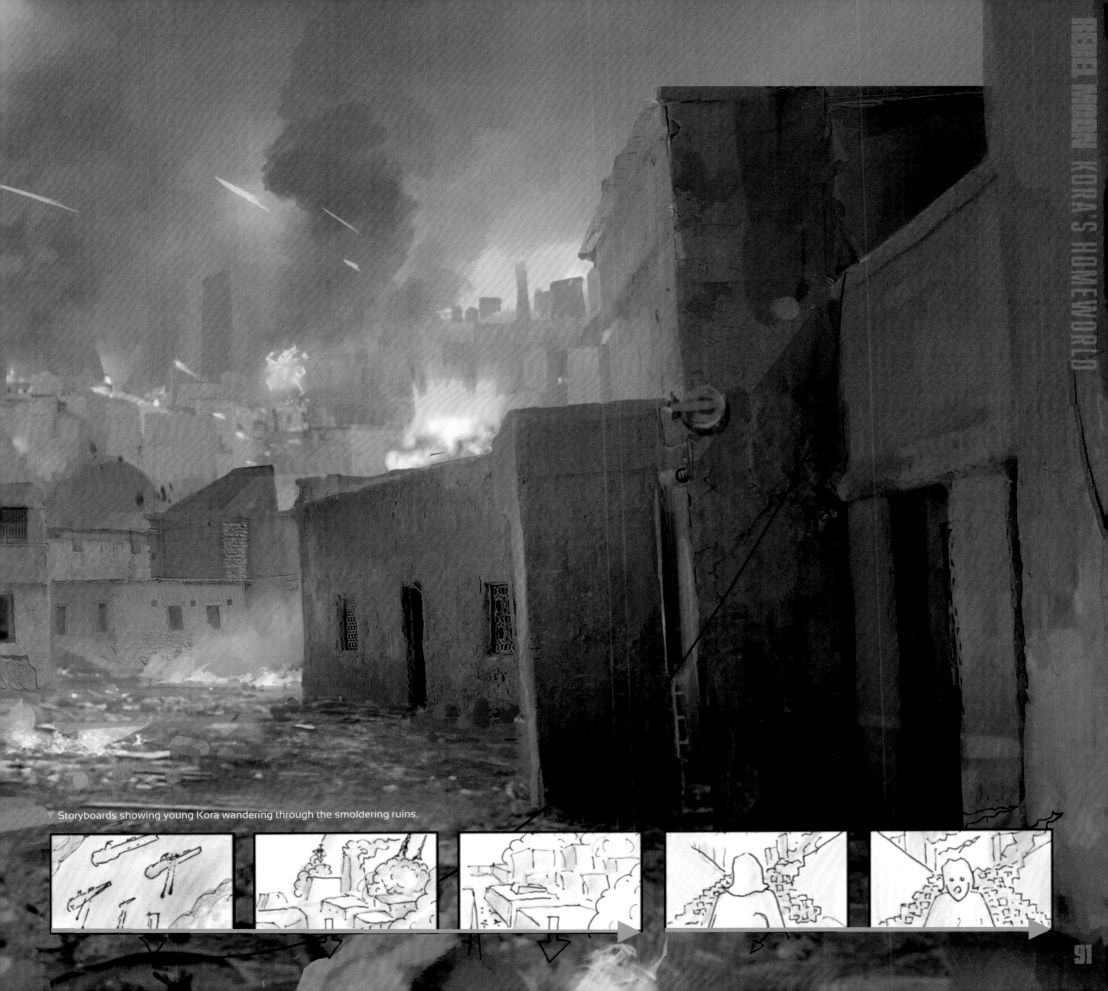

Storyboards showing young Kora wandering through the smoldering ruins.

TEEN KORA

WHEN SHE WAS ONLY thirteen, Balisarius took Kora along with him to a newly conquered planet. There she witnessed the leaders of the world surrendering to the Motherworld—and being executed on the spot. "The style of the people is almost biblical, because we wanted to make sure that it felt like they were kings, that the culture of the people the Motherworld was facing was ancient," Snyder says.

When visiting many worlds, often in rapid succession, it's helpful to find distinctive locations and elements for the audience to hold on to. "One way we differentiated that was by going into an interior environment, as opposed to an exterior environment," Dechant explains. "Zack was thinking along the lines of a cathedral. We have quite a few cathedral-type environments, so I had just looked at a Taschen book about libraries, and thought, 'What if this is a library?' Every time the Motherworld is coming through, there's just so much loss.

I was thinking about the Library of Alexandria, and what it means to lose your civilization." The result was a small but poignant build, with VFX extensions showing the walls lined with shelves of books that would soon be lost to history.

The action, too, had to be every bit as brutal as that cultural loss. "We had a big head-wound to do where a king was shot in the back of the head. He had one of the sacks over his head," special effects supervisor Michael Gaspar says. "That was a last-minute addition from Zack, so it was a rig we put together rather quickly. Up through the costume, through the hood, in front of his face—but you couldn't see his face because of the hood. Then pneumatically we blew out the front of that hood and exploded quite a bit of blood onto the ground. It's quite over the top, but Zack's really amenable with me to drive gags in a good way. Since I've worked with him before, I have a feeling where he wants to go with it."

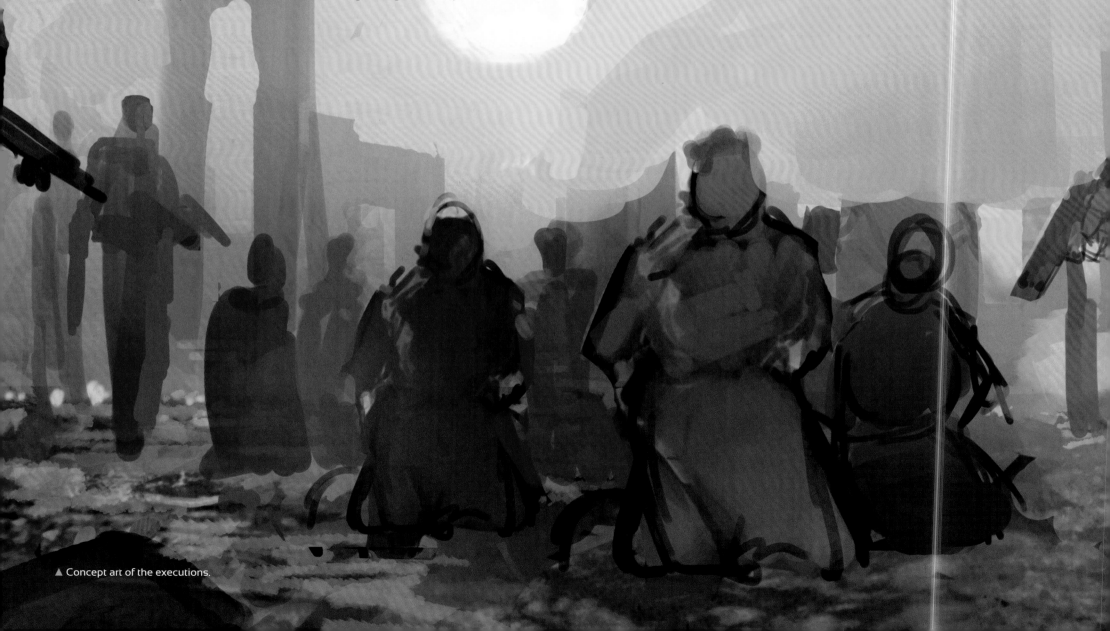

▲ Concept art of the executions.

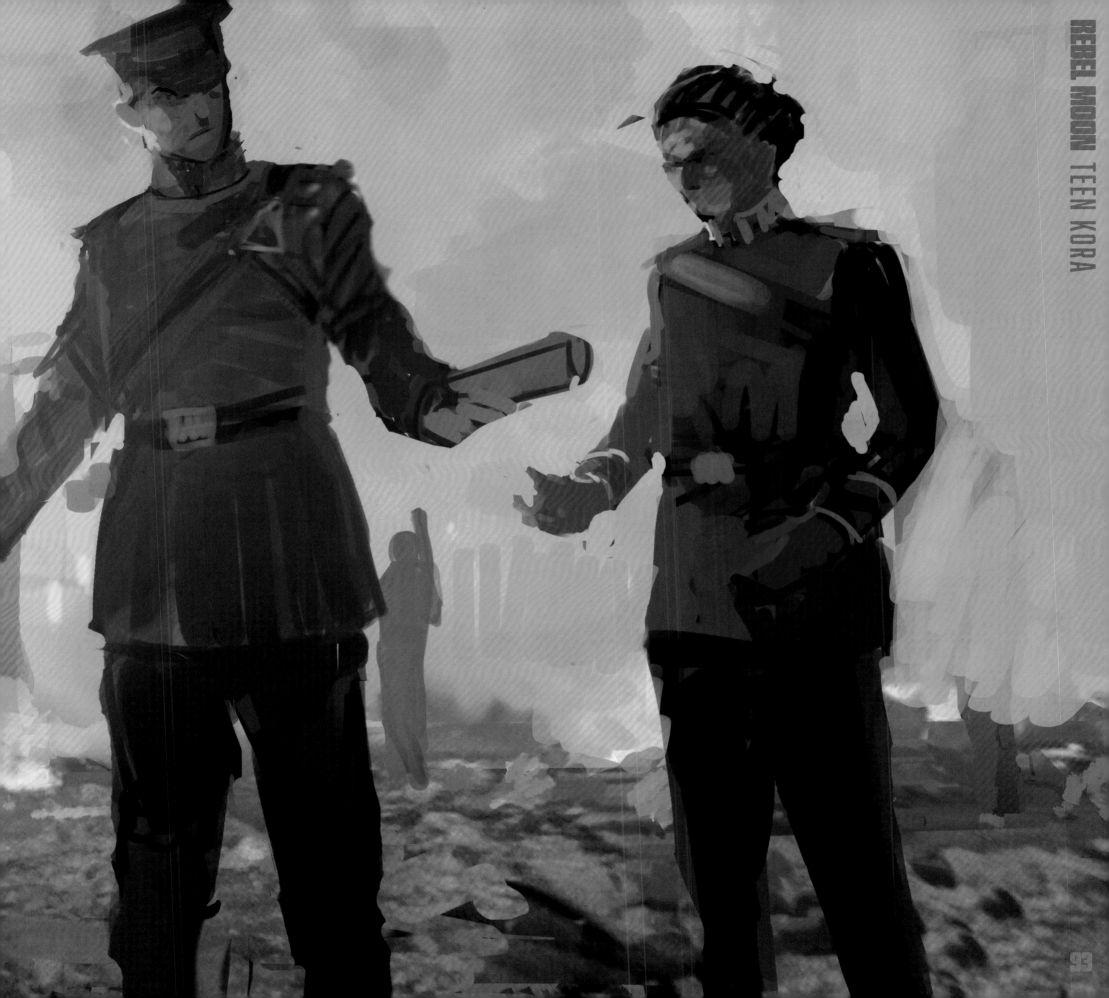

NEWLY GRADUATED KORA

NEWLY GRADUATED from the Imperial Military Academy, Kora led troops into battle for the very first time. It was a hard slog through snow and mud, but they managed to take out a concrete bunker and achieve a victory for the King. "It's a place where the Realm is facing some stiff resistance," Snyder explains. "It's certainly far out from the Motherworld, our core, and our men are far from home. A World War I battlefield was the inspiration. I wanted it to feel like the sort of hellscape that you see in those photographs. But also, the pillboxes up on the hill are eating them alive, kind of like the [World War II] Normandy landings." It's essentially the worst of both World Wars, and while we never see who they are fighting, we do see the effects of the defenders' barrage on the Motherworld soldiers.

"One of Zack's first films in Art Center was a really great story about World War I. He actually rented the vehicles to dig a trench in his neighbor's yard to shoot it. So, I think there's an element of Zack that is interested in the aesthetic of that time period," Dechant says. "Basically, we built a very narrow stretch of set, so that we only had to encompass where Kora was and those who were right next to her. That allowed us to have a fair amount of distance from the green screen, so we weren't having green spill all over the set. We built the pillbox, and then shot her on top of that with her waving the flag. We were down at Sunset Gower Studios, and they're not the tallest stages, so we were pretty much maxed out. But it all worked."

Originally, the script called for a rainy, muddy battlefield, but a couple of considerations convinced the filmmakers to alter that plan. "There was a feeling that the mud and the reflective quality of the puddles might impact how the visual effects tied into everything," Dechant explains. "So [VFX supervisor] Marcus [Taormina] suggested that it be a *snowy*, muddy battlefield, which was great. It was another look we could have." Gaspar adds that the problem of what to do with the rainwater on the set was also a factor: "It's a big deal, because you've got to get rid of the water and not have it flood the stage, and it's hard to pump mud out. So we came up with snow, which is 'dry.'"

SFX was happy to provide the snow, along with many other practical effects for that scene. "It was one of the last things we did in the movie," Gaspar says. "It's Kora running out of the ship. It was snowing, these big ground hits are going off, and she took cover at a wall that's part of a column, and bullet hits in there blow big chunks of concrete off near her. That was all so interactive. It's one of the coolest shots in the movie."

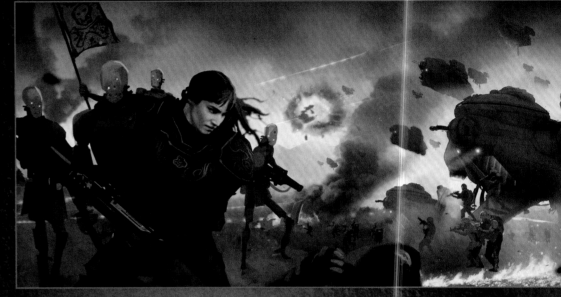

▲ Concept art of Kora leading troops, including Mechanicas Militarium, for the first time.

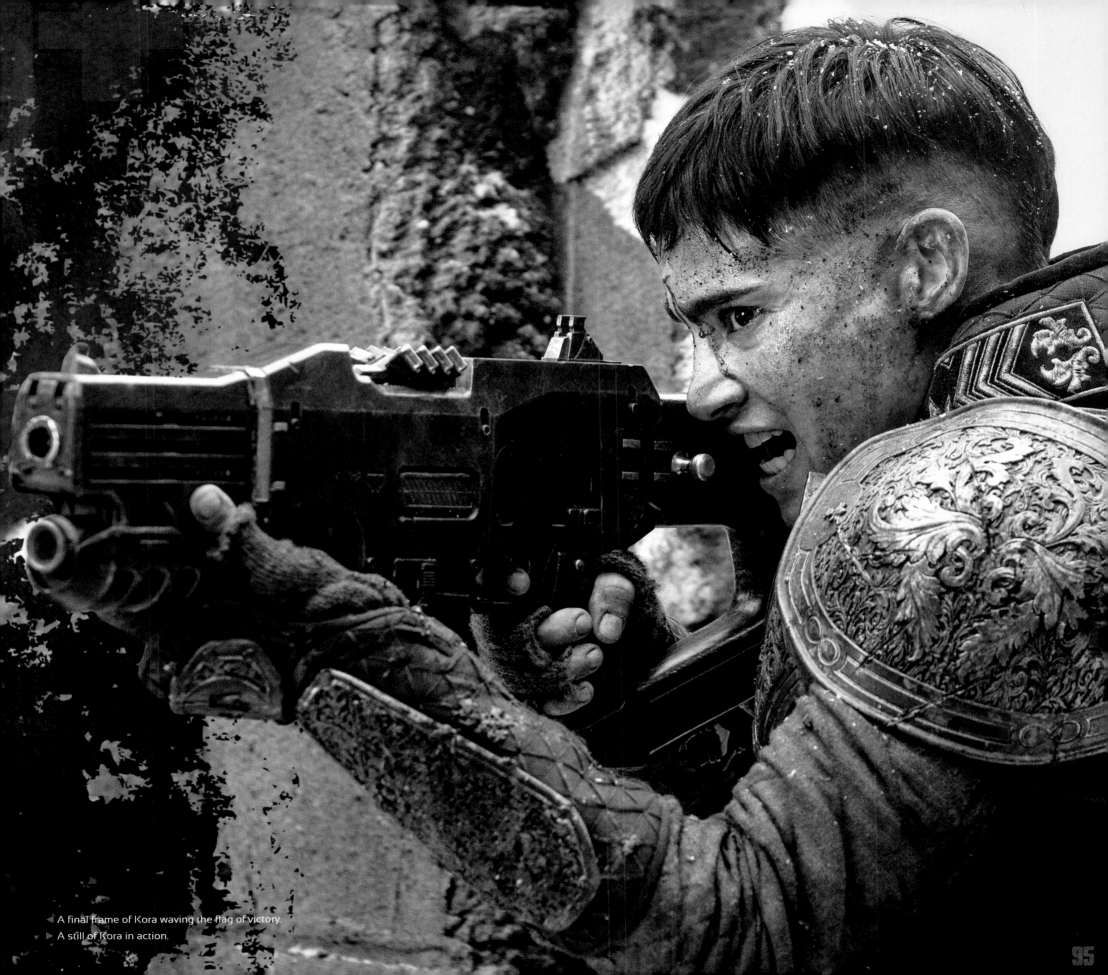

A final frame of Kora waving the flag of victory.
▶ A still of Kora in action.

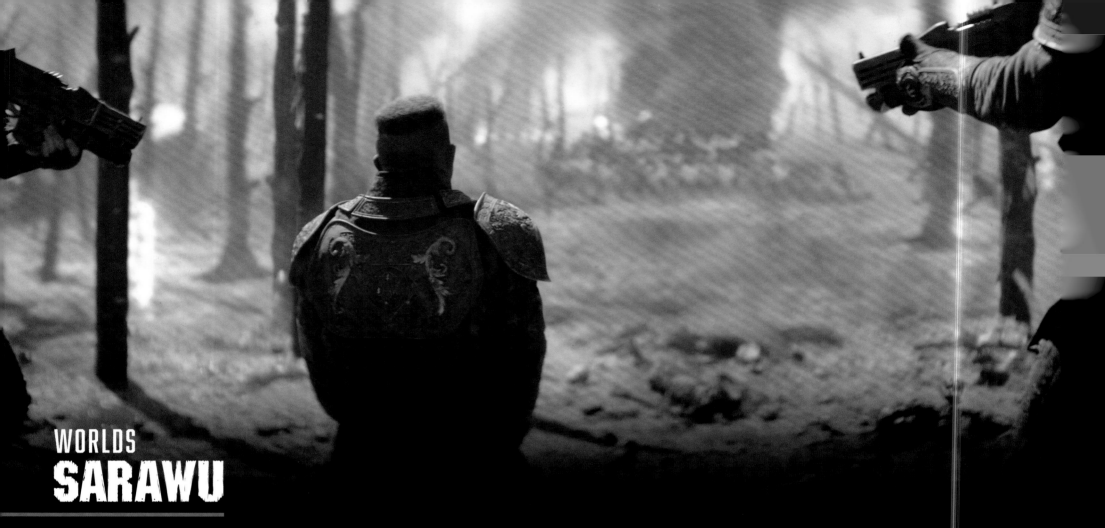

WORLDS
SARAWU

WHEN GENERAL TITUS REBELLED against the excessive cruelty of the Motherworld, he and his troops sought refuge on Sarawu. Eventually the Imperial Fleet caught up to them, and it did not go well—for them or the planet. "Originally, that was a jungle planet, a lush, forested planet, but after the dreadnought devastated it, it was just a burned-out, forest-fire-looking place," Snyder says. Production designer Stefan Dechant adds, "Sarawu was wanting to lean into where Zack's aesthetic interests lie. That was very much that classic World War I, trees ripped away look, and then the battlefield being torn open. We started playing with the idea of ash falling onto the set. There's a brutality and a beauty, and the mix of that's going on in the final image."

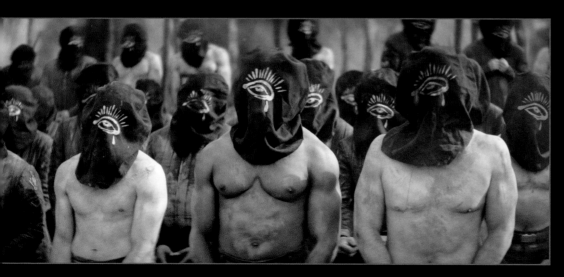

▲ ▲ Final frame of General Titus after his capture amidst the devastation of Sarawu.

▲ Filming the mass execution of Titus's captured troops.

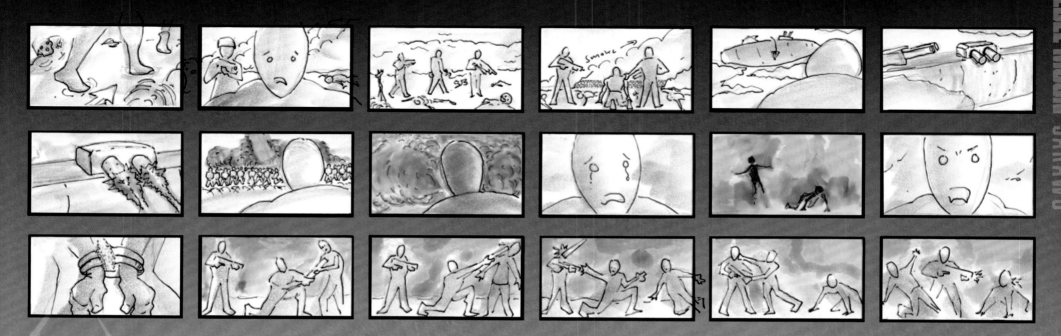

General Titus witnesses the execution of his loyal troops before breaking free and escaping.

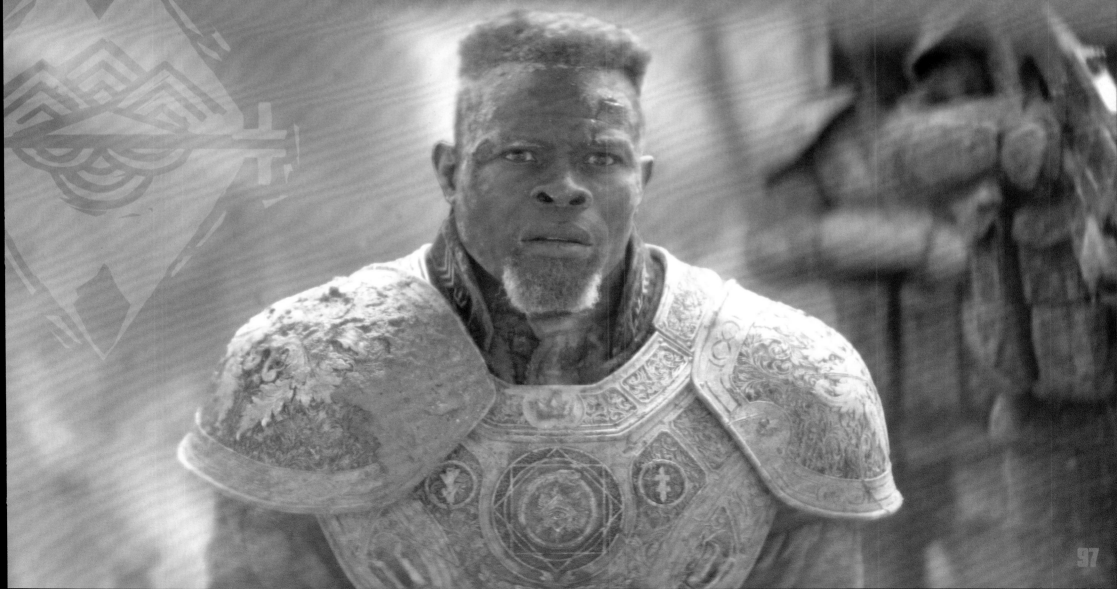

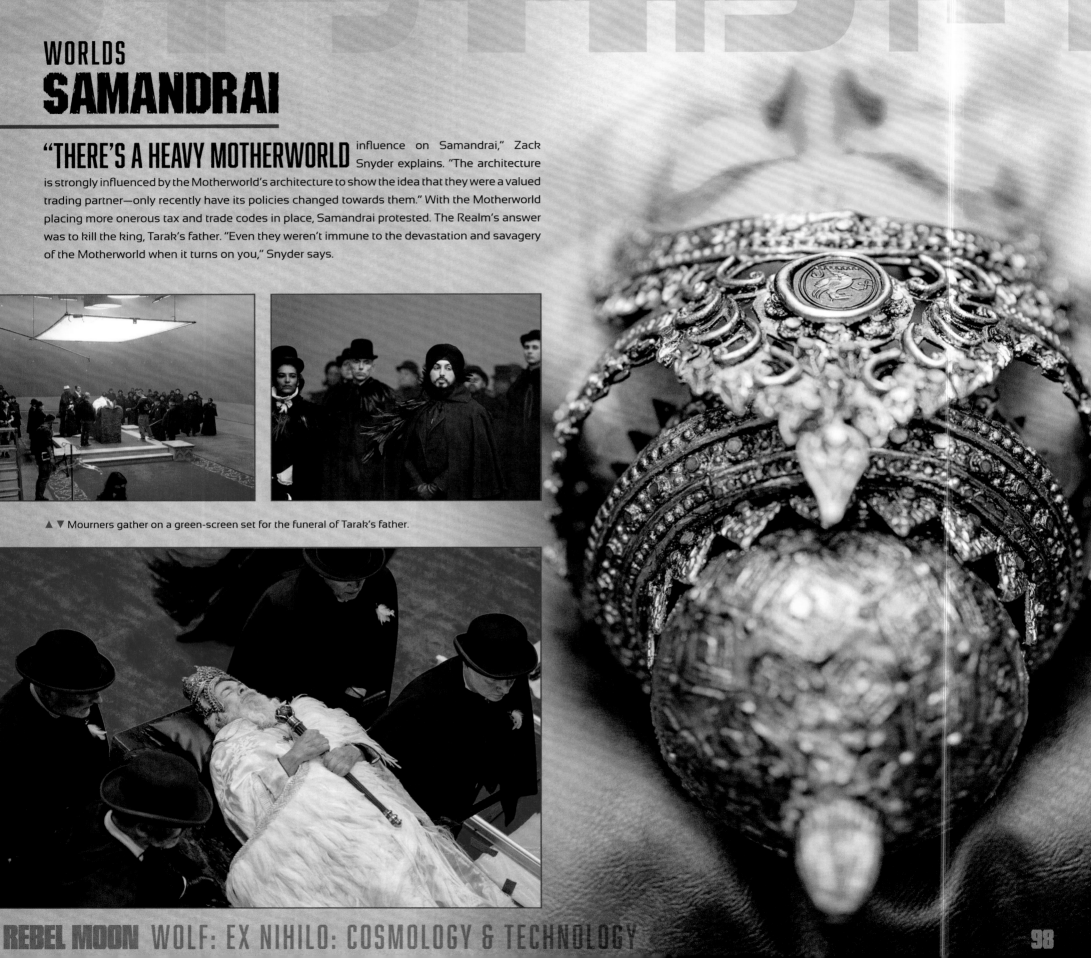

WORLDS
SAMANDRAI

"THERE'S A HEAVY MOTHERWORLD influence on Samandrai," Zack Snyder explains. "The architecture is strongly influenced by the Motherworld's architecture to show the idea that they were a valued trading partner—only recently have its policies changed towards them." With the Motherworld placing more onerous tax and trade codes in place, Samandrai protested. The Realm's answer was to kill the king, Tarak's father. "Even they weren't immune to the devastation and savagery of the Motherworld when it turns on you," Snyder says.

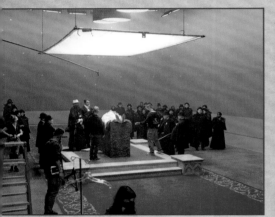
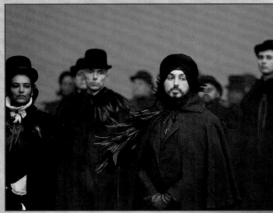

▲▼ Mourners gather on a green-screen set for the funeral of Tarak's father.

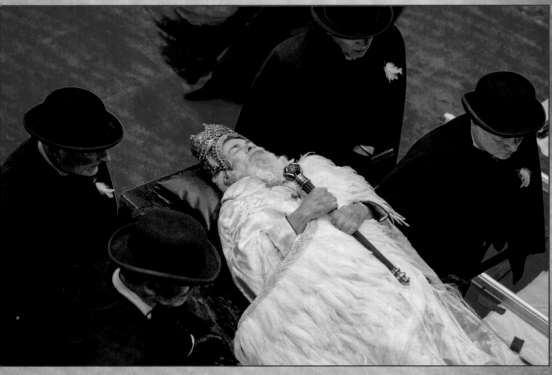

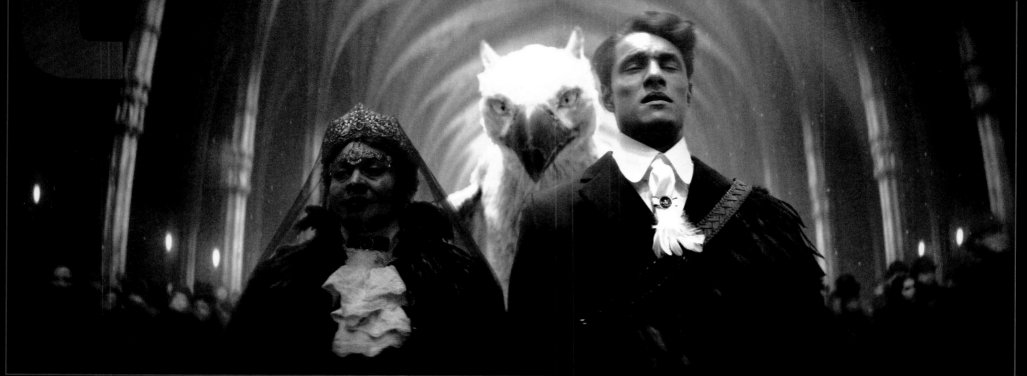

For the king's funeral, production design centered around a Neo-Gothic style. "Even the people that are there have an aesthetic that's very similar to the Motherworld in terms of the costume design and the Victorian qualities that are in there," Dechant says. "I think if we'd been shooting in Europe, we probably would have found a cathedral. There were several that Zack was interested in. If we were in a different multiverse, we would have shot at a practical location." As it was, the walls and ceiling of the cathedral were digital effects and only the floor was dressed. "Props did a casket, and they were moving him over a giant sixteen-foot-wide by 200- or 300- foot red runner that we needed to stencil a pattern on to—the gold border," says set decorator Claudia Bonfe.

Apart from glimpses of subtle iconography, what differentiates Samandrai from the Motherworld is the feeling that is conveyed during that scene. "It's not like I'm designing out the entire world of where the Klingons live. I'm looking for what's going on in the story. What's the emotional impact of what's going on?" Dechant explains. "One of the areas I was leaning into were World War II photographs of air raids over London at night. There's an aesthetic there that's evocative—the spotlights going across, illuminating planes, or those dirigibles that they would have up there to get caught up in the German fighters. Looking off the balcony, letting the fog roll in, so that we can see these massive ships in silhouette breaking through. That sense that the enemy is arriving; fear and oppression being on our doorstep. That felt like a good starting point."

▲ ▲ Final still of the queen (Soma Mitra), Tarak, and ceremonial white bennu at the funeral.
▲ Concept art for the royal funeral.

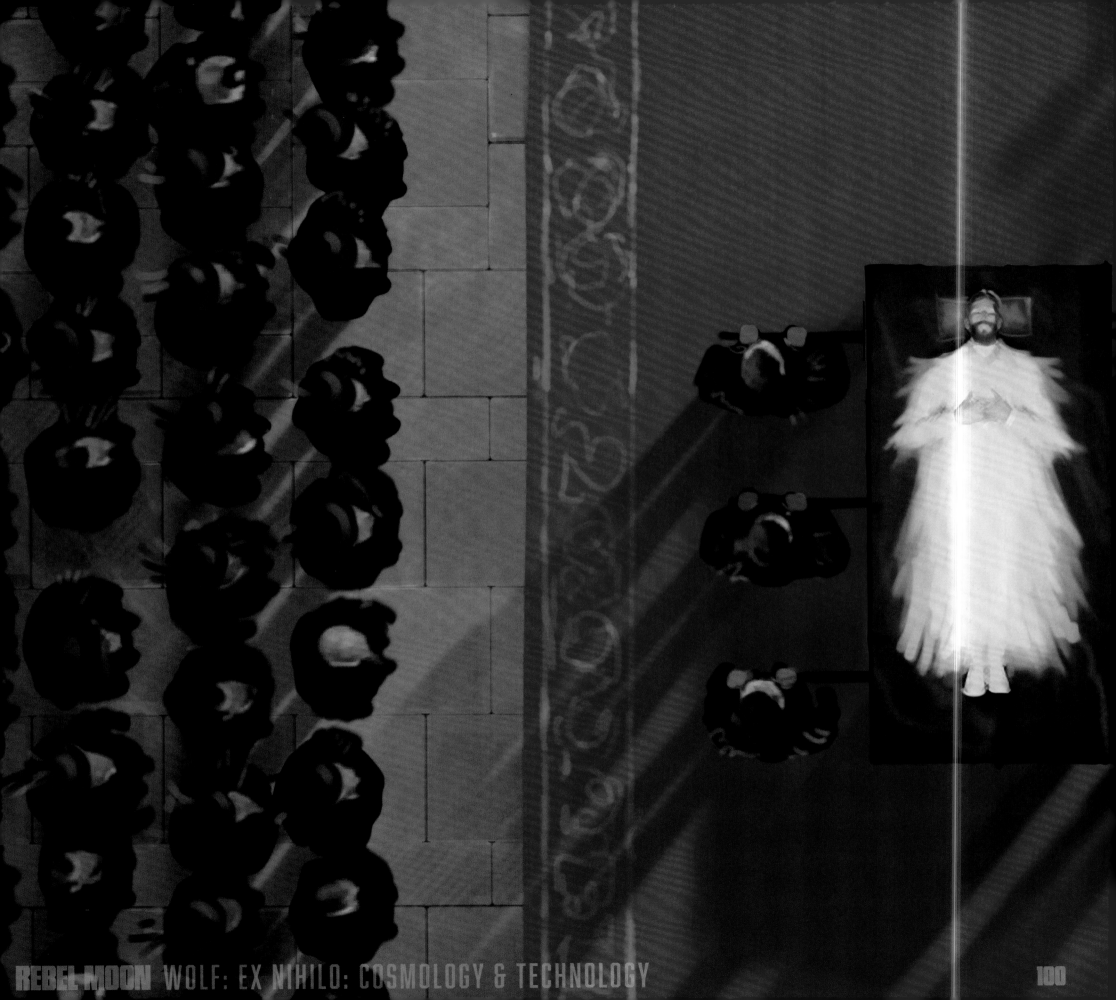

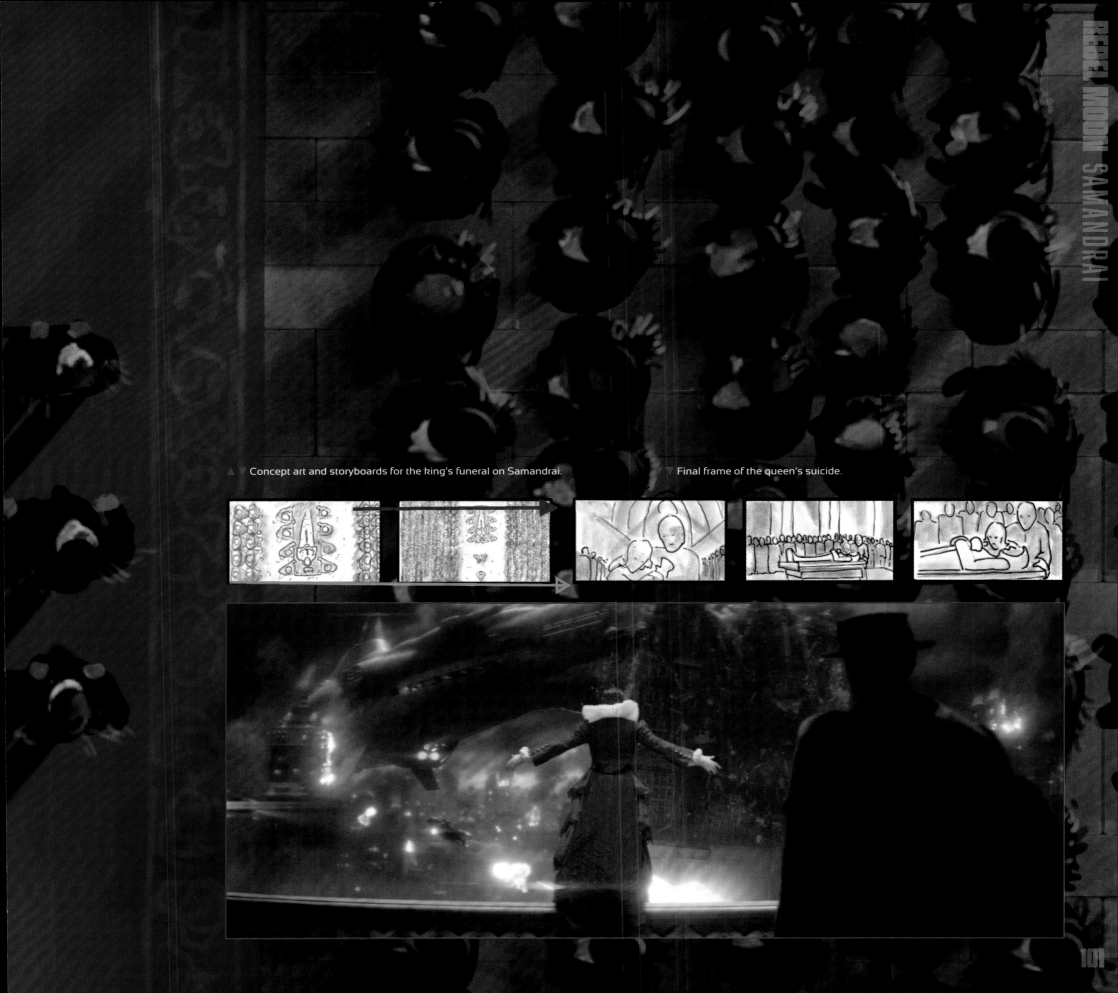

Concept art and storyboards for the king's funeral on Samandrai.

Final frame of the queen's suicide.

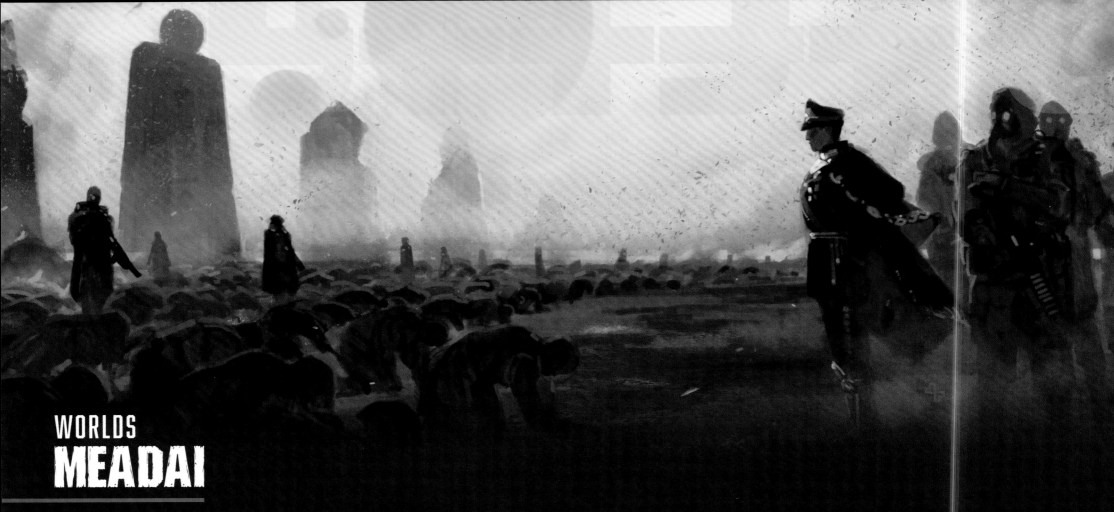

WORLDS
MEADAI

MILIUS'S EXPERIENCE with Imperial aggression might seem familiar, but their doomed culture is distinctive. "They're an ancient, agricultural people," Snyder explains. "They have these giant sculptures, like Easter Island. They're not necessarily the ones who built these giant statues, but they live in great harmony with nature. They're a pretty peaceful and kind people. And then the Motherworld comes along and turns them into slaves and sets the world on fire."

"Zack had done sketches of what those statues would look like, so there was an aesthetic there," Dechant recalls. "There's a Gong Li film called *Red Sorghum* [1988], and at the end, I remember, Gong Li is dead, and the Japanese have attacked, and her son is singing a song to her about the sun rising, and the smoke is wafting across these burning fields, and it's turning the sun red. I took frame grabs of that and sent them to Craig [Sellars, concept artist], and I said, 'Let's let the flames come in here. Let's play a little bit off that idea of color shifting.'" Thus, Meadai met its fate.

▲ ▼ The leaders of peaceful Meadai kneel to the Motherworld amidst the ancient stone colossi.

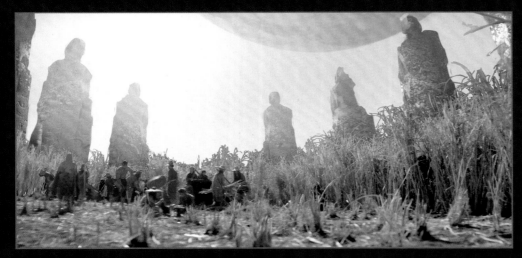

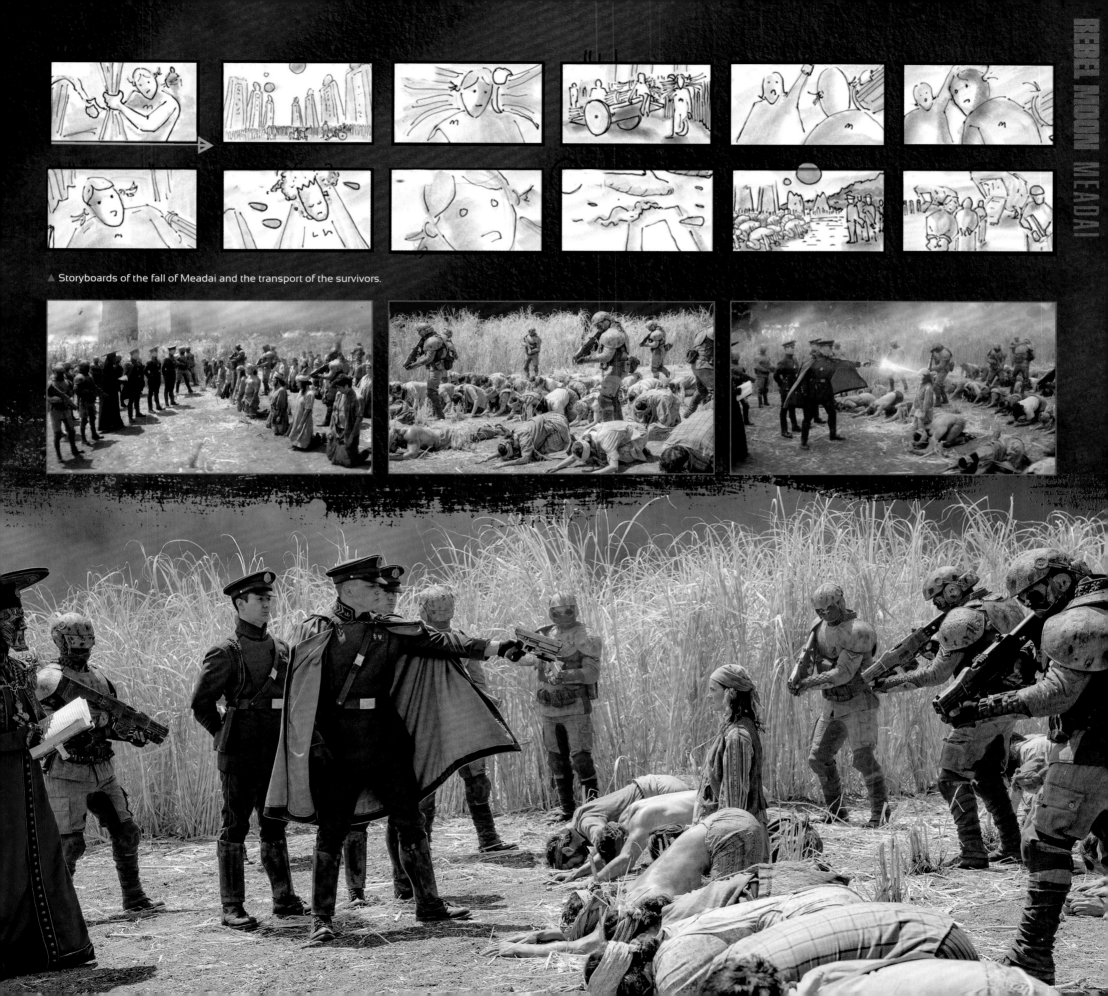

▲ Storyboards of the fall of Meadai and the transport of the survivors.

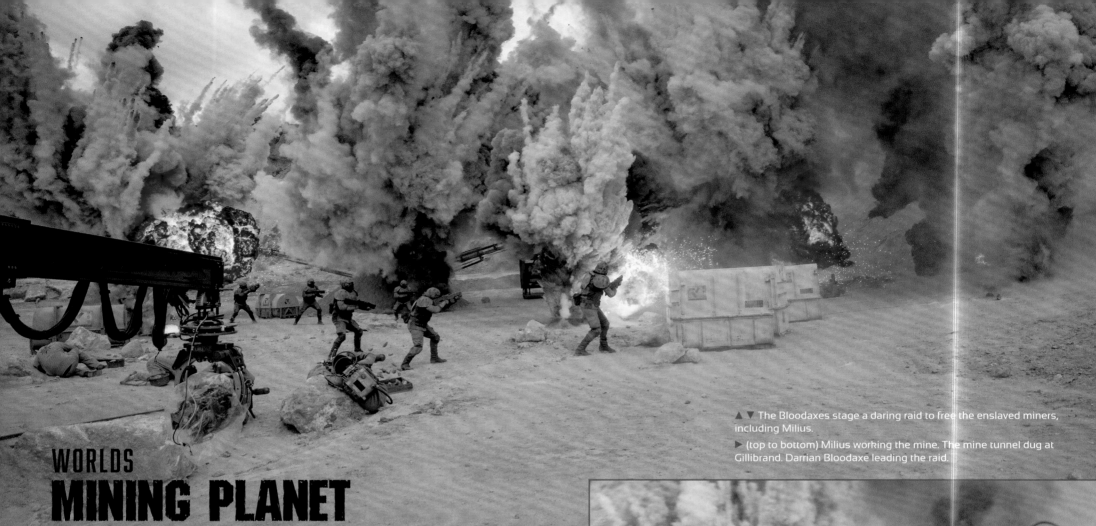

▲ ▼ The Bloodaxes stage a daring raid to free the enslaved miners, including Milius.

▶ (top to bottom) Milius working the mine. The mine tunnel dug at Gillibrand. Darrian Bloodaxe leading the raid.

MINING PLANET

SENT TO A HOT, BARREN PLANET to work the mines as a slave, Milius eventually got caught up in a slave revolt when the Bloodaxes made a rescue raid. Again, we experience only a small sliver of the planet, but it's enough to take in the callous despotism of the system. "All we see is this raped landscape of that world. It's dotted with Motherworld gunnery outposts and guard towers to keep an eye on the workers. They're pretty much twenty-four/seven working in the mines," Snyder says.

Shot at Gillibrand in Simi Valley, the mine set made use of an existing gravel quarry. All that remained was to dig the mine tunnel, dress it with some cargo boxes and mining equipment— and set off some gigantic explosions. "That was the first week of filming, which was really super busy," SFX supervisor Michael Gaspar recalls. "It was impressive. It got people's attention. Debbie [Snyder, producer] came up to me, and she goes, 'Holy crap, Mike!' And I go, 'Your jacket's all dirty. Do I owe you a cleaning fee?' because she was covered. After, one of the other producers said, 'If I wasn't sitting right here, I would've thought this was CGI, because the people looked about ant sized, and they were right next to the explosions when they're going off.' It was pretty cool."

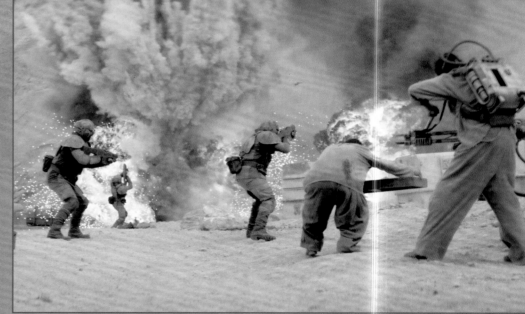

Milius, now an Insurgent fighter.

BYEOL

NEMESIS LIVED WITH HER FAMILY in a serene fishing and farming village on Byeol—but it was not always so tranquil. "They were a warrior people generations before," Snyder says. "But since then, they've lived in relative peace and have settled into a life in harmony with nature. That's until the Motherworld's forces come." Nemesis's village is another example of drawing inspiration from the heritage of the actor. Bae Doona, who plays the dual-sword wielder, is a native of South Korea; the designers modeled the simple, wide-planked, wooden houses on pre-Westernized Korean architecture.

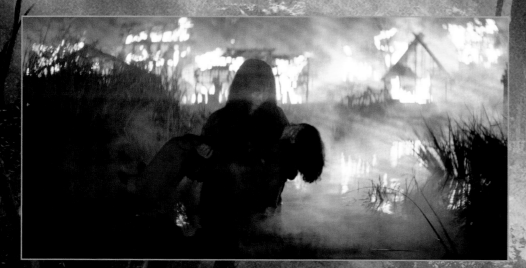

▶ Concept art for the destruction on Byeol and Nemesis's loss.

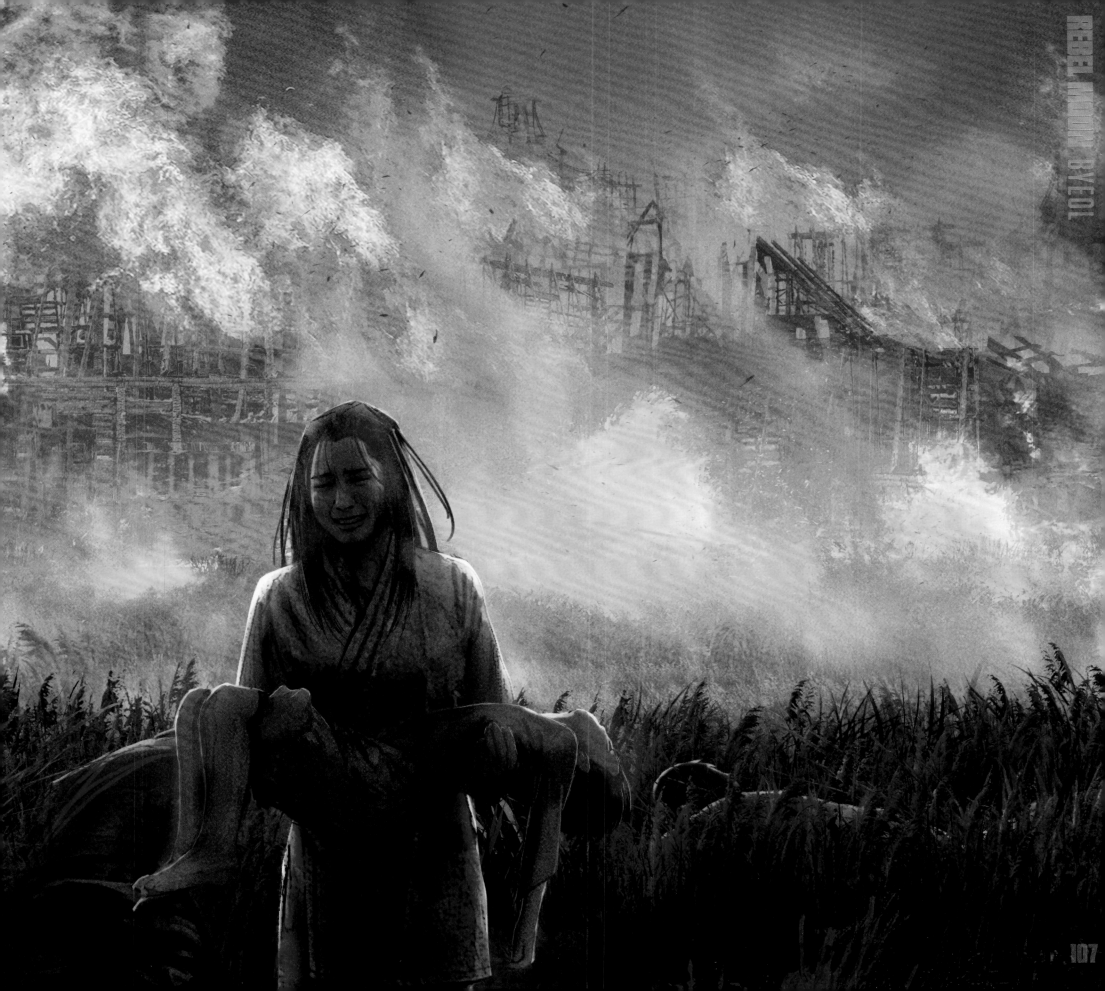

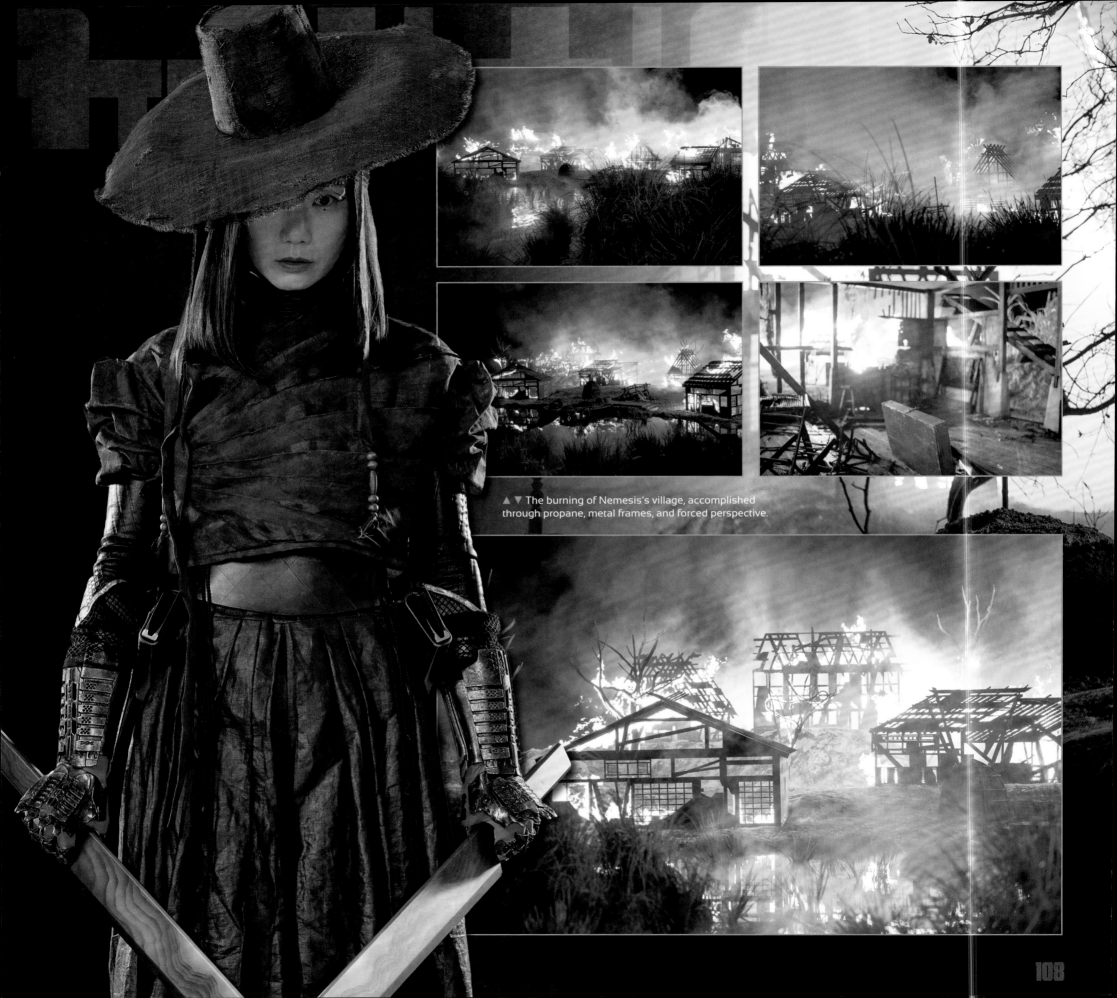

▲ ▼ The burning of Nemesis's village, accomplished through propane, metal frames, and forced perspective.

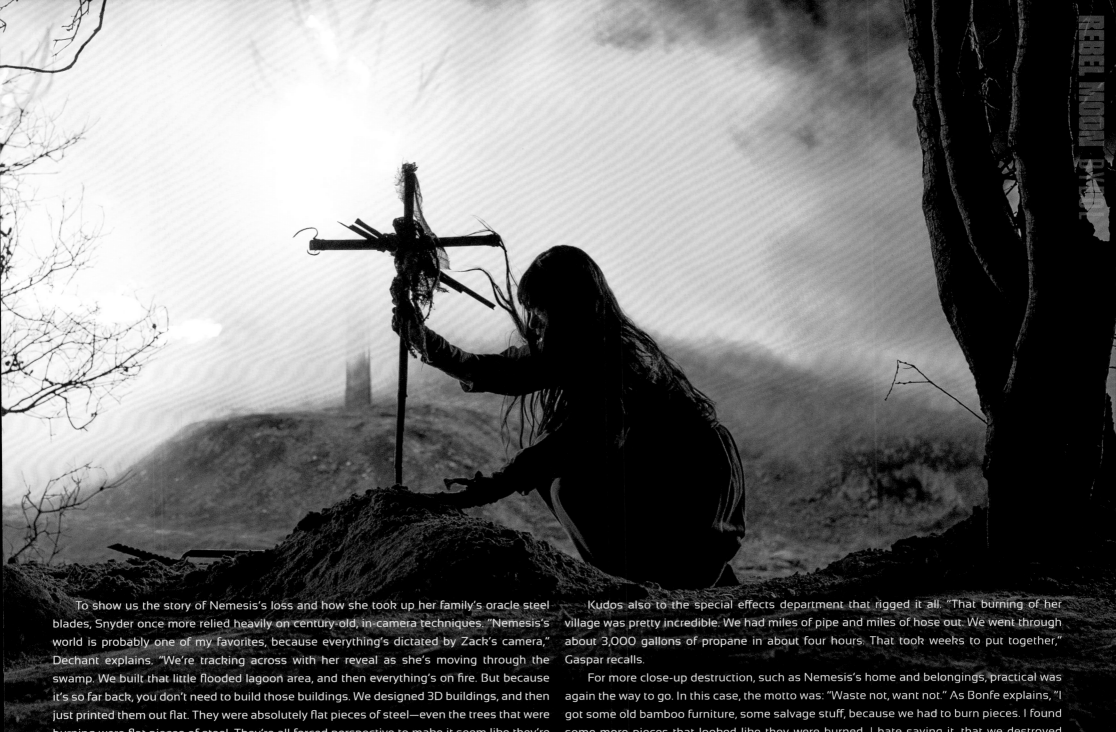

To show us the story of Nemesis's loss and how she took up her family's oracle steel blades, Snyder once more relied heavily on century-old, in-camera techniques. "Nemesis's world is probably one of my favorites, because everything's dictated by Zack's camera," Dechant explains. "We're tracking across with her reveal as she's moving through the swamp. We built that little flooded lagoon area, and then everything's on fire. But because it's so far back, you don't need to build those buildings. We designed 3D buildings, and then just printed them out flat. They were absolutely flat pieces of steel—even the trees that were burning were flat pieces of steel. They're all forced perspective to make it seem like they're way in the distance, but they're not. Then we had a great greens team who worked with the grasses and whatnot, making them seem smaller as we moved back. It was really clever and it worked well. I think it says a lot about Zack the director and Zack the cinematographer."

Kudos also to the special effects department that rigged it all. "That burning of her village was pretty incredible. We had miles of pipe and miles of hose out. We went through about 3,000 gallons of propane in about four hours. That took weeks to put together," Gaspar recalls.

For more close-up destruction, such as Nemesis's home and belongings, practical was again the way to go. In this case, the motto was: "Waste not, want not." As Bonfe explains, "I got some old bamboo furniture, some salvage stuff, because we had to burn pieces. I found some more pieces that looked like they were burned. I hate saying it, that we destroyed some furniture, but it was all furniture that is maybe not so precious! I was literally on a walk and my neighbor was throwing out some bamboo furniture. I went home, got my car, and put it in my car. That's what we have to do sometimes."

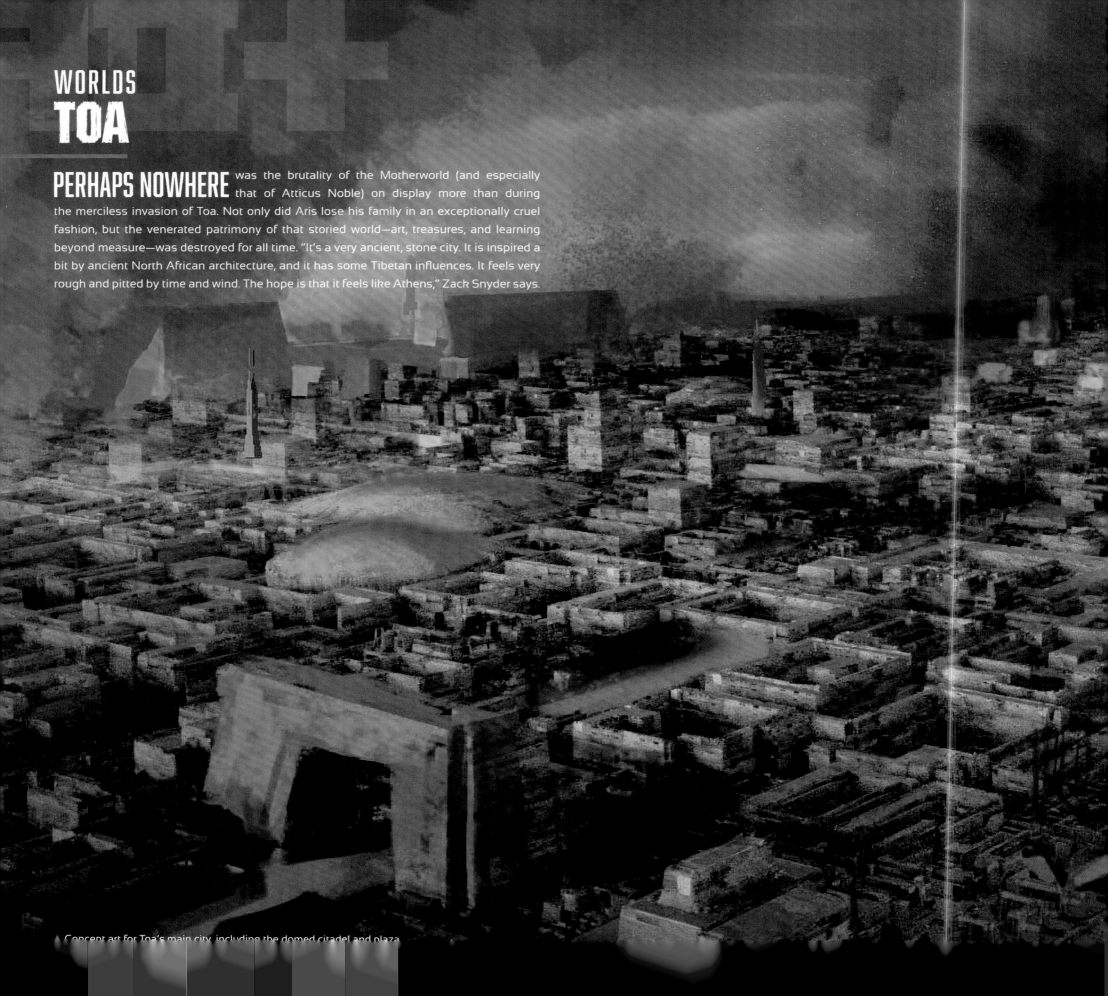

WORLDS
TOA

PERHAPS NOWHERE was the brutality of the Motherworld (and especially that of Atticus Noble) on display more than during the merciless invasion of Toa. Not only did Aris lose his family in an exceptionally cruel fashion, but the venerated patrimony of that storied world—art, treasures, and learning beyond measure—was destroyed for all time. "It's a very ancient, stone city. It is inspired a bit by ancient North African architecture, and it has some Tibetan influences. It feels very rough and pitted by time and wind. The hope is that it feels like Athens," Zack Snyder says.

▲ Concept art for Toa's main city, including the domed citadel and plaza.

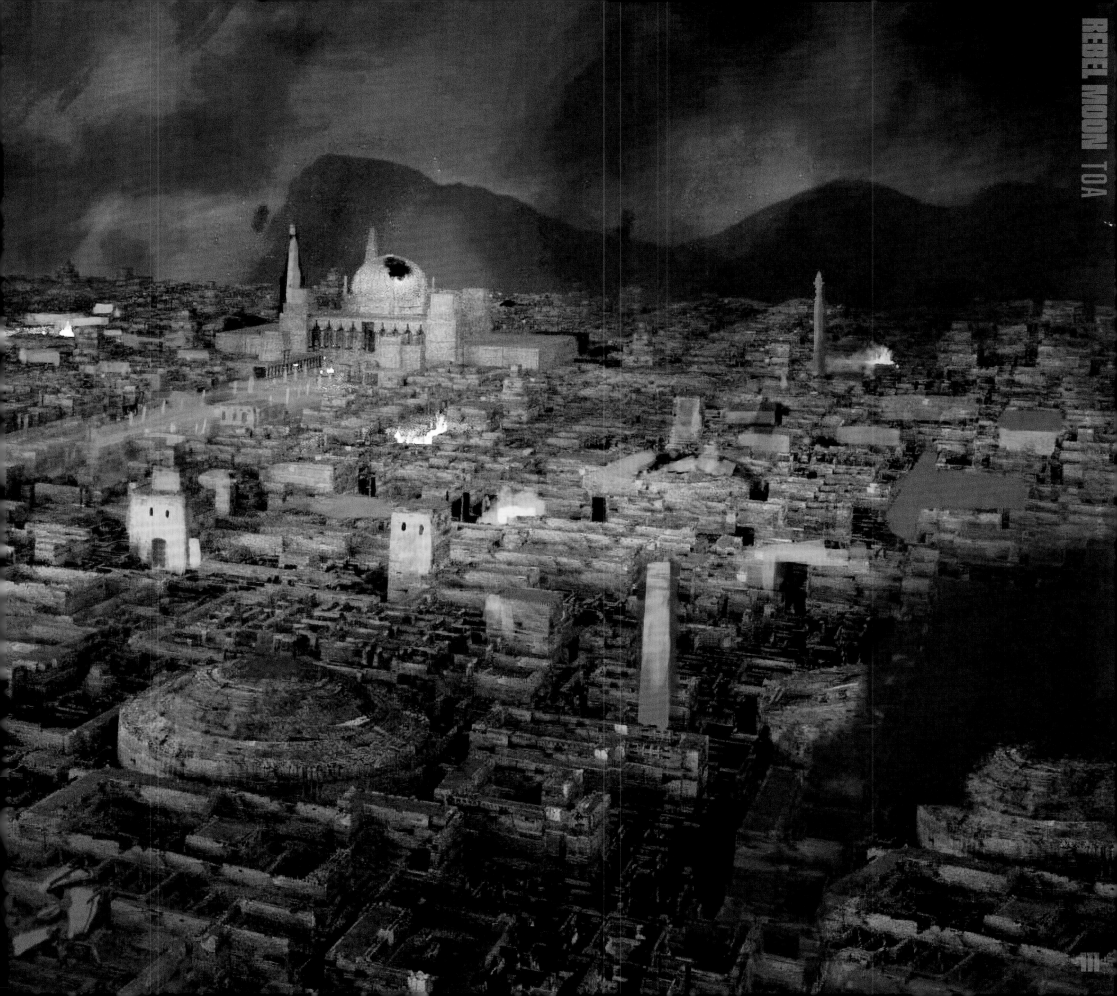

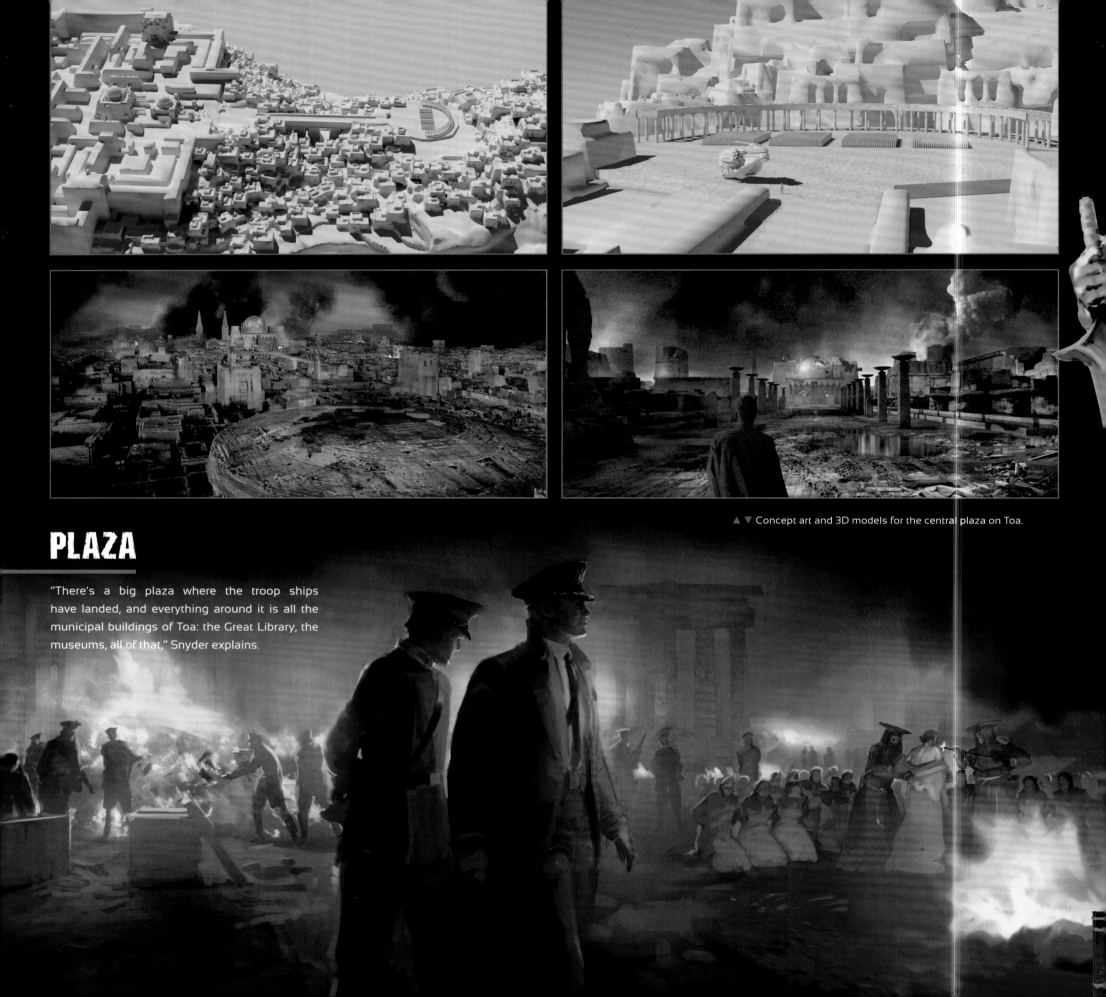

▲ ▼ Concept art and 3D models for the central plaza on Toa.

PLAZA

"There's a big plaza where the troop ships have landed, and everything around it is all the municipal buildings of Toa: the Great Library, the museums, all of that," Snyder explains.

CITADEL

"It's the seat of the royal family of Toa. It's where the throne room is, it's where all the official gatherings happen. It's not their palace, but it is the official building of the royal family," Snyder says. This is where the last stand on Toa takes place. It is also the final refuge of that doomed family.

The Toans also used the Citadel as a last-ditch warehouse to try to safeguard the treasures of their civilization. "They're under siege, and it was really important to Zack that they have all these antiquities and things that mean a lot to their ancestry that they're trying to salvage: all the beautiful tapestries on the wall, artwork, jewelry, silver, gold, tools like compasses, books—all things that are important," set decorator Claudia Bonfe says. "They would all go in these concrete tombs—I was calling them their 'tombs,' but they're concrete crates. It's my Indiana Jones crate! We pulled some World War II research of people getting artwork out of buildings. This is something that came from the prop house, and we basically built

the crate around it. The stone crates would have the same feel as the architecture, based off some really old Egyptian tombs."

Sadly, the Toans' plan did not protect the antiquities, and looting by Motherworld soldiers commenced. "The tops of the tombs were off, they got pushed over, and then all the sculptures, jewelry, the vases, everything, was all over the floor," Bonfe explains. Adding, "Zack really wanted them to have these old scrolls from throughout time. I found these old, metal Indian tube containers that had beautiful ornamentation and some stones. They were tiny, so what we did was we 3D printed our own bigger version of the scroll containers. We had two different styles and we spread them around. We printed all the scrolls on different kinds of paper: wax paper, some Japanese paper. Also, I said they were pulling textiles off the walls in their hallways to protect the artwork. Plus, it helps with giving some color—the gold and the burgundy add a lot of nice texture. I wanted it to look like a painting."

 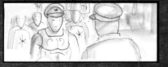

Motherworld troops prepare to assault the citadel, while the royal family flees inside.

◄▼ Concept art for the citadel.

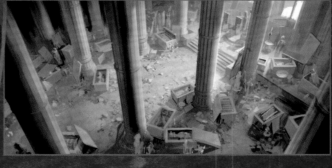 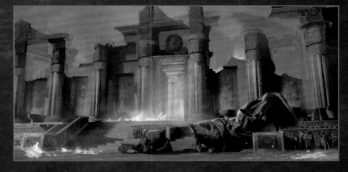

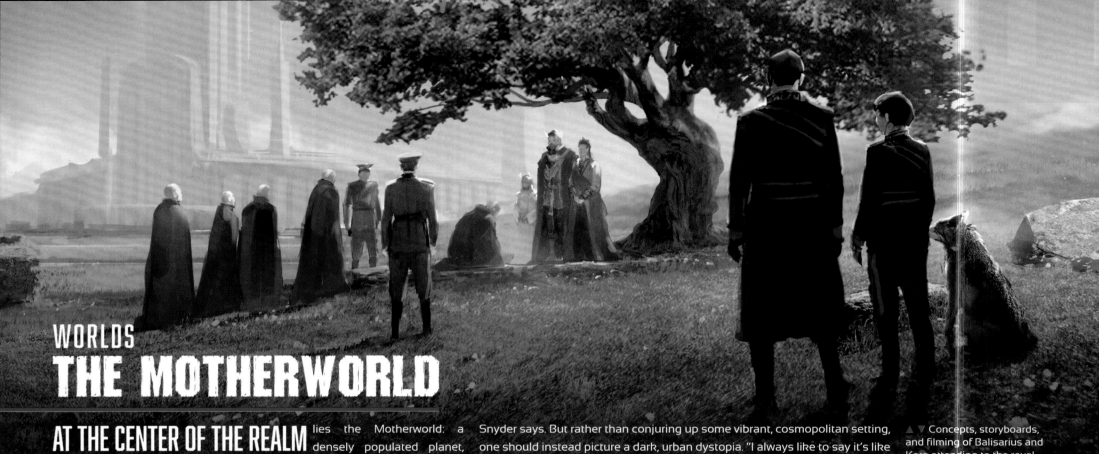

WORLDS
THE MOTHERWORLD

AT THE CENTER OF THE REALM lies the Motherworld: a densely populated planet, immensely old, where, over eons, successive civilizations have built atop the ruins of the previous ones. If it feels cold and impersonal, it is by design; this world is the only world in the *Rebel Moon* universe that hasn't been influenced by any single actor. "The Motherworld is also a bit of a melting pot. There's a lot of immigration from all the worlds that they've conquered," Zack Snyder says. But rather than conjuring up some vibrant, cosmopolitan setting, one should instead picture a dark, urban dystopia. "I always like to say it's like Victorian London and *Blade Runner* mixed up together. They've had to spend a lot of resources to expand as they have across the stars at this point. They've given so much of their attention to this expansionism, that they've lost sight of what's happening down on the streets below them, as far as maintaining the infrastructure," Snyder explains. The result is a core that is definitely rotting.

△ ▽ Concepts, storyboards, and filming of Balisarius and Kora attending to the royal family in the gardens of the country palace.

▷ Concept art for the royal dressing room, and filming Balisarius (Fra Fee) being dressed in his Regent's regalia.

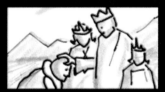

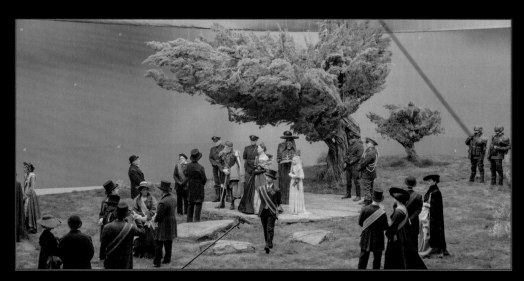
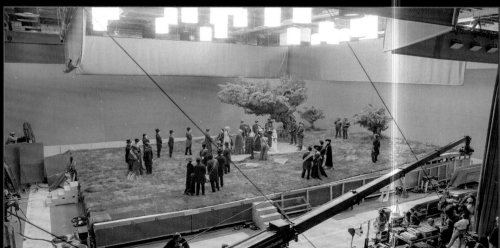

CITY PALACE

Not unlike England's Buckingham Palace on Earth, there is a royal palace at the heart of the urban sprawl of the Motherworld. This is a place where the King—or Regent Balisarius—can do the work of government, such as meeting with advisers and receiving emissaries from various planets. It is also where he can address the populace at large.

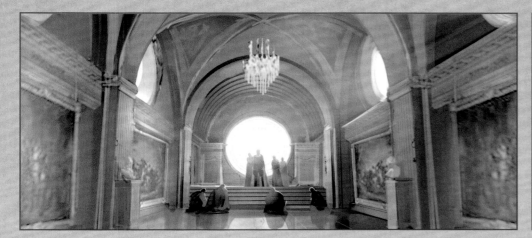

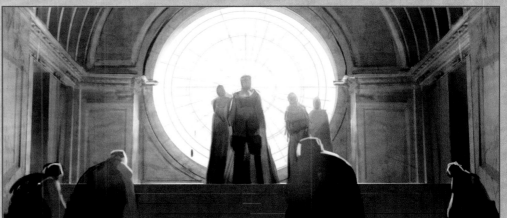

ROYAL DRESSING ROOM The grandeur of the Motherworld's violent history is on full display in the royal dressing room and adjoining hallway. "We created these four, six-foot by fourteen-and-a-half-foot paintings," production designer Stefan Dechant explains. "We were looking at what was in the public domain of the Romantic Era, this real Classical feeling like a painting of the Napoleonic Wars, and then putting it into our world. We were hunting for landscapes and ruins, and then we would remove figures, extend them, and then we would bring in our spaceships—just paint little items on the actual image. They were giant Photoshop files, we printed them out on canvas, and then we gessoed over them so that they had the feel of actual paintings."

The design and decor of the royal dressing room not only proclaims past glories, but also makes clear who is in charge. "I wanted to have something when we're there to frame Balisarius," Dechant explains. "The idea of having that circular picture window, the Regent is now the rising star on there, so you could see that he's the center of the universe." Bonfe adds, "I found this really interesting bench that had a curvature that went with the window. Then I added a couple of more pieces, like a chair and a little coffee station, just to give it some life and make it seem like these people actually eat and drink."

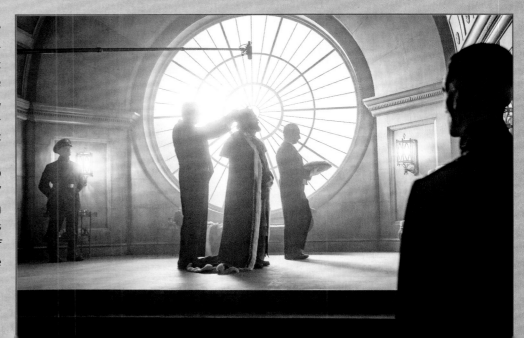

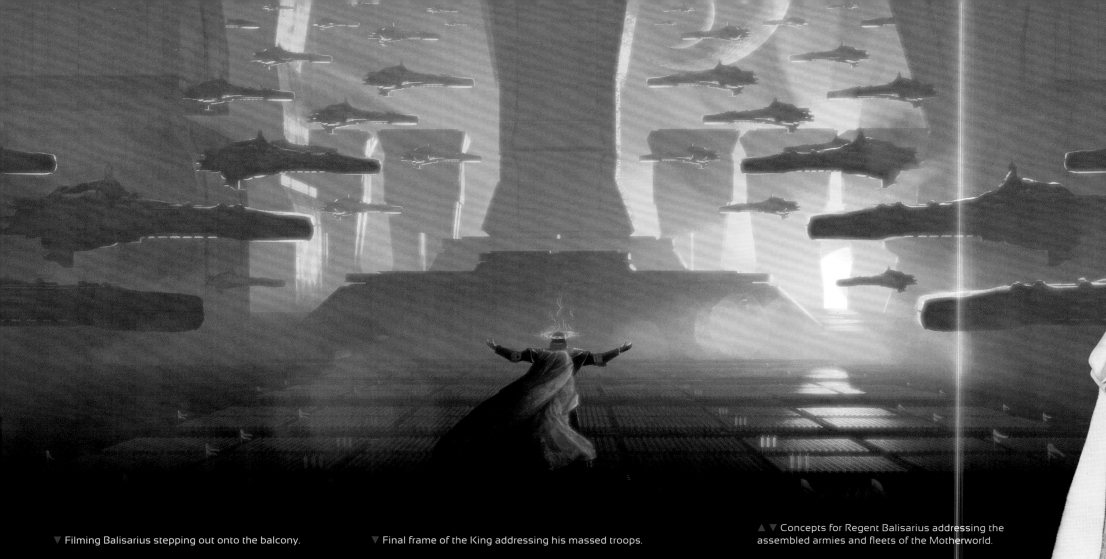

▼ Filming Balisarius stepping out onto the balcony.

▼ Final frame of the King addressing his massed troops.

▲ ▼ Concepts for Regent Balisarius addressing the assembled armies and fleets of the Motherworld.

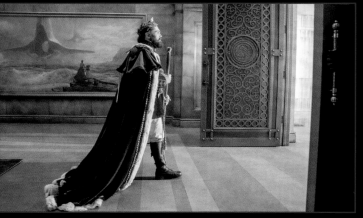

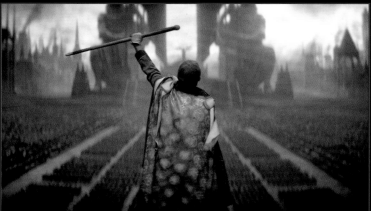

BALCONY & MILITARY ACADEMY COLISEUM

The hallway from the dressing area leads directly to the balcony overlooking the Military Academy coliseum. Dechant describes the scene: "You're looking out over the rows of soldiers and equipment; it is this [Nazi propaganda film director] Leni Riefenstahl kind of feel that we were trying to go for, in terms of having banners, dropships, and mechs all lined up there, with the setting sun and Balisarius."

From this vantage point we also catch glimpses of the city beyond. "Zack had five reference images that he gave me," Dechant explains. "They all had a dark, almost steampunky, retro feel, with a few Victorian Neo-Gothic elements to them. They became the touchstone for what was going to be the look of the Motherworld. It's something that's relatable, there's a historic quality to it, but it doesn't place itself in time."

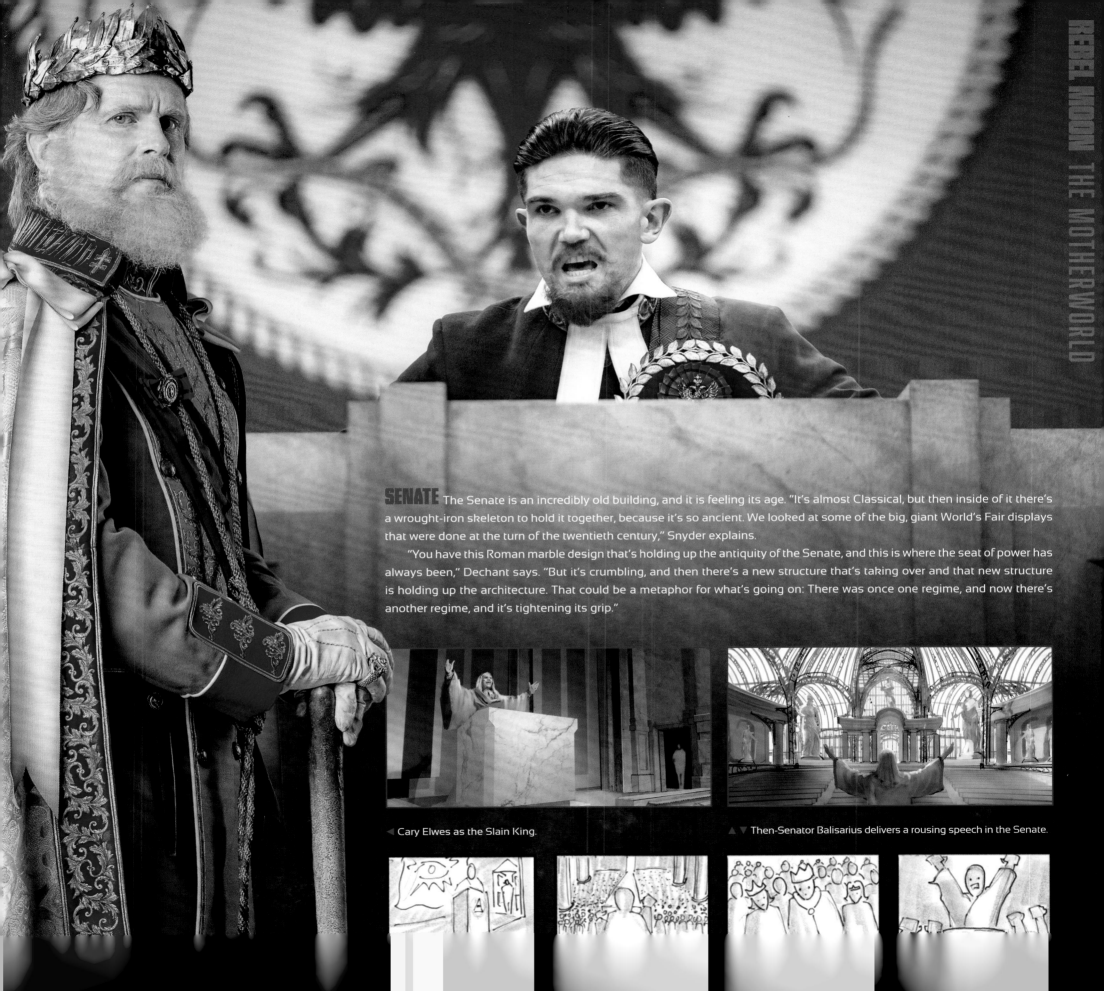

SENATE The Senate is an incredibly old building, and it is feeling its age. "It's almost Classical, but then inside of it there's a wrought-iron skeleton to hold it together, because it's so ancient. We looked at some of the big, giant World's Fair displays that were done at the turn of the twentieth century," Snyder explains.

"You have this Roman marble design that's holding up the antiquity of the Senate, and this is where the seat of power has always been," Dechant says. "But it's crumbling, and then there's a new structure that's taking over and that new structure is holding up the architecture. That could be a metaphor for what's going on: There was once one regime, and now there's another regime, and it's tightening its grip."

◀ Cary Elwes as the Slain King.

▲ ▼ Then-Senator Balisarius delivers a rousing speech in the Senate.

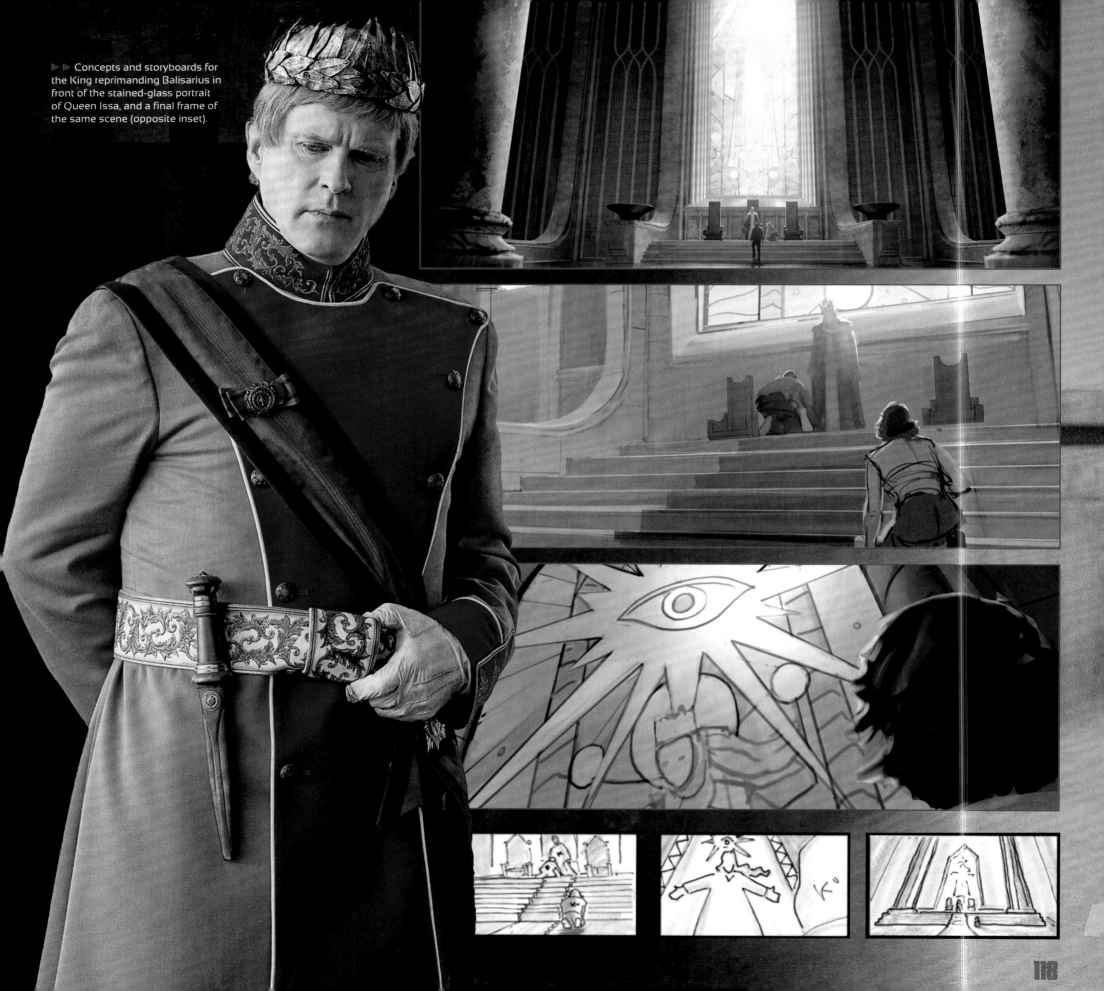

Concepts and storyboards for the King reprimanding Balisarius in front of the stained-glass portrait of Queen Issa, and a final frame of the same scene (opposite inset).

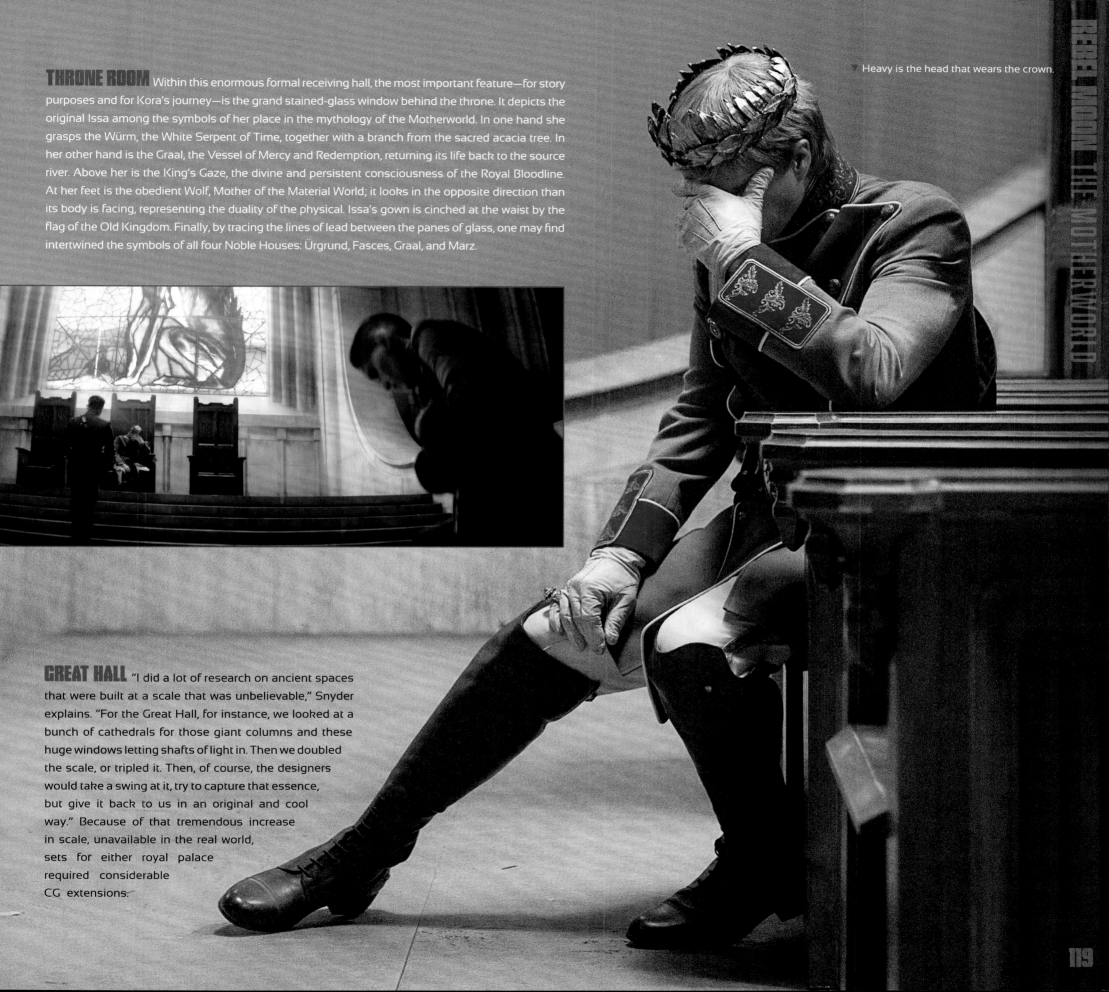

THRONE ROOM Within this enormous formal receiving hall, the most important feature—for story purposes and for Kora's journey—is the grand stained-glass window behind the throne. It depicts the original Issa among the symbols of her place in the mythology of the Motherworld. In one hand she grasps the Würm, the White Serpent of Time, together with a branch from the sacred acacia tree. In her other hand is the Graal, the Vessel of Mercy and Redemption, returning its life back to the source river. Above her is the King's Gaze, the divine and persistent consciousness of the Royal Bloodline. At her feet is the obedient Wolf, Mother of the Material World; it looks in the opposite direction than its body is facing, representing the duality of the physical. Issa's gown is cinched at the waist by the flag of the Old Kingdom. Finally, by tracing the lines of lead between the panes of glass, one may find intertwined the symbols of all four Noble Houses: Ürgrund, Fasces, Graal, and Marz.

▼ Heavy is the head that wears the crown.

GREAT HALL "I did a lot of research on ancient spaces that were built at a scale that was unbelievable," Snyder explains. "For the Great Hall, for instance, we looked at a bunch of cathedrals for those giant columns and these huge windows letting shafts of light in. Then we doubled the scale, or tripled it. Then, of course, the designers would take a swing at it, try to capture that essence, but give it back to us in an original and cool way." Because of that tremendous increase in scale, unavailable in the real world, sets for either royal palace required considerable CG extensions.

119

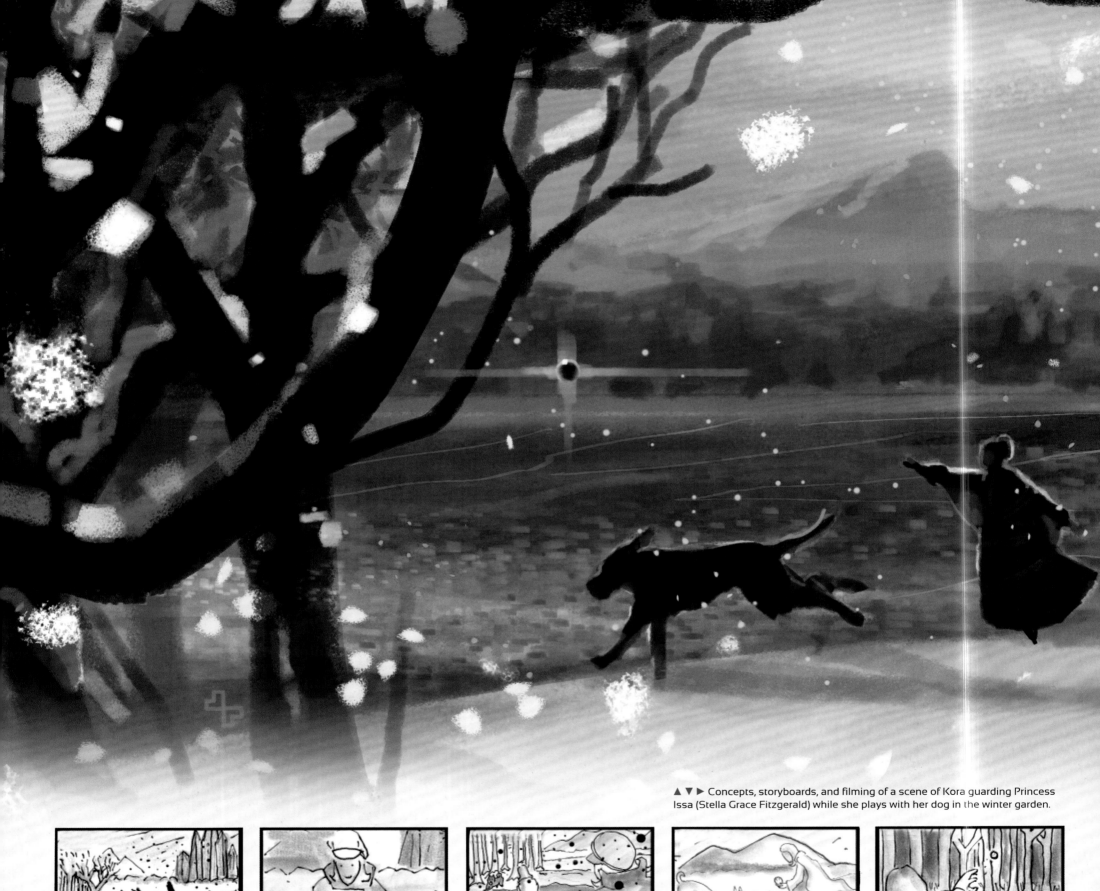

▲ ▼ ▶ Concepts, storyboards, and filming of a scene of Kora guarding Princess Issa (Stella Grace Fitzgerald) while she plays with her dog in the winter garden.

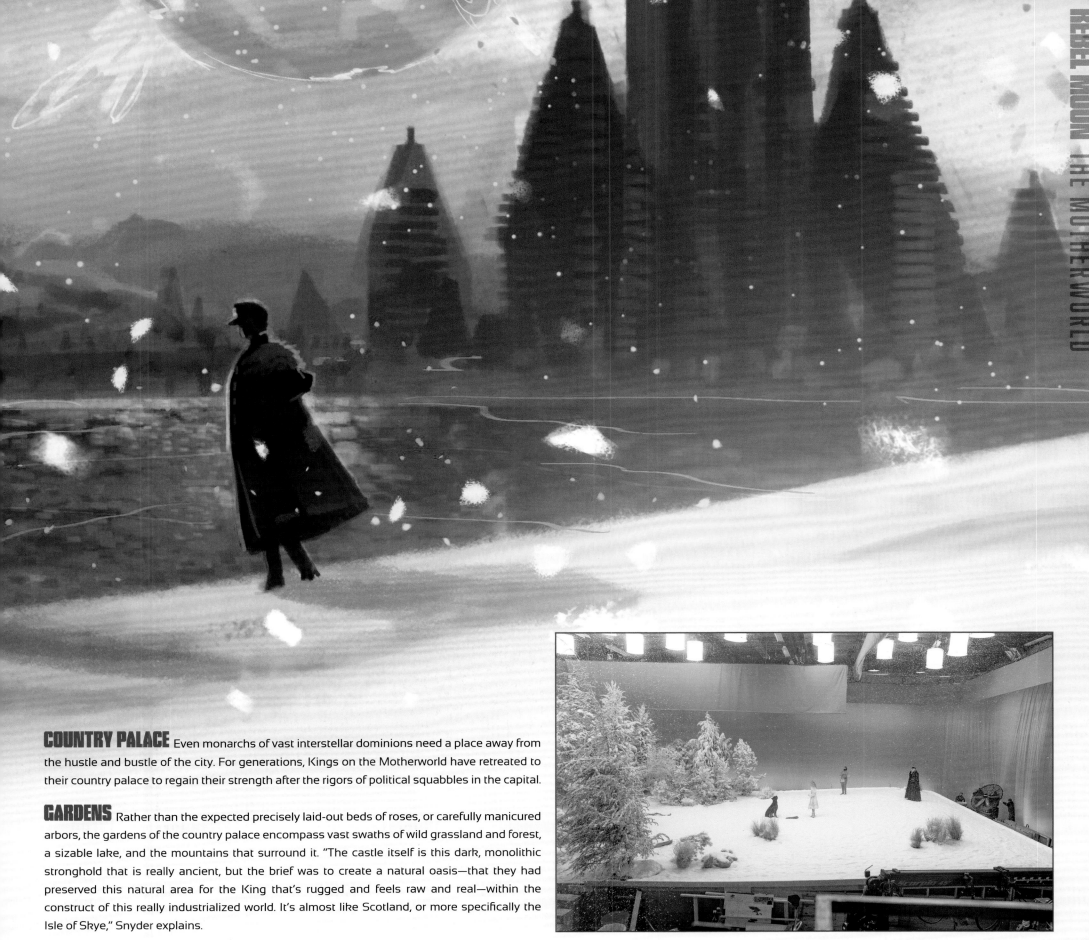

COUNTRY PALACE Even monarchs of vast interstellar dominions need a place away from the hustle and bustle of the city. For generations, Kings on the Motherworld have retreated to their country palace to regain their strength after the rigors of political squabbles in the capital.

GARDENS Rather than the expected precisely laid-out beds of roses, or carefully manicured arbors, the gardens of the country palace encompass vast swaths of wild grassland and forest, a sizable lake, and the mountains that surround it. "The castle itself is this dark, monolithic stronghold that is really ancient, but the brief was to create a natural oasis—that they had preserved this natural area for the King that's rugged and feels raw and real—within the construct of this really industrialized world. It's almost like Scotland, or more specifically the Isle of Skye," Snyder explains.

TECHNOLOGY

TECHNOLOGY
DREADNOUGHT-CLASS BATTLE CRUISER

A MASSIVE VESSEL a mile and a half long, this class of battle cruiser—often colloquially referred to simply as a "dreadnought" —is tasked with patrolling and showing the Imperial flag among the rougher outer reaches of the Realm, while the even larger and more precious super-dreadnoughts for the most part remain in the pacified systems closer the Motherworld. Brimming with guns of various calibers, the firepower it brings to bear is unmatched in ships of its size. It was aboard one of these vessels that Kora served and trained for five years before graduating from the Imperial Military Academy.

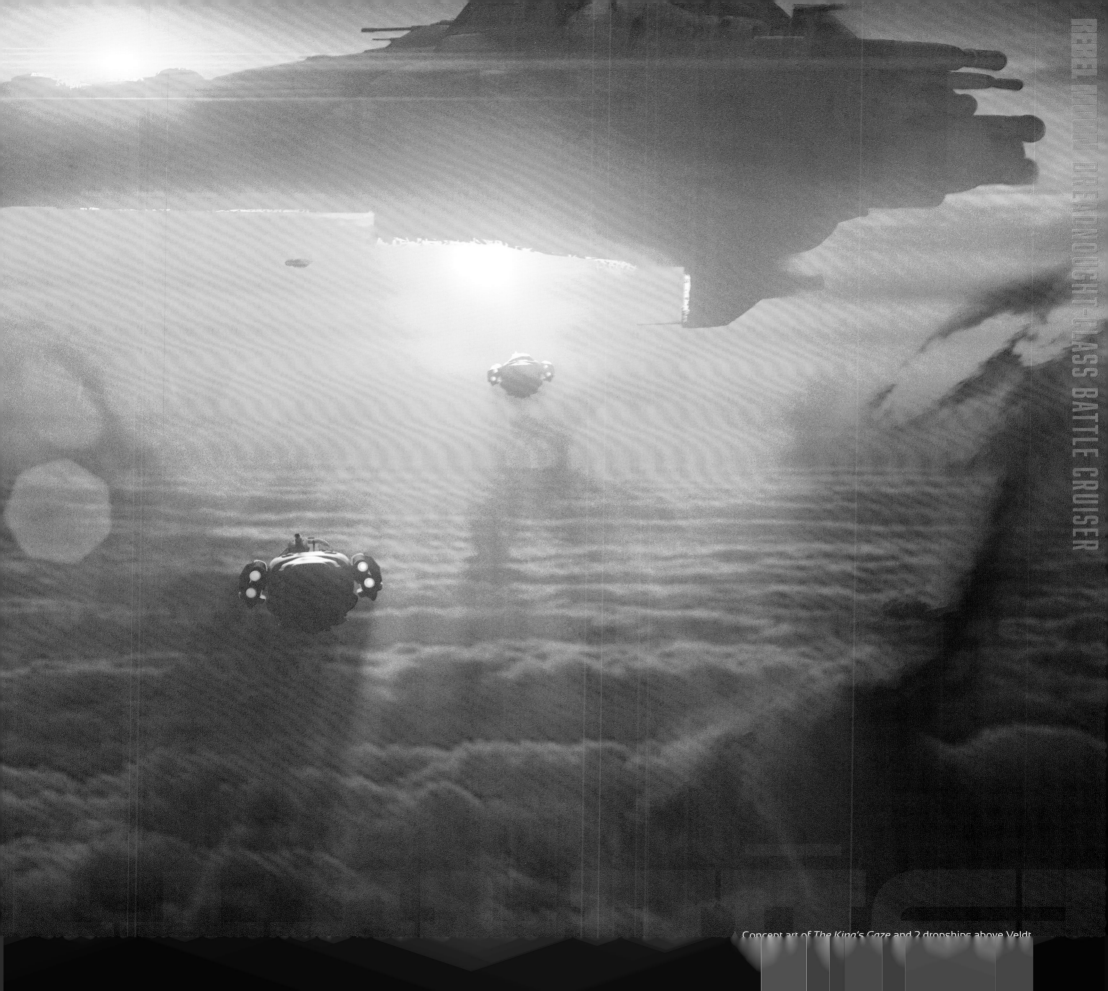

Concept art of *The King's Gaze* and 2 dropships above Veldt

THE KING'S GAZE

The dreadnought that features most heavily in the *Rebel Moon* films is *The King's Gaze*, the flagship of Admiral Atticus Noble. *The King's Gaze* carries inside it a sizable fleet of smaller craft, including dropships, mech-carriers, and the admiral's own fast-attack launch. If you are on bad terms with the Motherworld, it is not something you want orbiting your planet.

"The feeling right from the beginning in our conversations with Zack about the Motherworld, and especially in terms of the dreadnought, is that we should think about it as a giant weapon that's not really made for the men to work in there. It's not made for the crews," explains production designer Stefan Dechant. "So, we want it to be very confined. We don't want the hallways to feel like they were made for easy access. We want it to feel like it's an uncomfortable space."

With that brief in hand, the production achieved the effect by drawing inspiration from two very different sources. "We leaned heavily into looking at Soviet submarines," Dechant relates. "That gave us our hook. We weren't trying to recreate one and have this 1950s aesthetic in space—we just wanted to have a feel and then go on from there and work our own design into it. There's a little bit of looking at anime as well, and what it's like to design a ship that feels like it has nautical influences. We wanted to carry that through."

ORBITING CONSTRUCTION SITE & HANGAR

During one flashback, we glimpse *The King's Gaze* being built. As Dechant explains, "I had this idea of circular rings that the constructions are going off, and the ship is underneath it, so I can still see the shape of the ship and know what it is, and the audience knows where we are, but those rings tell us that it's a construction site, and it creates its own visual uniqueness."

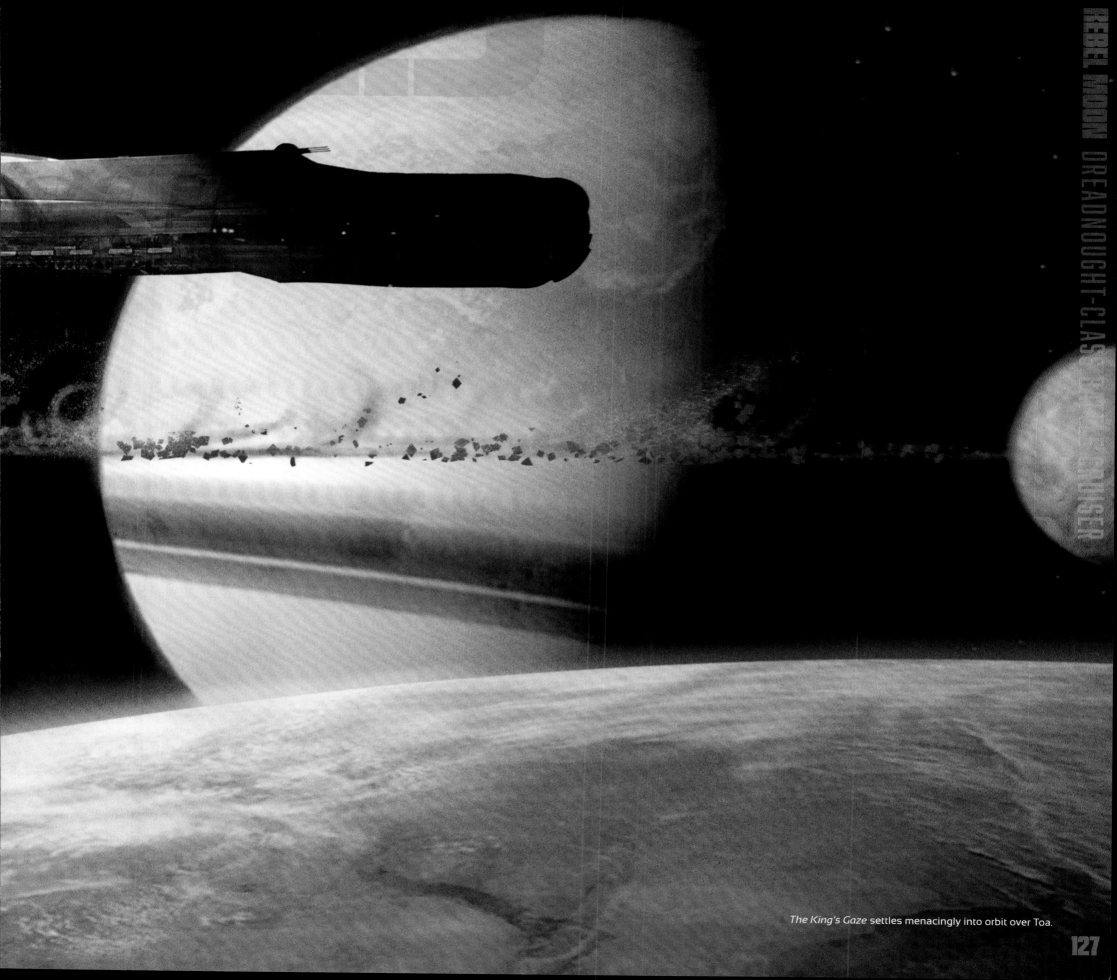

The King's Gaze settles menacingly into orbit over Toa.

ARMAMENT

In addition to many smaller caliber guns, the dreadnought battle cruiser possesses a formidable main battery consisting of two forty-inch-diameter guns, dubbed "The Sword of the King." Controlled from an integrated turret, the Sword can accurately hurl enormous, dense slabs of magma-like material thousands of miles—a devastating weapon, whether employed in ship-to-ship combat or planetary bombardment.

"The gun turret is one of my favorite sets on the dreadnought," says set decorator Claudia Bonfe. "What I loved about it is the periscope, which kind of reminded me of a Wes Anderson movie. I thought it was really cool in this big, badass, battle movie that we got a periscope." The special effects team, headed up by supervisor Michael Gaspar, rigged all the moving parts of the turret. "There's these big side pieces that turned opposite each other, so it looks like a gear, as if it's turning the column in the middle, and then they did a light scheme, so that it looks like the turret's rotating, but it's not," Gaspar says. Dechant explains, "It's rotating so that we understand what's going on in the exterior and the interior, even as the guns go up. The audience knows, 'I'm in here, and this is what's going on here. Here's a connection to what's happening in the exterior world.' In the bridge, it's the same thing, where you have these giant windows to help us define where we are in the outside world."

What is going on outside with the guns was determined not only by story, but also by aesthetics. "Everything that's in the Realm goes back to the dropship. It was one of the first vehicles designed, and something Zack used for reference," Dechant says. "That curving element—we wanted to keep that element in the dreadnought. Zack came up with the idea that the guns are so big, they only turn in one direction, which I thought was pretty cool. And when they do turn, one side of the ship has actually been designed with a cut-out, so when the Sword comes over, the ship itself tilts down to fire on the planet. The design informs how the ship moves."

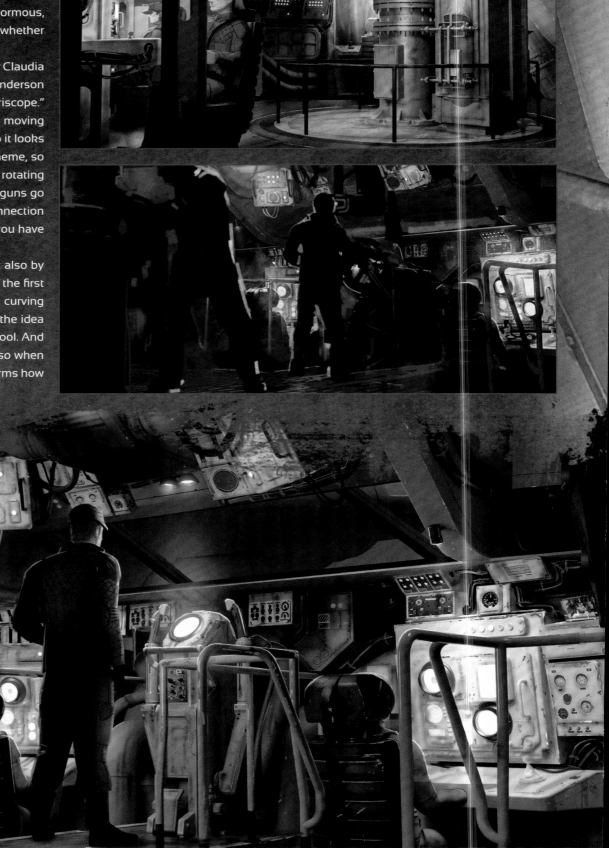

▲ Concepts for personnel placement and the utilitarian consoles of the main gun turret.

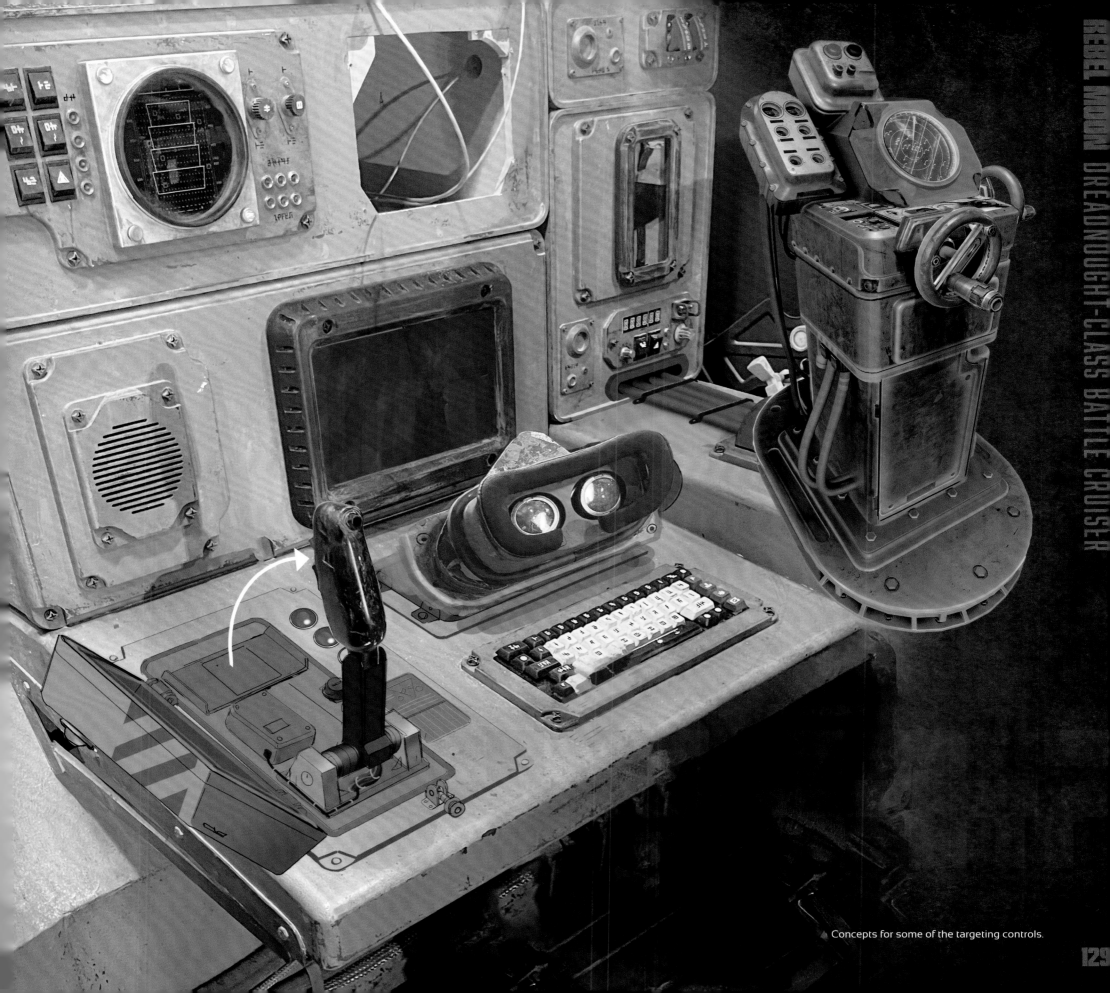

Concepts for some of the targeting controls.

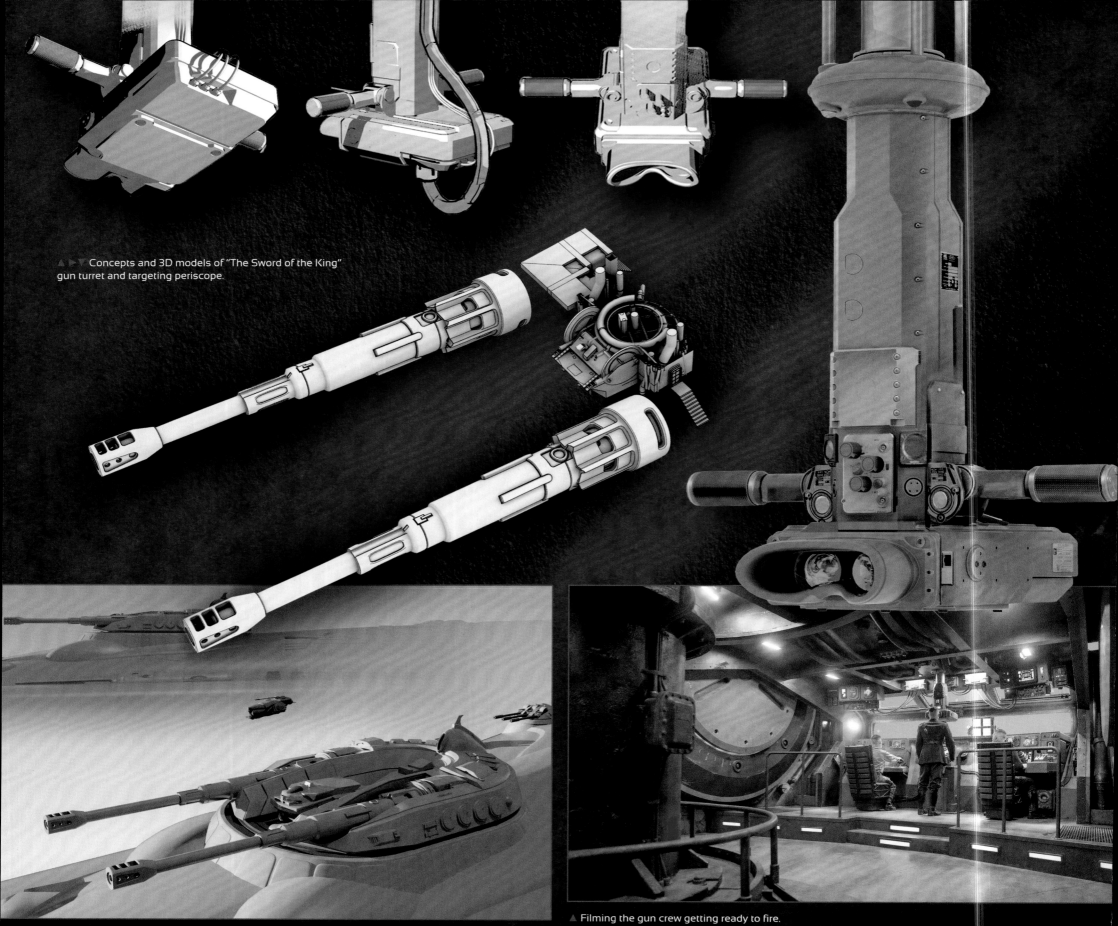

Concepts and 3D models of "The Sword of the King" gun turret and targeting periscope.

Filming the gun crew getting ready to fire.

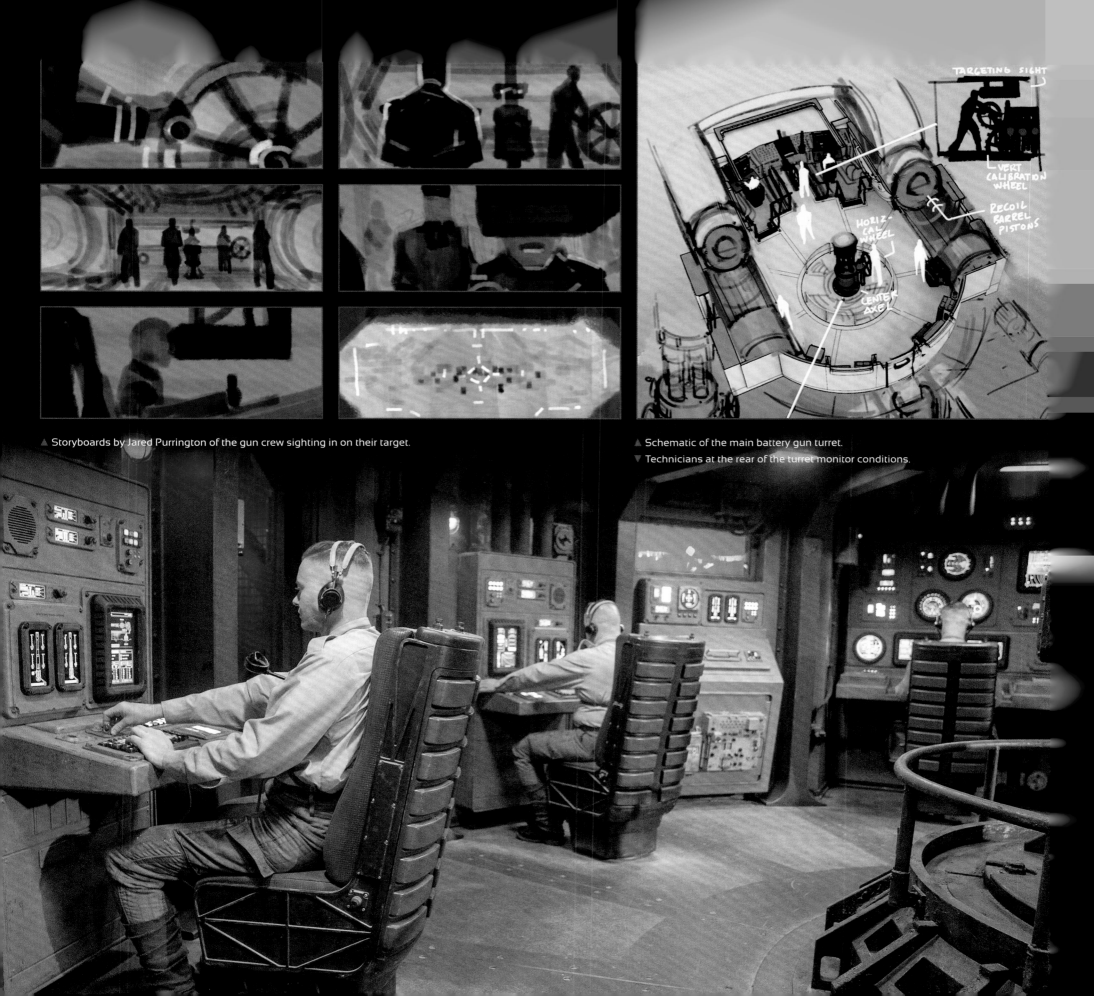

▲ Storyboards by Jared Purrington of the gun crew sighting in on their target.

▲ Schematic of the main battery gun turret.
▼ Technicians at the rear of the turret monitor conditions.

TARGETING SIGHT

VERT CALIBRATION WHEEL

RECOIL BARREL PISTONS

HORIZ- CAL WHEEL

CENTER AXEL

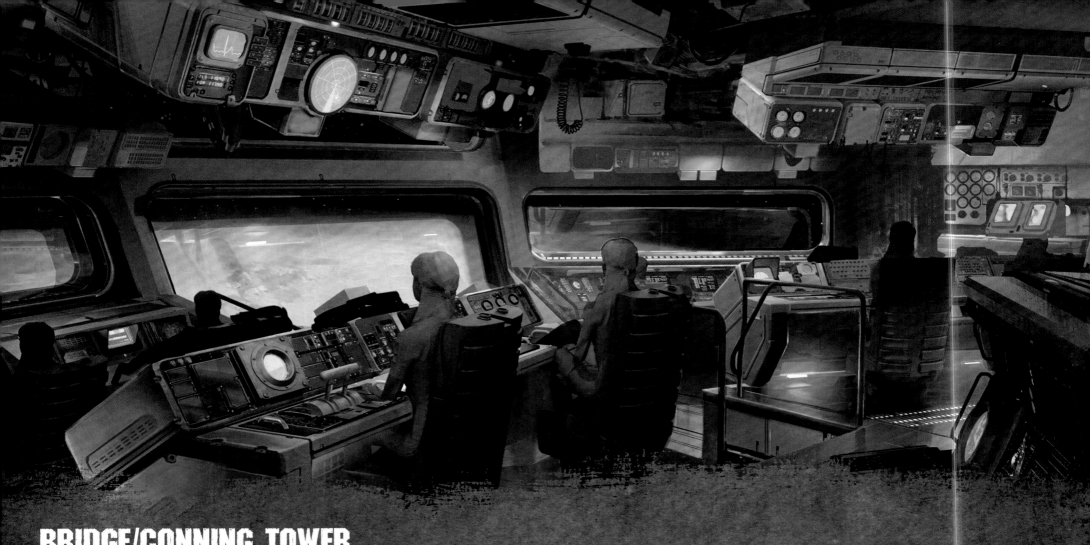

BRIDGE/CONNING TOWER

The overall nautical feel the filmmakers wanted is most notable in the design of the bridge. As Dechant explains, "The bridge has three tiers. It does feel like you're within a submarine, but then we have these large windows that look out over the bow of the ship, and that was intentional. I wanted that feeling of a commander of a ship that could go down to the railing and then look out over his conquered countries. Kind of create that nineteenth-century feel of a sea voyage in there."

In the old days, creating all the knobs, switches, and lights that could conceivably make up spaceship control panels meant having to hunt through hardware stores and flea markets, hoping to find things that looked close to what you wanted, and then modifying them to make them fit the bill. Nowadays, modern tools and materials allow art departments to manufacture exactly the parts they need. Artisans using laser cutters, vacuum molds, plasma cutters, CNC routers, 3D printers, and industrial lathes—aided by talented paint crews—can turn MDF (wood composite), acrylic, resins, LED lights, and metals into all the fixtures you can see, including all the tiny "gak" (art department speak for "stuff") around the monitors and panels.

Concept art of the bridge of *The King's Gaze*.

Filming on the bridge, with temporary planetary views added for context.

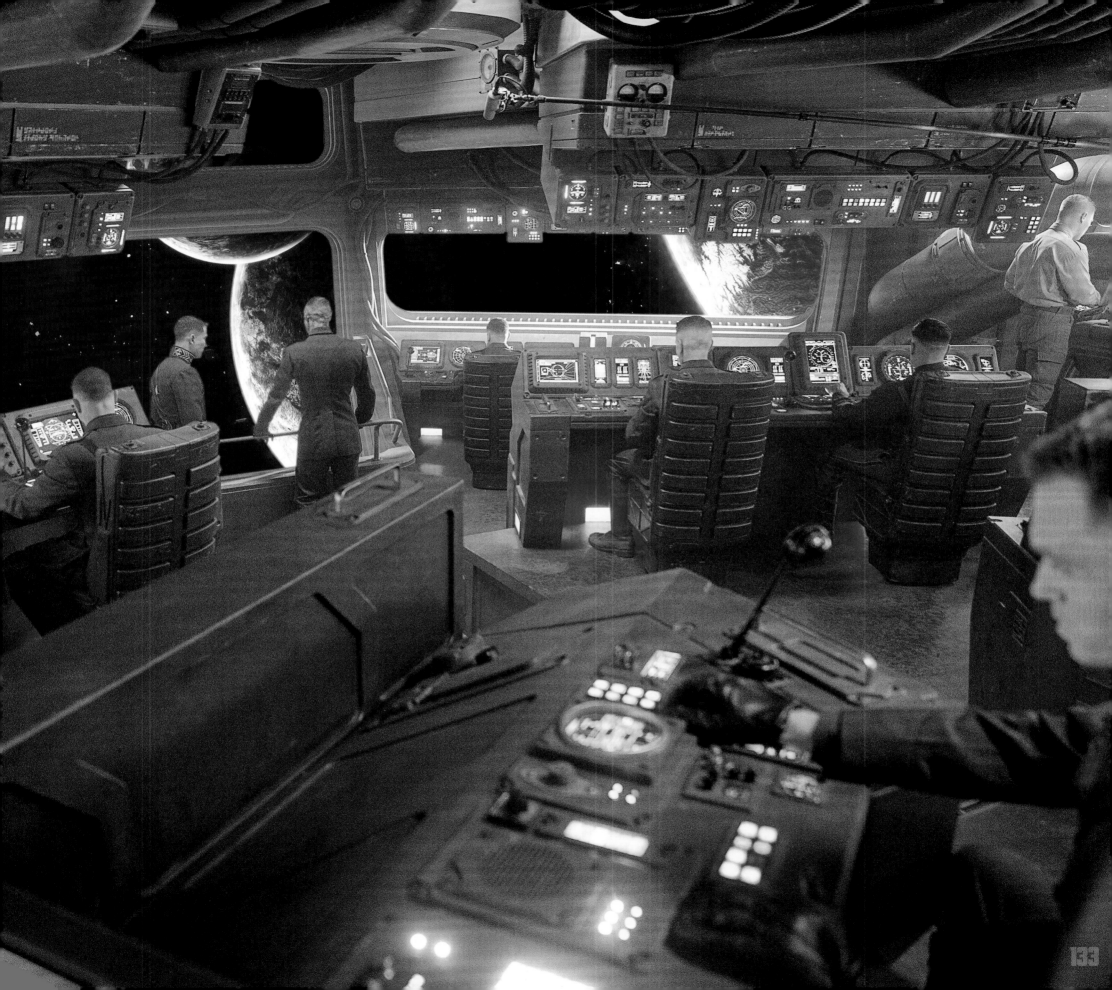

Of course, even with all those extraordinary capabilities available to them, set decorators and dressers never stop sifting through salvage yards and local prop houses for inspiration. "I've done a lot of spaceships in my career, but nothing like this," Bonfe says. "The stuff we had in there was from the '30s up until the '60s, so it was quite a range of years of equipment. Some of the knobs and some of the buttons we could find online or salvage pieces, like we'd take apart old computer electronic pieces and pull from there. Sometimes we would take those pieces if they only had one, and we would make more of them, manufactured in our prop shop."

Bonfe's earlier work on a Netflix project had already awakened a passion for all things nautical, and she was able to translate that into her work on the dreadnought. "I had to do a lot of research on cargo ships, and just kind of fell in love with it," she recalls. "The pieces are so incredible. Everything is watertight and has a different feel. There's a couple of places in Los Angeles

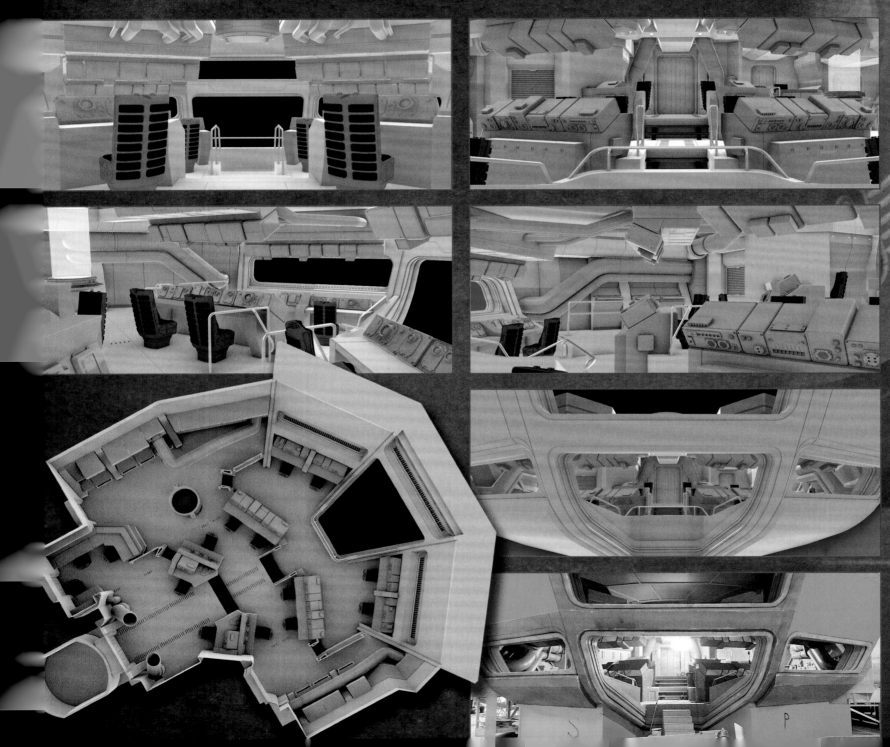

3D models of the bridge layout, with an exterior view of the final build on stage.

Cassius (Alfonso Herrera) and Noble see something that concerns them.

that have all kinds of ship dressing, so that's the way I approached it. We took pieces that I salvaged from submarines and navy ships, and used those on the walls for the electrical boxes and other parts. The set looks like it would be something that would float on water."

The bridge is the brain center and tactical hub of the dreadnought. It's where decisions are made. Decisions require information, and displaying that information means screens. Lots and lots of screens. "That was probably, in my career, the biggest control room that I've ever done, with custom consoles throughout—there were twenty-something of them. That was where my fabrication shop did the most work on the movie," Bonfe says.

"They have to feel like you're running a ship," says Dechant. "We're not looking at every screen and going, 'We're loading some kind of fuel into this port, and that's creating such and such a reaction.' What we're looking at is what's important to the narrative. Let's focus on that. In the background, it's about creating an aesthetic, the impression that the environment is alive and that the ship is a real entity. We kind of had a fifty/fifty split in creating the screens, so that fifty per cent of them were light boxes that have translucency. We can vary the intensity of light to give it a little bit of life. But those are far in the background, though we'll pepper in real screens so that there's some movement and some life in the deep background. Anything that's coming up closer to camera, we want to have a real screen in there. The closer it is to the character and more important it is to the narrative, the more we'll track that in terms of what you're seeing. 'Is this scanning? Is it running an engine? Is it part of communications?' You balance that to make it work."

Although it's the most advanced power in the known universe, the Motherworld's reliance on retro-looking, almost obsolete-seeming technology carries through on the bridge's displays. "We wanted it to feel like an IBM computer of 1983," says Dechant. "There's a lot of text going on there. That was all written in its own language. Everything we put on those screens—all the language, all the graphics—have meaning. I would go to the graphic designer and say, 'It should be saying something like this. Please don't put any Easter eggs in it. Please don't mention friends or family. Just make it as honest as possible, because at some point somebody's going to go through there, stop the screen, and start deciphering what we've written.'"

Dechant adds, "We were fortunate enough that Samsung provided us with tablets, phones, and screens, so that we could create animations and could give life to that set. So, quite literally, that ship is being driven by Samsung."

▼ Concept art of the dreadnought bridge.

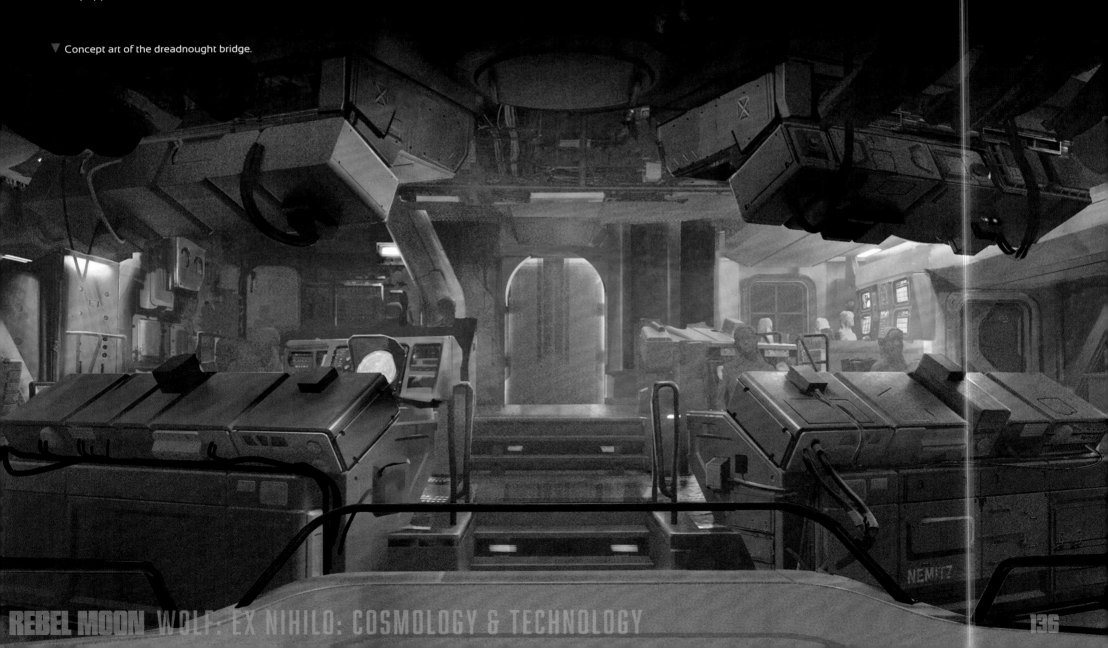

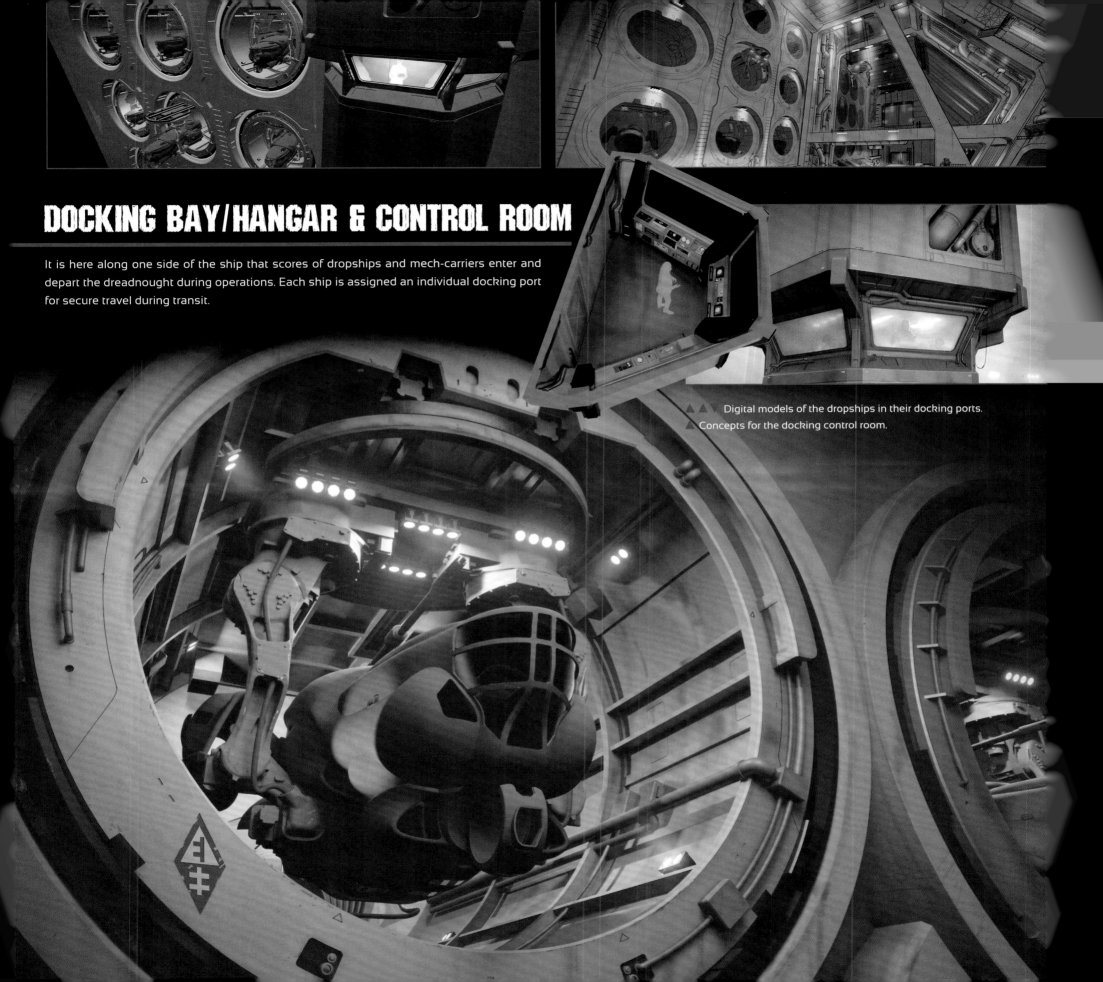

DOCKING BAY/HANGAR & CONTROL ROOM

It is here along one side of the ship that scores of dropships and mech-carriers enter and depart the dreadnought during operations. Each ship is assigned an individual docking port for secure travel during transit.

Digital models of the dropships in their docking ports.
Concepts for the docking control room.

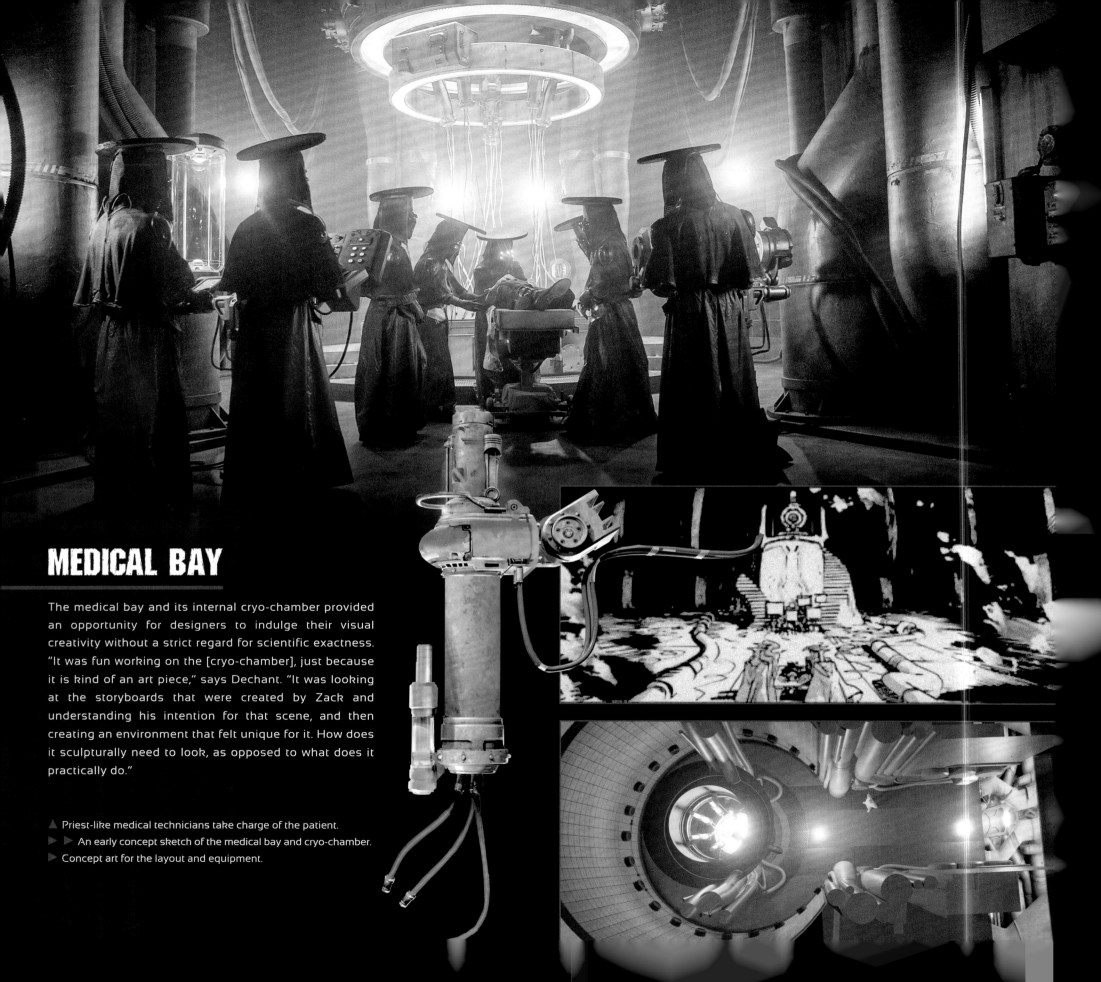

MEDICAL BAY

The medical bay and its internal cryo-chamber provided an opportunity for designers to indulge their visual creativity without a strict regard for scientific exactness. "It was fun working on the [cryo-chamber], just because it is kind of an art piece," says Dechant. "It was looking at the storyboards that were created by Zack and understanding his intention for that scene, and then creating an environment that felt unique for it. How does it sculpturally need to look, as opposed to what does it practically do."

▲ Priest-like medical technicians take charge of the patient.
▶ ▶ An early concept sketch of the medical bay and cryo-chamber.
▶ Concept art for the layout and equipment.

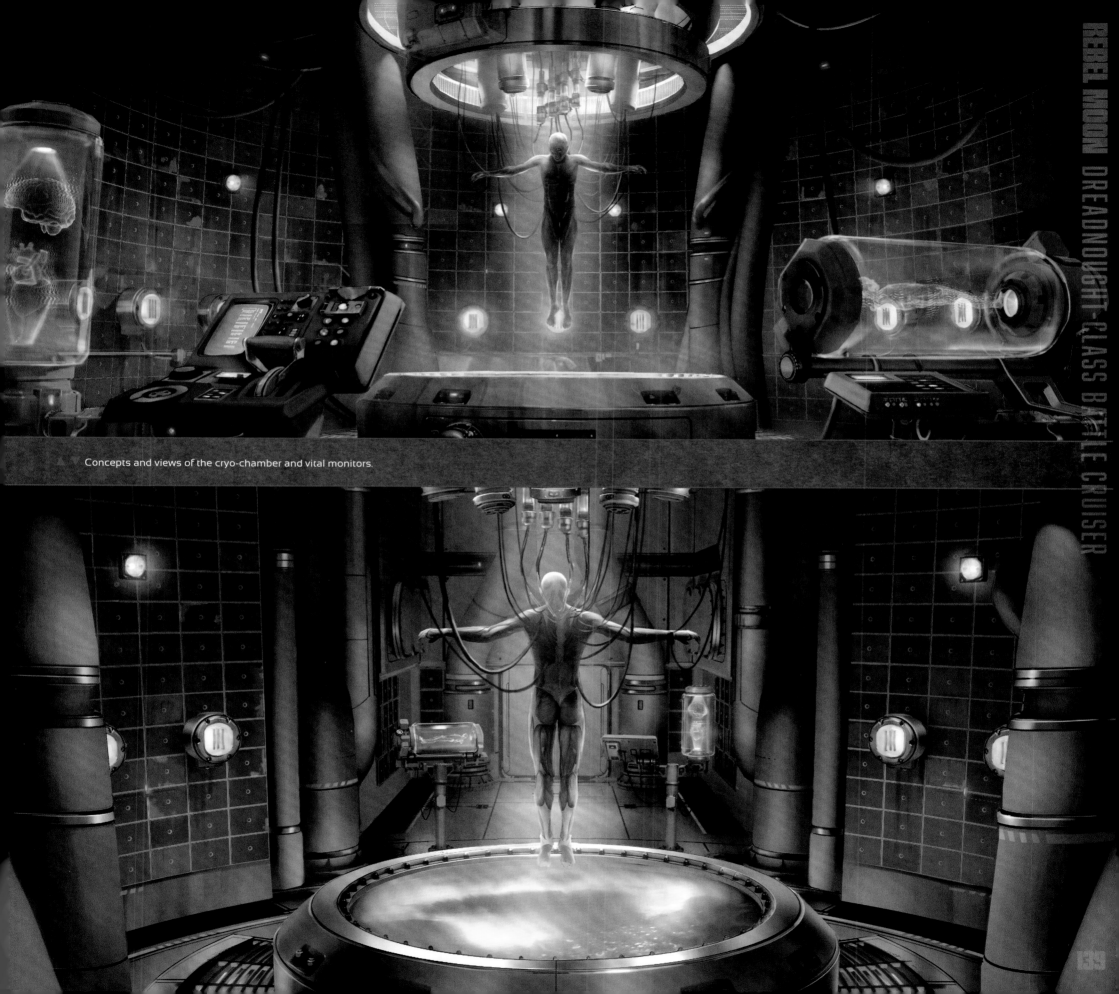

Concepts and views of the cryo-chamber and vital monitors.

ENGINE ROOM

Visitors to the engine room of the dreadnought might be shocked to find the incongruous sight of crewmen shoveling what looks like coal into enormous furnaces. But, rather than being steam-powered, the dreadnought is "Kali-powered." For over half a millennium, the fleets of the Motherworld had slowly expanded into its local solar neighborhood, limited by the universal speed limit of slower-than-light travel. The discovery of the Kalis changed all that. Exactly how this process works is a closely guarded Imperial secret.

If anything, the engine room was designed with even more of a low-tech, industrial aesthetic than the rest of the dreadnought. "Zack wanted a console for a guy that's sitting at a desk. We made a console and again found some really cool, old 1920s and '30s salvage pieces that were knob- and tube-looking things. That was the style we went for," Bonfe says.

▲ ▼ Concepts for the Kali and engine room furnaces.

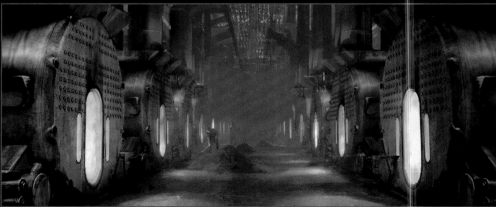

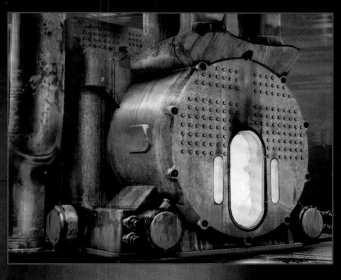 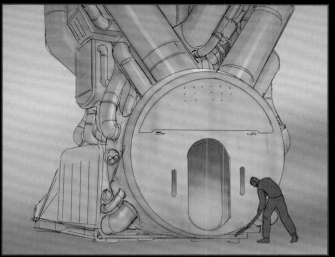 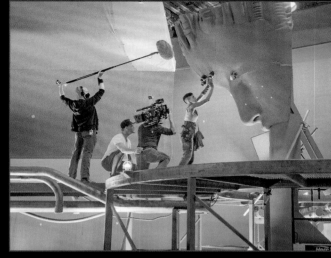

▲ Furnace details and filming the Kali.
▼ Concept art of a fuel-supply belt above the furnaces.

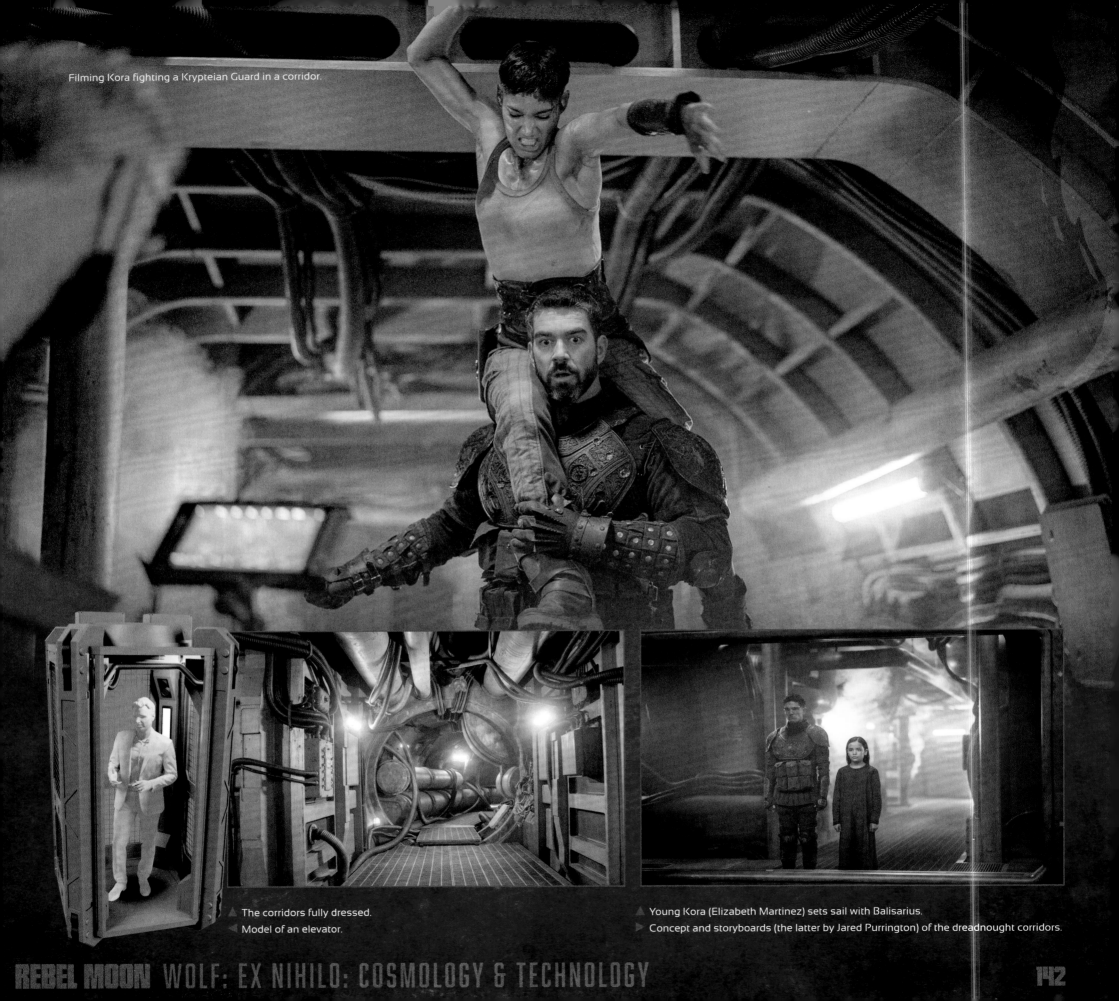

Filming Kora fighting a Krypteian Guard in a corridor.

▲ The corridors fully dressed.
◄ Model of an elevator.

▲ Young Kora (Elizabeth Martinez) sets sail with Balisarius.
► Concept and storyboards (the latter by Jared Purrington) of the dreadnought corridors.

ELEVATORS & CORRIDORS

hether we are on Veldt, the Motherworld, or a dreadnought in deep space, the unstated values the people that inhabit it are often shown most clearly in the utilitarian spaces—especially how they're designed and maintained. The elevators aboard the dreadnought, for example, rather cramped. The narrow corridors must seem like a labyrinth to new recruits. The trick to create those spaces in a thoughtful and efficient way. "I think the sets I'm most fond of probably in the dreadnought," says Dechant. "I like the layering texture in there. I like how u could get lost in the corridors. I also like that we were pretty clever in terms of how those rridors could disassemble and reassemble and be different parts of the ship."

The corridors also have the hindrance of a multitude of cables, pipes, and conduits running ough them. "I am always surprised by how much hose we go through that line the hallways d hang from the ceiling. I mean, just so much hose!" says art department member Cole bbit. "We take Techflex, which is sort of like this braided fabric, and we sleeve soaker hose ough it to give it different looks and we have it aged in different ways."

That unease of access, combined with overarching Imperial mission concerns, produce ship that appears neglected, not unlike the Motherworld herself. "We can joke about the eadnought being a little run down, but really that's not the priority of these people," explains chant. "The priority is devastation and destruction and oppression. They're working within weapon, and that weapon doesn't need to be cleaned. The weapon just needs to function a weapon, and that's why the design of the dreadnought is what it is. It's a pretty dirty ship.

They could clean it a little bit, but it's a hell of a lot of fun to make, and all that texture was fun to work on."

Sharp-eyed viewers might notice something familiar about some of the lighting fixtures found throughout *The King's Gaze*. "There was this light that I found at a prop house," Bonfe explains. "It was a tube light that had all these holes in it. It was about eighteen inches long. [Zack] loved it for Kora's sleeping quarters [in Veldt]. Then, when we started doing the dreadnought and we started talking about lighting, Zack said, 'I want Kora's light.' So we basically took that same light, we used PVC pipe and took perforated metal and bent it to make it at a larger scale. The end caps, we just did a little mold on those. We made almost a hundred of them at different sizes, four-foot and two-foot lengths, and it didn't cost very much. We used those, and then something as simple as the jelly jars that you typically see on a ship." As in the Veldt village and Providence, many of the lights in the dreadnought were battery operated and portable, to allow greater flexibility while filming.

Of course, like every military vessel, there is plenty of signage in the corridors to indicate where we are, what equipment might be dangerous, what actions are not permitted, and so on. "All the signage in this movie can be translated. They all have meaning and purpose. We tried very hard not to put any Easter eggs in that. We wanted to have a legitimacy in there. Though hidden in the hallways is a sign along one of the pipes noting that there's no skateboarding allowed in the dreadnought," says Dechant.

NOBLE'S BED CHAMBER

en an admiral needs respite from the stress of command once in a while, and Atticus oble is no exception. His choice of off-duty activities might not differ from that of the erage Imperial officer, but his taste in partners for said activities might.

Designers naturally gave special attention to Noble's bed. It had to match his unreserved rsonality and sense of style, so it could not be a run-of-the-mill, standard-issue military nk. "It was inspired by an Eames chaise lounge—the legs, the shape," Bonfe explains. e frame was machined out of aluminum using 3D routers, and after construction was mpleted it was broken down into several parts for reassembly on set. She adds, "We had custom mattress made for it. Zack didn't want him to have any blankets or pillows, so it as just a vinyl cushion we put on top of it." The vinyl made clean up easier, presumably.

Other furniture had to be carefully selected to round out the decor, not always an easy cess. "He had to have a chair that he could sit in," Bonfe says. "I showed Zack so many

pictures, but I didn't really feel it, either. I wasn't inspired. I was kind of grasping at straws, and then I saw this piece at one of the prop houses, which was a rare, Italian chair. I brought it in for when I was showing Zack my furniture inside of the hangar set. I said, 'I know this is a little out there, but what do you think?' He loved it. He sat in it. So, that was successful, and it looked really cool on the set. After that, other pieces fell into place. [Zack] wanted Noble to have a special area as his dressing area. One of my ship salvage places had these really cool lockers that also had a sink, and it all came out of a ship. Then we did a little map table for him. He had books and journals. We found some old, cool maps and a leather map case... And [costume designer] Stefanie Porter (who has been so lovely through the whole shoot) gave me some of his hero pieces, and it just completed the set," she concludes. "It was a rewarding set, I would say, and fun to do something with personality inside of the dreadnought."

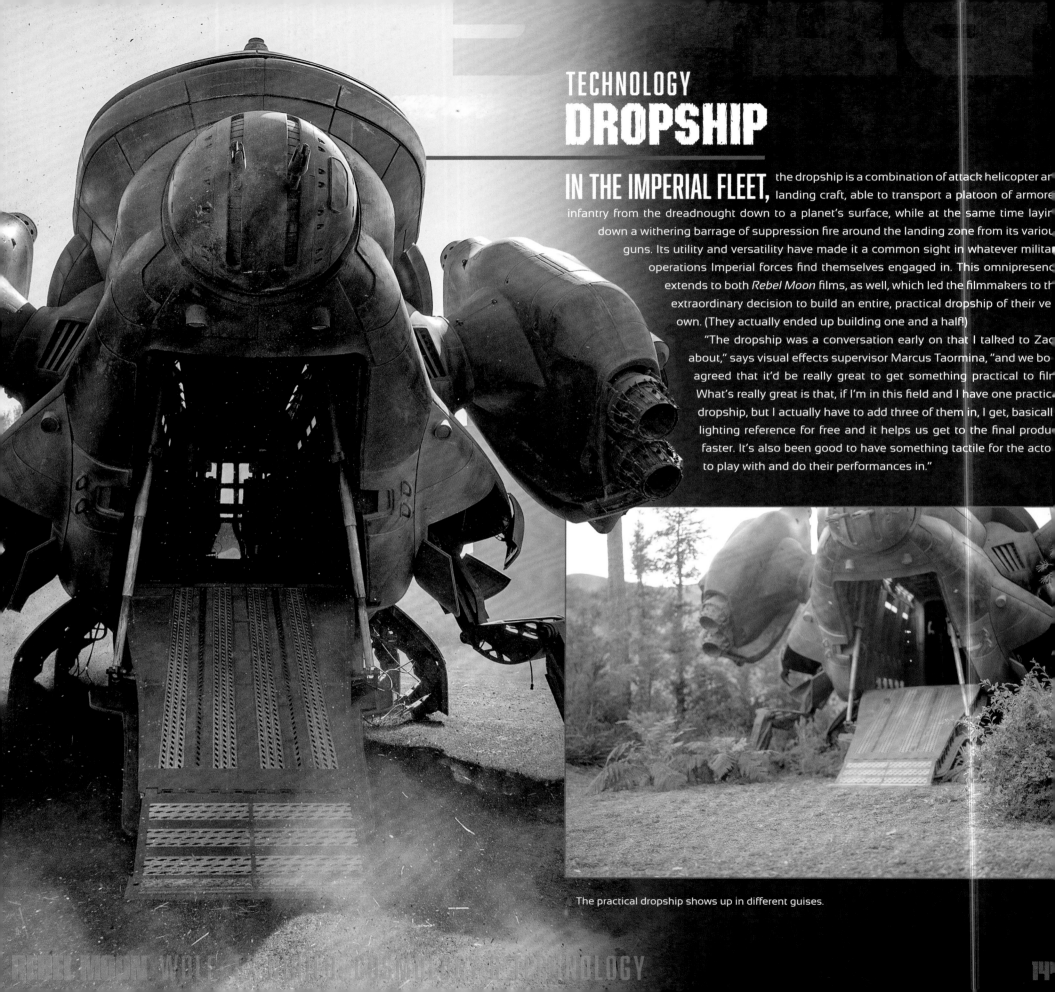

DROPSHIP

IN THE IMPERIAL FLEET, the dropship is a combination of attack helicopter an

landing craft, able to transport a platoon of armored infantry from the dreadnought down to a planet's surface, while at the same time layin down a withering barrage of suppression fire around the landing zone from its variou guns. Its utility and versatility have made it a common sight in whatever militar operations Imperial forces find themselves engaged in. This omnipresenc extends to both *Rebel Moon* films, as well, which led the filmmakers to th extraordinary decision to build an entire, practical dropship of their ve own. (They actually ended up building one and a half!)

"The dropship was a conversation early on that I talked to Zac about," says visual effects supervisor Marcus Taormina, "and we bo agreed that it'd be really great to get something practical to fil What's really great is that, if I'm in this field and I have one practic dropship, but I actually have to add three of them in, I get, basicall lighting reference for free and it helps us get to the final produc faster. It's also been good to have something tactile for the acto to play with and do their performances in."

The practical dropship shows up in different guises.

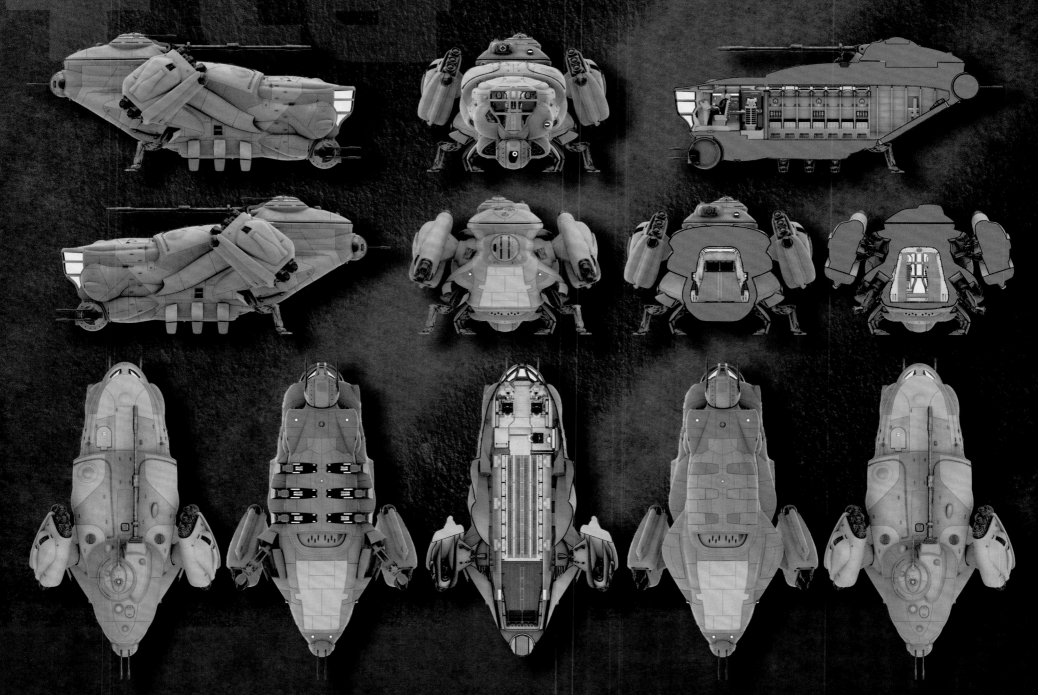

▲ Digital models with cutaways of the dropship.

▼ Plans for the dropship cockpit.

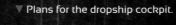

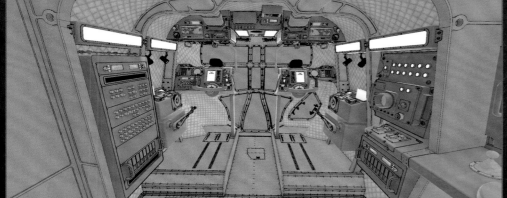

Those sentiments are echoed by production designer Stefan Dechant. "When there's explosions near that, we really get the feeling of it being right there in the scene. Also, it gives Zack flexibility as an image maker and as a director, that he can change his mind on the day. If he decides he wants to move his camera around or he has a new, better idea, the ship is set up for that." For Zack Snyder, the benefits far outweighed the cost. "There's so much that happens in and around the dropships of the Motherworld that we thought we should build a full one, because it's just cheaper—and cooler, frankly," he says with a laugh.

Following 3D renderings furnished by a team headed up by set designers Scott Schneider and Sam Page, seven engineers from Aria Group generated detailed plans for a completely custom-built, functional, and structurally sound dropship that could be manufactured, assembled, and taken apart as needed. Normally a firm that produces high-end sports car and aircraft prototypes, Aria Group has also created stunning vehicles for other Hollywood productions. It took more than four solid months of non-stop 3D printing to produce parts for

the ship, along with even more parts molded from foam and carbon fiber, and a multitude of structural elements machined from steel and titanium.

"The ship is actually going to be a complete exterior," explained dropship project manager Josh Foster during construction. "All the guns articulate, so they pivot up and down, left and right. The ball turrets move, the legs articulate, the door is functional, so that would go up and down. The whole interior loading bay will be complete. The only thing this ship won't have is a cockpit, and we're actually building a [partial] second set that's due later that will represent the cockpit." He added, "This is probably, in terms of size, one of the biggest things we've made."

The forty-two-foot-long, 20,000-pound finished product required eight trucks to ship from the Aria Group production facility in Irvine to the Veldt set up north in Santa Clarita for "final looks" of paint, dressing, and props. It proved to be just as versatile as its film-universe inspiration. "The art department deserves a ton of credit for building a dropship that not

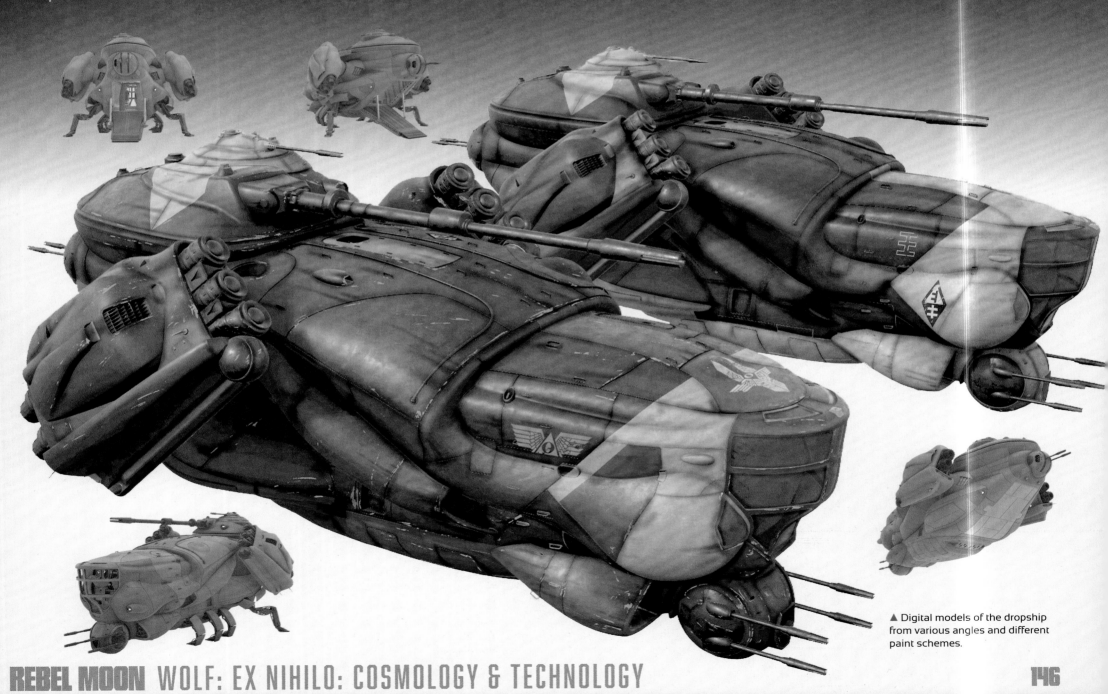

▲ Digital models of the dropship from various angles and different paint schemes.

only has the visual impact and presence that it does, but also is manageable," says producer Wesley Coller. "We can take it apart, we can truck it from place to place. It's got a huge steel base so we can set up so it's sitting upright; we can lean it on its side if it's a scene where it's found its way into a crash sequence. It plays multiple dropships, from different eras, and depending on when we're using it and where it's at, it requires a different paint job. We actually had one day during the middle of the shoot that one side was painted one way, and while we shot it, the other side was being painted for the next day for the opposite shot."

The choice to build a partial second ship increased the flexibility overall. "We have one on [the Veldt] set that's a full build and gives us something for people to enter and exit. Then we have another version on stage with a fully dressed out cockpit and interior," Coller notes. "So, in between those two, [the actors] have the ability to exist in and out and around these ships in a way that I think will really bring them to life on film."

Another way the filmmakers brought the dropships to life was through practical effects on real environments—oddly enough, championed by the head of the visual effects department. As Taormina relates it, there was some debate about how to film the dropships landing. "These are spaceships with a ton of wash off the engine. So, I talked to Zack: 'Hey, let's use the helicopter. Let's get real rotor wash.' We have this vast, acre or so of set, and when the helicopter wash came down, it blew and it impacted all the way up until the longhouse, and you got this beautiful dust wave. We [in VFX] could do it, but it would've taken so long. And to be honest, I always lean into the practical effects if we can, because there's a reality to them. It was so fantastic, and you get all the counter-performances from the actors that are there. They're reacting to that dust wave. There's a feeling that gives you. It's a rush."

▲ Cutaways of the dropship.
▼ Kora's crashed dropship on Veldt.

MECH-CARRIER

SIMPLE AND EFFICIENT, mech-carriers travel inside the dreadnought so they can ferry down mechs wherever they're needed, on whatever far-flung planet. "We had a fantastic illustrator, Chris Glenn, who was on the show from the very beginning right down to the end," production designer Stefan Dechant recalls. "We were trying to figure out a cool way to make it work. At first we were doing a certain Sikorsky [Skycrane] helicopter, and we'd have the cockpit in the front. But something felt a bit pedestrian. We went back, and he came up with these arms that lifted the mech from the front. I really liked that."

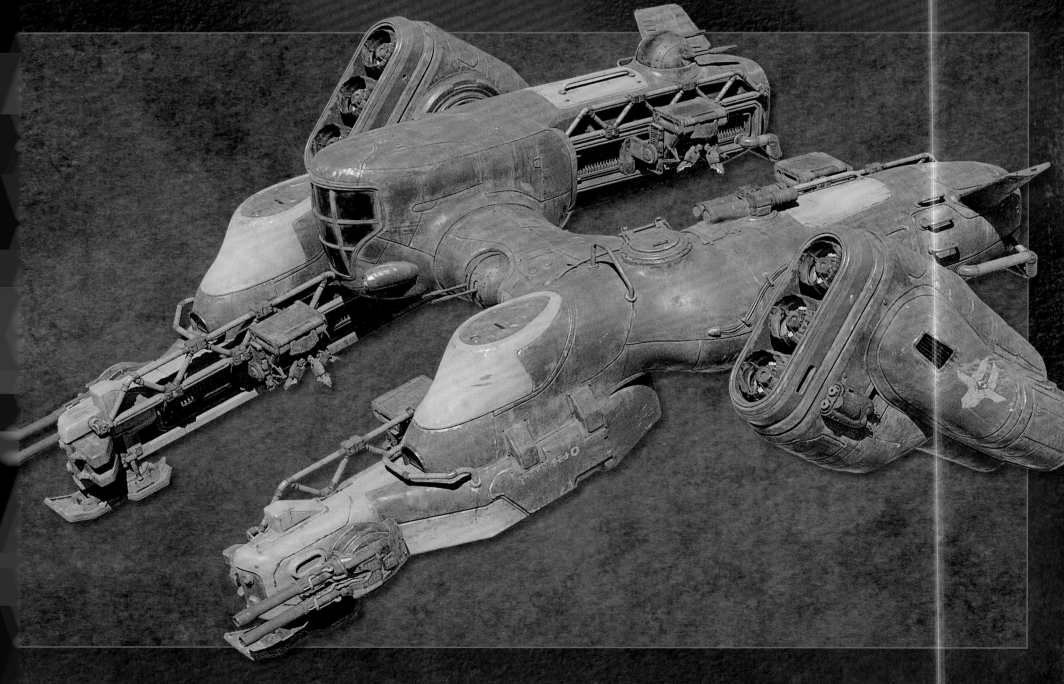

Various views of the final digital model of the mech-carrier.

TECHNOLOGY
FAST-ATTACK LAUNCH

BERTHED IN THE BOW OF THE DREADNOUGHT and released through a hatch in the underside, the sleek fast-attack launch is both the admiral's personal barge and a capable escort for its capital ship. "It's a good size, it can hold a lot of troops, and while *The King's Gaze* is engaged in battle, it can go and fight ahead or behind, based on the needs. So it fulfills that desired strategic need of having something that's quicker and a little more nimble than the dreadnought," Zack Snyder explains.

▶ Details of the launch, including the doors located on the underside of the fuselage.

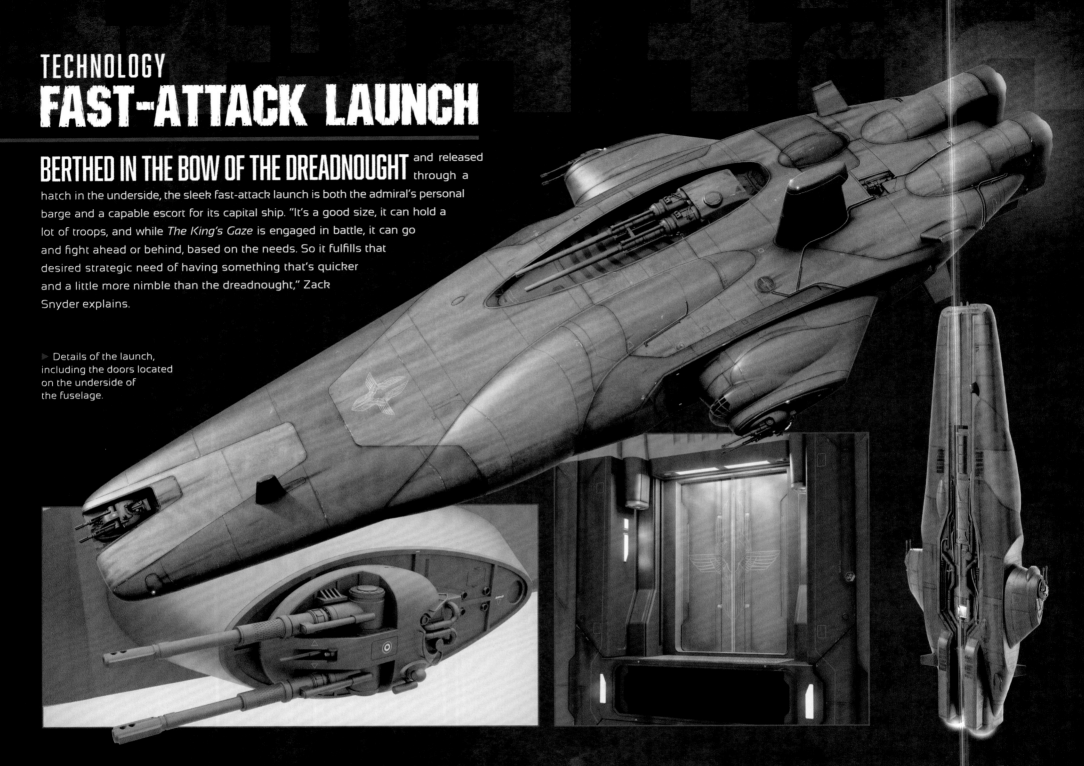

"We aimed for a strong visual connection between this and other Motherworld craft," production designer Stephen Swain says. "I was keen to present an overall sense of symmetry with smaller, isolated moments of asymmetry within the ship's silhouette. Working closely with Chris Glenn and the dropship team ensured a similar build quality and attention to detail."

Despite its size, the launch boasts a feature that still allows it to take advantage of smaller landing pads, such as the floating docks above Gondival. "It pivots around the cockpit," Snyder says, "so it can fly straight ahead, getting more aerodynamic and really going quickly, or the ship pivots down and it flies vertically, where it lands."

One of the most dramatic moments in the battle at Gondival is when Bloodaxe jumps on the cockpit canopy and stabs the pilot through the windscreen. To make that happen, form had to follow function. "We needed a place where the character can jump to and land, so we needed to place handholds and footholds," Dechant explains. "Concept artist Daniel Frank was working on that with Kevin Ishioka, who was one of the art directors on all the vehicles. It looked like one of those Japanese kendo masks. I liked the look of that, and it was something new that I hadn't seen. But again, it's all derived for the action."

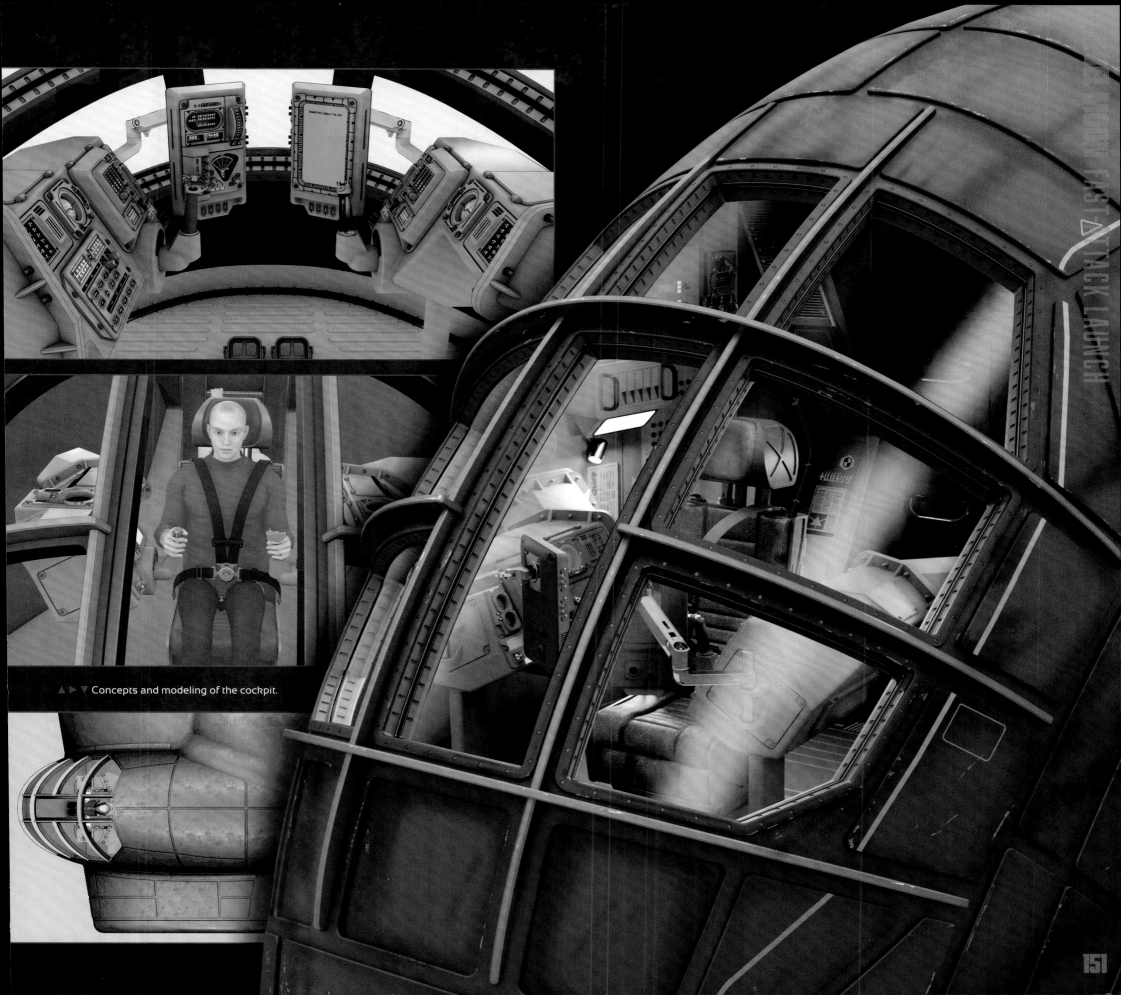

Concepts and modeling of the cockpit.

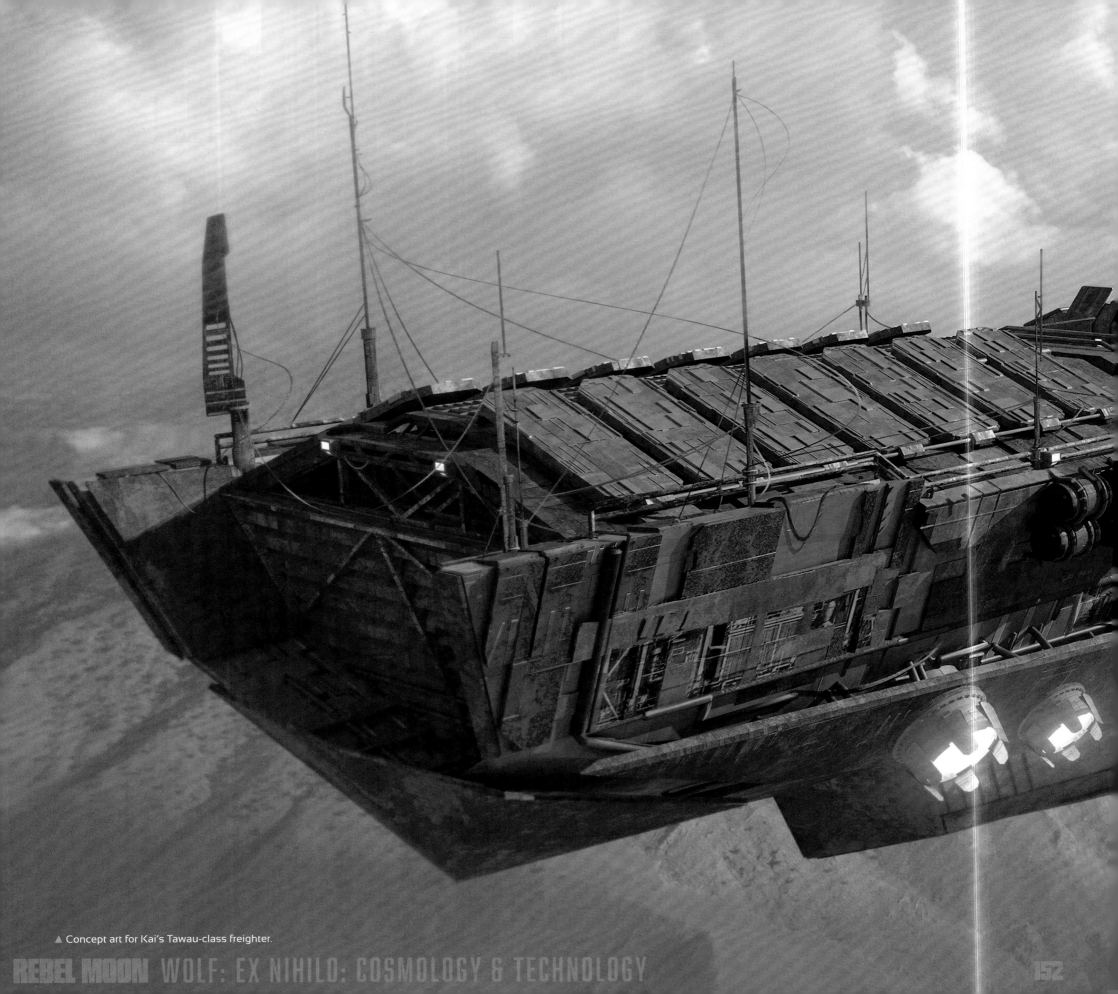

▲ Concept art for Kai's Tawau-class freighter.

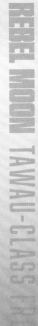

TECHNOLOGY
TAWAU-CLASS FREIGHTER

IF YOU NEED TO MOVE GOODS from one end of the Realm to the other, you could do worse than hiring a trader with a Tawau-class freighter in good repair. A reliable workhorse, this ship is not only solidly built with ample cargo space, but it also has a reasonable top speed. "It's kind of built off a crab boat. So, it's big, but not gigantic," Zack Snyder says. That crab boat influence might be seen most clearly in the freighter's distinctive bridge design. In addition to the bridge, the stern of the freighter—including the landing struts, lift gate, and cargo area—were completely practical sets.

"I worked closely with concept artist Ace Carman in the latter stages of this process, and I felt it was important to show the physical signs of wear and any subsequent repairs or modifications to the ship," production designer Stephen Swain says. "Rather than focusing on space travel, I used commercial shipping vessels as a direct point of reference. Roll-on/roll-off ferries proved very interesting in this context, as there seemed to be a direct correlation between the two."

In dressing the interior of Kai's freighter, designers studied not only modern cargo carriers, but also leaned heavily on the singular personality of the pilot.

"I call him an independent contractor of space cargo. He's a world traveler," set decorator Claudia Bonfe explains. "He steals things, so maybe he takes some stuff out of people's cargo. He likes jewelry. He likes things from all of his travels, but he doesn't pay for it."

Understanding Kai also informed the type of repairs you might see around the ship. Since paying for repairs would cut into his profit margins, he usually does them himself, with whatever materials he has lying around. "Our designer handed me a reference photo of a military cargo area in a plane," Bonfe explains. "One of the elements that I loved were things like the heating pipe that had fabric over it, and someone had repaired it. It looked like they took a strap from the cargo net and then tied it and just did a makeshift repair. So, we took that and did it ten times more, all over the back of the ship.

With the cargo nets on the side, he would use other things when he ran out of straps. So, he used a belt to tie some of the cargo, or he used some sort of decorative fabric that he found on his travels that had a Moroccan feel—whatever he had available. Nobody goes back there, and he's not having any inspections in his ship."

The bridge dressing also embraced this cobbled-together ambience. "We repurposed and took apart a lot of electronics, like aviation equipment and pieces of submarines and naval ships. Just a bunch of electronics salvage, nothing was new," Bonfe says. While that might sound like the process used to dress the bridge on *The King's Gaze*, Bonfe makes it clear that the end results were very different: "His ship is nothing like the dreadnought, which is very expensive, top-of-the-line equipment."

▼ Concepts of the freighter bridge and exterior.

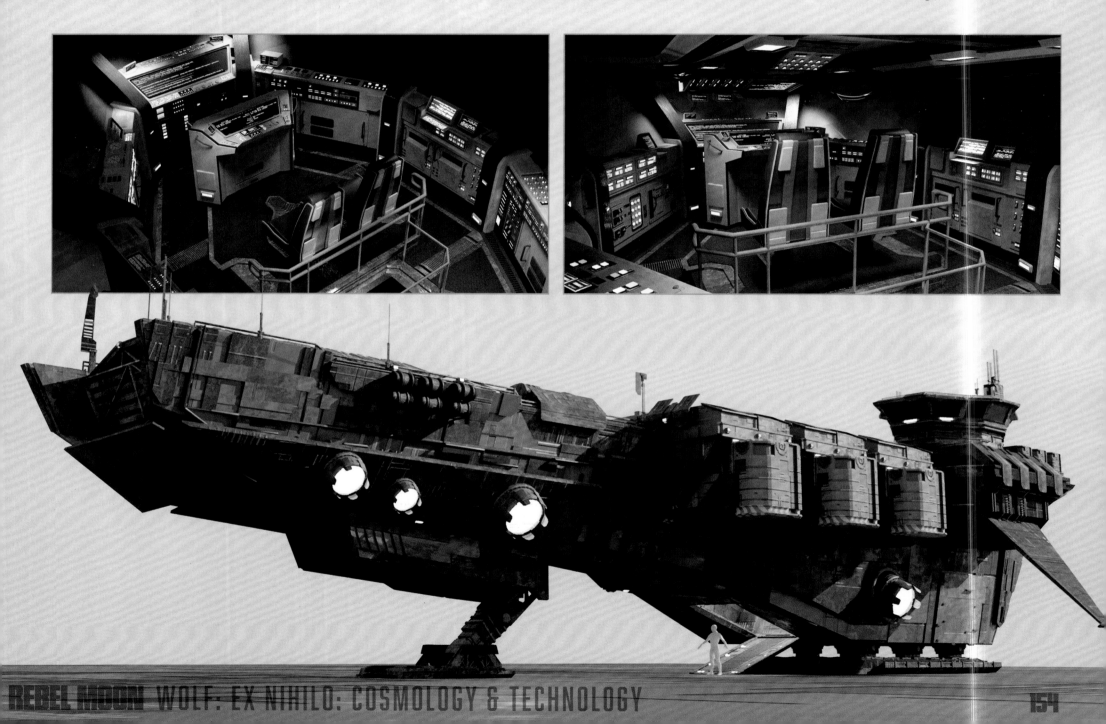

▲ ▲ Concept art of the freighter landed on Pollux.　　　　　▲ Kai on the ship's bridge.

If that's the case, then Kai's bridge computers appear to be nearly obsolete models, running dated software. "There's a feel we were trying to lean into in Kai's freighter that harkens to the early 1980s, late 1970s filmmaking," production designer Stefan Dechant explains. "There's a simplicity to that, almost an 8-bit quality. Those screens look like CRTs, even though they're not CRTs." As Swain recalls, "My old Commodore 64 proved a vital source of inspiration for the interior. As with the main hold, the cockpit was intended to feel slightly ramshackle and modified through age."

That retro look even extended to the color palette used aboard the freighter.

Second chances are a big theme in *Rebel Moon*, and that also apparently applies to sets and scenes. "There was supposed to be this whole scene between Gunnar and Kora where there was a bunch of bunk beds," Bonfe explains. "The art department built an extension to the cargo area, but it was basically just a box. We came up with an idea of how to take all the cargo boxes and make a bed, but it's really subtle. It was supposed to be background, just to give some depth, but I guess Zack really liked it, so he decided to change the scene. Gunnar is lying in the little bed area, and Kora is cleaning up and talking to him. So this boring little box became something more interesting."

▲ The cargo hold, with its jury-rigged tie-downs.

▼ A cozy sleeping nook.

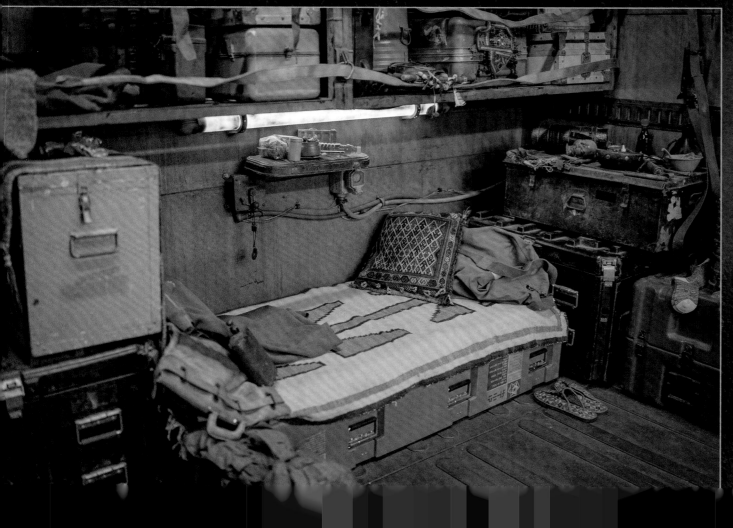

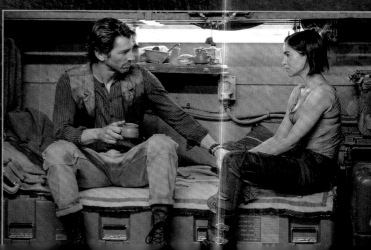

TECHNOLOGY
HAWKSHAW SHIP

MERCENARIES AND bounty hunters employed by the Realm for a variety of unsavory tasks, Hawkshaws make use of ships that are just as no nonsense as they are. Zack Snyder describes them as "these chunky sort of vertical ships, with a whole lot of cargo room for hauling prisoners and stuff inside of them. They're kind of beat up, and they're not really that well maintained."

Once more, practicalities of filming and visual language helped steer the design of the Hawshaws' ship. "It's for clarity. You didn't have so many ships, so you want to have these very clean graphics that set one off from the other," production designer Stefan Dechant explains. "The Hawkshaw look is, among the rest of the Motherworld, a different, more squared-off aesthetic. Also, we wanted a design that would work in the limited stage space, and still allow us to have angles where we could shoot across the ramp and see Noble coming towards us. If we had elevated landing gear, that shot wouldn't be in camera. So, the ship comes in, and it's got so much bulk, but it can land on that exterior skid plate and keep itself up."

▶ ▼ Concept art for the hulking Hawkshaw ship.

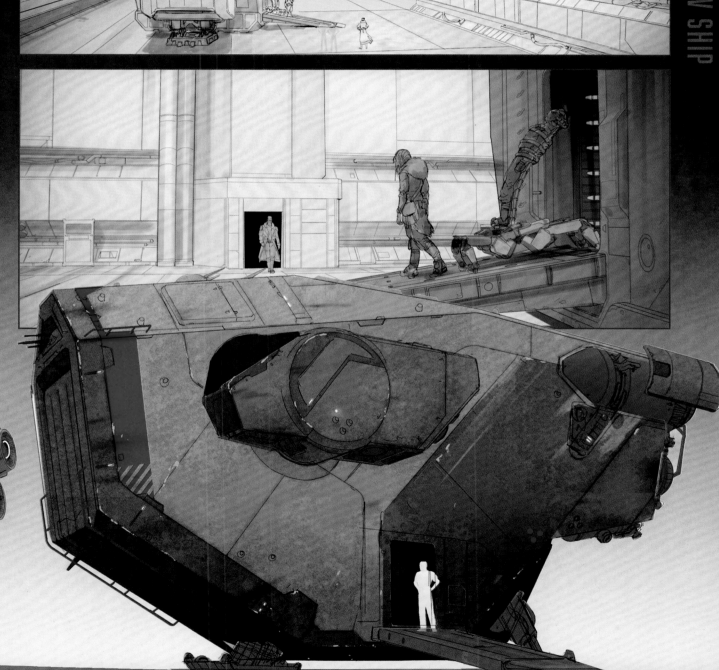

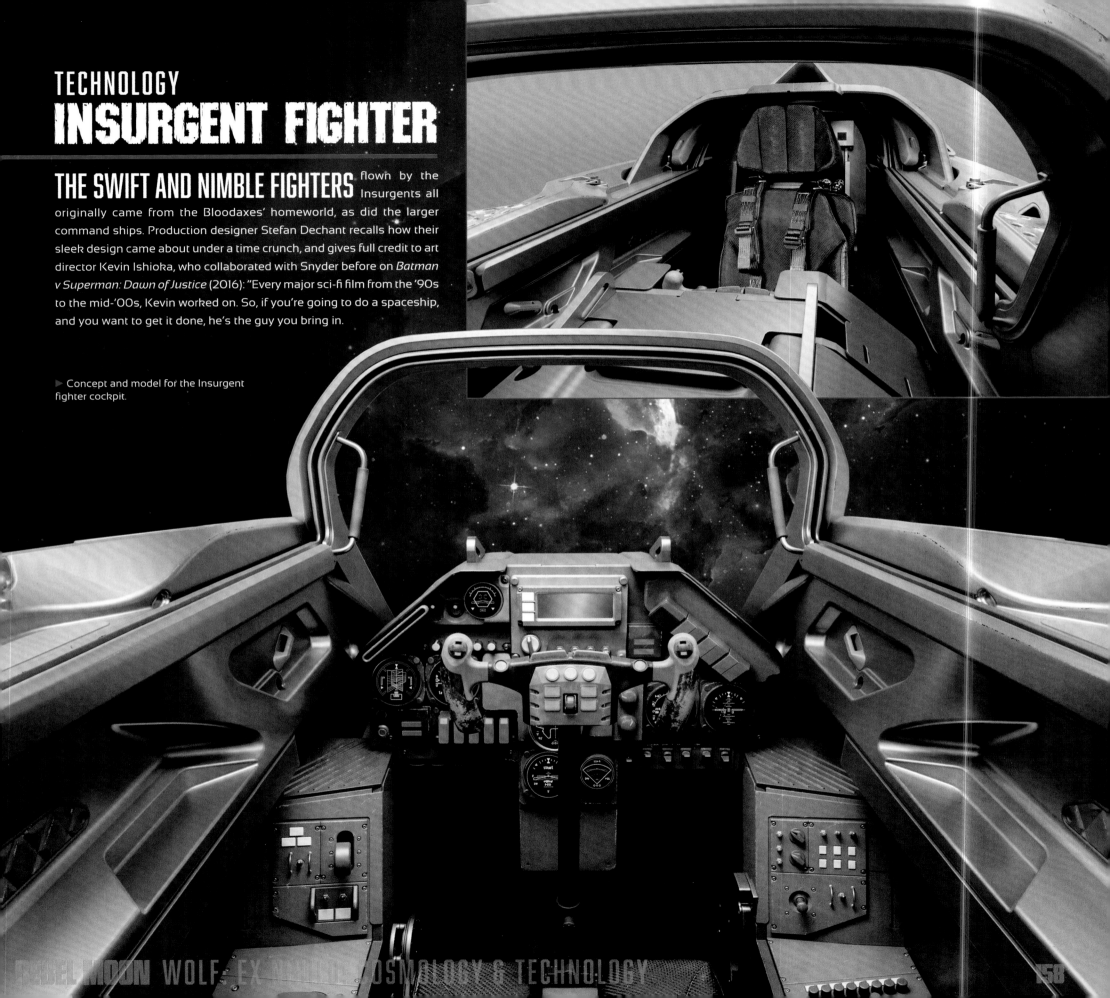

TECHNOLOGY
INSURGENT FIGHTER

THE SWIFT AND NIMBLE FIGHTERS flown by the Insurgents all originally came from the Bloodaxes' homeworld, as did the larger command ships. Production designer Stefan Dechant recalls how their sleek design came about under a time crunch, and gives full credit to art director Kevin Ishioka, who collaborated with Snyder before on *Batman v Superman: Dawn of Justice* (2016): "Every major sci-fi film from the '90s to the mid-'00s, Kevin worked on. So, if you're going to do a spaceship, and you want to get it done, he's the guy you bring in.

▶ Concept and model for the Insurgent fighter cockpit.

▲ ▶ Modeling the fighter and cockpit.

▼ The fighters come in for a landing at the docks above Gondival.

"We were looking at some anime models that Kevin has—stacks and stacks of Japanese model kits. We only had ten weeks to get that cockpit designed and up and shot. There was a design that came back, and it looked like a crayfish, a pistol on one hand and a claw on the other. It felt unique. The claw was important, because we needed it for the gag at Gondival, where characters jumped from ship to ship. It was approved. We were going ahead, but I was looking at a model, and it seemed rather complex. It wasn't a clean, easy design. I always thought the cool part about a good spaceship needs to be that if you're ten or you're eight,

you can draw that thing on the inside of your notebook when you're supposed to be paying attention in class! So we got rid of the claw, and we have two gun pieces that looked better. It was a cleaner shape.

"Then another art director, Ron Mendell, came and was working with Kevin to design that cockpit," Dechant continues. "That was all built in 3D. We grew those parts, and we had an outside contractor manufacture that thing. Ron is the only person I know that has ejection seats in storage, so we rented his ejection seats and put them in there."

TECHNOLOGY
INSURGENT COMMAND SHIP

"FOR THE COMMAND AND control ships, I was looking for something that gave a sense of confidence. You knew they were strong and capable," Zack Snyder says.

Like the Insurgent fighter, this ship went through an exacting process, and a couple of iterations, to get it just right for the final product. "The Bloodaxe ship was originally designed by Pat Presley, hunting for shapes that would set it apart, and we got that shape approved," Dechant says. "Then, when we were turning things over to visual effects, I told Chris Glenn, 'Before we turn over the ship, it's only been sketched and painted. We should build a 3D model.' We did, and it had a compressed look. So, Chris did a secondary pass, where we pulled that out a little bit." Dechant also notes that another feature was added: "We have ramps galore in this movie, and we wanted a different way to introduce the Bloodaxes. So, the idea of this platform coming down seemed a nice way to introduce these people and have them brought to camera. Sherry Ratliff helped me design that lift. She's a fantastic set designer and art director."

▲ The Bloodaxe command ship makes its approach on Sharaan.

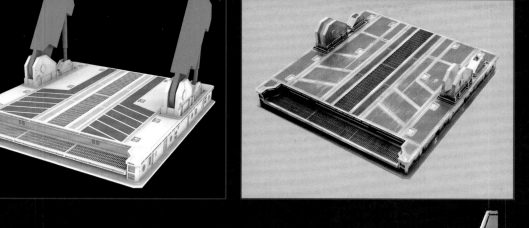

◀ Models of the access platform.

▼ Detailed concept art for the Bloodaxe command ship.

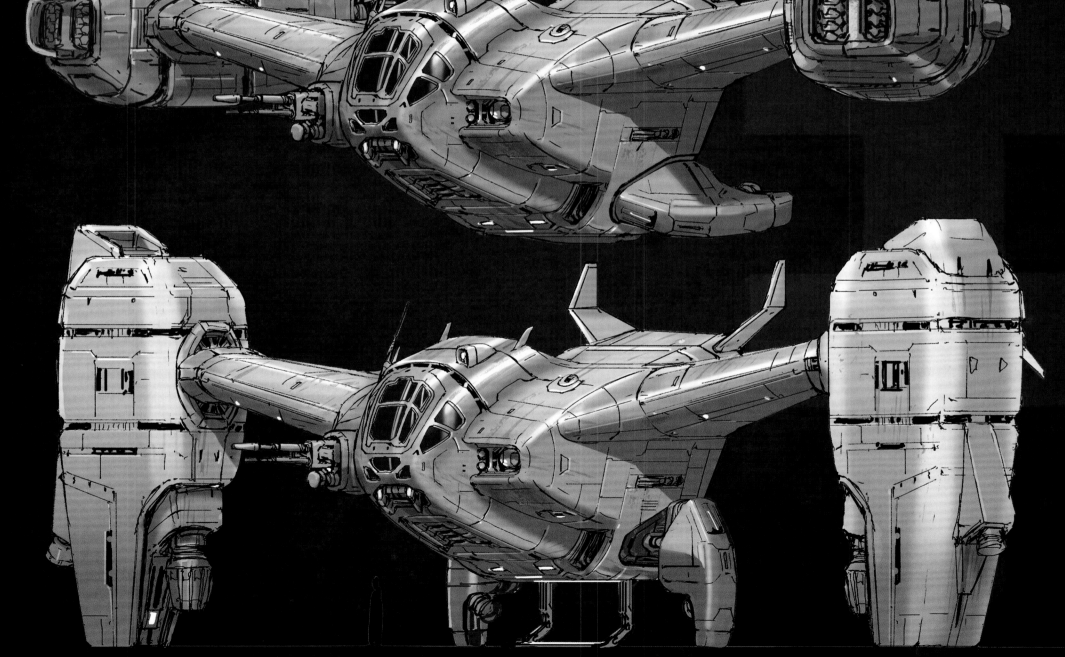

KORA'S GUARDIAN GUN

THE SIDEARM KORA LEFT AT THE DROPSHIP crash site (which Hagen retrieved) functions and in general shape appears much like any other Realm-issued pistol, but the ornamentation on it holds much greater meaning. It is a reminder and a bitter tie to a tragic past. "The Guardian Gun is the same basic gun, but with a lot of elaborate carving and different coloring," prop master Brad Elliott explains. "We wanted to give Kora a special thing, because she has this elite position. She's the Royal Guard, and we wanted to reflect that in the ornateness of the gun. There's an engraving on the side that says, 'My Life For Hers,' which implies that the owner will die before they let the princess die. That gives it much more emotional importance when Hagen gives it back to her. When she gets it back, she's going back to war. She's going back to being that super soldier."

ARMAMENT

It's worth noting that none of the guns in *Rebel Moon*—despite containing many practical elements, like LED lights to simulate muzzle flashes or reciprocating slides to boost recoil—fired live rounds. Following a policy that proved so successful for Snyder on *Army of the Dead*, this proved to be not only safer for cast and crew, but also allowed much faster reset times between shots.

Kora's gun is loaded with meaning about her past and future.

TECHNOLOGY
NEMESIS'S SWORDS & GAUNTLETS

WHEN NEMESIS'S VILLAGE WAS DESTROYED and her family killed, she reverted to the ancient martial ways of her people, took up her family's heirloom swords, and vowed revenge on the Motherworld. "Those were the swords of her father's father, and when she chose the life of a warrior, she didn't even know how to fight," Zack Snyder explains. "Somehow, there's a bio-link that when she cuts off her arms and puts the mechanical arms on, she breathes in the life of her ancestors' knowledge and she's able to fight at their level."

That fighting skill is multiplied by the properties of oracle steel, the incredibly rare metal from which her blades were forged. In addition to being amazingly sharp, the blades receive power from her body and movements, channeled through the conduit of her prosthetic gauntlets, to become super-heated. At that point, there is nothing Nemesis can't slice through.

To design and produce those practical/VFX-hybrid gauntlets, the filmmakers turned to specialty shop Fractured FX, Inc., headed up by Academy®-, BAFTA-, and Emmy-Award winning makeup effects artist Justin Raleigh. "None of it's molded. It's all 3D printed in a rubberized elastomer, so it's stunt safe. Each glove is twenty to twenty-six different components. All the joints have a lot of negative in them to become a blue screen or green screen element—whatever visual effects needed. The underside of the hand is pretty much all digital, the wrist is all digital. Everything else is all us. So it's a nice marriage between the two. We had hero and stunt versions.

We also had to make prop versions when she first pulls the gauntlets out of the box. Aesthetically, they look very cool, almost like a black, anodized look. And it has this bluing, you imagine from holding these hot blades, kind of like the muffler on a motorcycle," Raleigh explains.

Of course, creative briefs are always evolving as new ideas and requirements come in, and artists have to roll with the changes. "Zack decided he wanted to have light added to them after the fact," Raleigh recalls. "We ended up having to, in a very limited amount of space, try and figure out a way to get some LEDs in there that would match the blades, so when her blades come on, her gauntlets would glow. That became the trickiest part of the build, but we had some physical, interactive light that was added."

▶ Nemesis is ready for vengeance.
◀ ◀ The heirloom box where Nemesis's blades and gauntlets are stored.
◀ The oracle steel blades heating up and at full, searing power.
▼ Nemesis wields the super-heated blades.

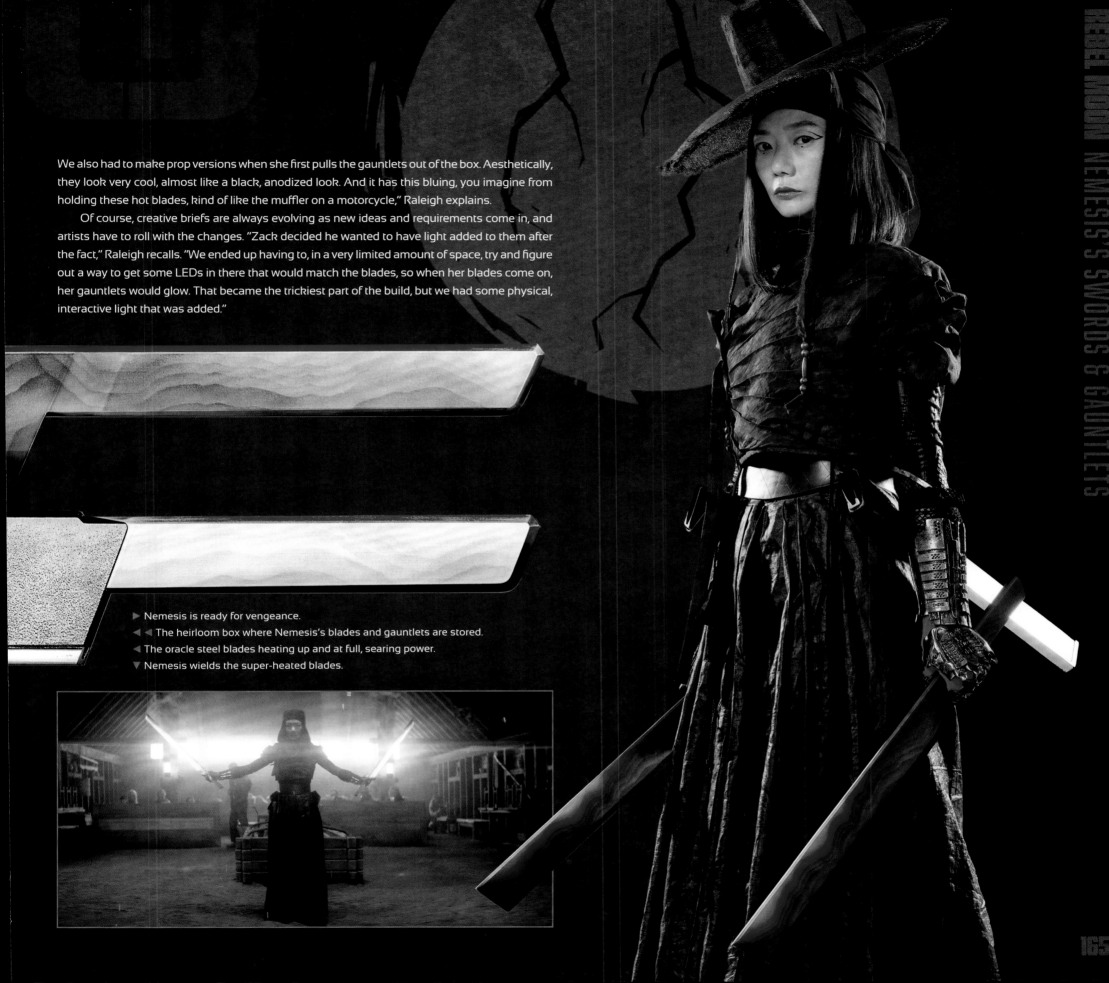

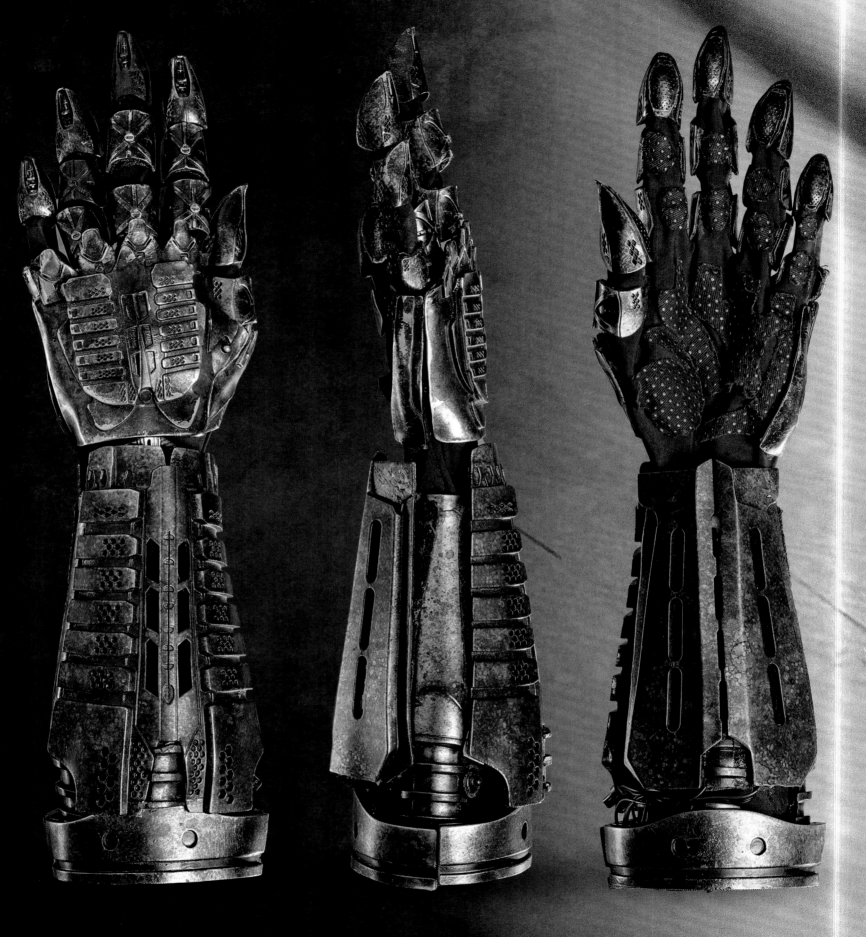

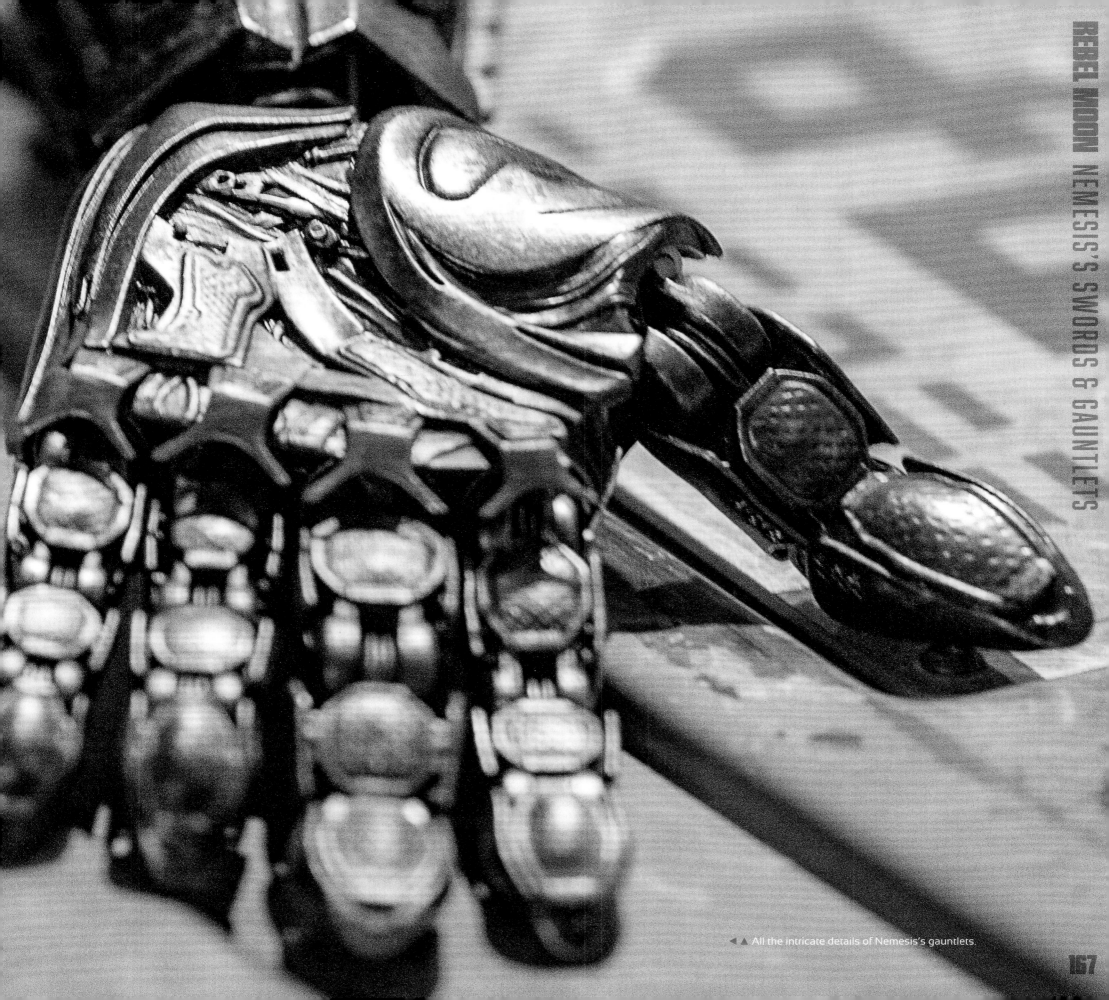

◀▲ All the intricate details of Nemesis's gauntlets.

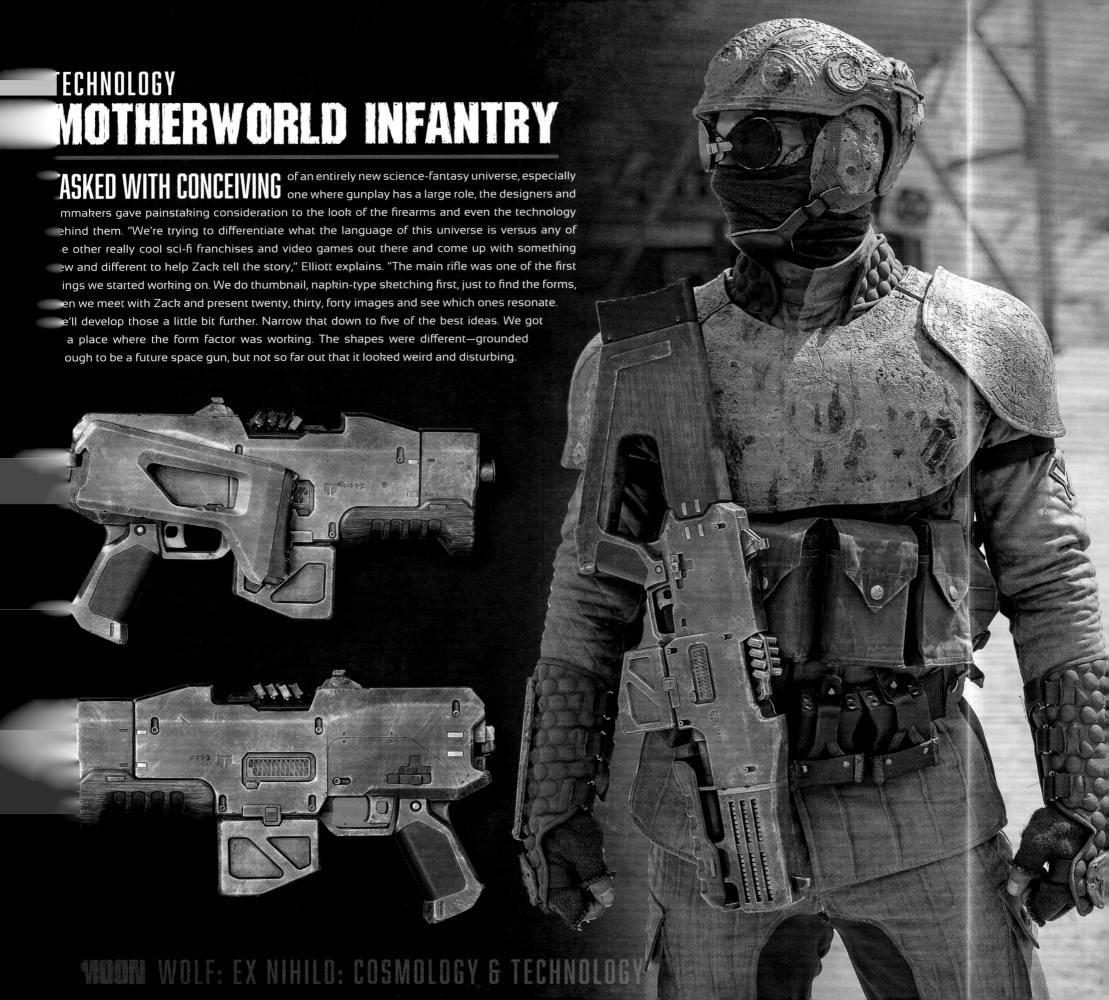

MOTHERWORLD INFANTRY

TASKED WITH CONCEIVING of an entirely new science-fantasy universe, especially one where gunplay has a large role, the designers and filmmakers gave painstaking consideration to the look of the firearms and even the technology behind them. "We're trying to differentiate what the language of this universe is versus any of the other really cool sci-fi franchises and video games out there and come up with something new and different to help Zack tell the story," Elliott explains. "The main rifle was one of the first things we started working on. We do thumbnail, napkin-type sketching first, just to find the forms, then we meet with Zack and present twenty, thirty, forty images and see which ones resonate. We'll develop those a little bit further. Narrow that down to five of the best ideas. We got to a place where the form factor was working. The shapes were different—grounded enough to be a future space gun, but not so far out that it looked weird and disturbing.

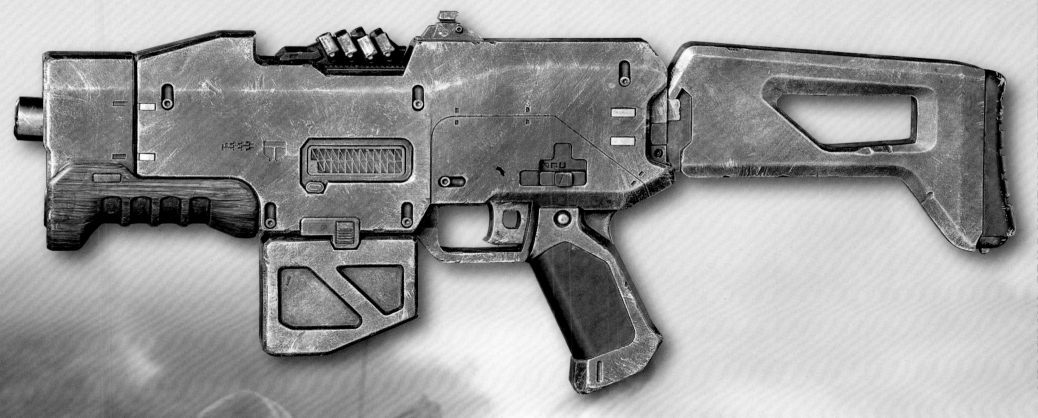

◄◄ Motherworld submachine gun with folding stock.

◄ An infantryman with the main battle rifle clipped on.

◄ Another view of the submachine gun with stock extended.

▲ The infantry advances.

It's something you could imagine in fifty years you might be able to pull off a shelf."

Those conversations generated a creative back-and-forth, with design elements inspiring thoughts on how the guns would actually work, and then those practical considerations feeding back into the look and dynamics. "Our main Motherworld rifle, for example, was designed with this really cool, chunky bit of technology on top—nobody really knew what that was," Elliot recalls. "Our guns shoot this burning piece of heavy, dense plasma, like a chunk of lava the size of a cork. If it hit you, it would make a hole in you and probably knock you over. My first thought went to, 'They're going to get hot.

We're going to need to dissipate this heat.' So, a lot of our gun design is focused really heavily on heat sinks. That little top chunk that we had on the AR [assault rifle] is now something that's going to reciprocate back and forth as if it's cycling some coolant into the barrel or it's a radiator fanning itself. We're also putting an inertial piece inside of them that reciprocates; a weight on a piston that's going to drive back and forth with the trigger pull, so it'll simulate recoil in the actors' hands. We have a muzzle flash that the interactive lighting department is coming up with, and a glow in the front of the barrel, so that practically, on the day, the dimmer board operator will be able to dial these things up and down, as far as how hot they are. They're

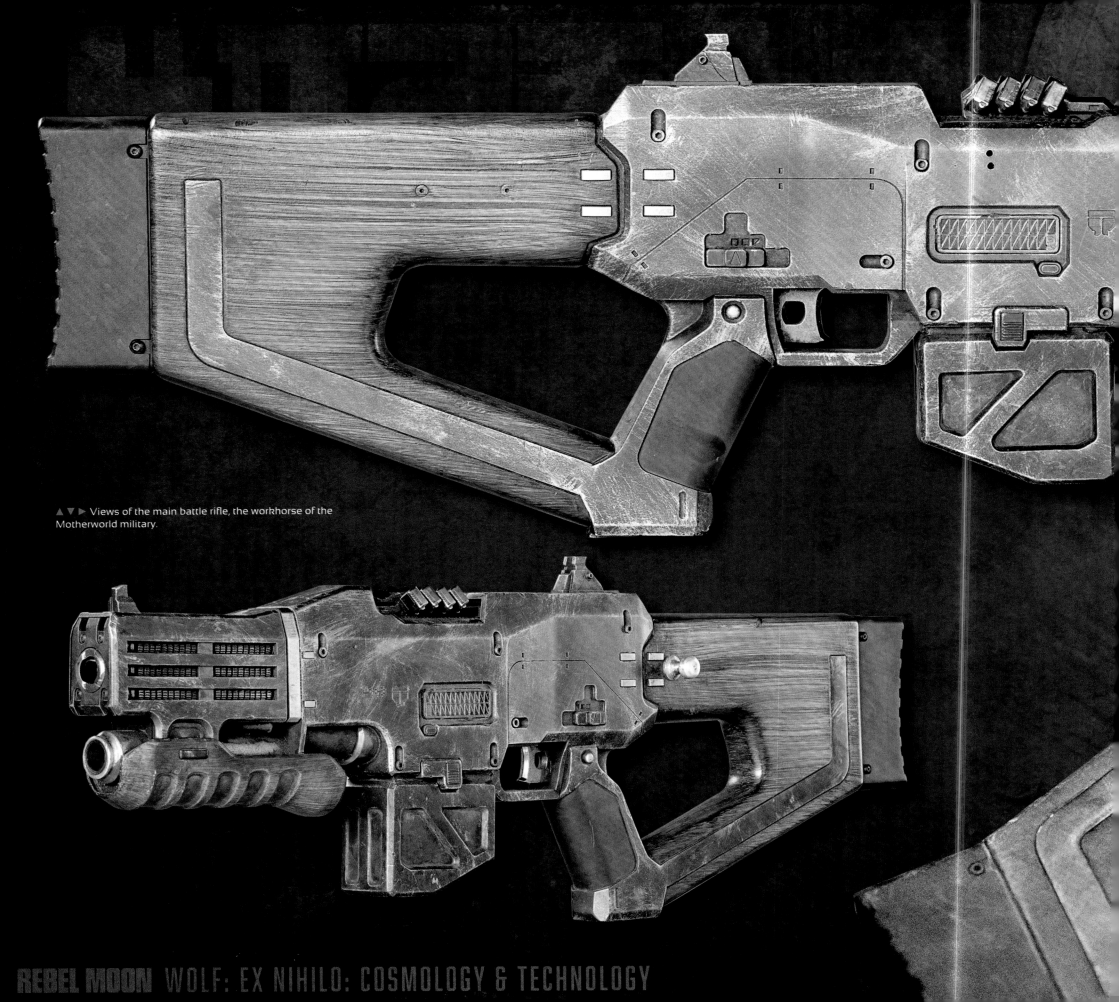

▲ ▼ ▶ Views of the main battle rifle, the workhorse of the Motherworld military.

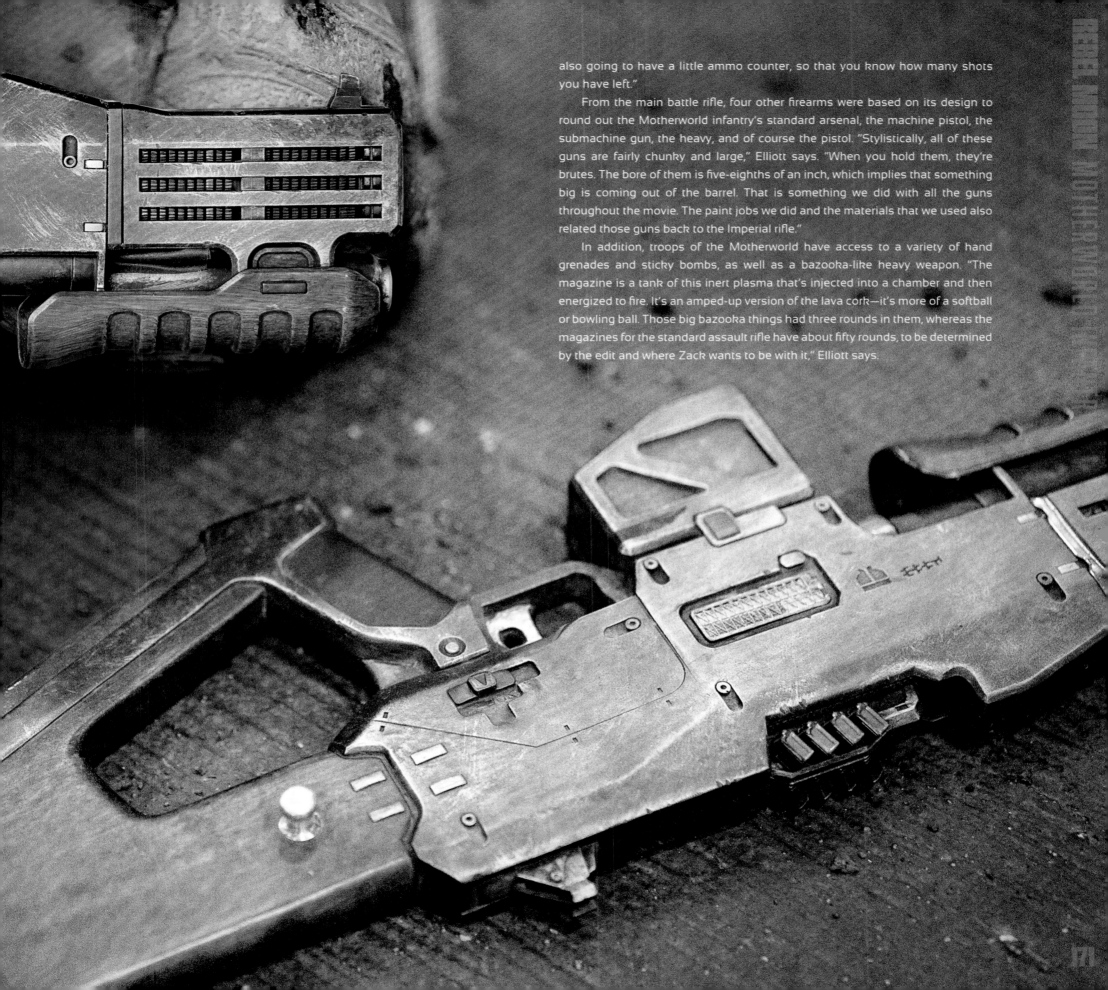

also going to have a little ammo counter, so that you know how many shots you have left."

From the main battle rifle, four other firearms were based on its design to round out the Motherworld infantry's standard arsenal, the machine pistol, the submachine gun, the heavy, and of course the pistol. "Stylistically, all of these guns are fairly chunky and large," Elliott says. "When you hold them, they're brutes. The bore of them is five-eighths of an inch, which implies that something big is coming out of the barrel. That is something we did with all the guns throughout the movie. The paint jobs we did and the materials that we used also related those guns back to the Imperial rifle."

In addition, troops of the Motherworld have access to a variety of hand grenades and sticky bombs, as well as a bazooka-like heavy weapon. "The magazine is a tank of this inert plasma that's injected into a chamber and then energized to fire. It's an amped-up version of the lava cork—it's more of a softball or bowling ball. Those big bazooka things had three rounds in them, whereas the magazines for the standard assault rifle have about fifty rounds, to be determined by the edit and where Zack wants to be with it," Elliott says.

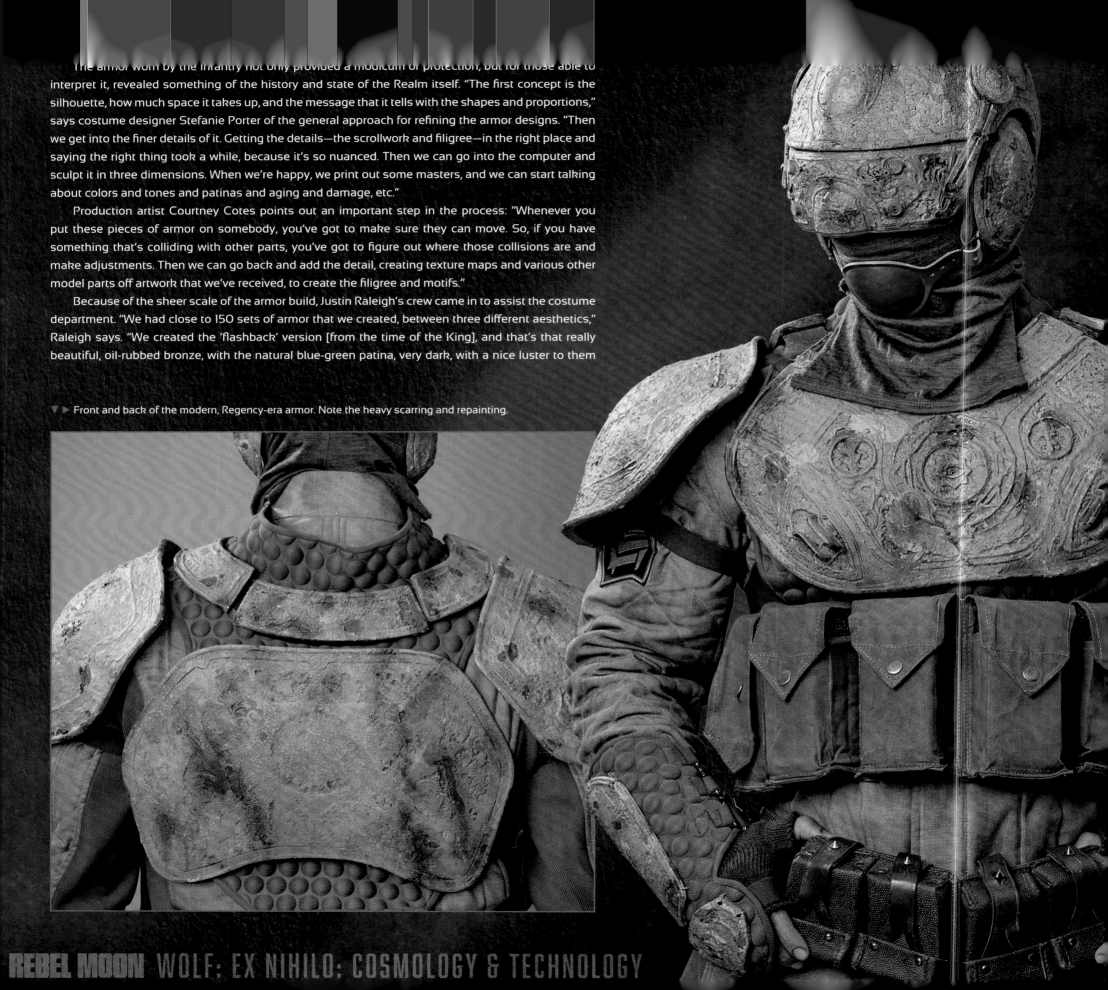

The armor worn by the Infantry not only provided a modicum of protection, but for those able to interpret it, revealed something of the history and state of the Realm itself. "The first concept is the silhouette, how much space it takes up, and the message that it tells with the shapes and proportions," says costume designer Stefanie Porter of the general approach for refining the armor designs. "Then we get into the finer details of it. Getting the details—the scrollwork and filigree—in the right place and saying the right thing took a while, because it's so nuanced. Then we can go into the computer and sculpt it in three dimensions. When we're happy, we print out some masters, and we can start talking about colors and tones and patinas and aging and damage, etc."

Production artist Courtney Cotes points out an important step in the process: "Whenever you put these pieces of armor on somebody, you've got to make sure they can move. So, if you have something that's colliding with other parts, you've got to figure out where those collisions are and make adjustments. Then we can go back and add the detail, creating texture maps and various other model parts off artwork that we've received, to create the filigree and motifs."

Because of the sheer scale of the armor build, Justin Raleigh's crew came in to assist the costume department. "We had close to 150 sets of armor that we created, between three different aesthetics," Raleigh says. "We created the 'flashback' version [from the time of the King], and that's that really beautiful, oil-rubbed bronze, with the natural blue-green patina, very dark, with a nice luster to them

▼ ▶ Front and back of the modern, Regency-era armor. Note the heavy scarring and repainting.

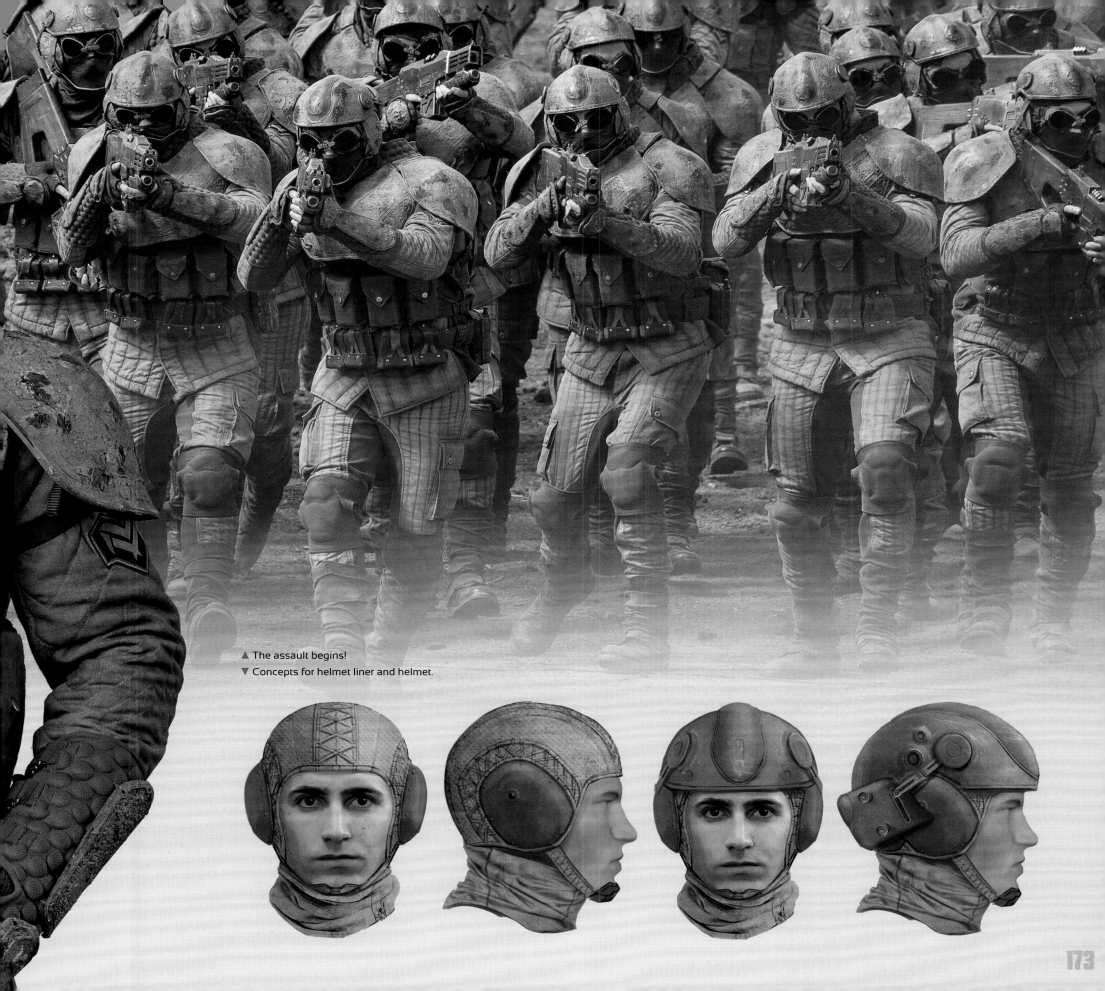

▲ The assault begins!
▼ Concepts for helmet liner and helmet.

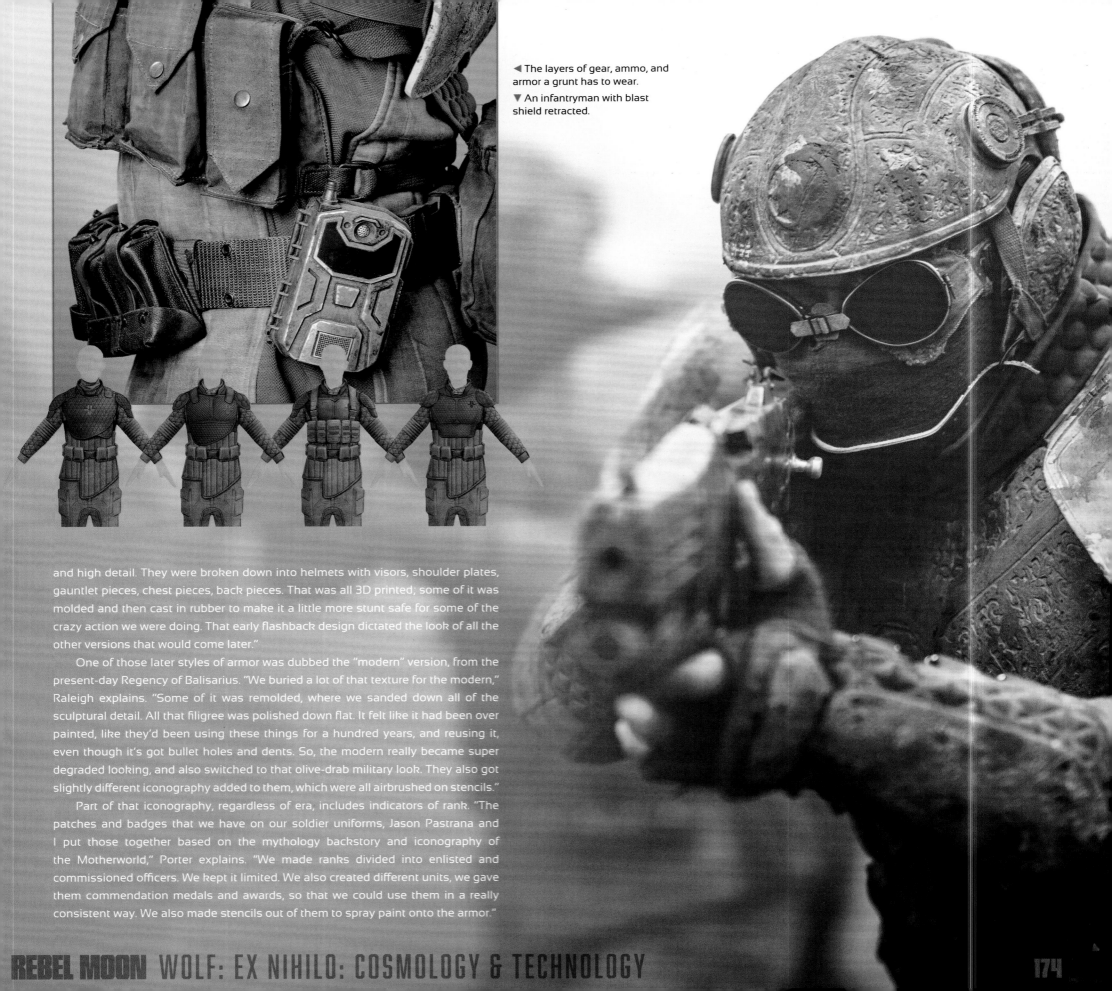

◀ The layers of gear, ammo, and armor a grunt has to wear.
▼ An infantryman with blast shield retracted.

and high detail. They were broken down into helmets with visors, shoulder plates, gauntlet pieces, chest pieces, back pieces. That was all 3D printed; some of it was molded and then cast in rubber to make it a little more stunt safe for some of the crazy action we were doing. That early flashback design dictated the look of all the other versions that would come later."

One of those later styles of armor was dubbed the "modern" version, from the present-day Regency of Balisarius. "We buried a lot of that texture for the modern," Raleigh explains. "Some of it was remolded, where we sanded down all of the sculptural detail. All that filigree was polished down flat. It felt like it had been over painted, like they'd been using these things for a hundred years, and reusing it, even though it's got bullet holes and dents. So, the modern really became super degraded looking, and also switched to that olive-drab military look. They also got slightly different iconography added to them, which were all airbrushed on stencils."

Part of that iconography, regardless of era, includes indicators of rank. "The patches and badges that we have on our soldier uniforms, Jason Pastrana and I put those together based on the mythology backstory and iconography of the Motherworld," Porter explains. "We made ranks divided into enlisted and commissioned officers. We kept it limited. We also created different units, we gave them commendation medals and awards, so that we could use them in a really consistent way. We also made stencils out of them to spray paint onto the armor."

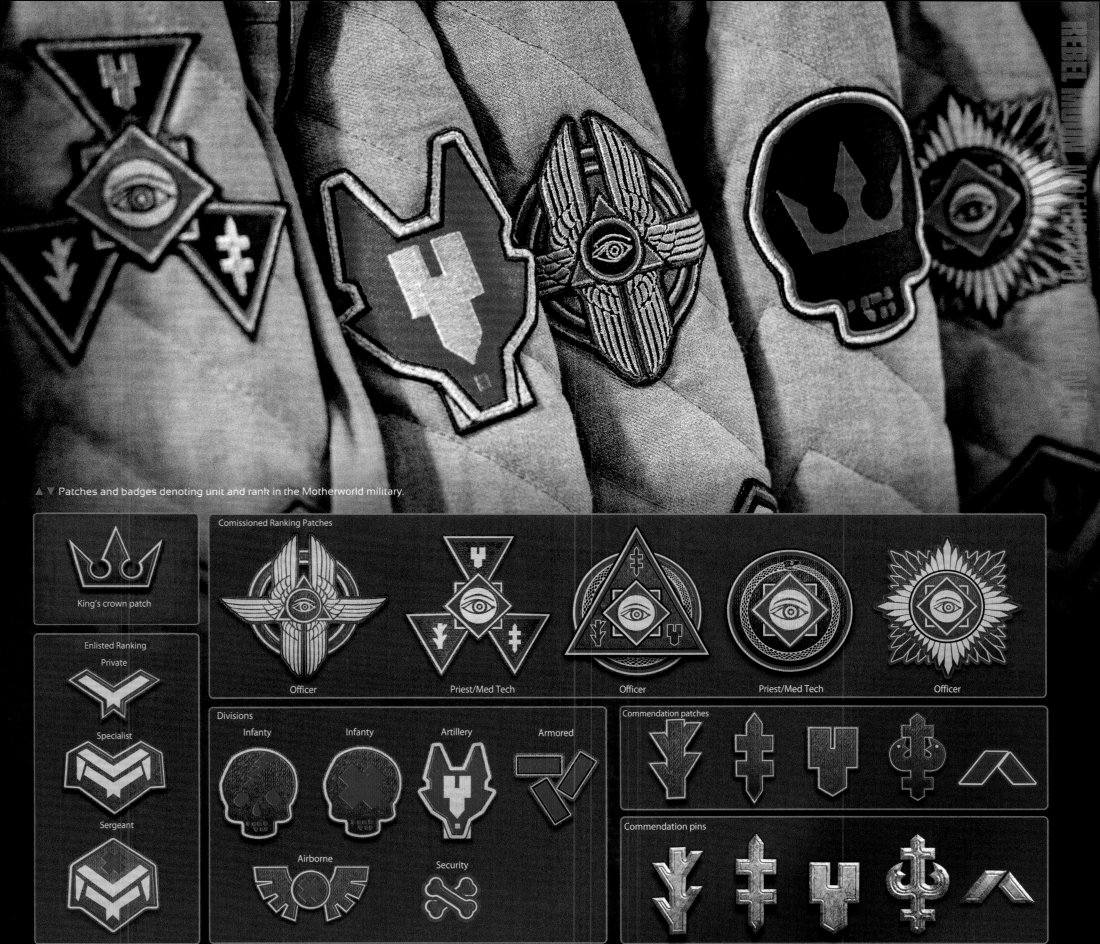

▲ ▼ Patches and badges denoting unit and rank in the Motherworld military.

King's crown patch

Enlisted Ranking

Private

Specialist

Sergeant

Comissioned Ranking Patches

Officer

Priest/Med Tech

Officer

Priest/Med Tech

Officer

Divisions

Infanty

Infanty

Artillery

Armored

Airborne

Security

Commendation patches

Commendation pins

KRYPTEIAN GUARD

THE THIRD VERSION of the Motherworld armor belongs to that elite corps of the military, the Krypteian Guard. "We took the really beautiful, pristine, flashback armor, and then did a black-on-black version of it, like a tactical version. It's varying degrees of black—sections of matte black, sections of gloss black—and then we did some degrading, bullet hits, all that kind of stuff, but it's basically the same armor," Raleigh says.

However, it is the weaponry—both ranged and melee—that the Kryteians employ that truly sets them apart. Their standard firearm, for example, is the heavy. "We gave that to both the Jimmys and to the Krypteians, figuring that this gun was so big you'd need to be one of the super soldiers to deal with it," Elliott says. For close combat, "They have their oracle-steel swords, that are externally powered," Snyder explains. "There's a little power unit on them. Clumsy wiring, crude. Those are unlike Nemesis's swords, which are made of the same kind of metal but are more elegant because her power source is her. She's more in harmony with her swords. The Krypteians have had to retrofit and glue things on to make them work, and so defile the beautiful symmetry of the thing. That's why they wear those gloves, so they can hold the swords. It's kind of like an oven mitt."

▶ A Krypteian (Richard Cetrone) readies his oracle steel blade.

◀ Concept for pristine, flashback Krypteian armor with blast shield down.

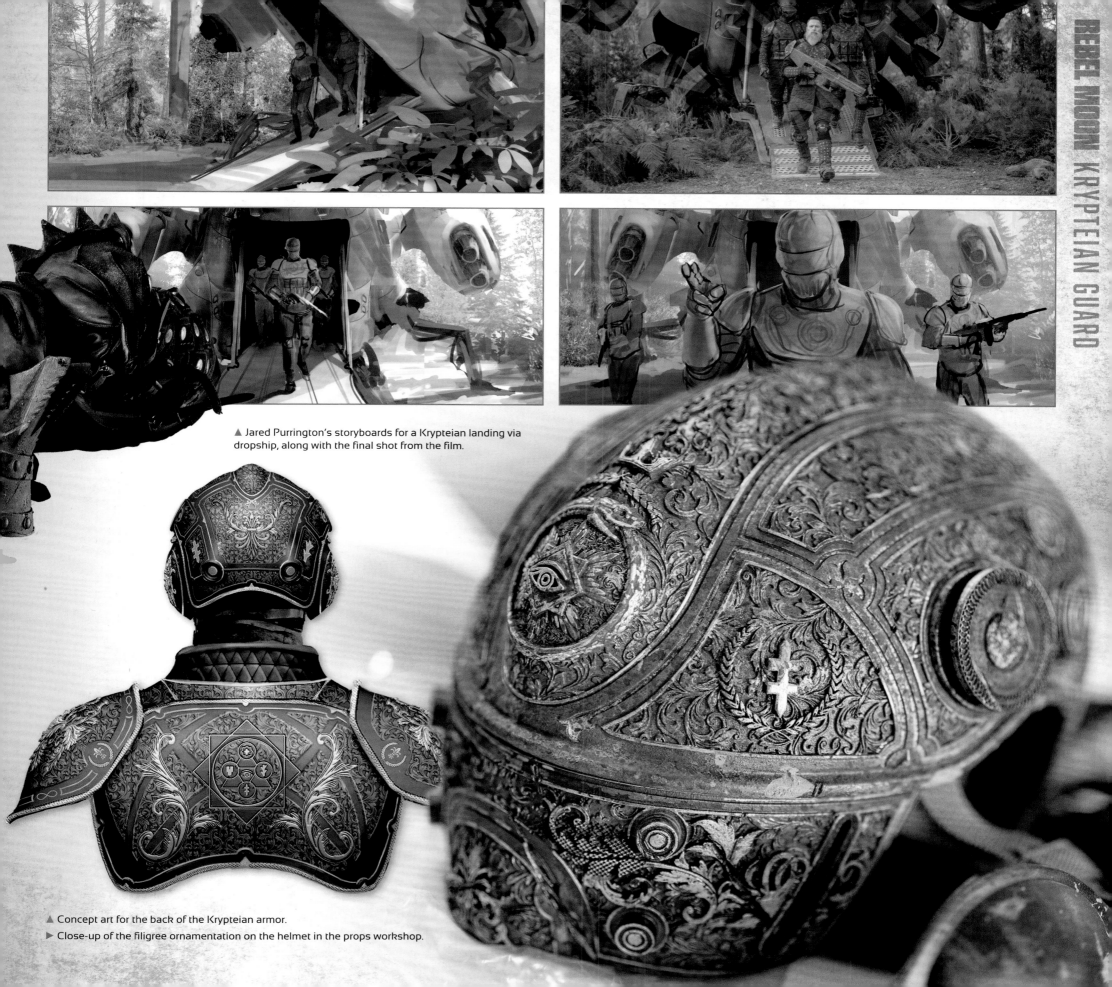

▲ Jared Purrington's storyboards for a Krypteian landing via dropship, along with the final shot from the film.

▲ Concept art for the back of the Krypteian armor.
▶ Close-up of the filigree ornamentation on the helmet in the props workshop.

TECHNOLOGY
MECHANICAS MILITARIUM

CALLED "JIMMYS" somewhat derisively by the human troops of the Motherworld, the battle robots of the Mechanicas Militarum faithfully served the King for untold eons. With the death of the entire Royal Family, however, those to whom they had sworn their loyalty were no more, and the Jimmys laid down their weapons and refused to fight any longer. Unable to reprogram them, the modern military uses these once super soldiers for menial tasks, such as moving supplies or digging trenches. "I wanted them to feel like ancient robots. I really wanted to give them a sense of time and a sense of history," Snyder explains. "I also didn't want them looking like a human, as in features, or skin, or anything like that."

"Jimmys were originally supposed to be all visual effects, but Zack really loves having something practical in camera as well, says Raleigh, recalling the lengthy cooperative process for developing the Jimmy suit. "Stephanie [Porter] and her team did the conceptual work, but we did all the manufacturing, and 3D printing, and painting. We worked in tandem with the art department and visual effects to develop that character, and we hired Aaron Sims' company to come in and help us with a lot of the 3D modeling and the detail work. We could provide all of those non-functional, more static components—the hard plates and so on— then everything in between that, a functional gear, or anything that's moving, or anything cutting into the human body, becomes visual effects. You put that all together onto somebody who could actually wear this thing, a big, 3D-printed suit of armor. I would say three-quarters of what you will see will be practical from the knees up, and then the rest will be digital on top of that character. I think the whole suit probably weighed twenty-five pounds when he was wearing it.

◀◀ Filming a moment of Jimmy's awakening in the fields of Veldt.
◀ A 3D model of a Jimmy in fairly pristine condition.
▶ Dustin Ceithammer in hybrid mocap/Jimmy armor.

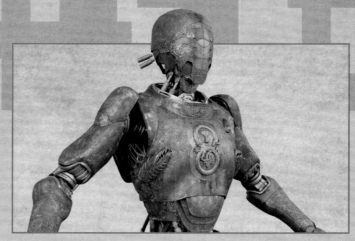

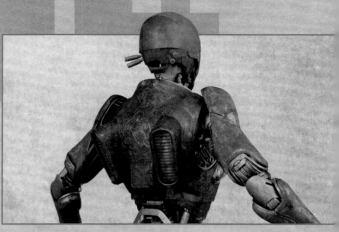

"It was a straight up robot: big mechanical joint elements, big mechanical waist elements, a lot of very large shells that make up the torso, the shoulders, the forearms, and the head. It has this really beautiful filigree to it, like incredibly ornate sculptures. A medieval, wax-acid etch look to it, but all raised, fine detail. It also has a bit of this Russian-esque, 1800s vibe in a lot of the aesthetics. It's got these beautiful serpent/fish heads that come up its chest," Raleigh says. Production designer Stefan Dechant adds, "A lot of the facial work came from Aaron Sims, but Chris Glenn designed all that filigree, based on the iconography that had been laid out."

As with the infantry armor, the history of the Mechanicas Militarum is written plainly on the Jimmys for all to see. "In our flashback world, they have this oil-rubbed bronze patina to them. There's a lot more luster, and you can really read all the details and textures. They feel very pristine. Flash forward to where we are now, it's a bit more cobbled together. Zack wanted it to feel gritty, really worn in. They did some repairs to it, and it feels heavily corroded and repainted. All that beautiful patina is buried in that olive-drab, modern paint.

Then we did a bunch of distressing and aging on top of that: Anywhere you would see plates sliding over each other, they're polished down and abraded, over years of rubbing against each other," Raleigh says.

In addition to the army of artists who crafted the suit and its CG elements, a few more individuals were necessary to bring the Jimmys to life. "We ended up getting Dustin Ceithamer, who's six foot eight and about 150 pounds. He perfectly fit inside this design, because you need a very slim person to deal with how thin the waist is, and how thin some of the joints are," Raleigh explains.

To help Ceithamer emote through a closed-off helmet there was a light-up display. "He's got about a dozen individual lights down his face, and that's all programmable. Our DMX team on the set could actually control the lighting, turn them on or off, make individual eye lights, or whatever Zack wanted on the day or whatever VFX needed for interactive light with other people. Honestly, it's a really beautiful character, and when you put [Sir Anthony] Hopkins' voice into this as well, it's very unique, very cool," Raleigh says.

TECHNOLOGY
MECHS

THE GENERAL DESIGN
of the Motherworld's crawling tanks was settled rather early, but still proved a challenge as requirements evolved during filming. "Those mechs were, again, from one of those Zack/Jared [Purrington] sessions," Dechant explains, "and we always thought it was going to be rendered digitally, so we put it on the back burner. We had a second pass that was done by Daniel Frank. We played around with the different types of legs. Then Zack said, 'I want to go inside. We'll repurpose the cockpit from the launch.' So, we repurposed the shell, and added a new interior, so that it felt like a completely different ship. We took that element and built the exterior. We had a rough scale that we worked out between Zack and VFX, and we did a final refinement pass, this time with Chris Glenn. But it all came from the original Jared/Zack sketch."

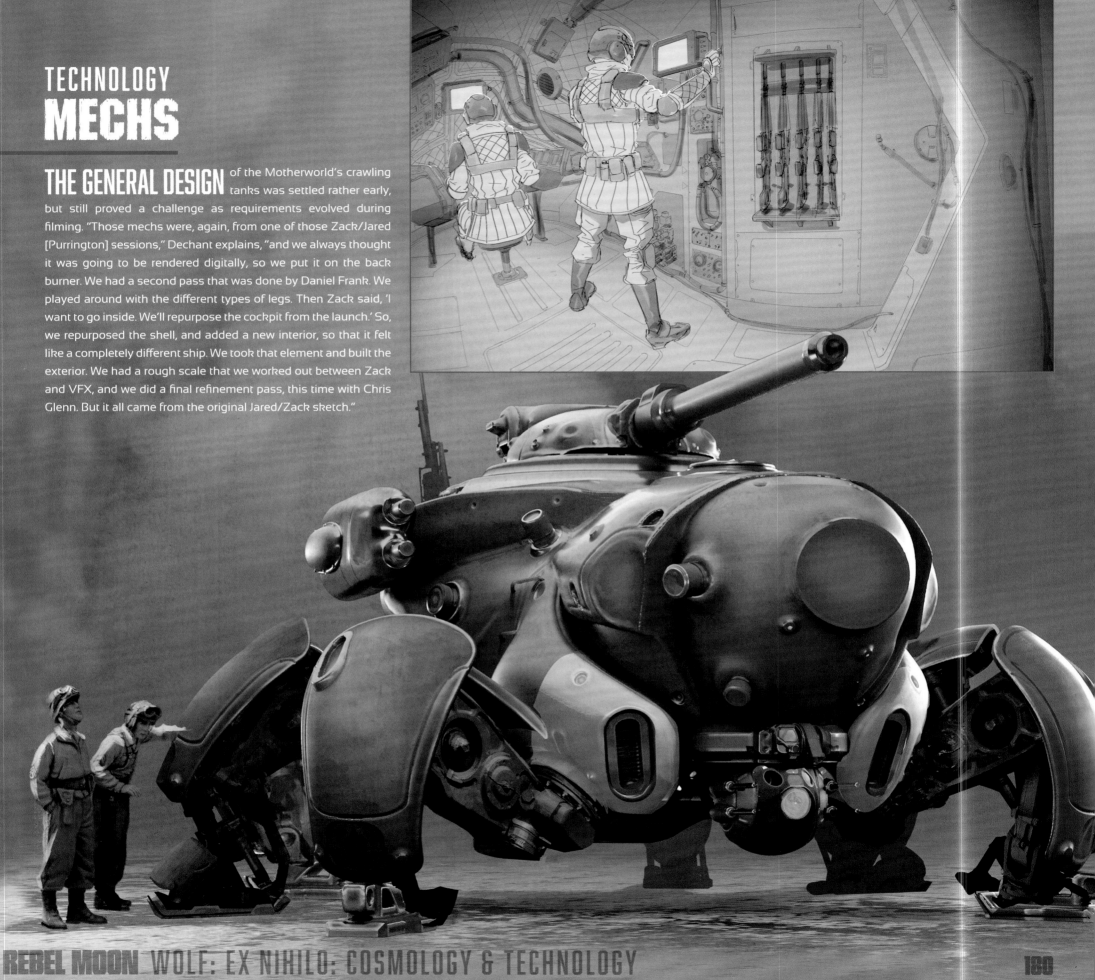

◀▲▼ Concept art and digital models for the mechs.

▼ Redesign of the forward ball turret with lengthened gun barrels.

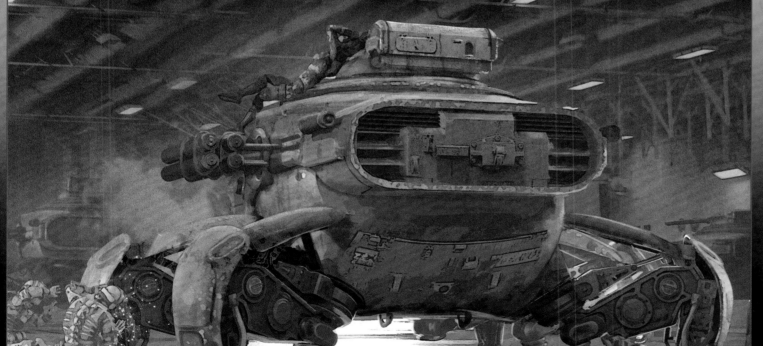

NEW TURRET

3' 6"

NEW TURRET

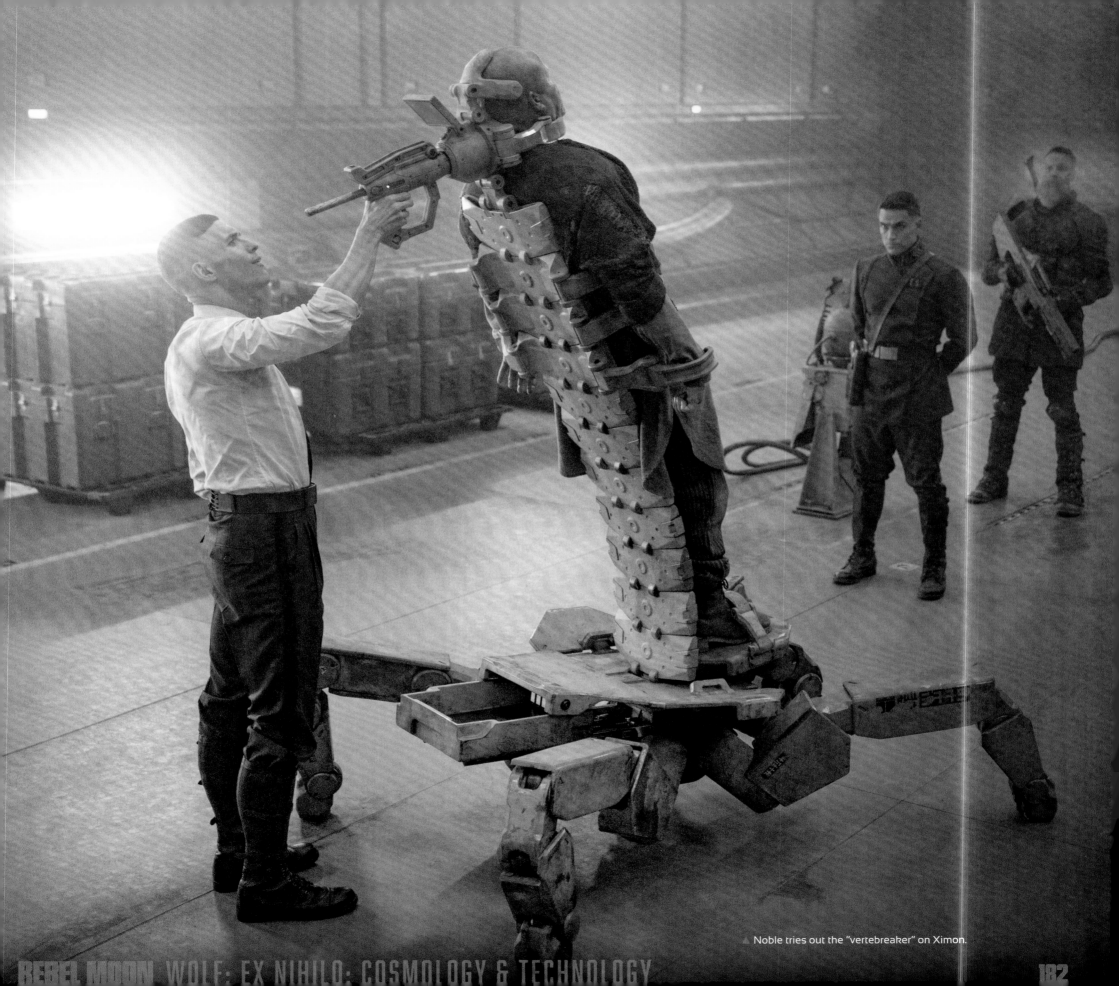

▲ Noble tries out the "vertebreaker" on Ximon.

EXOSKELETAL RESTRAINTS

HUNTING BOUNTIES across the Realm, Hawkshaws need a way to control dangerous prisoners for delivery. That need birthed the scorpion-like exoskeletal restraints (also called "Beetlejuice chairs" by the crew; look for "BJC" in Imperial script on the back). Along with the neck-snapping bolt gun (aka "the vertebreaker"), these hideous devices make sure that no one in their custody can give them any trouble. "We built five of those with the help of Weta Workshop," prop master Brad Elliott says. "We built them to be adjustable, as they needed to be able to handle actors who ranged from five-foot-four to six-foot-three. They had to be modular, so the legs could come off, and they had to be safe enough to hold a person who was struggling against it—and be able to get these people out of these chairs quickly. They're really quite constricted. Originally, they were going to come out of crates, then Zack decided they were also the crates, much like a Transformer. That's a puzzle that [VFX supervisor] Marcus [Taormina] will solve in post."

Making one of these restraints travel down the street in Providence in real time, however, was a puzzle the special effects department solved with a modified motorized scooter. "We made carriages that sat on top. It can run on dirt and mud and then on stage also," special effects supervisor Michael Gaspar explains. "We put a track down part of that street. We had a guide so we could run it without trying to steer it. It's sort of like Autopia at Disneyland, but it was tight so it couldn't wobble around."

▲ Filming Noble's capture of Kora on the Gondival docks.

▲ Hawkshaws transport Ximon (Christopher Matthew Cook) through the streets of Providence.
▼ Snyder's storyboards for the interrogation of Ximon.

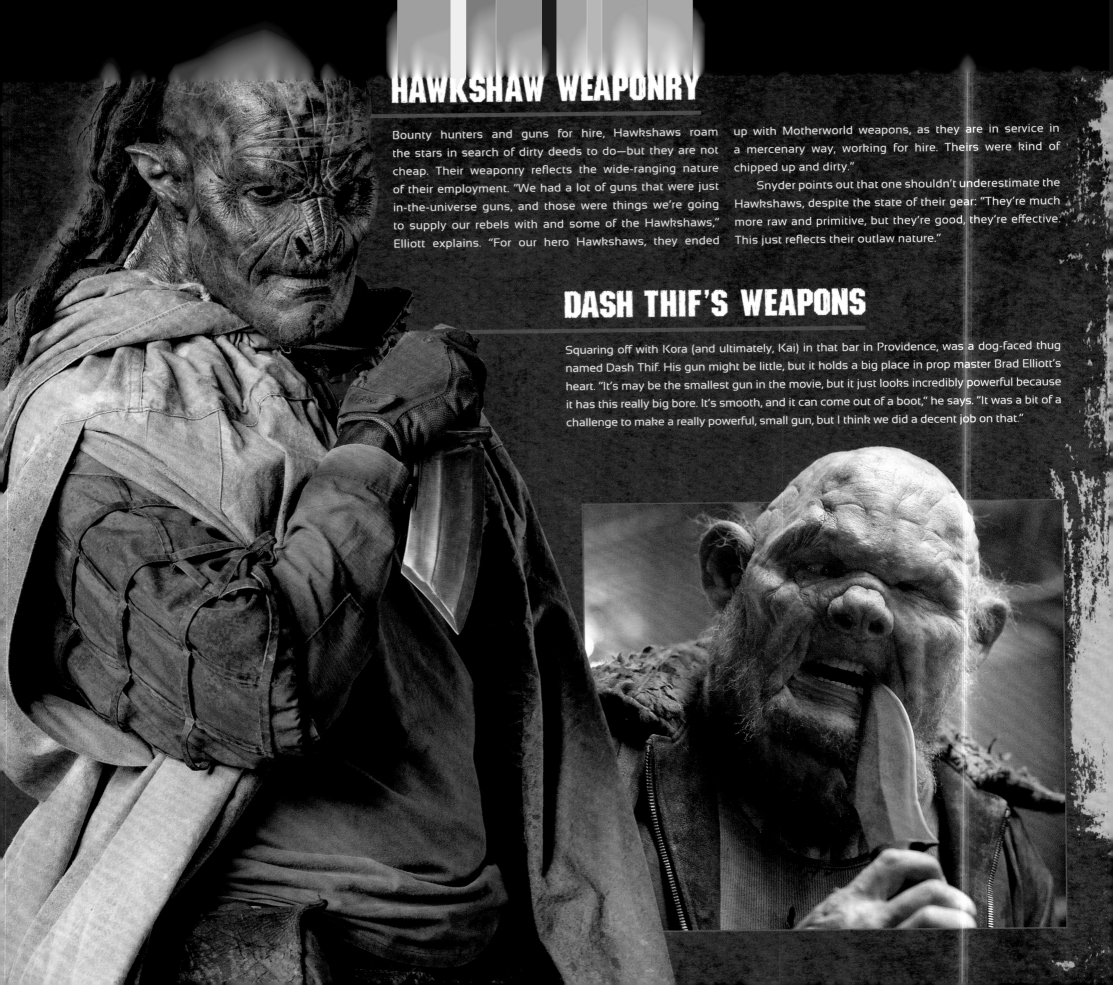

HAWKSHAW WEAPONRY

Bounty hunters and guns for hire, Hawkshaws roam the stars in search of dirty deeds to do—but they are not cheap. Their weaponry reflects the wide-ranging nature of their employment. "We had a lot of guns that were just in-the-universe guns, and those were things we're going to supply our rebels with and some of the Hawkshaws," Elliott explains. "For our hero Hawkshaws, they ended up with Motherworld weapons, as they are in service in a mercenary way, working for hire. Theirs were kind of chipped up and dirty."

Snyder points out that one shouldn't underestimate the Hawkshaws, despite the state of their gear: "They're much more raw and primitive, but they're good, they're effective. This just reflects their outlaw nature."

DASH THIF'S WEAPONS

Squaring off with Kora (and ultimately, Kai) in that bar in Providence, was a dog-faced thug named Dash Thif. His gun might be little, but it holds a big place in prop master Brad Elliott's heart. "It's may be the smallest gun in the movie, but it just looks incredibly powerful because it has this really big bore. It's smooth, and it can come out of a boot," he says. "It was a bit of a challenge to make a really powerful, small gun, but I think we did a decent job on that."

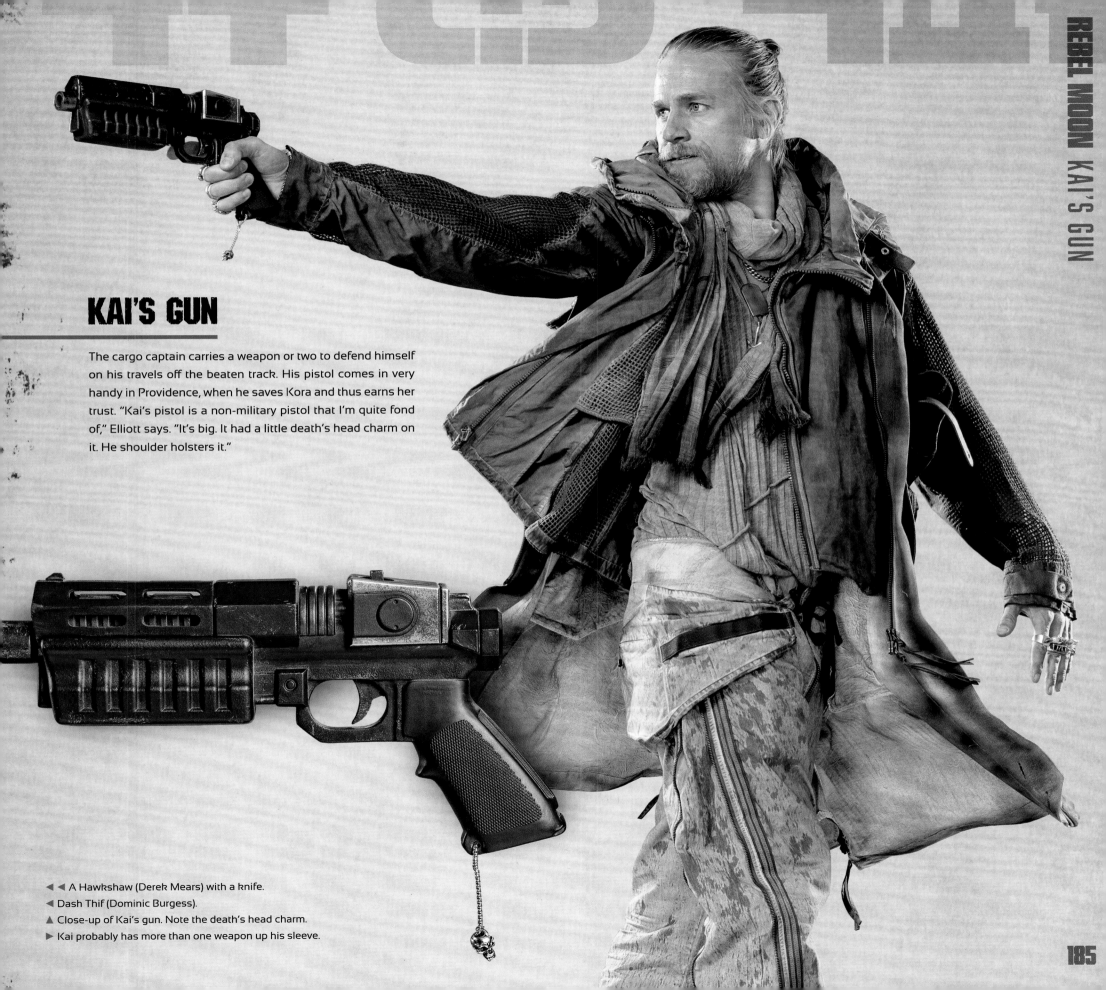

KAI'S GUN

The cargo captain carries a weapon or two to defend himself on his travels off the beaten track. His pistol comes in very handy in Providence, when he saves Kora and thus earns her trust. "Kai's pistol is a non-military pistol that I'm quite fond of," Elliott says. "It's big. It had a little death's head charm on it. He shoulder holsters it."

◄◄ A Hawkshaw (Derek Mears) with a knife.
◄ Dash Thif (Dominic Burgess).
▲ Close-up of Kai's gun. Note the death's head charm.
► Kai probably has more than one weapon up his sleeve.

INSURGENT WEAPONRY

LIKE THE HAWKSHAWS,
the Insurgents carry a mix of firearms, including a few Motherworld models, though of course those weren't issued to them. "Some of the rebels carry Motherworld weapons, because we figured that they would've captured some of them," Elliott says. "We tweaked them a little bit, like we gave them a leather wrap around the handle. We made some indication on a lot of those guns of how many kills they had by tying little bones to them, like trophies; they take finger bones or something from the officers, or somebody in a pillbox you made an amazing kill shot on. It's the same idea as Vlad the Impaler, who used to put human heads on pikes. It's that shock value."

MILIUS'S GUN

This Insurgent-turned-idealist follows Darrian Bloodaxe's lead to help Kora and her cause, and ends up following her all the way back to Veldt. "When E. Duffy came in to do a fitting for the mining backpack very early on, I asked them if they'd like to look at some of these weapons to see if any of them spoke to them," Elliott recalls, "and they picked my favorite of those we originally built as background guns. It's a fairly short weapon, because they're not real big, and it has a very open stock that almost looks like it has a pneumatic piston as part of the stock's construction. We made that a hero weapon: We tied some finger bones to it and wrapped it in leather, and made it special just for that character."

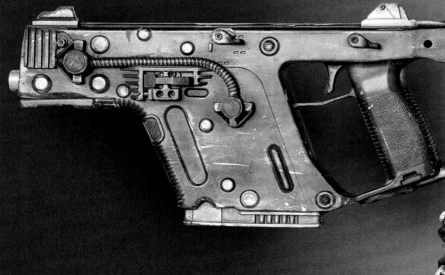

▶ Milius's gun is as unique and effective as they are.
▲ Note the customization and finger-bone trophies.

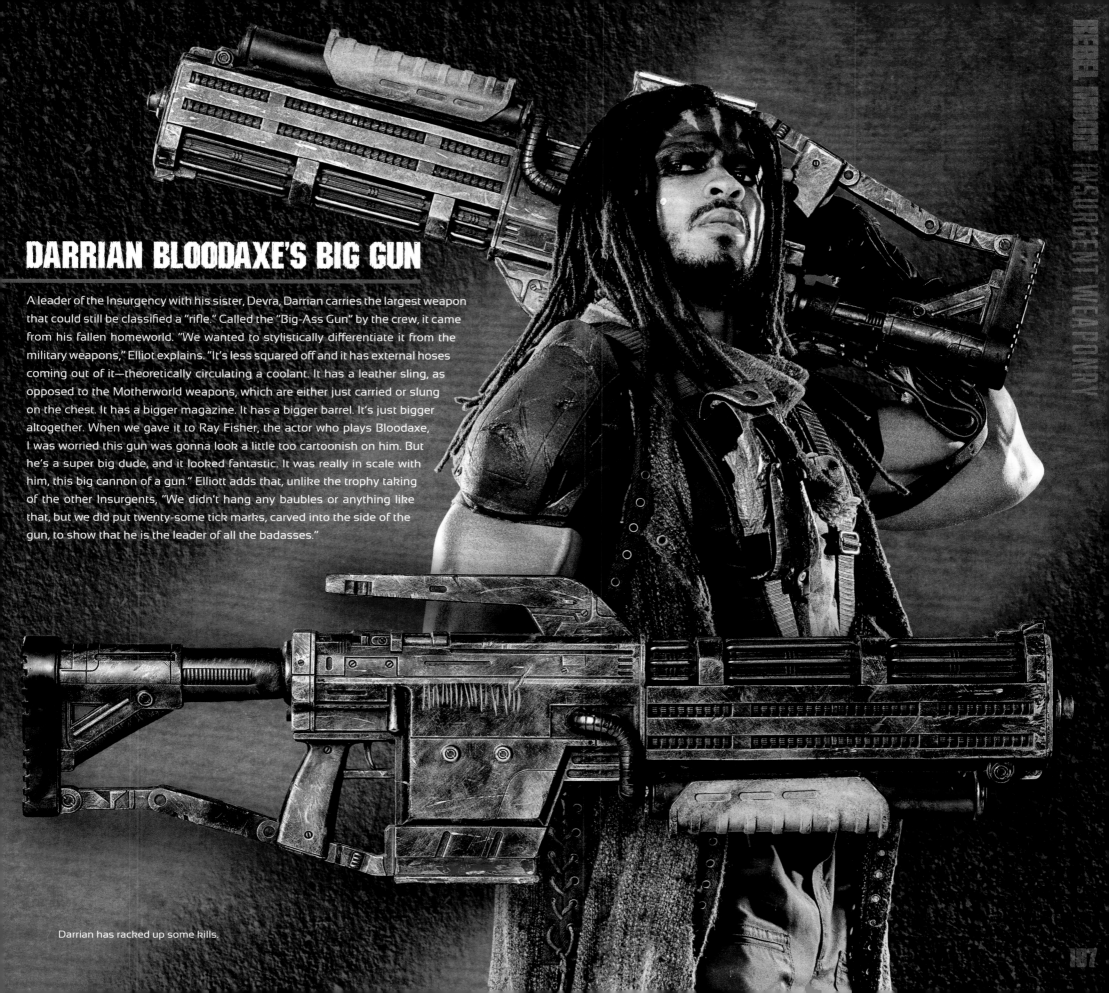

DARRIAN BLOODAXE'S BIG GUN

A leader of the Insurgency with his sister, Devra, Darrian carries the largest weapon that could still be classified a "rifle." Called the "Big-Ass Gun" by the crew, it came from his fallen homeworld. "We wanted to stylistically differentiate it from the military weapons," Elliot explains. "It's less squared off and it has external hoses coming out of it—theoretically circulating a coolant. It has a leather sling, as opposed to the Motherworld weapons, which are either just carried or slung on the chest. It has a bigger magazine. It has a bigger barrel. It's just bigger altogether. When we gave it to Ray Fisher, the actor who plays Bloodaxe, I was worried this gun was gonna look a little too cartoonish on him. But he's a super big dude, and it looked fantastic. It was really in scale with him, this big cannon of a gun." Elliott adds that, unlike the trophy taking of the other Insurgents, "We didn't hang any baubles or anything like that, but we did put twenty-some tick marks, carved into the side of the gun, to show that he is the leader of all the badasses."

Darrian has racked up some kills.

VELDT FARMER WEAPONS

THE FARMERS on Veldt lead an exceptionally peaceful existence, but that doesn't mean they are without weapons. After all, game is plentiful in the wilds, and more than a few villagers are crack shots with their locally produced hunting rifles. "We tried to find some different form factors," Elliott explains, "as far as cutting away parts of the stocks and things like that. Zack wanted to put some customizing beading on them or little brass rivets, like you might find among the early Native Americans and how they adorned some of their rifles. None of our rifles have scopes; they all have iron sights. They have those little vents in the side to deal with the heat. They have very long barrels, and we imagine they shoot a really powerful round. So, if the Motherworld gun shoots the equivalent of a .223 at a high rate of fire, these hunting rifles would shoot something more like a .45 caliber or .50 caliber round. To tame them down, we had to make them single-shot guns, so that they weren't overpowered."

Elliott describes the somewhat complicated loading process: "We gave them five orders of operation to load. You have to flip up the rear sight, then you rock up the side panel, and then you put this little puck in—a hard, condensed bit of fuel that's like caseless ammo. Then you close the side, and close the rear sight. It's one, two, three, four, five, and then you can shoot, boom! There's no ejection."

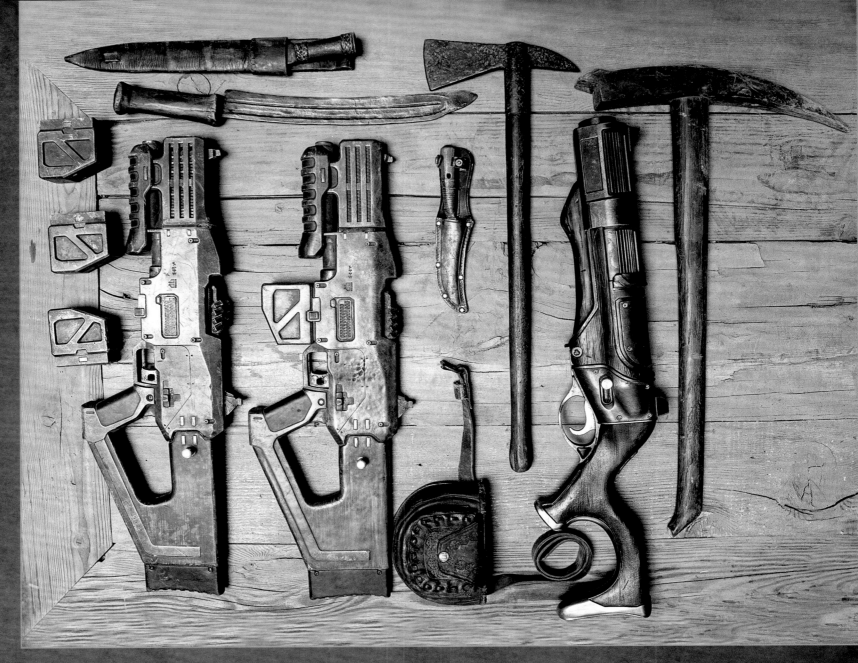

◄ Sam prepares to unleash her blunderbuss.

▲ An assortment of some of the things the Veldt villagers have gathered to defend themselves with.

The villagers also have a firearm that one imagines dates back to the earliest days of the settlement, when encounters with dangerous wildlife were more common. "The blunderbuss is maybe one of my favorite guns in the movie, because it was something I had suggested to Zack as a way to give a really powerful [character] moment," Elliott says. "It's got that really wide barrel, with a bore that's maybe two and a half inches, or something like that. Again, we gave it an order of operations to load, because we didn't want it to just go boom, boom, boom, boom, like it's a repeating grenade launcher. There was a switch in the back that opened the breach. You load one of these solid charge fuel things in, which was larger than those in the hunting rifles by almost double, then you close the breach, and pull back the bolt, and then you're ready to shoot."

Finally, when forced to defend themselves, the villagers also resort to the simple farming implements they've used their entire lives. But that

didn't mean the filmmakers needed to invent a more science-fantasy version of the pitchfork. "We're always working in service of story and character. You never want a prop to become so distracting that people are noticing it too much and it takes them out of the story," Elliott explains. "We didn't reach for anything crazy. Machetes are machetes, and hand sickles are hand sickles. We used regular scythes, because that thing has been around for hundreds and hundreds of years and we're probably not going to do a better job. We took some World War II trench tools and elongated the handles so that they were similar and not distracting, but they had a T-handle, which was just a slightly different look for a big shovel. We also had one shovel that was hand carved out of wood and then clad in certain places on the spade with metal, which made it really unique."

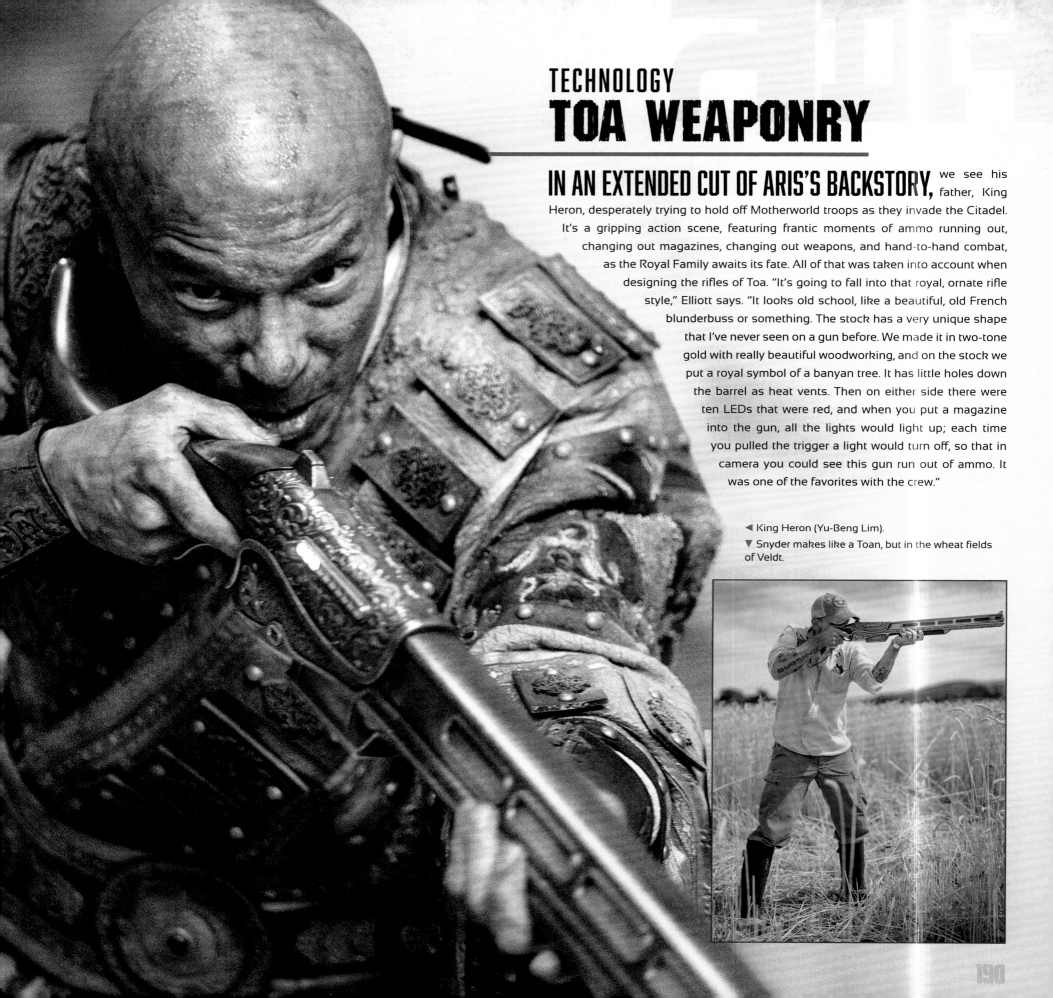

TECHNOLOGY
TOA WEAPONRY

IN AN EXTENDED CUT OF ARIS'S BACKSTORY, we see his father, King Heron, desperately trying to hold off Motherworld troops as they invade the Citadel. It's a gripping action scene, featuring frantic moments of ammo running out, changing out magazines, changing out weapons, and hand-to-hand combat, as the Royal Family awaits its fate. All of that was taken into account when designing the rifles of Toa. "It's going to fall into that royal, ornate rifle style," Elliott says. "It looks old school, like a beautiful, old French blunderbuss or something. The stock has a very unique shape that I've never seen on a gun before. We made it in two-tone gold with really beautiful woodworking, and on the stock we put a royal symbol of a banyan tree. It has little holes down the barrel as heat vents. Then on either side there were ten LEDs that were red, and when you put a magazine into the gun, all the lights would light up; each time you pulled the trigger a light would turn off, so that in camera you could see this gun run out of ammo. It was one of the favorites with the crew."

◄ King Heron (Yu-Beng Lim).
▼ Snyder makes like a Toan, but in the wheat fields of Veldt.

HOLOGRAPHIC TRANSMITTER

Holographic transmission is the preferred mode of two-way communication across vast distances in the Motherworld military, and they have several devices to achieve it. For example, aboard *The King's Gaze* there is a space-saving model on the bridge that pulls down and flips open. Troops in the field are issued the newest portable version. Hawkshaws make do with similar but slightly clunkier, older portable designs while on official business for the Realm.

HOVER GURNEY Although this is a simple transportation device used by medical technicians throughout the Motherworld fleet, a lot of thought went into its construction and look. Besides being motorized so it could be driven around like a remote-control car while being structurally sound enough to safely hold actors, it also needed to speak to the function-over-form approach of Motherworld technology. "Zack liked the idea of a gurney that looked very medical on top, with exposed technology underneath," Elliott explains. "It's not sleek. It's a little clumsy, much like the little power units on the Krypteian swords. It ties into the look of the ship, which has a lot of exposed piping and stuff."

AUTOMATIC DOORS One of the few technological luxuries the villagers on Veldt allow themselves is automatic doors. "We had electric slide-door actuators in Den and Hagen's houses, and also at the bar in Providence. We had a guy on a remote control when people walked up to the door, and it automatically slid open," Gaspar explains.

FLATBED HOVER WAGON

Another piece of advanced technology the Veldt villagers employ, hover wagons are useful for carrying equipment around the fields or hauling produce to market. Acquired in Providence, each probably represents a couple of seasons of profit from their wheat sales.

 Built by special effects, an ingenious method was devised not only to move it around the set quickly, but also to realistically simulate hovering. "Zack's really fast, and he doesn't like a lot of setup time," Gaspar says. "The wagon was big, sixteen feet long by eight feet wide, and weighed a couple thousand pounds. So, we designed it so that we could put it on an extended forklift, on any side, and push the arm out fifty feet. If you were walking on it, it would have that bounce to it, because it's cantilevered so far out. It's all practical."

▲ ▲ Filming Aris making a false progress report to Noble via holographic transmitter.
▲ Snyder's storyboards for that scene.
▼ Concept art model (left) and filming with the practical hover wagon prop in the Veldt wheat fields (right).

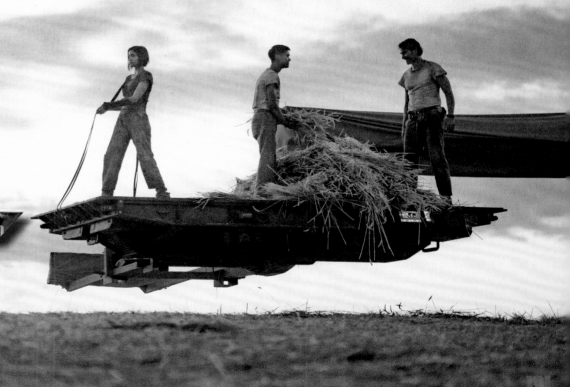

ACKNOWLEDGMENTS

WE WOULD LIKE TO EXTEND A SPECIAL THANKS to all the incredibly talented writers, actors, artists, designers, photographers, technicians, and countless other accomplished crew members, vendors, and partners who joined us on this epic journey. It is your combined talent, creativity, brilliance, and dedication that make it possible to create the expansive universe of an ambitious endeavor like REBEL MOON.

It was an amazing adventure making this film and we are incredibly thankful to have been able to go on this tremendous journey with each and every one of you.

We would also like to say thank you to everyone at Netflix for their enthusiastic support throughout the process, making the realization of this film possible.

Sincerely,

Zack, Debbie, Wesley & Eric

I WOULD LIKE TO THANK the filmmakers for this peek into Veldt, the Motherworld, and the rest of this fascinating universe they've created. This naturally includes the producers, but also the many, many department heads, cast, and crew who donated their invaluable time and quotes to making this book a reality.

Hats off and thanks to editor Jo Boylett and the team at Titan, including Nick Landau, Vivian Cheung, Laura Price, and designers Tim Scrivens and William Robinson, for all the guidance and the fantastic layouts.

Special thanks to Adam Forman at The Stone Quarry, who, with digital asset manager Chris Lipton, found the answers to all of my annoying questions.

Peter Aperlo